UPLAND
GAME BIRD
CARVING

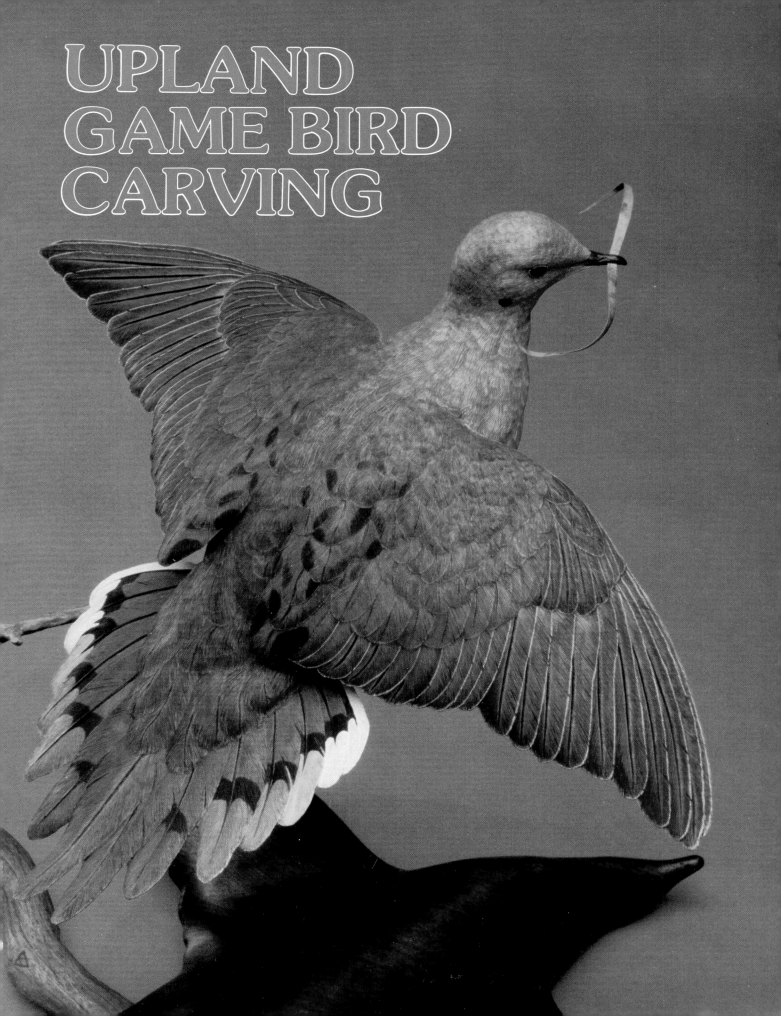

Other books by Rosalyn Leach Daisey

Songbird Carving

Songbird Carving II

Published by Schiffer Publishing, Ltd.
1469 Morstein Road
West Chester, Pennsylvania 19380
Please write for a free catalog.
This book may be purchased from the publisher.
Please include $2.00 postage.
Try your bookstore first.

We are interested in hearing from authors
with book ideas on related subjects.

Printed in the United States of America.
ISBN: 0-88740-349-2

Dedication

This work is dedicated to my father, Brady Leach, Sr., who passed away in November, 1990. Dad, your spirit touches my life daily!

Is This The Man?

Is this the man whose strength was so tangible it bound us together like a giant tether?

Is this the man whose fierce honesty sometimes frightened but never failed to challenge and inspire us?

Is this the man whose guidance and understanding allowed us the flexibility to develop our own styles without losing sight of common core values and principles?

Is this the man whose tenderness, though hidden with some, was always visible with his children?

Is this the man whose quiet love offered protection to grow up in a caring, warm and uncomplicated environment?

Yes, yes, this is the man—Our Dad!

A poem written by Dale Raciti, my sister, and read at our father's funeral in Southport, North Carolina, and at his memorial service in Wilmington, Delaware.

Schiffer Publishing Ltd

1469 Morstein Road, West Chester, Pennsylvania 19380

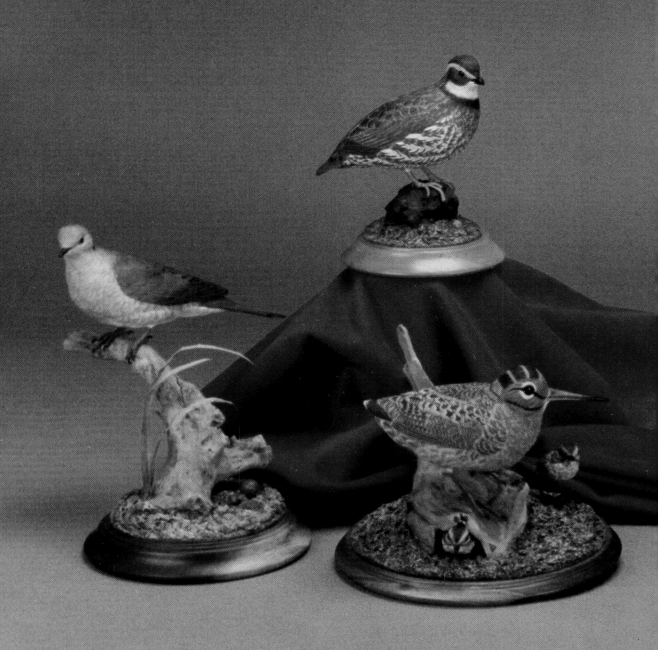

UPLAND GAME BIRD CARVING

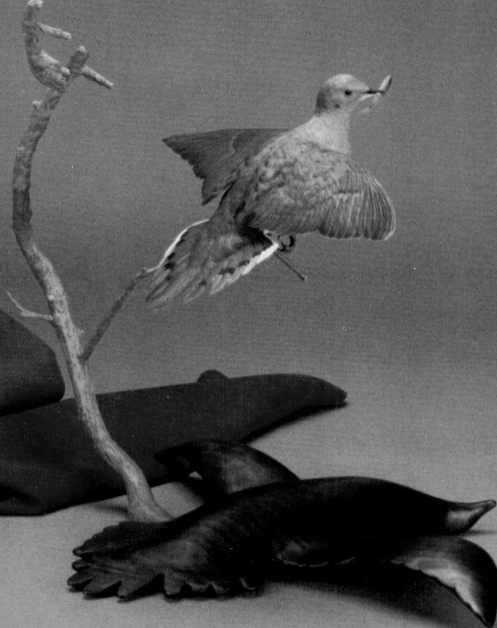

Rosalyn Leach Daisey

Acknowledgments

My very best thanks to all the students who attend my seminars. Your caring and support keep me going, and I thank you all!

My warmest thanks to my friend, Bill Veasey, who suggested lighting the flying mourning dove project. Thank you, Bill, for all of your help, suggestions, ideas, and constructive comments!

I wish to thank Roy DeWalt for his expertise on wiring and lighting. Thank you, Roy!

My thanks also go to Gene Hess of the Delaware Museum of Natural History for his helpful assistance. Thank you, Gene!

My warmest thanks to my friend, Chuck Lockwood, for finding and delivering that wonderfully wide piece of poplar that I used for the base in the flying mourning dove project. Thank you, Chuck!

My sincerest thanks to Jim Seibert for the location of the woodcock and quail. Thanks, Jim!

My warmest thanks to Ellen J. (Sue) Taylor and Douglas Congdon-Martin of Schiffer Publishing for their expert assistance and warm working environment. Both of these extremely talented people take my mumbo-jumbo work and turn it into a work of art! Thank you both!

I am most appreciative to both of my children, Jason and Jenna. I am blessed with two great kids, who care about the earth and all those that live here. Their enthusiastic and thoughtful support and understanding of my efforts in this project have been tremendous! Thank you, Jason and Jenna!

Contents

Introduction

There is something very magical that happens to people when they are carving birds! I feel it inside of me and I see it in the eyes of my students. It is as if there is a conductive path between the person and the bird with bits of energy traversing back and forth. If you want to feel this energy, pick up a bird blank and a sharp tool and start carving!

But you say, "Where do I start?" and "What do I carve away?" Open the pages of this book and just follow the instructions. Look at the drawings and pictures—I mean really look! Hold your bird up to the photographs and the drawings. What matches? What does not? Keep following the step-by-step instructions.

Finally, when the paint is dry, you will have a creation that you can be proud of! How do I know this? Because, from people at the wildfowl and art shows I go to and the letters and phone calls I receive, I hear that folks are now able to carve and paint birds that they are proud of!

Since *Songbird Carving, Songbird Carving II,* and *Shorebird Carving* have been published, I hear from people who had never carved before that they are now carving and have completed really good birds!

Upland Game Bird Carving is the same step-by-step instructional text as my previous three books. It includes five carving projects. The male mourning dove is a particularly fun project, not only because the bird has opened wings but also because it is lighted from within the branch of the piece. The perched dove, a female, is always one of my favorites because of the elegance of the dove itself. The complexity of the female woodcock is balanced with the simplistic cuteness of the chick project. And the challenging bobwhite quail has always intrigued me because of its interesting feather patterns. The illustrations, carving directions and explanations, and the photographs are five conclusive seminars in tangible form. The complete instructions will lead you through the carving, texturing and painting of all five projects.

Working on the projects themselves and the book has been a bunch of fun for me. Oh yes, there have been problems, but solving them with creative solutions has been part of the fun. If I seem enthusiastic, it is because I am! Carving a block of wood into a bird speaks to something inside of me that nothing else does! Does it speak to you? Let's get started!

Rosalyn Leach Daisey
Newark, Delaware

Chapter 1.
Gamebird Anatomy

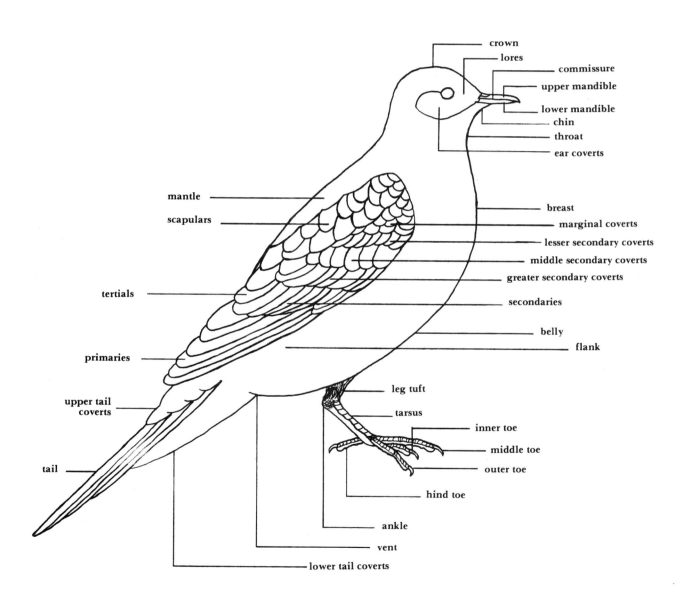

crown
lores
commissure
upper mandible
lower mandible
chin
throat
ear coverts

mantle
scapulars

breast
marginal coverts
lesser secondary coverts
middle secondary coverts
greater secondary coverts
secondaries
belly
flank

tertials

primaries

upper tail
coverts

tail

leg tuft
tarsus
inner toe
middle toe
outer toe
hind toe

ankle

vent

lower tail coverts

TOP PLAINVIEW

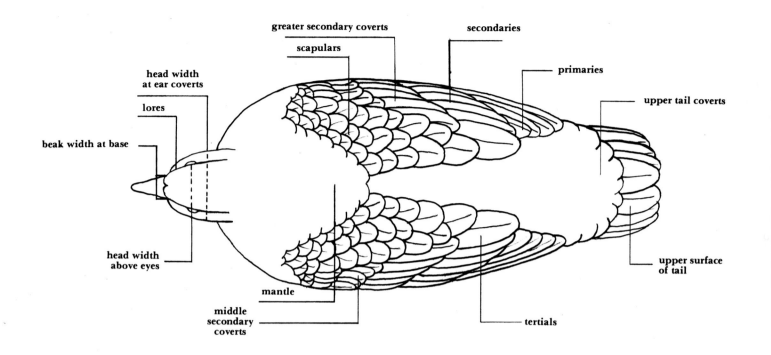

greater secondary coverts

scapulars

secondaries

primaries

head width
at ear coverts

lores

beak width at base

upper tail coverts

head width
above eyes

upper surface
of tail

mantle

middle
secondary
coverts

tertials

Under Planview

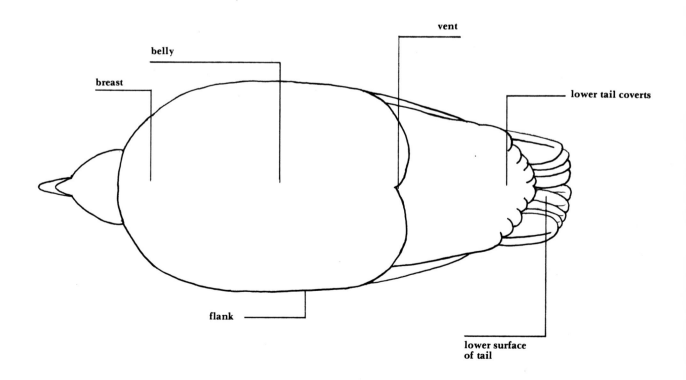

belly

vent

breast

lower tail coverts

flank

lower surface
of tail

WING FEATHER GROUPS

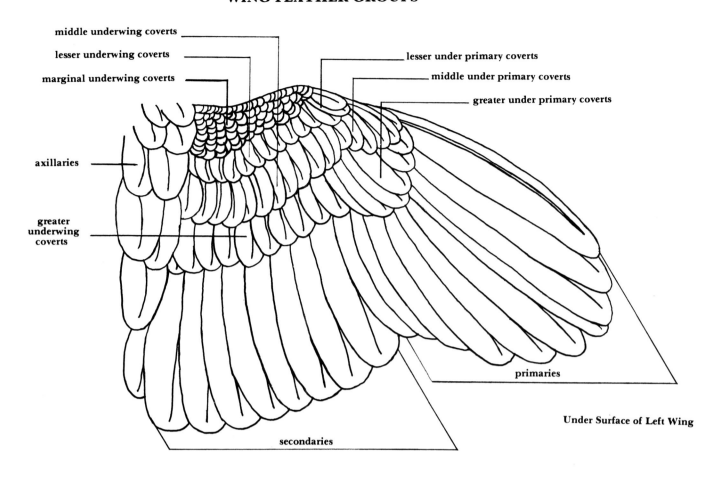

middle underwing coverts

lesser underwing coverts

marginal underwing coverts

lesser under primary coverts

middle under primary coverts

greater under primary coverts

axillaries

greater underwing coverts

primaries

secondaries

Under Surface of Left Wing

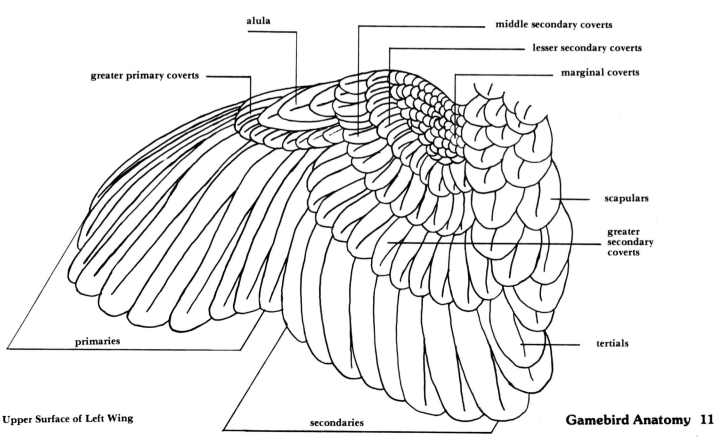

alula

middle secondary coverts

lesser secondary coverts

greater primary coverts

marginal coverts

scapulars

greater secondary coverts

primaries

tertials

Upper Surface of Left Wing

secondaries

Gamebird Anatomy 11

Chapter 2.
Basic Techniques

Feather Contouring and Stoning

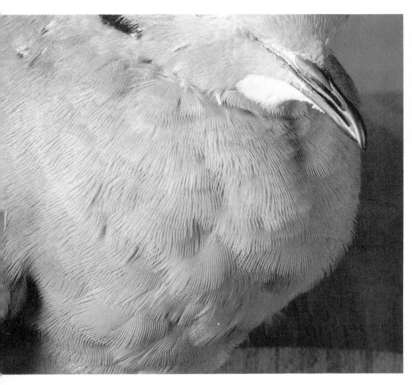

Figure 1. In the shadows underneath the beak, you can see the undulations of the fluffs of feathers. These undulations are called feather contouring, feather fluffs or landscaping, or "lumps and bumps." Close observation of live birds reveals this contouring. Not only is there convex contouring on groups of feathers, but even a single feather has that same contouring. Next time you are out for a walk, pick up a body feather, usually found underneath tree branches where a bird might preen, and really look at its surface. You will notice that it has a definite curvature from side to side and from base to tip. Imagine a bunch of this convex shaped feathers together—that's right, there's a feather fluff!

The neat thing about feather contouring on a carving is that there is no one right way to do it! When a live bird fluffs its feathers or preens, the feathers will be arranged differently each time.

Figure 2. When drawing in the contouring, letting your imagination take control will enhance the creativity of the shapes and patterns. Think in terms of flowing "S" curves and motion. Motion keeps the viewer's eye moving on the surface looking at various shapes. Creating interesting shapes will break up the monotonous surface of a breast, belly, upper and lower tail coverts, and even the head and neck. A variety of sizes, shapes, and contours is the goal. Most of us want to make both sides of the bird the same. On my own pieces, I have to force myself to make each side different in terms of sizes and shapes of contouring and also in terms of feather groups and flows.

One way that I have found helpful is to draw large sweeping curves on whatever surface is to be contoured. Then, break the large areas down into smaller areas with shorter flowing lines, remembering to vary the shapes. The important consideration here is to create areas of interest that enhance the fluidity, motion, and naturalness of the composition.

Figure 3. Channeling along the contouring lines will give the surface the low areas that are desired. Some people do all of the channels first and then come back and round over the mounds. Others do a few channels in a given area and round over these mounds before moving on to a new area. If you make all of your channels at one time, there is a tendency to make them all the same depth, when in actuality, you want the surface to have various depths. So, go back and deepen random channels. Once the channels are made, decide on a spot on each mound that will be the high point and then round down from there.

Lighting is very important to all of the carving and texturing procedures. First of all, if you cannot see it, you cannot carve or texture it! Whenever I am teaching a seminar, I will take the bird that I have demonstrated stoning on and shine the adjustable light across the texturing at a low angle. Then I move the light so that it is shining straight down on the texturing. The students are flabbergasted with the difference. The same principle holds true with contours, too. Light shining across the contours will allow you to see the undulations much more clearly than light shining straight down onto the surface. In the photo of the mourning dove above, the surface of the left side of the mantle and scapulars looks flat because the light is vertical to that part of the bird. Toward the middle of the mantle and more so on the right side of the bird, the contours become much more evident because the light is at a low angle to the surface.

Figure 4. When the rounding of the feather fluffs is completed, the surface will need smoothing. Use a worn cartridge roll sander. If you have a new one, wear it down a little on a scrap of wood before touching it to your bird. On large birds you can use a padded drum sander. On small and miniature birds, a fine stone can be used for smoothing. On every bird, there will usually be places that the sanders will not be able to reach. These are ideal places to use the stone.

Whatever means you decide to use to smooth, you will need to sand with the grain. Usually this means going down hill. For example, on the middle of the belly at the high point, the smoothest way to sand (or stone) is from the high point down towards the tail and then from the high point down towards the head. In the photo above, I have the bird turned with his head down so that I will be smoothing the wood by running the stone clockwise. Another example is on the top of the head. From the high point it will be smoother to sand down the back of the head and then down on the forehead. Naturally, there are exceptions! Wood is a swirly mass of grain sometimes. The grain changes in the wood sometimes. Also turning the head or tail in the wood will alter the direction for smoothest sanding or stoning.

The one thing that makes it easy to tell if you are going against the grain is that, with a good light shining across the surface, you can see the roughness. That means that it is time to turn it around and go the other way!

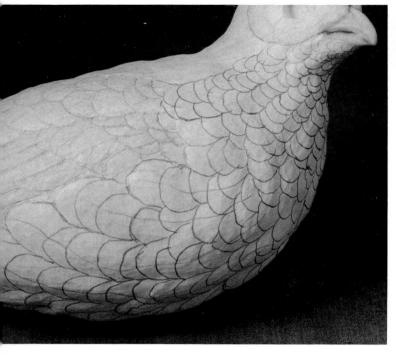

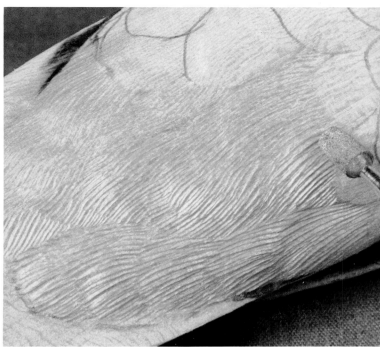

Figure 5. On the smooth surface, draw in the individual feathers. Vary the amount of the feather tips showing. Though feathers tend to form in rows, do not have "corn rows' all over the bird. By varying the amount of exposed feather and the tip's shape, you will create more interesting areas to look at.

Figure 6. When held at an angle to the wood's surface, the corner of the stone grinds away bits of wood. It is very important to keep stoning strokes close together so that there are no unstoned strips in between. Maintaining a consistent angle is also important. Laying the tool down too far or holding the tool too vertically creates lopsided stoning with one side of the groove or the other too long. Experiment to determine satisfactory grooves.

Stones of various shapes will create grooves with different angled sides. Most people find that some stones will give more life-like texturing on the end grain and others do a better job on the flat grain. Try different stones on the same area to determine which one gives the more natural look.

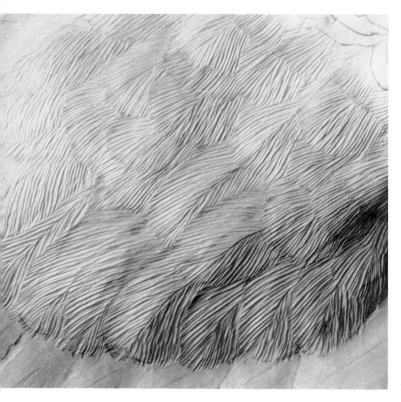

Figure 7. On larger feathers, a quill should be stoned in first and then the barbs. Maintaining curvature in the quills and the barbs will give a softer look to the feathering.

Start the stoning at the tip of whatever group you are working on. Texturing the feather on top of another one allows the upper stoned tips to cover the bases of the underneath one, much as the positioning of feathers on a real bird. Varying the depth of the stoned strokes enhances the fluffy appearance.

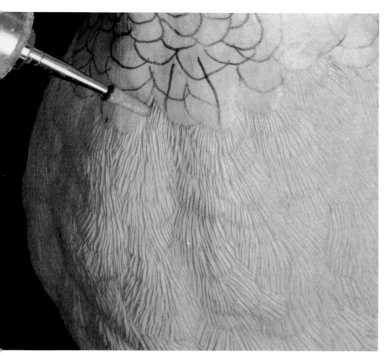

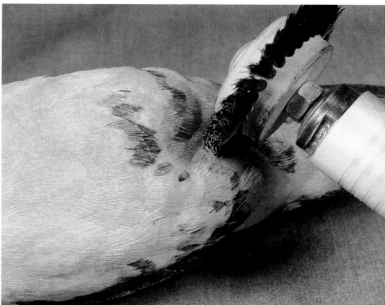

Figure 8. From the high point on the belly, the stoning progresses down the breast with the bird's head held down. For the breast and throat feathers, the stoned strokes will start at the tip of each feather and go toward its base.

Figure 9. All stoning should be cleaned up to remove the dust and fuzz. One tool that cleans up stoning nicely is the laboratory bristle brush. Its bristles even seem to get down into the grooves to clean the surface. Be careful not to burn the stoning away by pressing too hard or running the brush too fast. Occasionally on basswood, there will be fuzz that the brush does not whisk away. A burning pen will scorch this fuzz off.

Figure 10. Using defuzzer pads on a mandrel is another way of cleaning stoning. Again, use a light touch and low speed so that you do not whisk away the stoning.

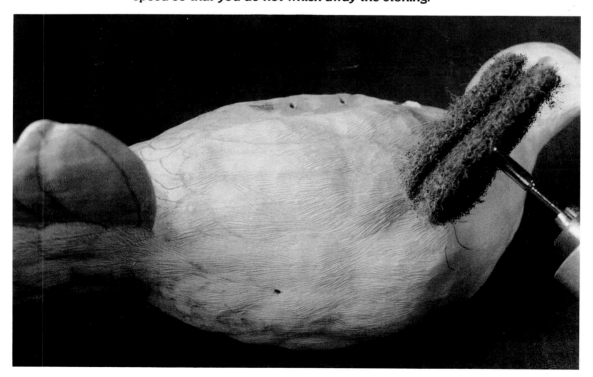

Burning

Burning in the barbs on feathers helps to create realism. The rheostat type of burning pen has a sharply beveled tip that will burn small grooves in the wood. Texturing the surface with "v" grooves from burning and stoning, I am convinced, enhances the soft quality of any carving because of the light reflection. One side of the "v" groove will reflect the light while the other will not. Viewing the carving from many angles will cause different light reflective values. Burning too deep will cause less reflection and a very difficult painting job.

As with stoning, burned strokes should be kept as close as possible with no flat unburned spaces in between. Each time you texture a bird, strive to tighten up the burning a little more so that eventually there are no microscopic flat spaces between the lines. As with any skill, practice improves the final result.

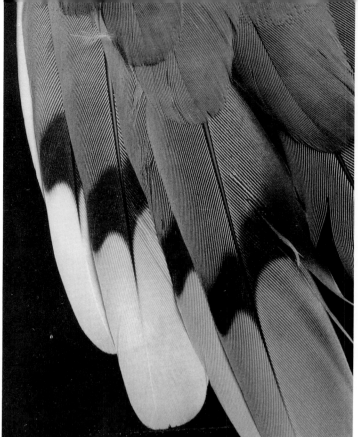

Figure 12. Note the angle and direction that the barbs come off the quill on the dove's tail feathers. As the barbs approach the feather edge, they curve down toward the tip.

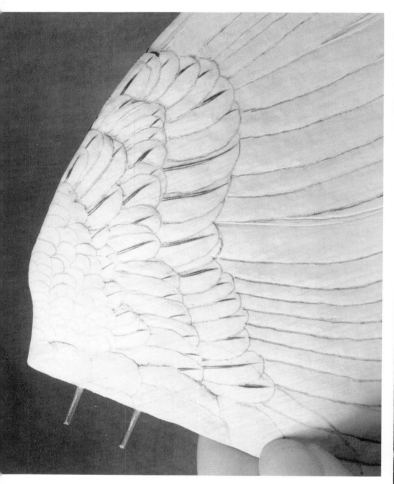

Figure 11. After drawing in the quills, hold the burning pen vertically and burn in one side of the quill from the base of the feather to the tip. Burn the second stroke leaving a small strip of wood in between the two strokes. The two strokes should get closer as they near the tip and finally merge into a point near the feather tip. The strip in between the two strokes will be the raised quill since the burning will depress the wood on each side. On small feathers, a single burned stroke will suffice for a quill.

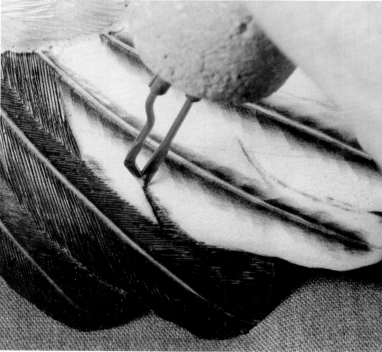

Figure 13. Burn in the barbs at this sharp angle and begin to curve them down toward the tip as each stroke nears the feather edge, just as on the real feather.

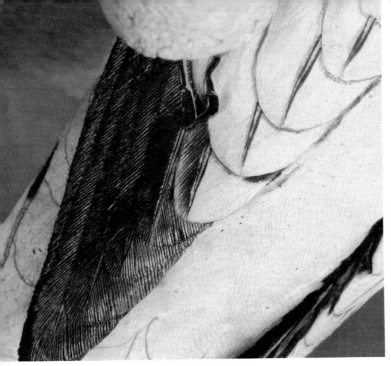

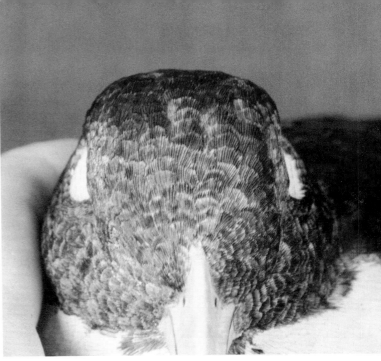

Figure 14. Begin burning on each group at the lowest feather edge and work upward. This upward progression allows you to burn in the feather on top with its barbs snuggling the edge down onto the feather below. On some feathers, you will need to turn the bird around and burn from the edge toward the base to keep the heel of the burning pen from damaging the feather below.

Figure 16. On the head of a bird, I burn in the feathers on the forehead and front sides from the front to the back. Hesitating with the burning stroke at the base of each feather allows the burning pen to sink a little deeper which gives the illusion that the base is a little deeper than the tip. This type of burning is called indent burning. It gives the appearance that the feathers are raised.

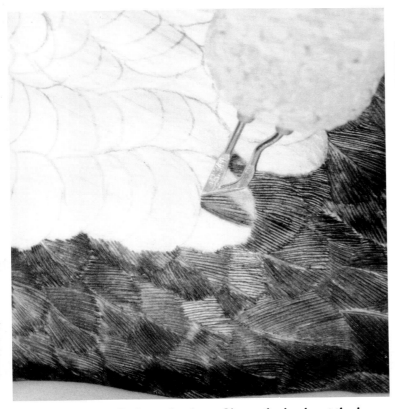

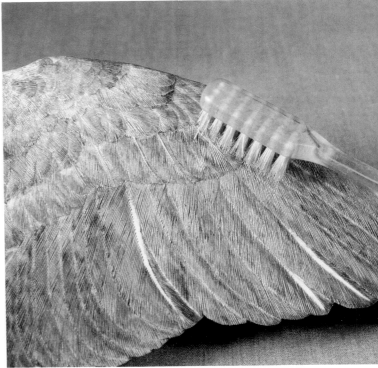

Figure 15. On large feathers, I burn the barbs at the base of the feather first. Then, I finish the edge. Burning long strokes very tightly is difficult.

Figure 17. All burning should be cleaned with a tooth-brush which will whisk away any carbon deposits.

Figure 18. Check the eyes for fit and sufficient depth. It is frustrating to have to take the eyes out and drill the hole deeper because the eye is bottoming out.

Figure 19. Fill the eye holes with the oily clay.

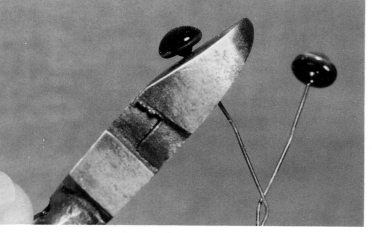

Figure 20. Cut the eye wires off the back of the eyes as close as possible without cracking the glass.

Figure 21. Press the eyes into the clay with the wooden handle of a tool.

Figure 22. The eyes should be pressed into the clay so that they are balanced in depth. They should not be so deep that you have to look down into the eye socket to see them and yet should not be left out so far that the bird looks bug-eyed.

Figure 23. Use a dissecting needle or sharp end of a clay tool to clean the excess clay from around the eye. The putty will not adhere if clay is left in the crevice.

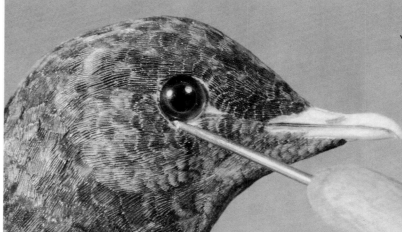

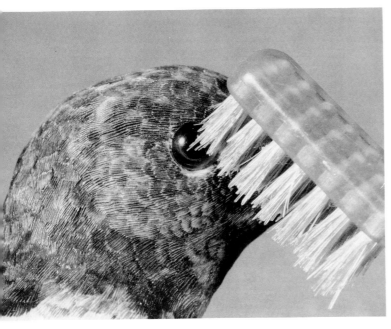

Figure 24. Use a toothbrush to clean the clay off the eye and surrounding texturing.

Figure 26. Roll a small amount of the putty into a small worm.

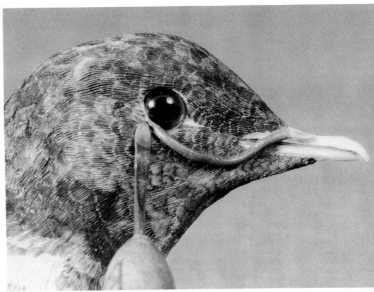

Figure 27. Press the worm into the crevice around the eye. Cut off any excess length. As you press the putty down into the crevice, you can easily form the very small ridge around the eye called the eye ring.

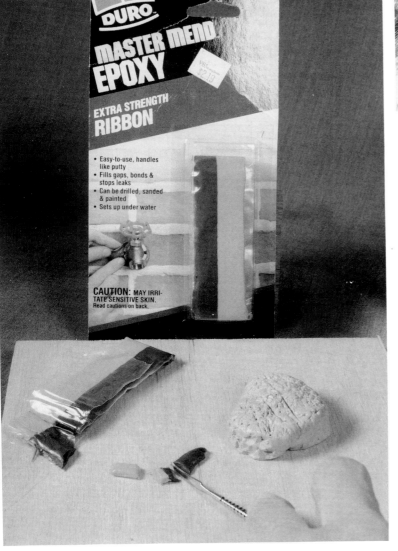

Figure 25. Cut a piece of the ribbon epoxy putty. Cut and discard the center section where the two parts have already chemically mixed and hardened. Knead the putty to an even green color. The mound of clay on the right is used to prevent the putty from sticking to the tool when working the putty. When pushing the putty around, you will feel and even hear it sticking to the tool. By pressing the tool into the clay, you may go back to the putty without it sticking.

Figure 28. If the eye ring starts creeping onto the eye too far and closing the eye down, just push it away unless you want a sleepy-eyed bird.

Figure 29. If the worm is too big, you will need to remove the excess. A small amount is all that is needed. You want only to cover the crevice, not the side of the head.

Figure 30. Pull the putty edge into the surrounding texturing. When the shape and size of the eye ring are satisfactory, texture the ridge itself. Using the end of a dental tool or a small knife blade, score the eye ring by pressing in small lines radiating around the circumference.

During a seminar when I demonstrate the eye ring technique, my students tease me that I always do the easy one. One of the trickiest things to avoid is damaging the first one while working on the second! Allow several hours for the putty to harden before painting or handling.

Constructing Feet

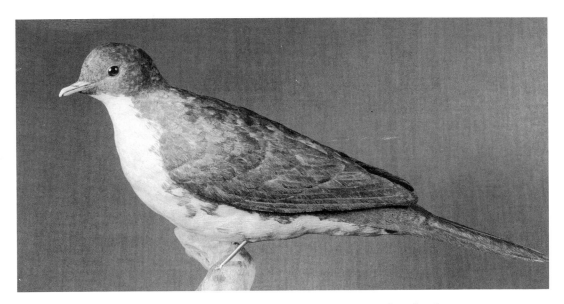

Figure 31. There is no one measurement for the feet placement points. The real bird's feet will exit the feathers at different points depending upon his position. Studying live birds is important in understanding the positioning process. Usually a bird will be balanced over his toes unless he is reaching for something, taking off, landing, or some other unusual activity. Hold the carving above the piece of driftwood or mount and mark the exit points of the feet.

Figure 32. Use an awl to start the hole so that the drill bit will not drift across the texturing on the belly. The holes will generally be located back near the vent and balanced across the centerline but nearer the flanks.

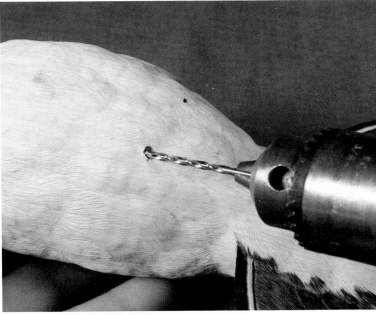

Figure 33. Drill the appropriate size hole for whatever size wire that the feet wires will be. Usually one-half inch is deep enough for the holes unless it is a particularly large bird which would require a deeper hole for more support.

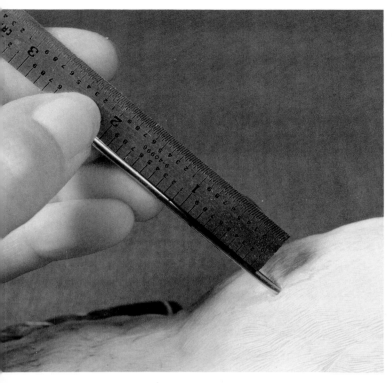

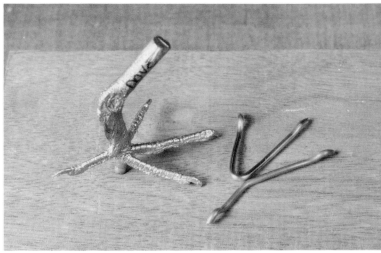

Figure 34. Measure and mark the amount of tarsus exposed. Allow extra wire (½ to ¾″) on the end of the main toe joint location to go into the mount or driftwood.

Figure 36. A pair of cast feet of whatever bird you are doing is very helpful. Take the measurements from the Dimension Chart and/or the castings for the three forward and one hind toe for each foot. Use the same size wire as the top part of toe casting measures. For the dove toes pictured here, 16 gauge copper wire was used for all four toes. On some birds, you will need 18 gauge copper wire for the smaller diameter hind toes.

Cut the wire the proper lengths. Make the bends for the main toe joint configuration. Bend the claws on the end of each toe.

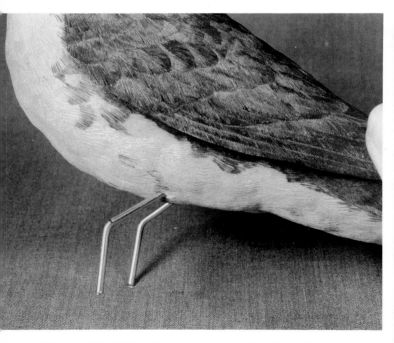

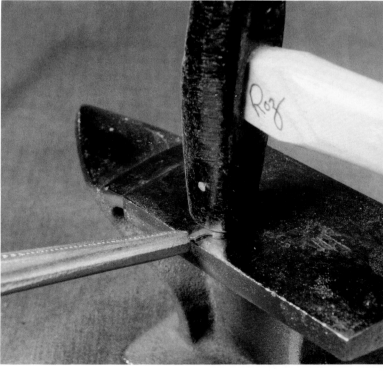

Figure 35. Make the appropriate bends and insert into the bird. Mark and drill slightly oversize holes in the driftwood or mount. Put the bird on his perch. Check to see that the bird is balanced over his toes from all viewing locations. If he leans to one side, adjust the feet wires to straighten him up.

Figure 37. Flatten the claws on an anvil with a hammer. The copper wire for the toes will flatten easily with a few taps.

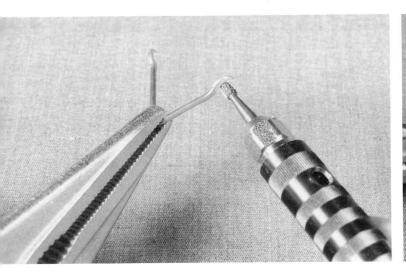

Figure 38. Shape the claw with a small carbide cutter.

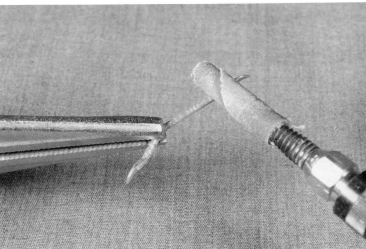

Figure 41. Smooth down the burrs left from the edges of the scales with a cartridge roll sander or sandpaper.

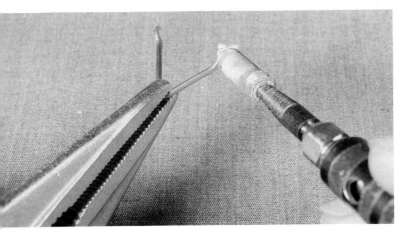

Figure 39. A cartridge roll sander will eliminate any rough spots.

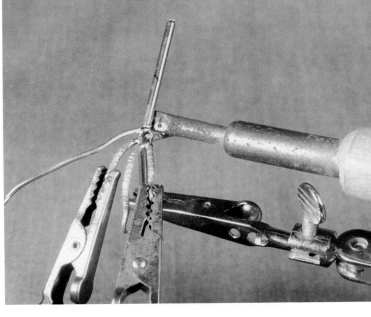

Figure 42. Bend the toes to approximate the contour of the mount. Clamp the foot wire and toes in their proper position using several pairs of helping hands jigs. It will require patience and dexterity to get the wires into their proper contact points.

Flux the area to be soldered. Apply heat to the wires and hold the solder so that hot wires will draw it into the joint. Silver soldering is accomplished in the same way, except a small butane torch is the heat source and silver solder is used. I use silver solder for every joint that is supportive since silver solder is stronger than the electrical variety.

Figure 40. File the scale markings across the top and sides of the toe wires. A square-edged bit will also accomplish this task, but sometimes it will grab the metal and run around its circumference. Tight control of the tool is essential if using a power tool.

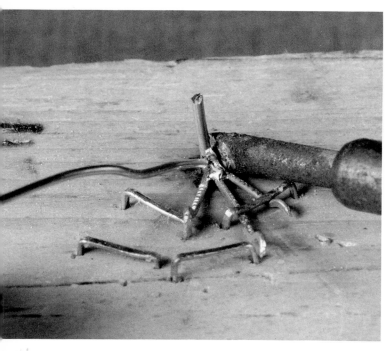

Figure 43. A block of wood can be used for holding the foot wire for smaller, less complicated bird feet. The toes can be held in place with staples into the wood.

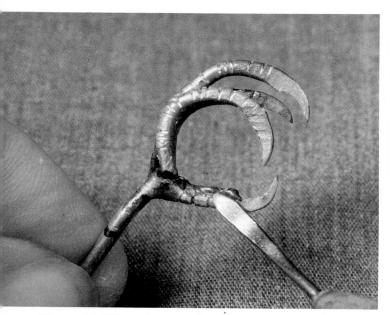

Figure 44. When the joints have cooled, wipe off any flux residue. A swab saturated with alcohol will clean away the flux. If you end up with an excessive amount of solder, grind some of it away with a carbide cutter, but do not grind so much that you weaken the joint. Do not use a ruby carver or diamond bit to grind away the excess solder as they will fill up their cutting edges with solder.

Mix up a small amount of the ribbon epoxy putty. Roll a small worm of the putty. Warm the wire a little with a hair dryer. Then apply the putty underneath the toe wires to simulate toe pads. Check the castings for the size and detail.

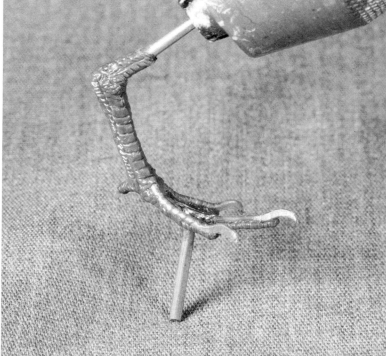

Figure 45. Apply the putty around the tarsus and ankle joint if exposed. The cast feet models allow you to see and duplicate the scales and details.

When the putty has hardened, the feet are ready to be glued into the bird.

PAINTING TECHNIQUES

Careful study of color and its application is as important as the study of form. To render a realistic bird, the unpainted bird needs to be characteristic of whatever species it is. Putting color on the bird should further that characteristic look. All of us perceive color differently. What may appear to you as a greenish grey may look grey-blue to me. And some people are partially or completely color-blind. There are some people who think they are color-blind when in fact, they simply have not worked with color or paid attention to it. Seeing color, just as seeing shape and form, is a learned skill. So, jump in and learn!

Learning to see color is something all of us can use and enjoy. Many of us look but do we really see? Observation of color is very important. If you cannot see the color, then you cannot mix it or paint it. When observing a color, I find myself asking what color is close to that particular color or what could I use to mix it. It is a problem solving situation. Playing with different color mixtures on a palette will eventually lead to the right color. Fear keeps us from trying new adventures. In the classes I teach, I always tell my students to relax with the painting procedures for at that point of the project, there is absolutely no color that they could put on the bird that cannot be corrected. So, relax and enjoy it!

Even though carved birds are three-dimensional, it is helpful to use two-dimensional painting techniques in rendering realism. Using darker values for shadows and lighter ones for highlights will certainly bring the carved bird to life. If you paint a bird a solid color like you would paint a wall, it will look flat. Just as a one-directional light will enable you to see contours more easily, darks, lights, and values in between will enhance the contours and not hide them.

Lights in the room where you are painting are very important. I was once doing a chickadee seminar and we had been painting on the birds several hours. One of the students had her bird near the window and it looked very greenish. In fact, everyone brought their birds over to the daylight streaming in the windows and all the birds were greenish! The problem ended up being the lights in the room. All of the overhead fixtures had cool florescent bulbs in them which were altering the color perceived on the bird. In my own studio, I have florescent overhead fixtures, but each one has a warm tube and cool tube for color balance. I also use one incandescent architect's light for close work and supply an individual light for each student. The two different florescent lights and the incandescent bulb provide a balanced light. When I am working on a bird, I do not always know under what kind of light it will be viewed. With the balanced light, the colors appear natural in most lighting situations.

The painting of these birds is done with acrylics. Different brand names of acrylics vary the colors of the same name. A *Speed Ball* raw umber is not the same color as a *Liquitex* raw umber. If you have difficulty matching a color, check the brand name of acrylic. I use *Liquitex* acrylics in the jar. *Liquitex* is the only paint manufacturer, that I am aware of, that has a different formulation in jars than in the tubes. *Liquitex* adds a small amount of flattening agent to their jars that is not in the tube paints. The colors are consistent in the jars and

tubes. The flattening agent in the paint keeps the multiple coats from getting too shiny.

Base Coats
Base coats are the first coats applied to a given area. Usually they are the medium value of the area. It will take several coats to cover the area. Keep the paint thin so the texturing does not get filled up and finally obliterated.

Wash
A wash is a very thin mixture of a small amount of pigment in a large amount of water. Washes are used to slightly alter or enhance the base coat color. It is always advisable to add more water than you think is necessary, since a thick wash may totally obscure the colors underneath. It is much safer to apply two very thin washes than one thicker one. If the wash contains too much pigment and not enough water, it may totally cover the details underneath. Because water seeks the lowest level, a wash deposits a small amount of pigment in the bottom of the texture grooves. When you make a wash, always touch your wet brush to a paper towel to remove some of the wash. A drippy brush will have the wash traveling all over the bird, going to places where you do not need that particular color.

Glaze
A glaze is similar to a wash in that a small amount of pigment is mixed in a liquid, only in a glaze the liquid is one of the mediums (matte or gloss). When adding small amounts of color to a beak, it is useful to use a glaze and gradually build up the color's intensity.

Dry-brush
To obtain a dry-brush effect, mix the color, load the brush and wipe most of the paint in the brush on a paper towel. Only a small amount of the paint will remain in the brush. Only this small amount of pigment will be transferred to the bird. Because this pigment is dry, it will be deposited on the high points of the texture grooves.

Blending
On a bird there will be dark patches of feathers next to light ones, and even on a single feather a dark area may be next to a light one. These contrasting colors will need to be blended for a natural, soft appearance. Three blending techniques are stippling, dry-brush, and wet-blend.

Stippling is a technique in which the two contrasting colors are dabbed into each other with the point or end of the brush. Dab the light one into the dark, let dry, and then dab the dark one into the light. It will take several applications to get a soft blend.

Dry-brushing a blend line is accomplished by loading the light color on a soft, sable brush, wiping most of the pigment on a paper towel and flicking the ends of the brush into the dark color. At the end of each flicking stroke, pull the brush up and away from the surface. Then load the dark color, wipe the brush on the paper towel and flick the dark color into the edge of the light one. It will take several applications to obtain a soft blend line.

To obtain a soft, natural transition between light and dark with wet-blending, both colors will need to be wet. You can use two brushes (one loaded with each color) or one brush wiped in between dabbing each color. Again, you pull the dark color into the edge of the light one and the light into the dark one. Usually there are several minutes to work the wet paint before the brush starts pulling off more paint than it deposits. When the paint starts pulling off, it is time to dry the paint completely and start wet-blending again. Pulling each color into the other several times will provide a softly blended line.

Chapter 3.
The American Woodcock
(Philohela minor)

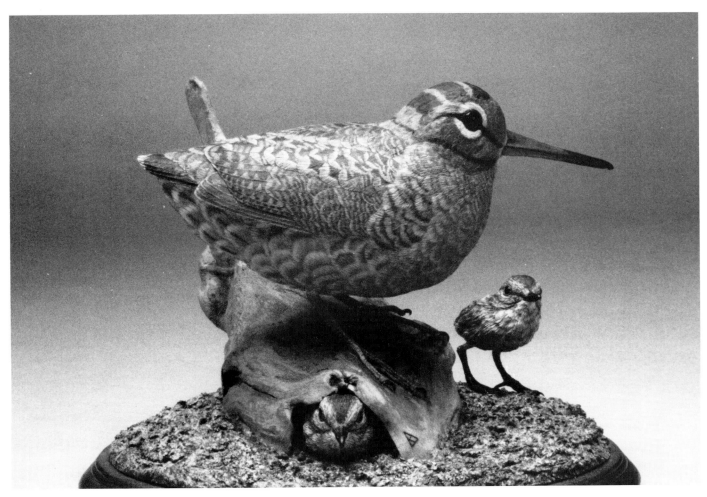

The American woodcock is a migratory game bird that is hunted in many states. The male's flight-displays are spectacular. During late evening or early morning, he circles high into the air and then descends with a zig-zag motion. When he has landed, he calls his familiar *peent* for his "lady bird." The female woodcock will feign injury, much as a killdeer will, to lure an intruder away from her chicks.

Both sexes are round little birds with long bills. The female is usually slightly larger in body size and has a slightly longer beak. The woodcock's beak has a flexible upper mandible, with a highly sensitive and moveable tip. Its feeding behavior consists of feet stamping to arouse the earthworms in the moist soil and plunging its beak deeply into the soil. The tip of the beak feels for the worms, separates to grasp the worm and yanks it out of the earth. During dry spells, the woodcock uses its beak to turn over leaves and debris in search of insects and their larvae. Occasionally, it consumes berries and the seeds from weeds and grasses.

The woodcock's nest is usually located in or along side of a field, pasture, or woods. The nest itself is a small depression in the earth, loosely lined with grasses. Since the woodcock depends upon its camouflage for concealment, there are usually many leaves in the nesting area. Hunters have told me that one has to almost step on a woodcock before it will flush. That is true confidence in its ability to blend in with the environment! The female incubates the speckled eggs for 20-21 days. Once the young have hatched, they will leave the nest when their feathers are dry (about 24 hours). Within a day or two, the chicks are probing for earthworms, much like the adult birds.

AMERICAN WOODCOCK

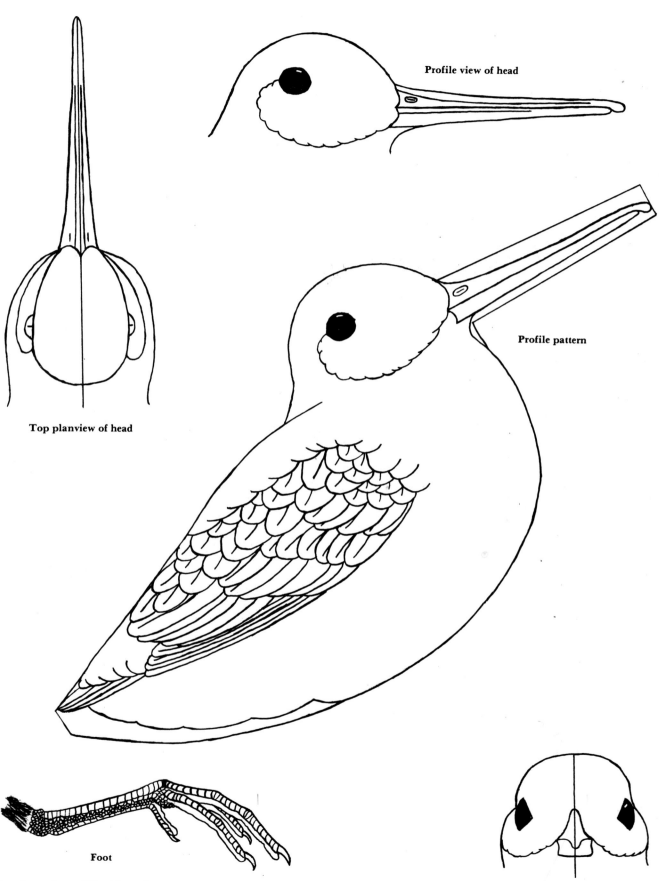

Profile view of head

Top planview of head

Profile pattern

Foot

Head-on view

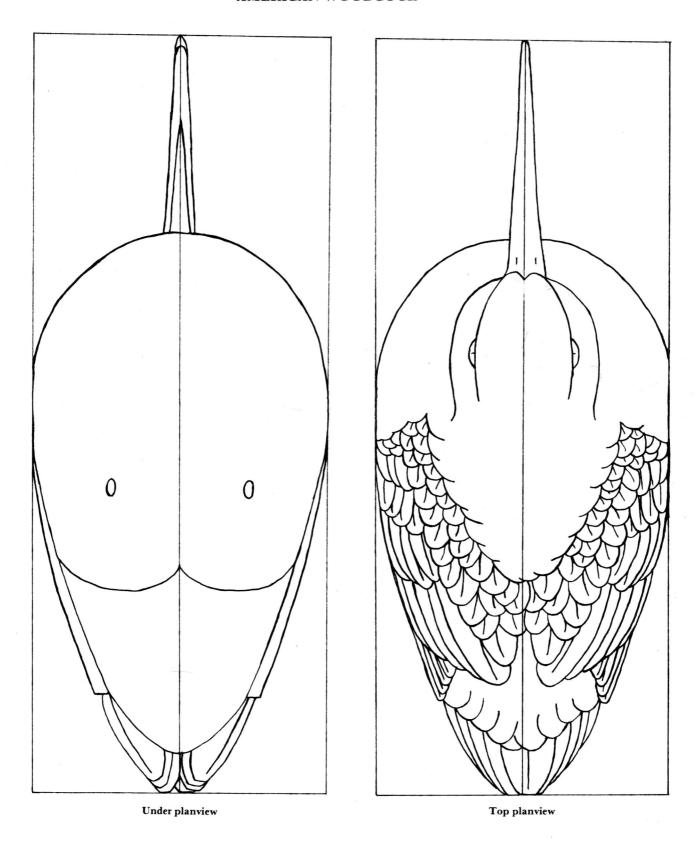

Under planview

Top planview

*Foreshortening may cause distortions on planviews. Check the dimension chart.

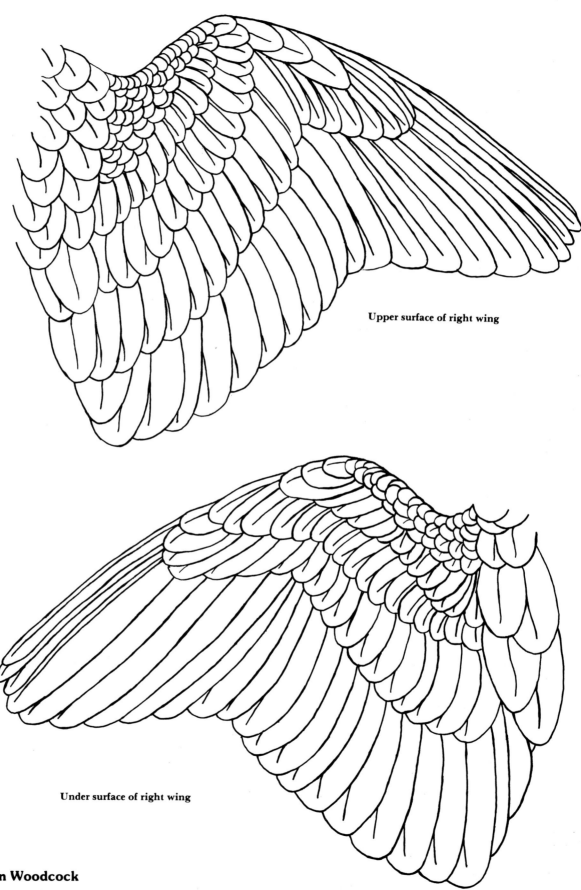

Upper surface of right wing

Under surface of right wing

DIMENSION CHART FOR FEMALE WOODCOCK

1. End of tail to end of primaries—1.0 inch
2. Length of wing—4.5 inches
3. End of primaries to alula—3.0 inches
4. End of primaries to top of first wing bar—1.3 inches
5. End of primaries to bottom of first wing bar—2.6 inches
6. End of primaries to mantle (wings folded)—1.4 inches
7. End of primaries to end of secondaries—.40 inches
8. End of primaries to end of scapulars—.40 inches
9. End of primaries to end of primary coverts—2.2 inches
10. End of tail to front of wing—5.5 inches
11. Tail length overall—2.6 inches
12. End of tail to upper tail coverts—.50 inches
13. End of tail to lower tail coverts—.40 inches
14. End of tail to vent—2.7 inches
15. Head width at ear coverts—1.5 inches
16. Head width above eyes—1.0 inches
17. End of beak to back of head—4.0 inches
18. Beak length
 - top—2.6 inches
 - center—2.4 inches
 - bottom—2.1 inches
19. Beak height at base—.48 inches
20. End of beak to center of eye (10mm. brown)—3.4 inches
21. Beak width at base—.40 inches
22. Tarsus length—1.2 inches
23. Toe length
 - inner—1.0 inches
 - middle—1.5 inches
 - outer—1.1 inches
 - hind—.45 inches
24. Breast to tail length—6.0 inches
25. Overall body width—3.1 inches
26. Overall body length*—8.7 inches

*All of these measurements are for woodcocks here in Delaware. According to Bergmann's Rule in ornithology, body size tends to be larger in cooler climates and smaller in warmer climates. Allen's Rule suggests that beaks, tails, and other extensions of the body tend to be longer in warmer climates and shorter in cooler climates. Accordingly, you may have to adjust lengths and widths depending on where you live.

TOOLS AND MATERIALS

Bandsaw (or coping saw)
Flexible shaft machine
Carbide bits
Ruby carvers and/or diamond bits
Variety of mounted stones
Pointed clay tool or dissecting needle
Compass
Calipers measuring in tenths of an inch
Ruler measuring in tenths of an inch
Rheostat burning machine
Awl
400 Grit sandpaper
Drill and drill bits
Laboratory bristle brush on a mandrel
Needle-nose pliers and wire cutters
Cartridge roll sander on a mandrel
Toothbrush
Safety glasses and dustmask
Super-glue and 5 minute epoxy
Oily clay (brand names Plasticene and Plastilena)
Duro ribbon epoxy putty (blue and yellow variety)
Krylon Crystal Clear 1301
Pair of 10 mm. brown eyes
Tupelo or basswood block 3.1" (W) x 4.2" (H) x 8.5" (L)
Pair of woodcock feet to use in bird or as a model for making feet
For making feet:
 1/16" brazing rod
 16 and 18 gauge copper wire
 solder, flux and soldering pen or gun (or silver solder, flux and butane torch)
 permanent ink marker
 hammer and small anvil
 small block of scrap wood and staples (or several pairs of helping hands holding jigs)

Figure 1. After bandsawing the profile pattern out of tupelo, draw in the plan view and centerlines. Cut away the excess from around the wings and tail. Measure, mark and draw in the top shape of the tail and the upper tail coverts .50 inches from the end of the tail. Measure and mark the distance from the end of the tail to the end of the wings 1.0 inch.

Figure 2. Roughly draw in the wing shapes including the lower wing edges. Using a large square-edged cylindrical carbide cutter, remove the excess wood from the sides of the tail and below the lower wing edges all the way to the belly edge.

Figure 3. Round the wings, back, upper tail coverts and top of tail.

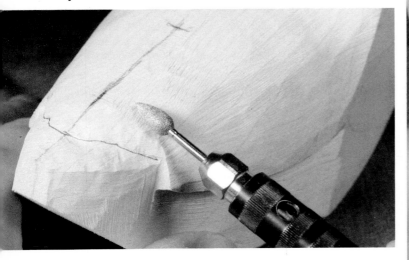

Figure 4. Redraw the upper tail coverts' shape. Channel around the upper tail coverts. Flow the channel out onto the tail, maintaining its convex shape. Round over the sharp edges of the coverts flowing them down to the base of the tail.

Figure 5. On the sides and tip of the tail, draw lines .15 inches from the top edge. On the underside of the bird, measure and mark the distance from the end of the tail to the lower tail coverts .40 inches and to the vent 2.7 inches. Draw in the shape of the lower tail coverts and the vent.

Figure 6. Remove the excess wood from the underside of the tail working towards the edge of the lower tail coverts and leaving the tail itself .15 of an inch thick.

Figure 7. Channel around the vent line using the tip of a medium tapered carbide cutter. Carry the channel around onto the side of the flanks with the channel angle toward the head. Work carefully so that the tip of the bit does not damage the lower wing edges.

Figure 10. Find the midpoint of the head by placing one finger at the base of the beak and another at the back of the head and sighting the halfway point on the high part of the head. Mark the midpoint on the centerline on the top of the head.

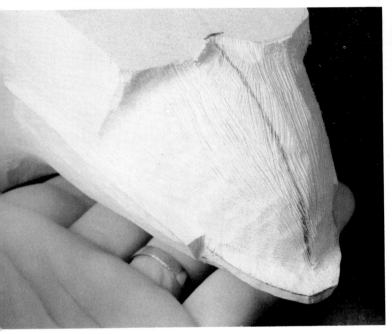

Figure 8. Round over the lower tail coverts, flowing their edges down to the base of the tail and eliminating the shelf created by the tail thinning procedure.

Figure 9. Carve a shallow channel from the vent to halfway up the belly on the centerline. Round over the entire belly and flow the flanks down to the sides of the lower tail coverts, eliminating the shelves left from working the vent.

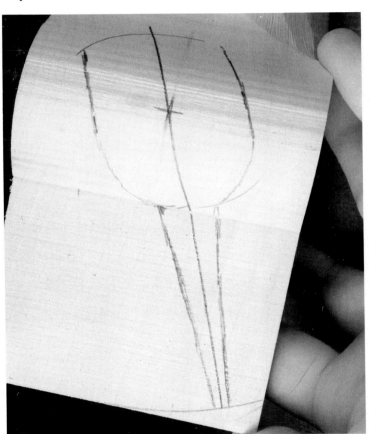

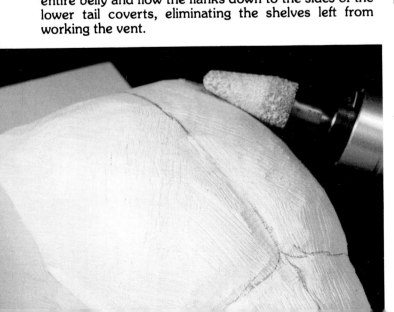

Figure 11. Using the midpoint mark as a pivot point, swing an arc with a compass from the tip of the beak and one from its base to the side to which you want to turn the bird's head. Swing a third arc to the opposite side the same distance as the back of the head. Draw a new centerline through the pivot point and intersecting all three arcs. The angle between the new and old centerlines will be the degree to which the head will be turned. It will be helpful and less confusing to erase the old centerline.

Laying a ruler perpendicular to the new centerline, measure and mark the ear covert width (1.5 inches). You should have .75 inches on both sides of the centerline. Draw in the plan view of the head encompassing these marks. Allow extra wood around the beak.

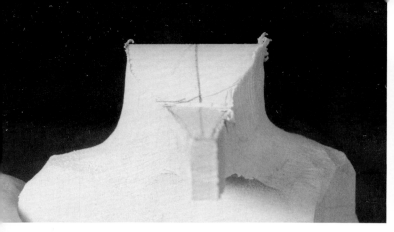

Figure 12. Cut away the excess wood from around the head. Keep the sides of the head and beak straight up and down, and parallel. Be careful to keep an equal amount of wood on each side of the centerline. Continue removing wood from each side until the calipers measure 1.5 inches.

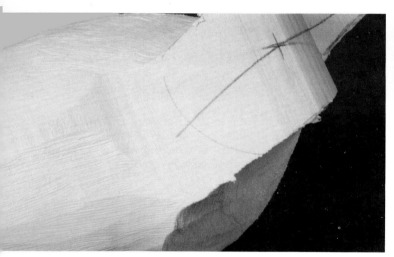

Figure 13. Flow the shelves out onto the shoulders. Note that no wood has been removed from the hindneck.

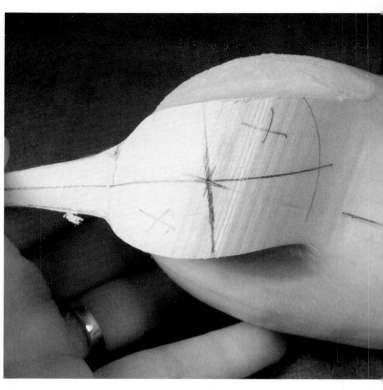

Figure 15. Draw a line across the top of the head through the pivot point, dividing the top of the head into quadrants. Turning the head of the bird in the wood causes the planes of the head and sometimes beak to be at weird angles. The quadrants marked with an "X" are the high ones: the front quadrant on the side to which the head is turned and the opposite back one.

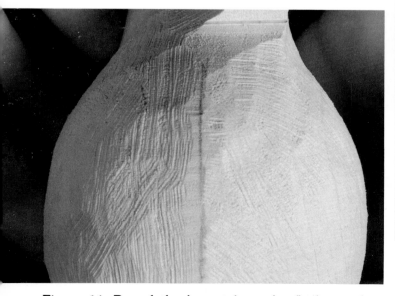

Figure 14. Round the breast from the flanks to the centerline. Do not remove any wood from the chin area.

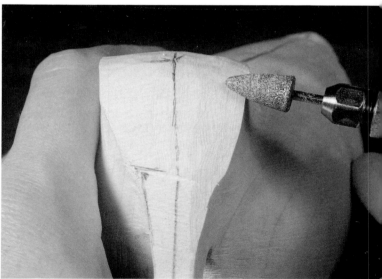

Figure 16. Using a ruby carver, remove the excess wood off the high front quadrant so that it matches the plane of the forehead's other side. Some wood may have to be removed from the top of the beak on that side, too, depending upon the degree of the head turn.

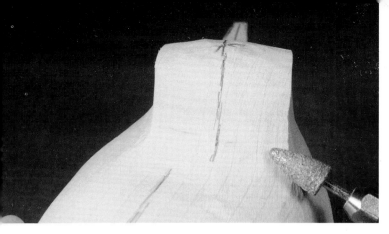

Figure 17. Carve away the excess wood on the high back quadrant and the hindneck. Flow the neck out onto the mantle. Redraw the head centerline.

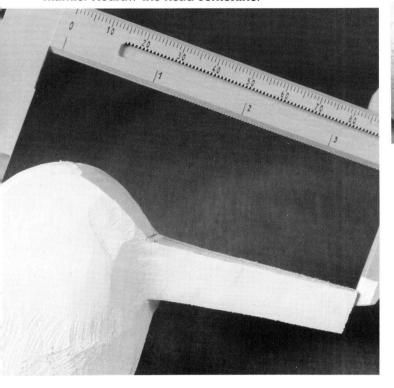

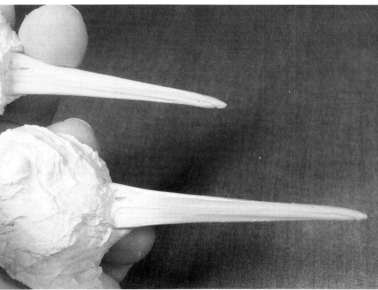

Figure 19. Note the difference between the male and female beak length. His (top study bill) beak is 2.25 inches long and hers is 2.4 inches long. Study bills are very helpful because they allow you to see the fine details.

Figure 18. Check the end of the beak to the back of the head measurement (4.0 inches). If it is too long, remove equal amounts of wood from the end of the beak and the back of the head. Use a fine ruby carver or cartridge roll sander to smooth the sides of the head and beak to make drawing easier.

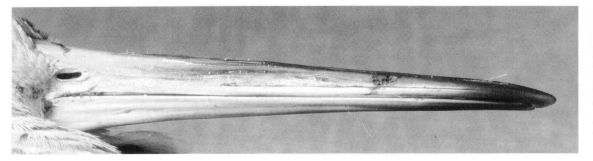

Figure 20. Profile of the woodcock beak.

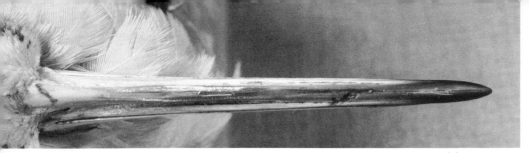

Figure 21. Top plan view.

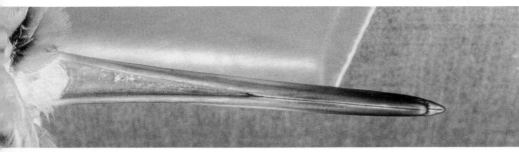

Figure 22. Underside details.

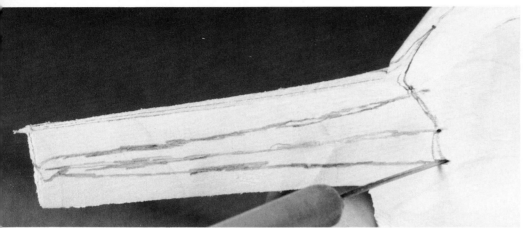

Figure 23. Transfer the eye and beak placement from the profile line drawing, making sure that both sides are balanced from the head-on view. Check the distance to the center of the eye, center beak length and beak height with the measurements listed on the Dimension Chart. Pinprick the center beak length (commissure line), the bottom of the lower mandible, and the eye centers.

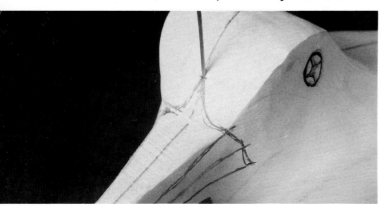

Figure 24. Measure, mark and pinprick the top beak length on the centerline 2.6 inches. Draw in the "V" shape on the top of the upper mandible and connect the line to the center beak length at the base of the commissure line on both sides.

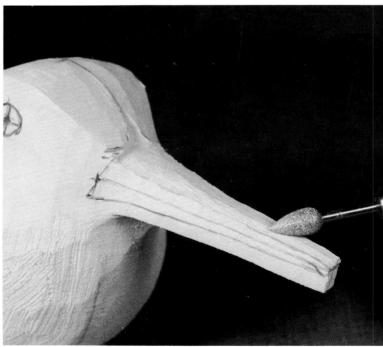

Figure 25. Using a pointed ruby carver, remove the excess from above the upper mandible. Keep the upper mandible flat at this time. Redraw the centerline.

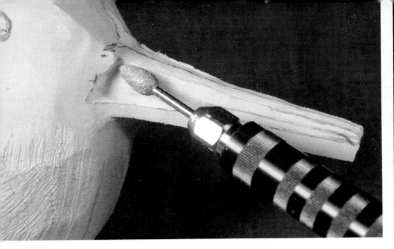

Figure 26. Grind away the excess on the sides of the beak's base until the beak width measures .40 inches. Keep checking the balance from the head-on view to maintain equal amounts of wood on each side of the centerline.

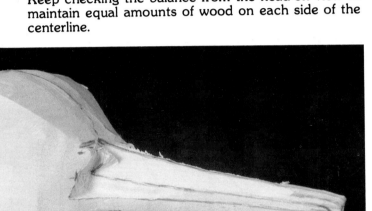

Figure 27. Draw in the little tuft of feathers on the base of each side of the upper mandible. Using a ruby carver, channel around the tufts, flow out the channel, and round over the tufts' sharp edges.

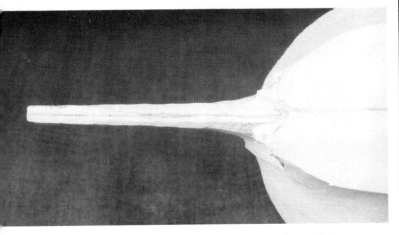

Figure 28. The culmen is the top ridge of the upper mandible. Thin the culmen to .10 inches wide at the base of the upper mandible. Narrow the sides of the beak until the midpoint width measures .20 inches and the tip width .15 inches. Keep the sides of the beak vertical and parallel. Redraw the balanced commissure lines.

Figure 29. Flow the forehead and sides of the head down to the base of the beak. Maintain the same planes and do not round at this time.

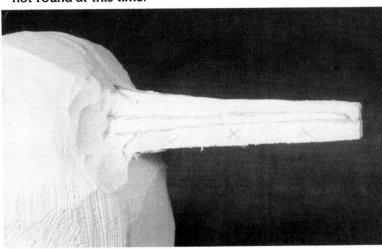

Figure 30. On the sides of the lower mandible, measure and mark the end of the little tuft of underneath feathers 2.1 inches from the tip.

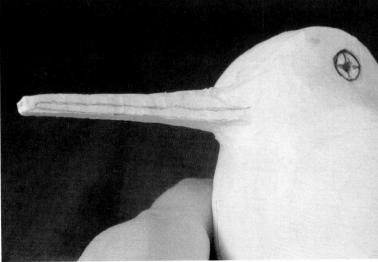

Figure 31. Using a ruby carver, grind away the excess wood from underneath the lower mandible back to the 2.1 inches mark. Carry the edges of the tuft back toward the base of the beak so that it is "V"-shaped.

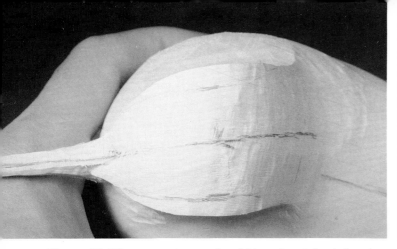

Figure 32. The eye centers should be pinpricked deeply so that their position is not lost when wood is cut away from this area. Measure and mark the distance across the crown (1.0 inch) above the eyes. Draw in the wedge shape of the head encompassing the width marks.

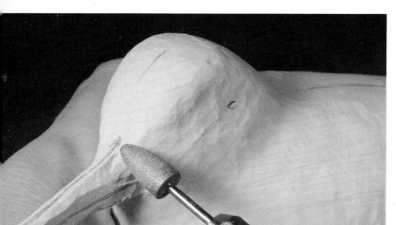

Figure 33. Narrow the width of the crown from the eyes to the square edge of the blank. When the width above the eyes measures 1.0 inch, lightly round the head from the forehead down to the hindneck.

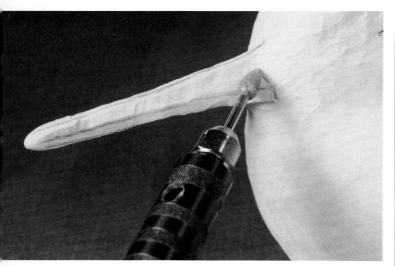

Figure 34. Angle the sides of the upper mandible from the commissure lines to the culmen. You may need to shorten the tufts on the side of the upper mandible.

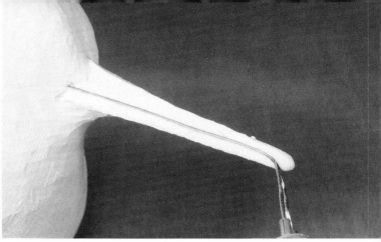

Figure 35. Burn in the commissure lines with the pen held vertically to the sides of the beak.

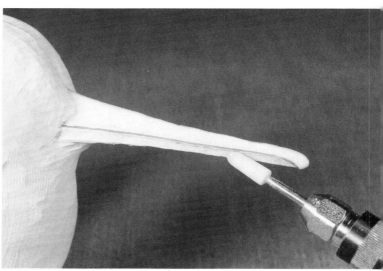

Figure 36. Deepen the depression on the upper mandible using a blunt-end stone. Create a depression along the sides of the lower mandible. Lightly round the upper mandible tip. Thin and round the tip of the lower mandible so that it tucks under the tip of the upper mandible.

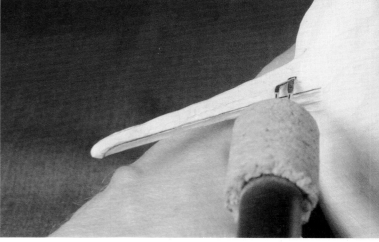

Figure 37. Draw in balanced nostrils. With the tip a small pointed burning pen, burn in a small slit for the nostrils.

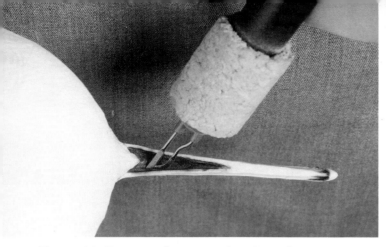

Figure 38. Depress the triangular shaped structure on the underside of the lower mandible.

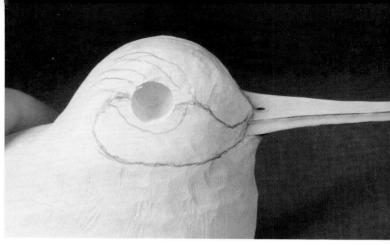

Figure 41. Draw in the ear covert, the "swoop" between the beak base and the eye and the other eye details.

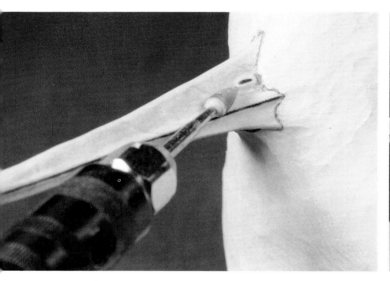

Figure 39. With a small pointed stone, create a ridge around the nostril slits. Fine sand the beak without distorting the details. Saturate the beak with super-glue. When the glue has dried, fine sand again.

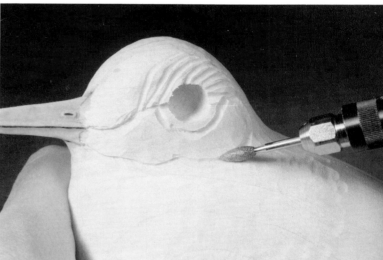

Figure 42. Using a medium pointed ruby carver, channel around the ear coverts, the "swoops," and the eye details.

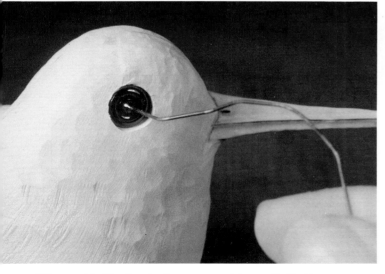

Figure 40. Recheck the eye positions. Drill 10 mm. eye holes and check eyes for proper fit.

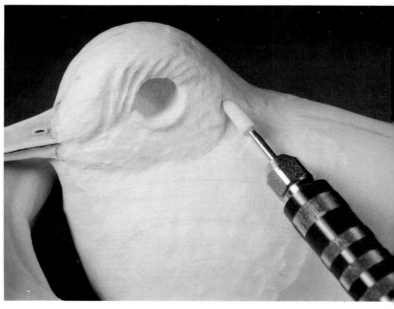

Figure 43. Flow the channels out and round over the sharp edges. Use a stone to smooth the structures.

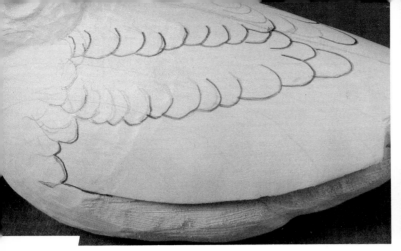

Figure 44. Use a stone, fine ruby, or cartridge roll sander to smooth the back and wings to make them easier to draw on. Draw in the mantle, scapulars, and the side breast feathers that lay over the front of the wings.

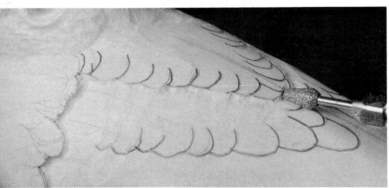

Figure 45. Laying a blunt ruby carver on its side, relieve the wood from the backside of the side breast and mantle feathers. Round over the edges and redraw the scapulars where they were cut away.

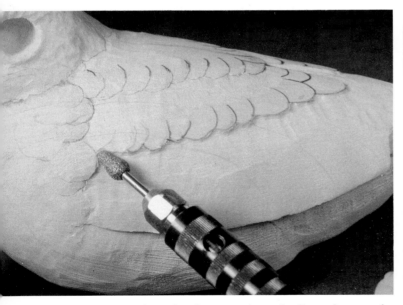

Figure 46. Lay the ruby down again and relieve the wood around the scapulars. Round over their sharp edges. Make sure that the wing appears to come out from underneath the scapulars and the side breast feathers.

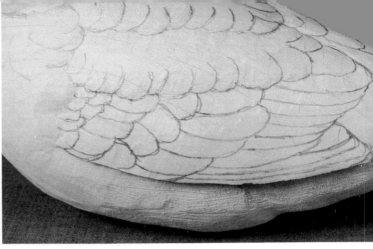

Figure 47. Draw in the wing feathers.

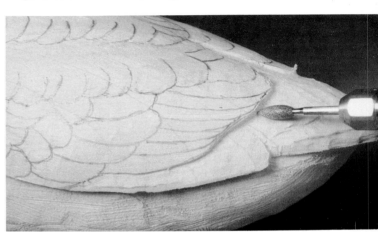

Figure 48. Using a pointed ruby carver, relieve the wood around the secondaries and tertials. Angle the trailing edges of the primaries toward the body. Flow the channel at the tips of the secondaries and tertials out onto the upper tail coverts and back.

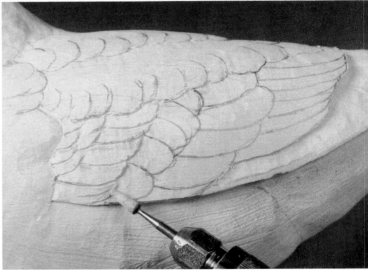

Figure 49. Begin cutting around the groups of wing feathers and then the individual feathers within the groups. Begin at the front of the wing and work back and down toward the primaries.

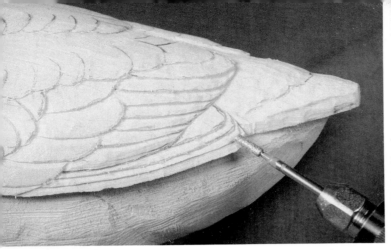

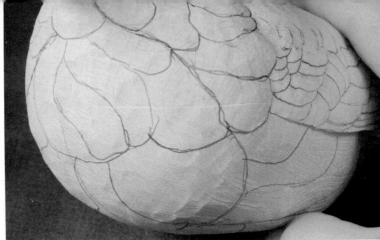

Figure 50. You can use stones, ruby carvers, or diamond bits to relieve around the feathers. Try several kinds and shapes to determine which gives the smoothest cut without digging into the soft wood.

Figure 53. Draw in the contouring lines on the breast.

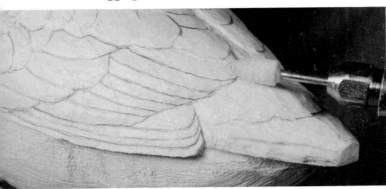

Figure 51. Use a bullet-shaped stone to smooth the edges of the mantle, scapulars and all of the wing feathers.

Figure 52. Draw in the contouring lines on the head, neck and mantle.

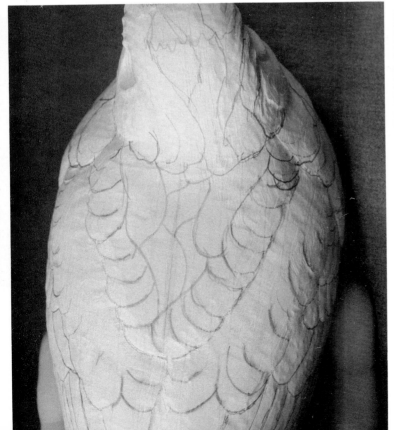

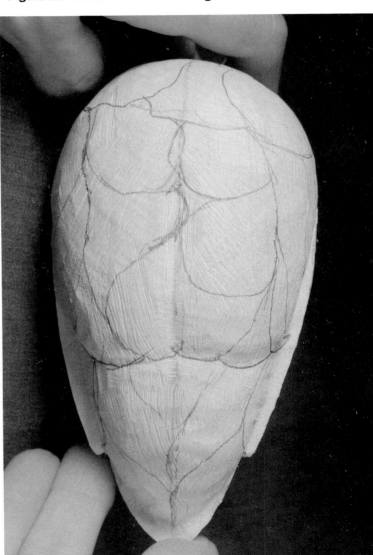

Figure 54. Vary the size and shape of the contour lines on the belly and lower tail coverts.

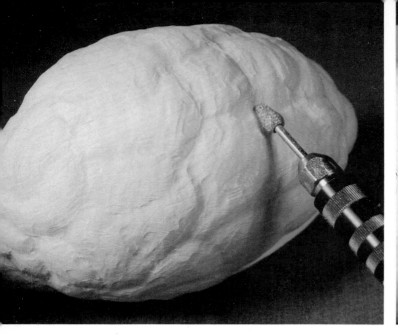

Figure 55. Channel along all of the contouring lines. Keep the channels on the head and neck shallower than on the remainder of the body. Round over each of the fluffs.

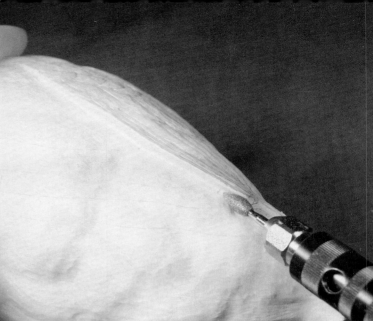

Figure 58. Use a pointed ruby carver to relieve the wood under the lower wing edges to give the appearance that the body goes up under the wings.

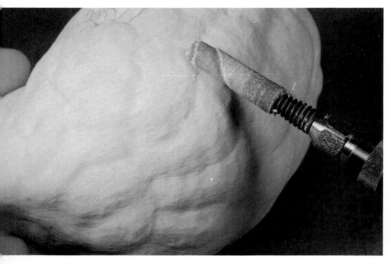

Figure 56. Smooth all of the contouring with a cartridge roll sander.

Figure 57. A bullet shaped stone is helpful in smoothing areas that the "tootsie roll" cannot reach.

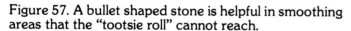

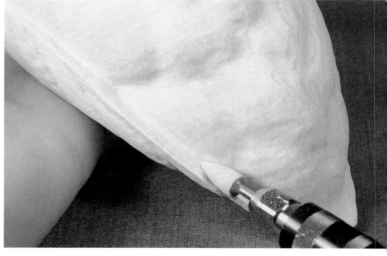

Figure 59. A pointed stone is helpful in smoothing the area under the wings.

Figure 60. Draw in the tail feathers on the top surface. Begin cutting around the center feathers and progress out toward the edge on both sides.

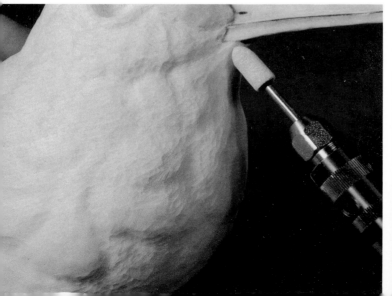

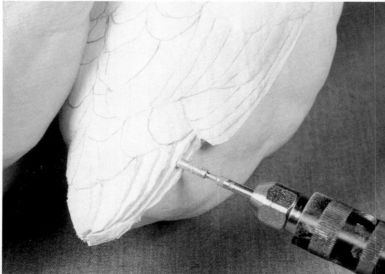

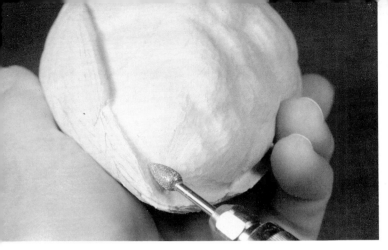

Figure 61. Use a pointed ruby carver to thin the tail from underneath.

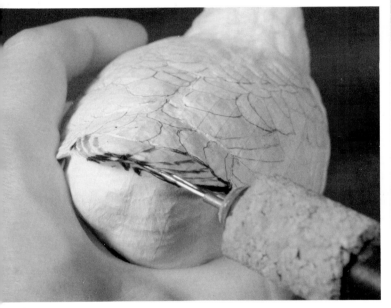

Figure 62. A burning pen is useful for cleaning up the edges of the tail feathers. Burn around the tip of each feather.

Figure 63. Draw in the underside edges of the tail feathers connecting the inside edges of the tips with the burned ones. Laying the burning pen on its side, burn in the edges of the feathers.

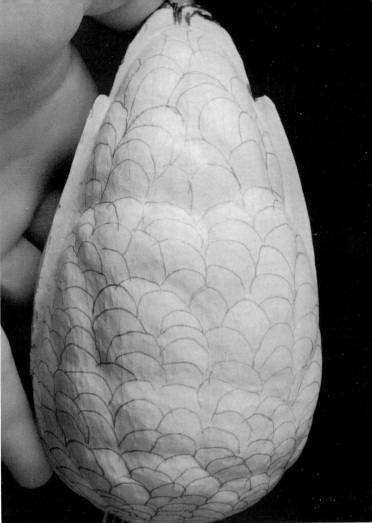

Figure 64. Draw in the feathers on the underside of the bird.

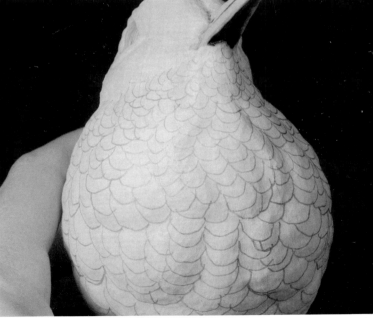

Figure 65. The feathers get smaller towards the head and beak.

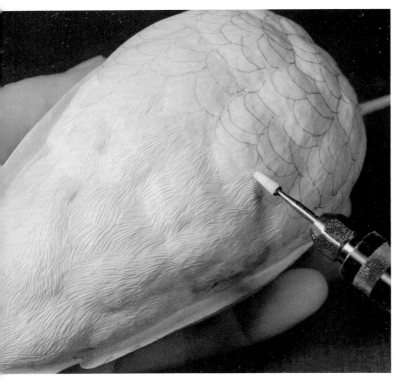

Figure 66. Begin stoning at the edge of the lower tail coverts and work up the belly, breast, throat and chin. Clean any fuzz off the stoning with the laboratory bristle brush at low speed.

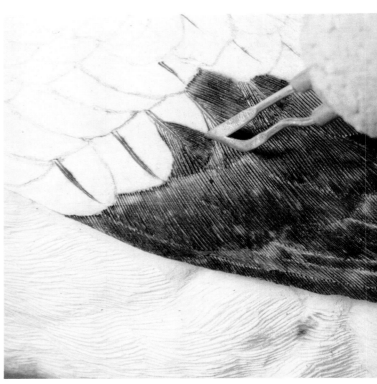

Figure 68. Burn in the barbs on the wings beginning with the lowest primary working upward and forward.

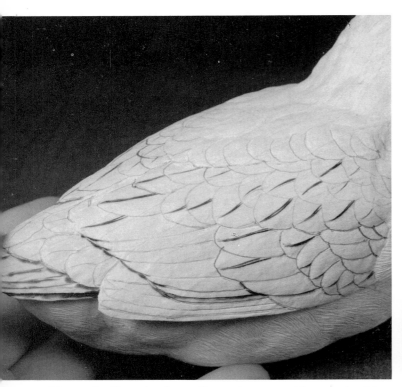

Figure 67. Draw in the quills on the wings. Burn in double quill lines on the larger feathers with the point just short of each feather tip.

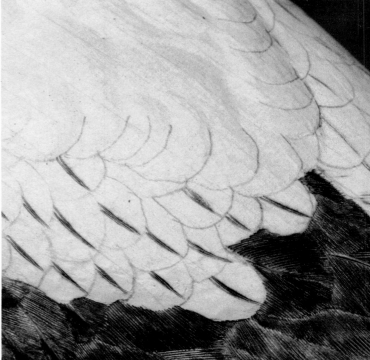

Figure 69. Draw in the scapular feathers and quills. Burn in the quills and then the barbs.

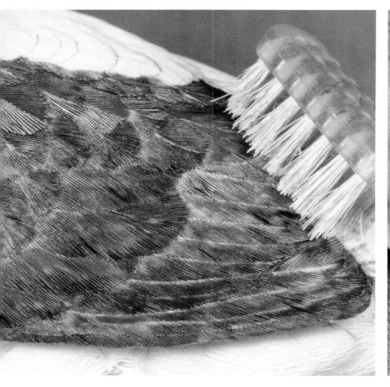

Figure 70. Clean all burning with the toothbrush.

Figure 72. Draw and burn in the quills on the tail's under surface. Burn in the barbs starting in the center and working toward the outer edges.

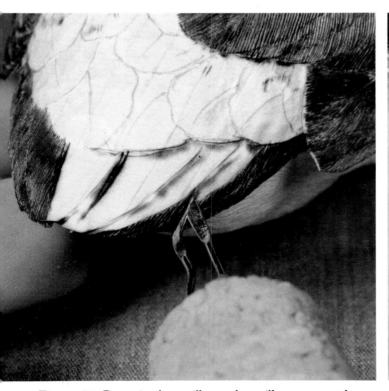

Figure 71. Draw in the quills on the tail's upper surface. Burn in the quills and then the barbs, starting on the outer edges and working towards the center feathers.

Figure 73. Burn in the quill on the lowest primary and then the barbs.

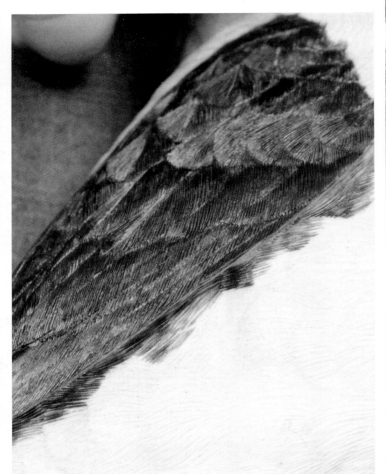

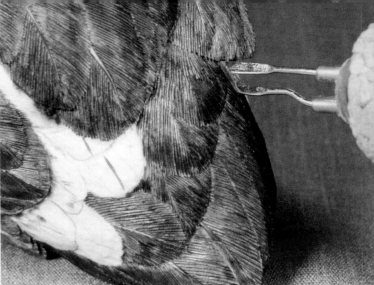

Figure 76. Draw in the upper tail coverts and their quills. Burn in their barbs, starting at their tips and working forward.

Figure 74. Burn in the barbs on the flank feathers near the lower wing edge that the stoning could not reach. Blend the burning into the stoning.

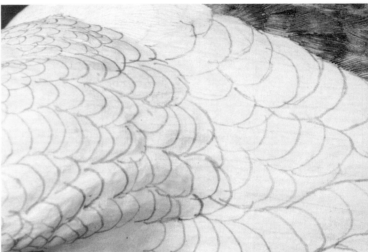

Figure 77. Draw in the mantle and neck feathers.

Figure 78. The feathers on the head are very small.

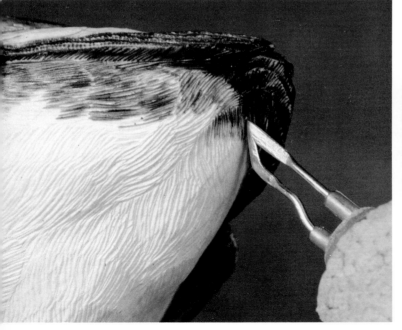

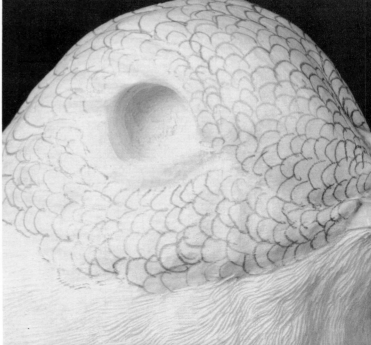

Figure 75. Burn in the edges of the lower tail coverts.

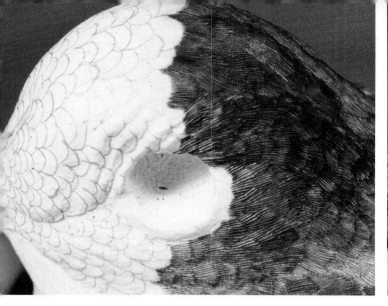

Figure 79. Starting at the edge and working forward, burn in the barbs on the mantle feathers and then the ones on the hindneck.

Figure 82. Drill 1/16" holes one-half inch deep into the body for the feet wires. Use 1/16" brazing rods for the feet wires.

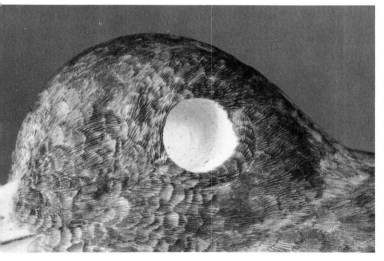

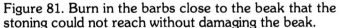

Figure 80. Burn the barbs on the head feathers. Note the circular ring of feathers around the eye.

Figure 81. Burn in the barbs close to the beak that the stoning could not reach without damaging the beak.

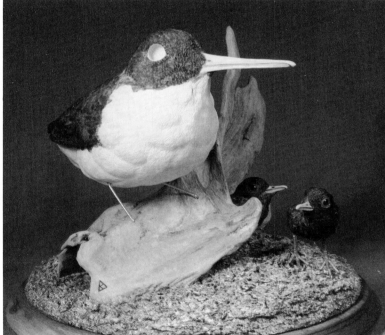

Figure 83. Position the woodcock on the driftwood so that she is balanced over her toes.

Figure 84. Use 16 gauge copper wire for the three forward toes of each foot and 18 gauge copper wire for the hind toes. Make the feet according to the directions at "Feet Construction" in *Basic Techniques*.

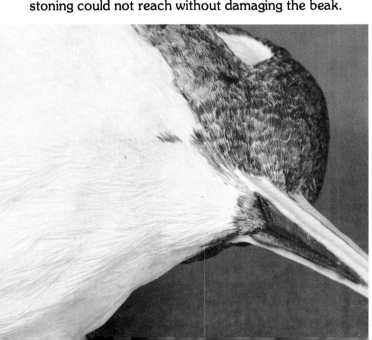

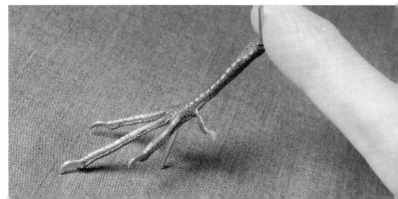

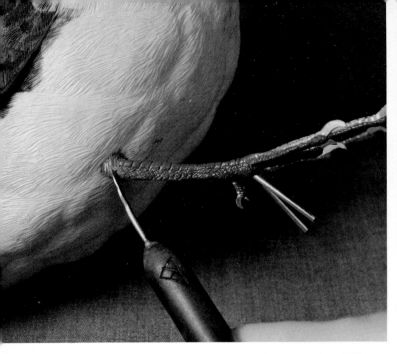

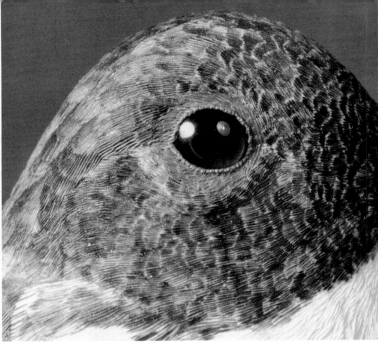

Figure 85. Glue the feet in place with super-glue. When the glue is dry, apply a small amount of ribbon putty to conceal the joint. Press some shaggy feathering into the putty.

Figure 86. Set the eyes according to the directions at "Setting Eyes" in *Basic Techniques*.

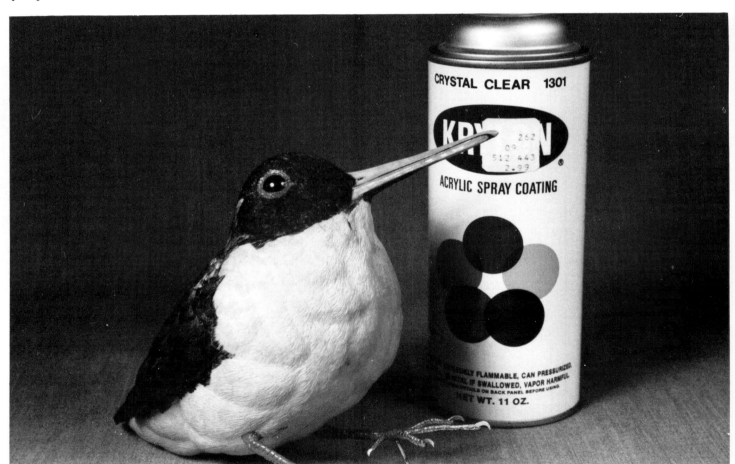

Figure 87. When the putty on the leg tufts and eyes has hardened, seal the bird with *Krylon Crystal Clear Spray*. When dry, the woodcock is ready for painting!

PAINTING THE AMERICAN WOODCOCK

Liquitex jar acrylic color:

Burnt umber=BU
Raw umber=RU
Raw sienna=RS
Paynes grey=PG
Cerulean blue=CB
Yellow ochre/oxide=YO
Titanium white=W
Mars black=B

An ***** indicates that a small amount should be added.

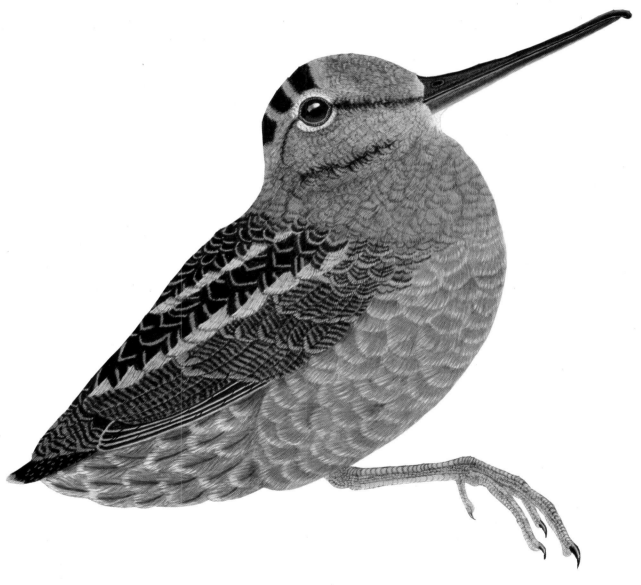

American Woodcock (female)

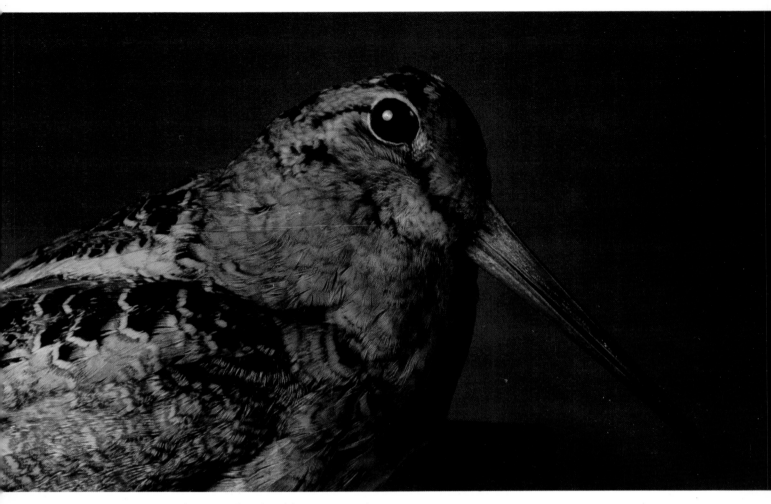

Figure 1. The dark feathers on the shoulder area are the front of the scapulars tucking under the neck feathers.

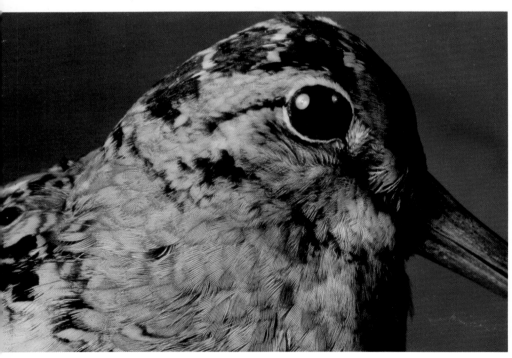

Figure 2. Note the dark streak coming out of the middle of the back of the eye.

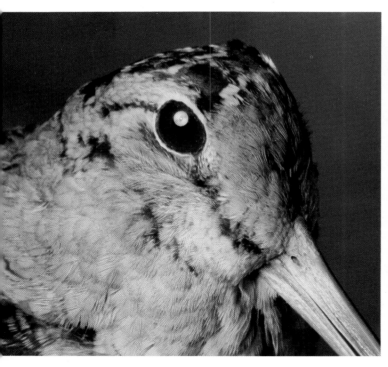

Figure 3. There are also dark streaks from the base of the beak to the front corner of the eye and a short dark streak on the forehead down the base of the beak.

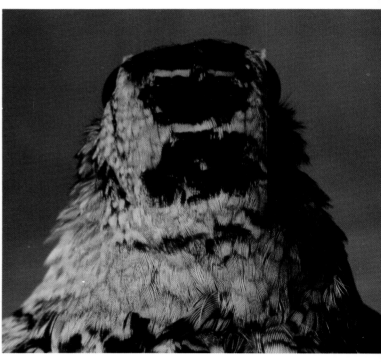

Figure 4. The dark area on the top of the head and neck is divided by three gold bars.

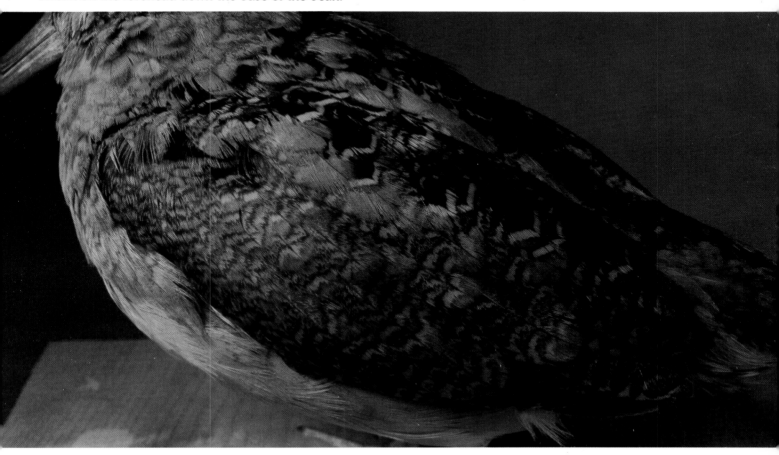

Figure 5. The dark feathers above the wing are the scapulars.

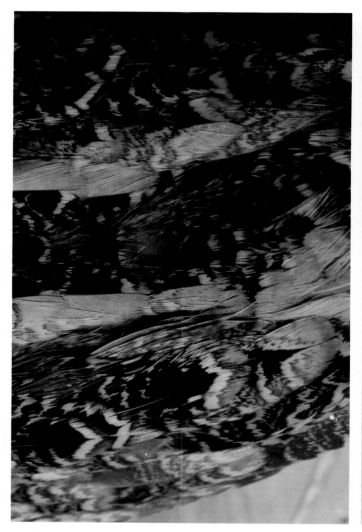

Figure 6. The close-up of the wing coverts reveals the zig-zag barring.

Figure 7. The grey feather pattern on the mantle is quite evident on the top plan view.

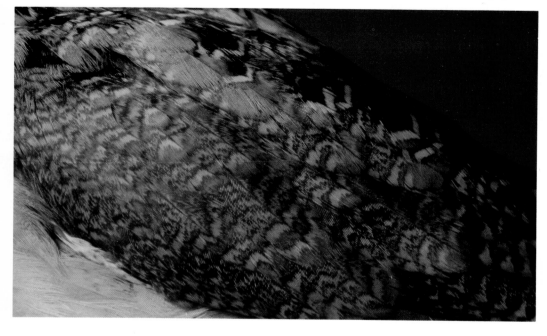

Figure 8. The grey outer feather halves are along the outer edge of the mantle. The grey inner tips are on the longer scapulars.

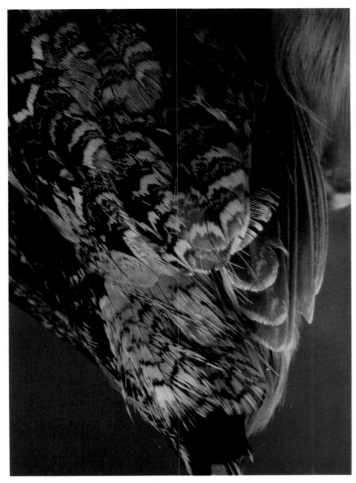

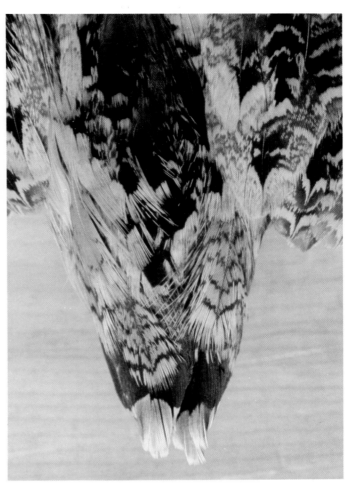

Figure 9. The upper tail coverts are a soft orange with dark brown zig-zag barring.

Figure 10. The base of the tail feathers is a dark brown, lightening near the tips and the edges are white.

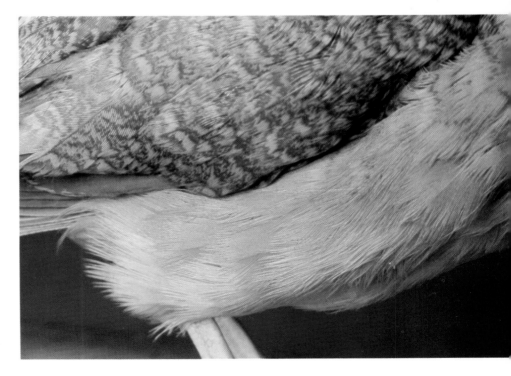

Figure 11. The flank feathers are a muted orange with lighter edges.

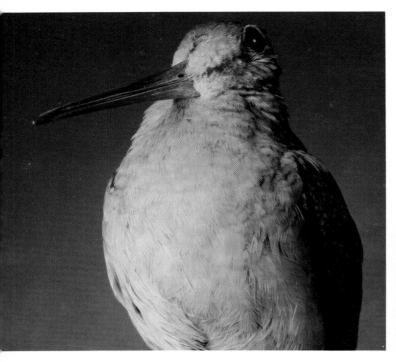

Figure 12. The breast is an orange-beige with lighter edges.

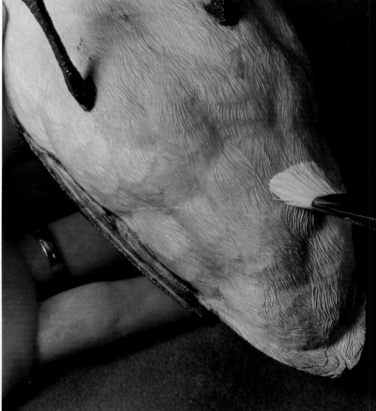

Figure 14. Using a stiff bristle brush, apply gesso right out of the jar. Adding water to gesso causes tiny pinholes to develop in the surface. Load the brush with gesso, wipe most of it on a paper towel and use a dry-brush technique scrubbing it down into the texturing grooves. The stiff brush is very important here because the firm bristles will keep the gesso from puddling in and filling up the texturing. Gesso the entire bird, feet, head, and beak included. It usually takes about two coats to even out the color differential of the stoning and burning. Sometimes, it requires a third application over the green putty areas. When the gesso is dry, carefully scrape the eyes.

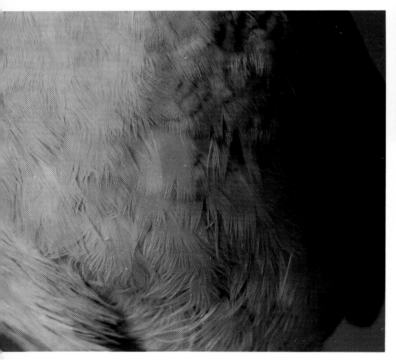

Figure 13. Note the dark barring on the feathers just in front of and below the wings.

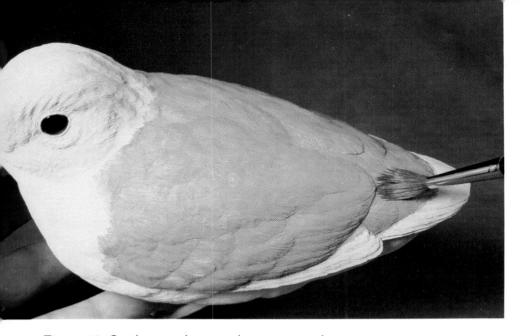

Fig. 15 Fig. 16

RS + W + *BU BU + *W

Figure 15. On the mantle, scapulars, upper tail coverts, and all wing feathers except the primaries, apply several basecoats of a mixture of raw sienna, white, and a small amount of burnt umber.

Figure 16. Blend a small amount of white into burnt umber and paint in the dark zig-zag barring on all of the wing coverts. A liner brush is helpful in getting fine lines.

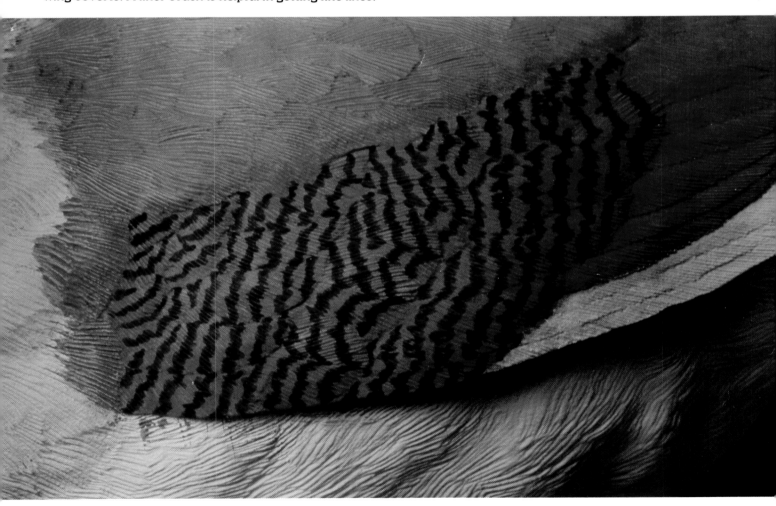

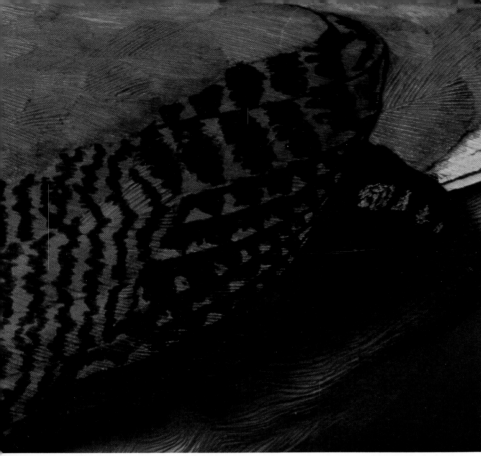

Figure 17. Using the same dark mixture, paint the tertials and edges of the secondaries with wider but more irregular edged bars. Add a little more white to the mixture and paint the primaries. When these are dry, dot an arrow-shaped pattern near the tip and across the quill.

Figure 18. Apply a thin burnt umber wash to the wings. When this is dry, paint the tips on the lesser, middle, and greater secondary coverts with a thin light grey mixture of burnt umber, paynes grey, and white. All of the wing feathers need to be edged with a mixture of raw sienna and white. Apply longer edging on the tips of the tertials, secondaries, and primaries. Highlight randomly between some of the bars. Apply a very thin wash of raw umber with a small amount of white added. To create a shadow, pull a thin line of watery burnt umber at the base of each feather just below the light edge of the feather above.

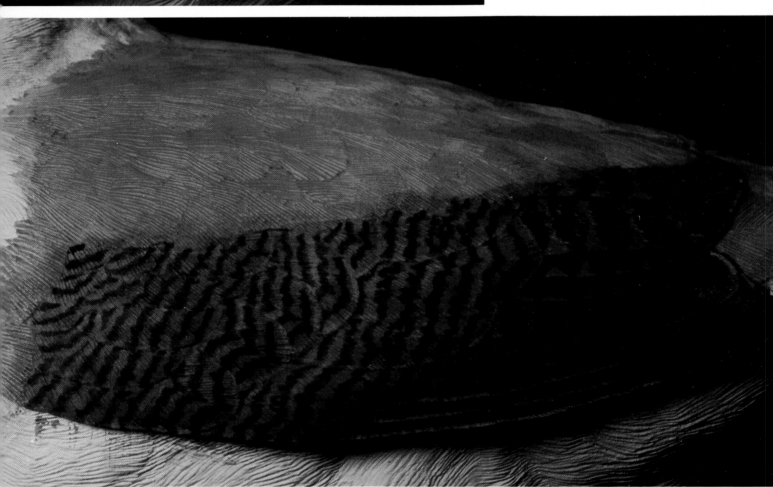

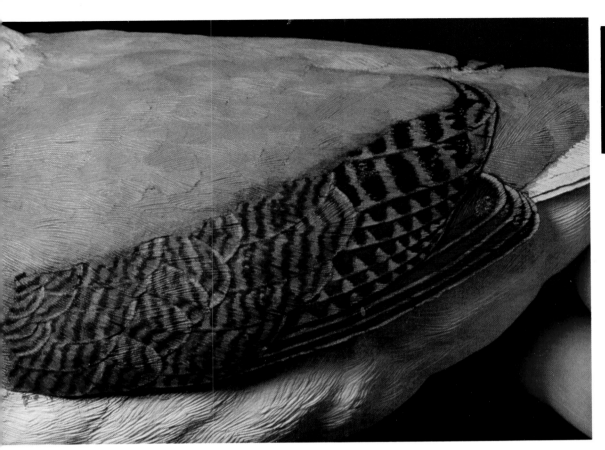

RU + PG + W

Fig. 20

Figure 19. You will need to work the dark colors and light colors back and forth until softness develops. If the raw umber washes leave too much greenish tinge, use a burnt umber wash. Avoid getting too dark with the colors since it is more difficult to lighten than to darken. If the orange color disappears, use a raw sienna and white wash.

Figure 20. Blend raw umber, paynes grey, and white to a light grey. Apply the grey to the leading half of each mantle along its edge. On the interior scapulars, paint a narrow band of light grey on each edge. On the forward scapulars, paint the outer leading half of each feather, and on the scapulars nearer the tail, paint wide bands at their tips.

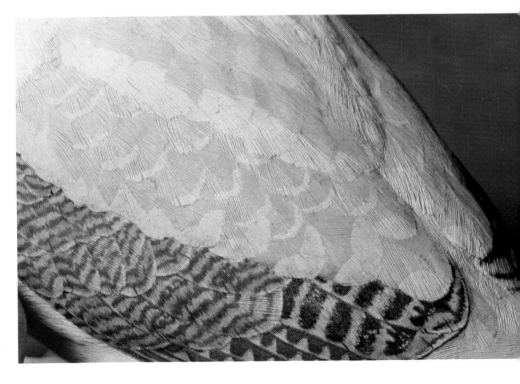

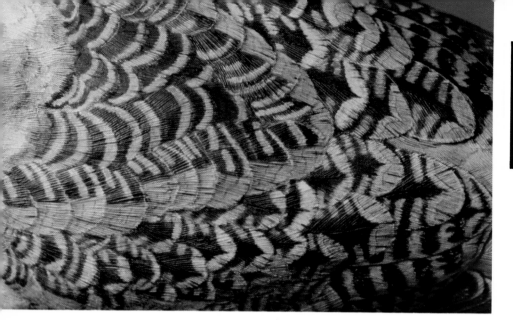

Figure 21. For the dark patterns on the mantle and scapulars, use a dark brown mixture of burnt umber with a small amount of paynes grey added. The gold bars on the mantle and scapulars are a mixture of yellow ochre, white, and a small amount of raw umber. Apply a very thin raw umber wash. You will need to work the darks and lights back and forth until there is soft blending. Use a watery line of burnt umber to create a shadow around each feather and to darken random splits. Lighten the tips of the scapulars with a lighter grey made by adding white to the light grey mixture. Adjust the color by using very thin burnt umber, raw sienna, or a mixture of raw umber and yellow ochre washes.

Figure 22. For the dark bars on the rump and upper tail coverts, apply a mixture of burnt umber and a small amount of paynes grey. The light grey tips are a mixture of raw umber, paynes grey, and white. The light bars are a mixture of yellow ochre, white, and a small amount of burnt umber. You will need to work all of the colors back and forth to get soft blend lines. Adjust the color by using very thin burnt umber, raw sienna, or a mixture of raw umber and yellow ochre washes.

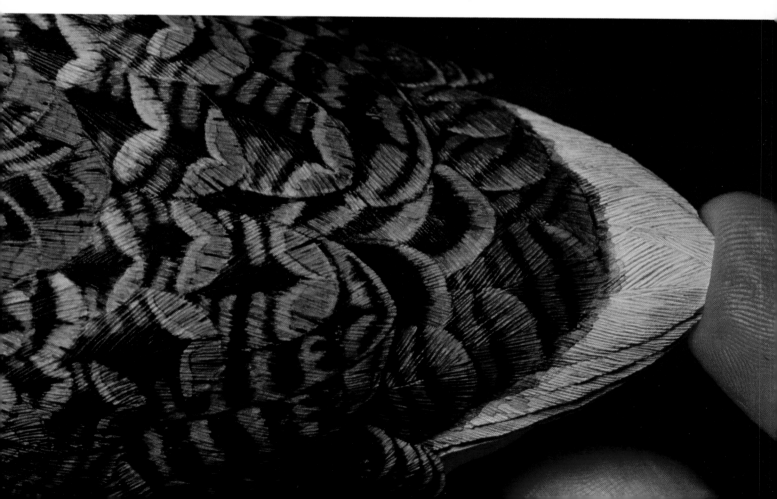

BU + *PG	W + BU + PG	YO + RS + W	RS + *RU + *W	Example of edging technique
Fig. 23	Fig. 23	Fig. 23	Fig. 24	Fig. 24

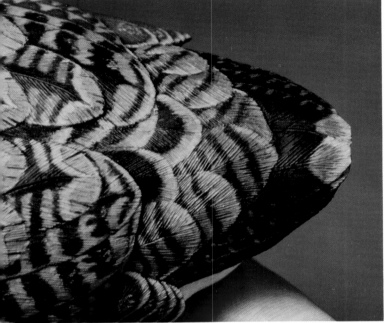

Figure 23. Apply the same dark mixture of burnt umber and a small amount of paynes grey to the bases of the tail feather's upper surface. Paint the "v"-shaped tips with a mixture of white, burnt umber, and paynes grey, and before these dry, wet-blend straight white along the outer edges. The orange spots on the leading edges of the tail feathers are a mixture of yellow ochre, raw sienna and white. When these are dry, apply a burnt umber wash to the upper tail. When dry, apply a raw umber wash.

Figure 24. For the basecoat on the underside of the bird and the head, apply a mixture of raw sienna and small amounts of raw umber and white. Before this dries, wet-blend a small amount of straight white in the center of the belly. Before the basecoat is dry, also wet-blend raw umber and white onto the head, neck, and breast, and before this dries, wet-blend white under the chin.

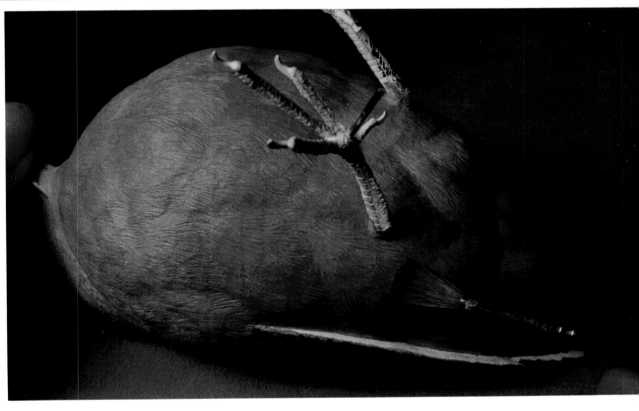

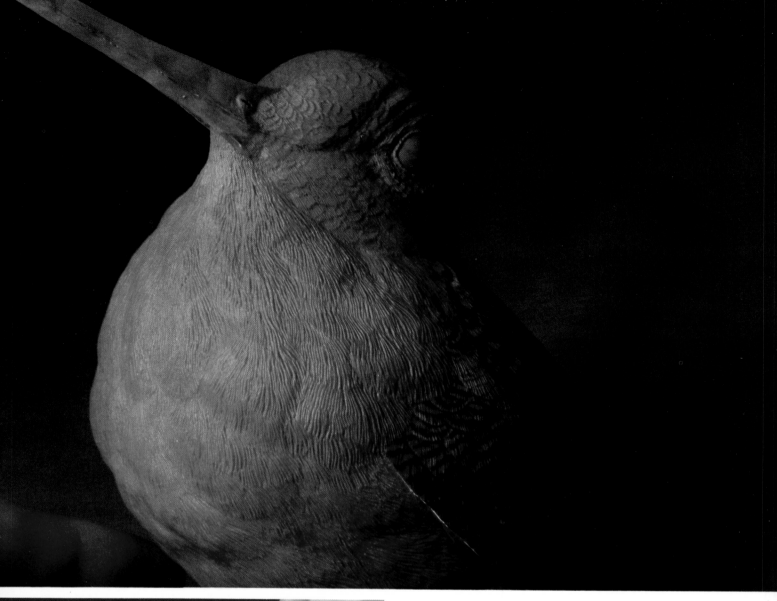

Figure 25. Note the slightly different hue on the head, neck and breast from wet-blending a small amount of raw umber and white into the orange basecoat.

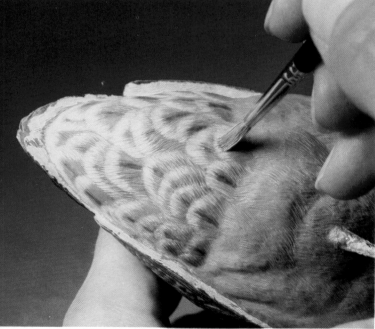

Figure 26. The dark centers of the lower tail coverts are a mixture of burnt umber and small amounts of paynes grey and white. For the light edgings, blend a mixture of white with small amounts of raw sienna and raw umber. Using a round sable brush, load the paint on the brush and wipe off any excess. Anchor your hand with your little finger on the surface for stability, hold the brush vertically to the bird's surface and pull the light edging from each feather tip toward its base for ⅛″ to ¼″, gradually lifting the brush up. When dry, apply a watery wash of a mixture of raw sienna and small amounts of raw umber and white. You will need to edge and wash several times until the area softens.

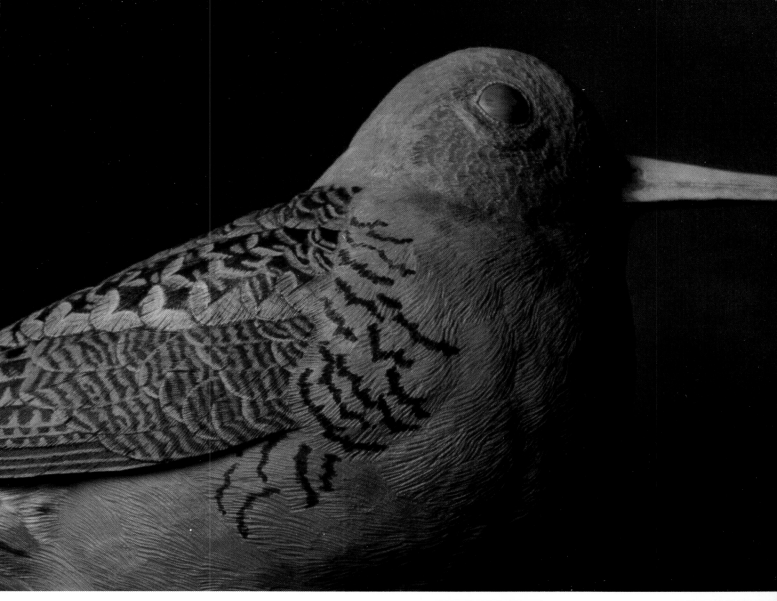

Figure 27. The dark squiggles on the side breast are a mixture of burnt umber and small amounts of raw sienna and white. Tip the feather edges on the breast, belly, flanks with a mixture of raw sienna, white, and a small amount of raw umber. Add water to this mixture, making a watery wash and apply two washes over the tipped feathers, drying in between.

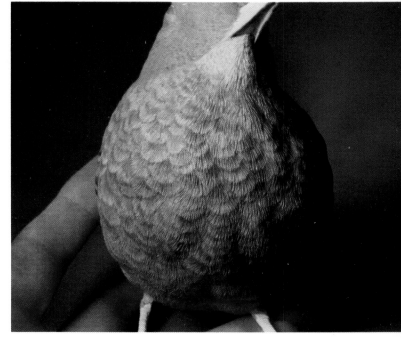

Figure 28A. Apply two watery burnt umber washes to the breast and neck, drying in between.

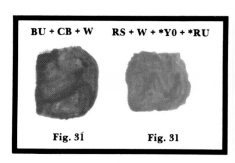

BU + CB + W RS + W + *Y0 + *RU

Fig. 3Ī Fig. 31

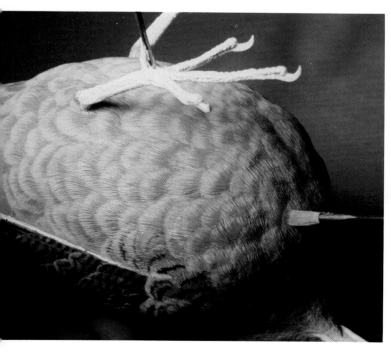

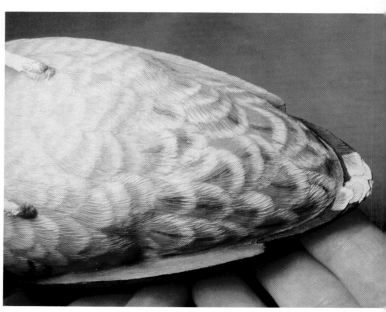

Figure 28B. When dry, apply the light edgings to the underside again. Washing and tipping several times will create a very soft look to the feathers. Applying a watery mixture of raw sienna and a small amount of raw umber will darken the breast up if it starts getting too light.

Figure 30. On the bases of the feathers on the underside of the tail, apply a mixture of burnt umber, paynes grey, and a small amount of white. Add more white to the base mixture for the tips, and before dry, wet-blend straight white to the edges.

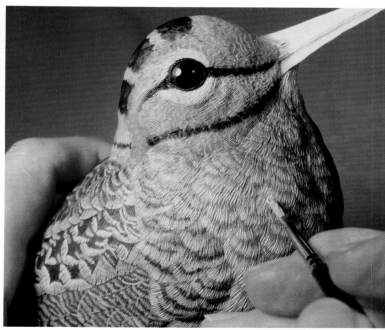

Figure 29. Paint the underwing edges with a mixture of burnt umber, white, and a small amount of paynes grey.

Figure 31. Carefully clean the eyes. For the dark stripes, bars, and the eye rings on the head, apply a mixture of burnt umber and paynes grey. The brownish grey on the hindneck, forehead, and sides of the head and neck is a mixture of burnt umber, cerulean blue, and white. Use a dry dabbing stroke to blend it into the basecoat color. The orange head bars are a mixture of raw sienna, white, and small amounts of yellow ochre and raw umber. Lighten above and below the eye and edge the neck feathers with a mixture of white and small amounts of raw sienna and raw umber.

YO + RS + RU + W

Fig. 34

Figure 32. Shadow the dark barring feathers with a thin line of very watery straight black at the base of each feather. Lighten the edges of the light head bars by adding white to their basecoat color, and paint a line of thin paint on their edges. Apply a very thin raw sienna wash to the top back of each ear covert, in front of each eye, and on the light bars on the forehead.

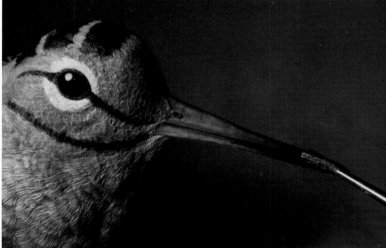

Figure 34. The basecoat for the beak is a mixture of yellow ochre, raw sienna, raw umber, and white. It will take several coats to sufficiently cover the gesso. When these are dry, make a wash of burnt umber and a small amount of paynes grey. Apply the wash to all of the beak about two times, drying in between. Then, darken the tip (about 1/3 of the beak's length) with several more washes. Also darken the nostrils and commissure lines.

Figure 33. There is a small narrow band of the orange color on each side of the short dark streak on the forehead. Use the head bar mixture of raw sienna, white, and small amounts of yellow ochre and raw umber. Apply a raw sienna wash to all of the orange barring. Carefully clean the eyes and touch up the eye rings if necessary.

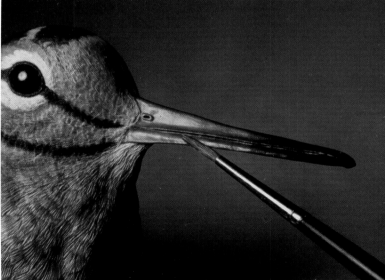

Figure 35. When the beak is dry, apply a 50/50 mixture of matte and gloss medium.

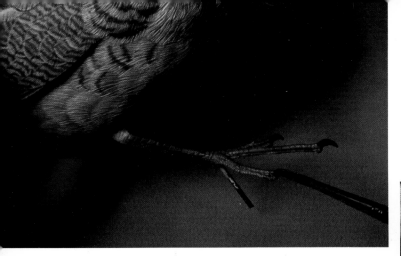

YO +RS + RU + W

Fig. 36

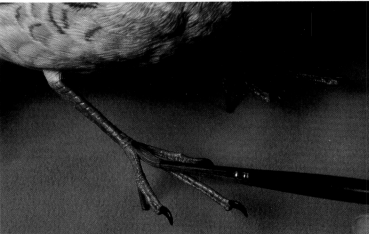

Figure 36. Apply several coats of a mixture of yellow ochre, raw sienna, raw umber and white for the feet basecoats. When these are dry, apply two very watery washes of a mixture of burnt umber and a small amount of paynes grey. When these are dry, apply straight burnt umber for the claws.

Figure 37. Put a small amount of gloss medium in a large puddle of water and apply to the feet. When this is dry, apply straight gloss to the claws. Also apply straight gloss to the quills on the wings and both surfaces of the tail. Glue the woodcock onto her mount with super-glue.

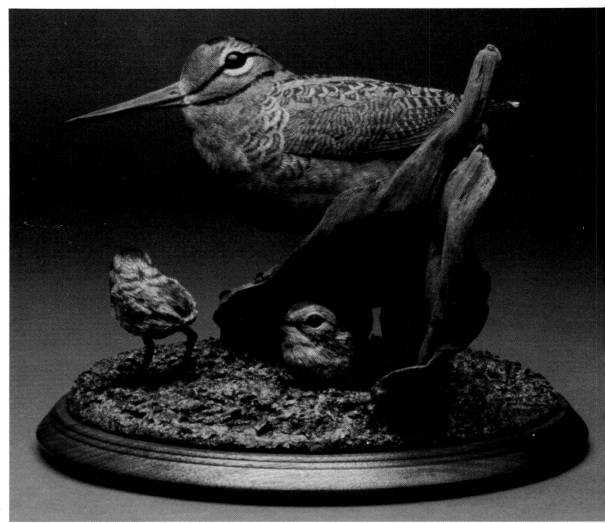

Figure 38. The finished woodcock.

Chapter 4.
American Woodcock Chicks
(Philohela minor)

Usually a woodcock hen lays 4 eggs and there are 4 chicks. I decided that three young birds were called for in this composition. The prancing chick and the one nestled in the large opening are the same pattern. The one with just his head sticking out has a flatter body.

Woodcock chicks in the wild usually leave their nest within 24 hours of hatching. Within another day or two, they are feeding on earthworms that they have caught themselves. While they are still downy, they will brood with the mother if the weather is cool or damp. The hairy down of the chicks usually lasts less than a week. The size of these chicks indicates that they are 2 or 3 days old. Within a week of hatching, woodcock chicks begin to develop their primary feathers. In approximately 3 weeks, they are able to fly short distances, and within 4 weeks, they are adult sized birds. At 6-8 weeks, they are on their own.

DIMENSION CHART
1. End of tail to end of winglet—.70 inches
2. Length of winglet—.60 inches
3. End of tail to front of winglet—1.3 inches
4. Head width at ear coverts—.8 inches
5. Head width above eyes—.60 inches
6. End of beak to back of head—1.4 inches
7. Beak length
 - top—.50 inches
 - center—.60 inches
 - bottom—.35 inches
8. Beak height at base—.17 inches
9. End of beak to center of eye (5 mm. brown)—.90 inches
10. Beak width at base—.18 inches
11. Beak width at tip—.10 inches
12. Tarsus length—.57 inches
13. Toe length
 - inner—.60 inches
 - middle—.80 inches
 - outer—.60 inches
 - hind—.25 inches
14. Overall body width—1.3 inches
15. Overall body length—2.4 inches

SEE PATTERNS ON PAGE 80

TOOLS AND MATERIALS
Bandsaw (or coping saw)
Flexible shaft machine
Carbide bits
Ruby carvers and/or diamond bits
Variety of mounted stones
Pointed clay tool or dissecting needle
Compass
Calipers measuring in tenths of an inch
Ruler measuring in tenths of an inch
Rheostat burning machine
Awl
400 Grit sandpaper
Drill and drill bits
Laboratory bristle brush on a mandrel
Needle-nose pliers and wire cutters
Toothbrush
Safety glasses and dustmask
Super-glue and 5 minute epoxy
Oily clay (brand names Plasticene and Plastilena)
Duro ribbon epoxy putty (blue and yellow variety)
Krylon Crystal Clear 1301
Pair of 5 mm. brown eyes for each chick
Tupelo block 1.4″ (W) x 1.6″ (H) x 2.5″ (L) for each chick
For making feet:
 16 gauge galvanized wire
 16 and 18 gauge copper wire
 solder, flux, and soldering pen or gun (or silver solder, flux and butane torch)
 permanent ink marker
 hammer and small anvil
 small block of scrap wood and staples (or several pairs of helping hands holding jigs)

Figure 1. After drawing the profile pattern on the tupelo block and cutting it out with a bandsaw or coping saw, draw in the plan view pattern on the topside of one or more chicks. Cut the excess wood from around the winglets and tail.

Figure 3. Find the middle of the top of the head, by placing a finger at the base of the beak and one at the back of the head and sighting the midpoint from the profile view.

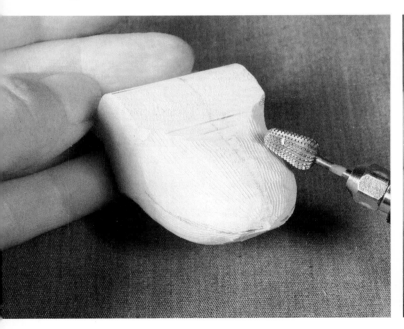

Figure 2. Put in a centerline on the top of the head, back and underside. Also put a centerline on the flanks. Using a ruby carver or stump cutter, round over the back from the flank centerline to the one on the back and round over the belly from the flank centerline to the one on the belly.

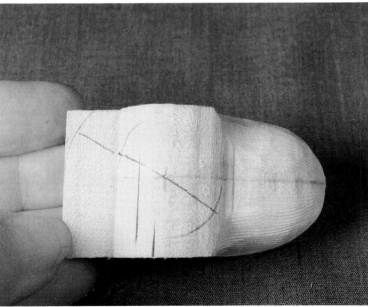

Figure 4. Put the point of a compass on the centerline at the midpoint. Remember that tupelo is a soft wood and pressing the point of the compass too hard will leave a crater in the top of the head. Swing an arc the same distance as the back of the head to the side to which you want the chick's head to turn. Swing another arc the same distance as the back of the head to the opposite side as the head turn. Swing one more arc to the head turn side the same distance as the end of the beak. Draw a new centerline intersecting all three arcs and passing through the pivot point. The angle between the new centerline and the old one will be the angle of the head turn.

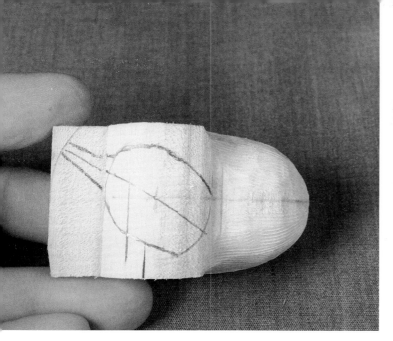

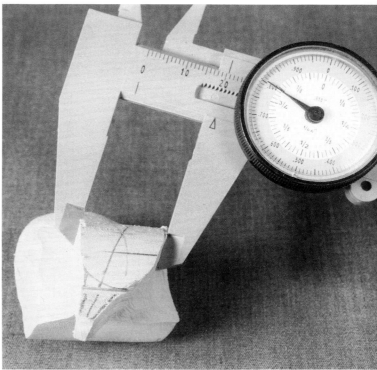

Figure 5. Holding a ruler perpendicular to the new centerline, measure and mark the distance of the head width at the ear coverts .8 of an inch. There should be .4 of an inch on each side of the centerline. Roughly draw in the top plan view of the head allowing extra width on the beak. The lines for the sides of the head should encompass the measurement marks.

Figure 7. Continue removing wood until the head width measures .80 inches with the calipers.

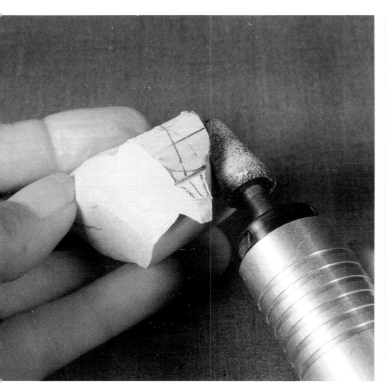

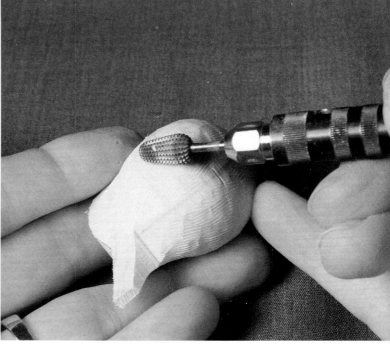

Figure 6. Narrow the head to the plan view lines. Keep equal amounts of wood on both sides of the centerline and keep the sides of the head straight up and down.

Figure 8. Flow the shelves from the head narrowing procedure out onto the shoulders. Round the breast from the flanks to the centerline. Do not remove any wood from the chin area.

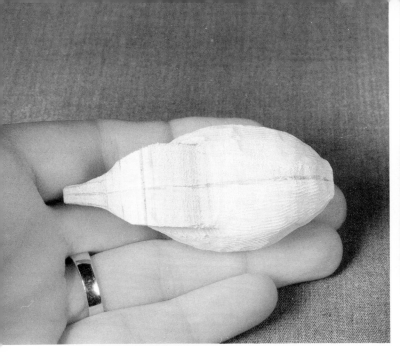

Figure 9. Here you see the chick that will be peeking out from the hole in the driftwood. Her head is not turned, but the carving procedure is still the same.

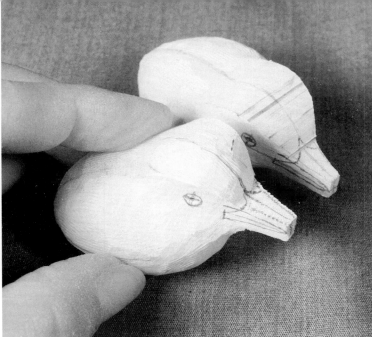

Figure 11. Use a fine cutting ruby carver to smooth the sides of the head and beak to make it easier to draw on. Transfer the eye and beak drawing from the profile pattern to the carving. Use a ruler or calipers to check all dimensions. Pinprick the beak center length (where the commissure line will be) and the eye centers. On the top of the beak, measure and pinprick .50 inches from the tip. Note the small "v"-shape on the top of the beak.

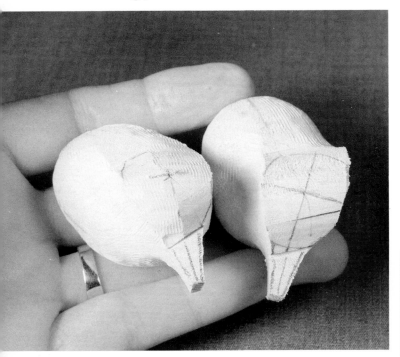

Figure 10. On the top of the head, draw a line through the pivot point perpendicular to the centerline that divides the head into quadrants. When the head of the bird is turned in the wood, the planes on the top of the head will not be the same as in the profile blank.

Looking head-on to the chick's head, mark the high quadrants. The front quadrant to be marked is on the side to which the head is turned and the back quadrant is opposite it. Carve the high quadrants down to the same level as the other side. When carving down the back quadrant, you will need to remove some wood off the back of the neck and flow the neck out onto the back.

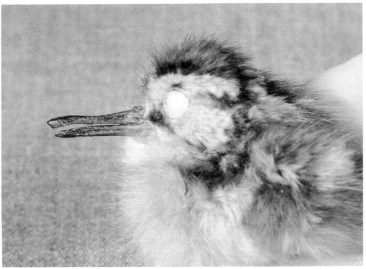

Figure 12. The profile of a woodcock chick's beak.

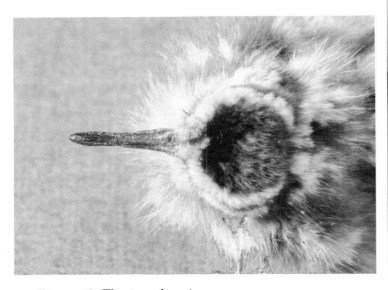

Figure 13. The top plan view.

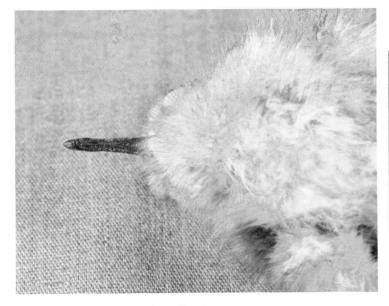

Figure 14. The underside plan view.

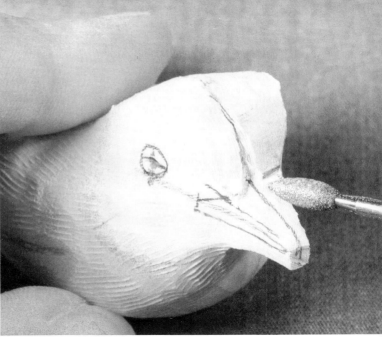

Figure 15. Use a small pointed ruby carver to grind away the excess wood above the upper mandible. Keep the surface flat at this time. Redraw the centerline.

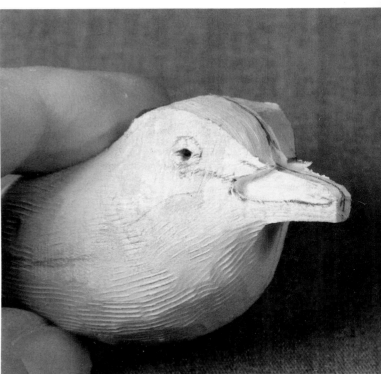

Figure 16. Begin removing wood from the sides of the beak, keeping them flat and vertical. Take a little off one side and then the other side. Checking from the head-on view will allow to keep both sides balanced across the centerline. There should be equal amounts of wood on each side of the centerline. Continue removing small amounts of wood until the base of the beak width measures .18 inches with the calipers. Redraw any lines cut away.

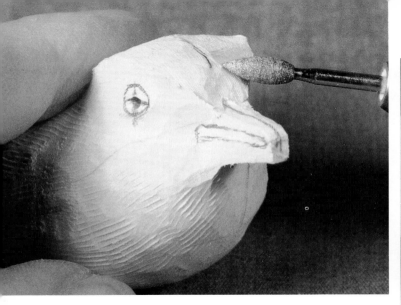

Figure 17. Flow the sides of the head and the forehead down to the base of the beak, maintaining their same flat planes.

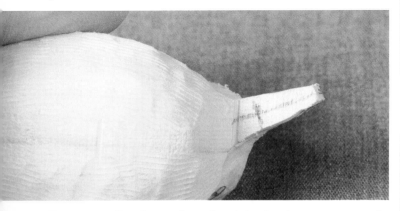

Figure 18. On the underside of the beak, measure and mark the distance to the little tuft of feathers .35 inches.

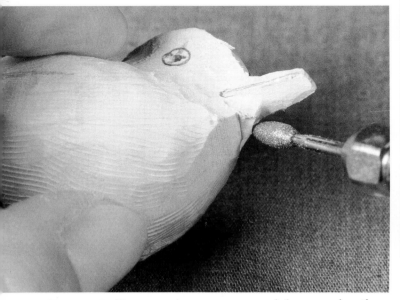

Figure 19. Remove the excess wood from under the lower mandible working the little tuft of feathers in an arc back towards the base of the beak on its sides.

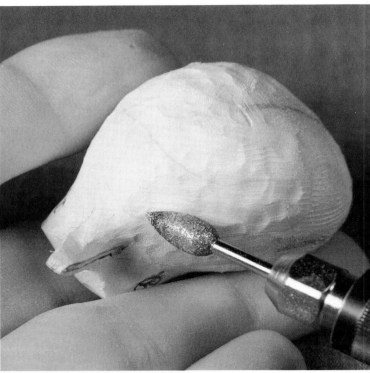

Figure 20. Flow the throat and chin down towards the base of the beak eliminating the shelf at the tuft of chin feathers. Round the throat and chin.

Figure 21. Across the crown above the eyes, measure and mark the head width .60 inches. Using a ruby carver, narrow the crown from the eye area to the top corner of the blank. Maintain the wedge shape of the head and beak.

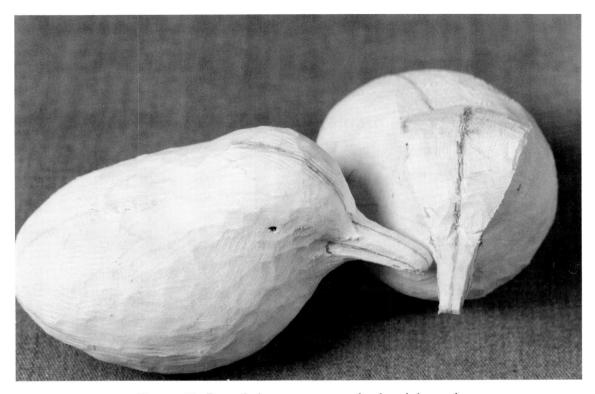

Figure 22. Round the corners on the head from the forehead to the back of the neck. Flow the back of the neck onto the back and shoulder areas.

Figure 23. Narrow the plan view of the beak along its sides. Keep both sides flat and vertical. Narrow the beak tip to .09 inches and gently round it.

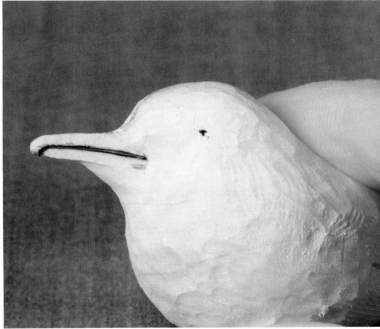

Figure 24. Check to see if the commissure lines are balanced from the head-on view. Burn in the commissure lines with the burning pen held vertical to the side of the beak's surface. You will not need much heat for this since tupelo is such a soft wood.

Figure 25. Draw a line on both sides of the upper mandible just a pencil point's width outside the top centerline. Angle the sides of the upper mandible from this line down to the commissure line.

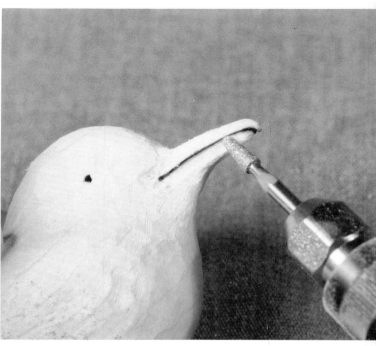

Figure 27. Also create a depression on each side of the lower mandible from the base to its tip. Narrow the tip, tucking it under the upper mandible.

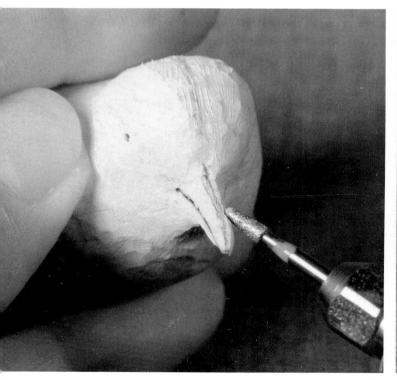

Figure 26. On this angled surface on each side of the upper mandible, create a depression with the rounded end of a diamond or stone to .20 inches from the tip. The nostrils are located in these depressions on each side of the beak.

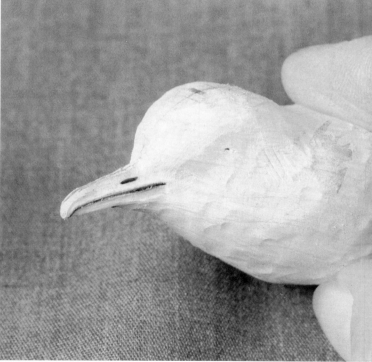

Figure 28. Draw and burn in a small slit on each side of the upper mandible for the nostrils. Make sure these are equal on each side. A small pointed spearpoint burning pen is useful for this procedure.

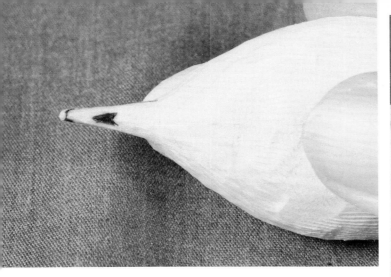

Figure 29. Also burn in the small triangle at the base of the lower mandible.

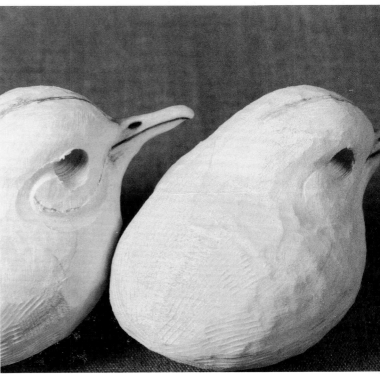

Figure 32. Draw in the ear coverts making sure that they are balanced in length and depth. Using a small diamond or ruby carver, channel around the ear coverts. Flow the channel out onto the surrounding neck area and round over the sharp corners on the coverts. You may need to remove a small amount of wood from the front corner and bottom of the eye holes so that the eyes have a slightly concave area in which to sit.

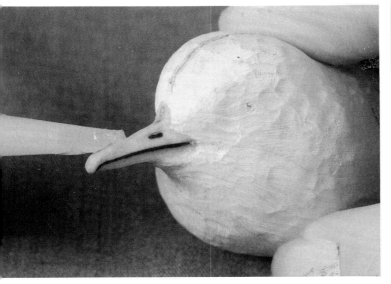

Figure 30. Fine sand the beak without disturbing the details. Saturate the beak with super-glue and when dry, fine sand again.

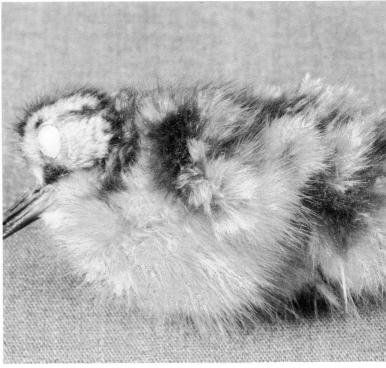

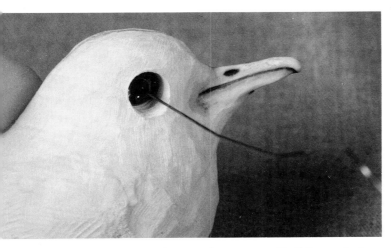

Figure 31. Recheck the eye placements. Drill 5 mm. holes and check eyes for the proper fit.

Figure 33. Note the winglet on the side of the woodcock chick study skin.

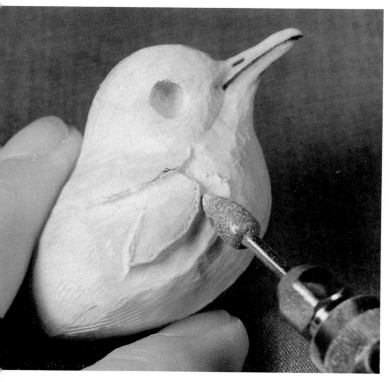

Figure 34. Transfer the winglet dimensions and drawing from the profile line drawing. Draw in the scapular fluff. The winglet comes out from underneath the scapular fluff. Relieve the wood around the winglet. Relieve the wood below the scapular fluff including the top edge of the winglet.

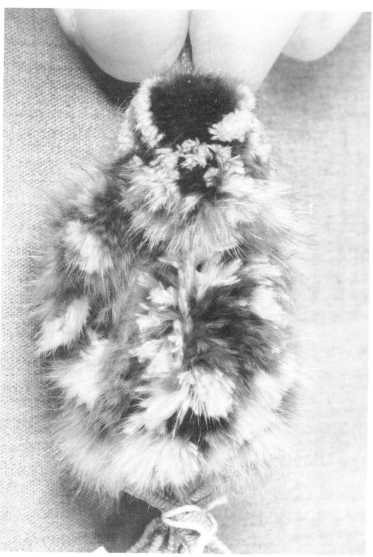

Figure 36. Note the hairy fluff of the woodcock chick.

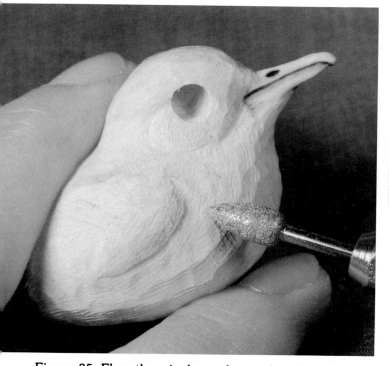

Figure 35. Flow the winglet and scapular channels out onto the surrounding area and round over the sharp corners on the winglet.

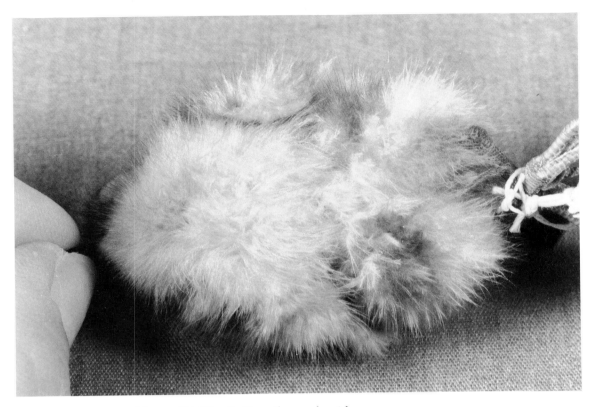

Figure 37. The fluff on the underside.

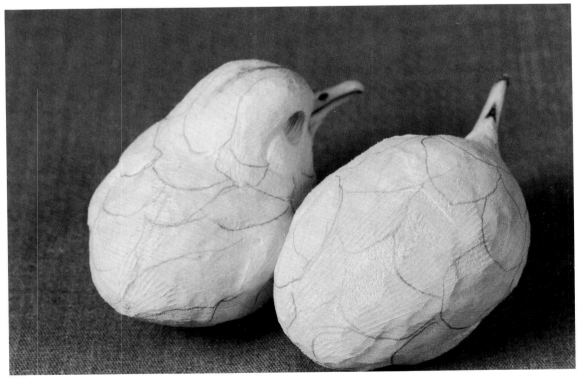

Figure 38. Draw in randomly sized and shaped areas for
the fluff contouring.

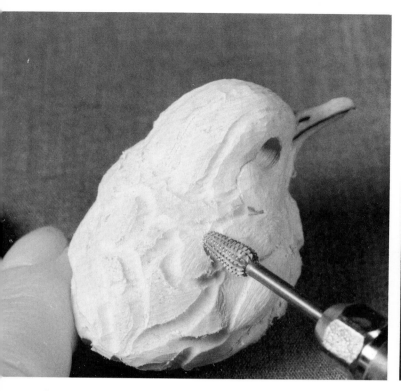

Figure 39. Channel along all of the contouring lines, more deeply on the body and more shallow on the head. Round over each of the fluffs.

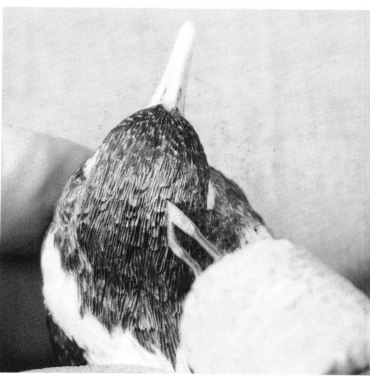

Figure 41. Begin burning in the fluff at the base of beak and work back towards the tail in all directions. Pressing more firmly at the beginning of each stroke and pulling off at the end of each stroke will give a hairy look to the surface.

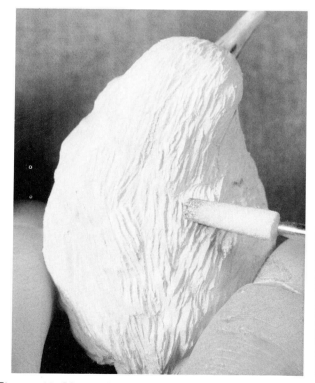

Figure 40. Using the sharp edge of a cylindrical stone held at an angle, begin the heavy texturing. Curving the heavily stoned strokes gives a naturalistic appearance.

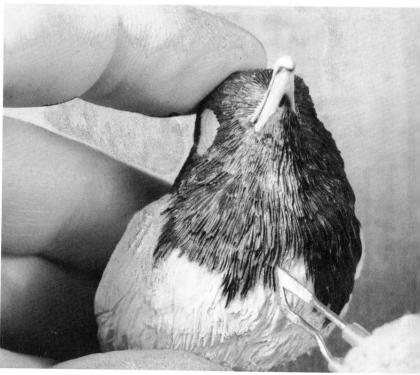

Figure 42. This type of burning is deeper and heavier than burning done on feathers.

76 American Woodcock Chicks

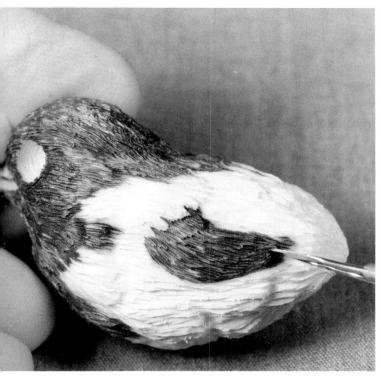

Figure 43. Burn the winglet from the edge of the scapular fluff to the tip.

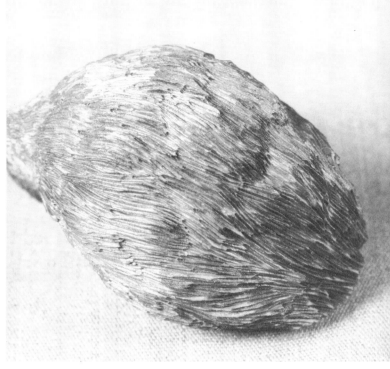

Figure 45. The underside fluff of the woodcock chick.

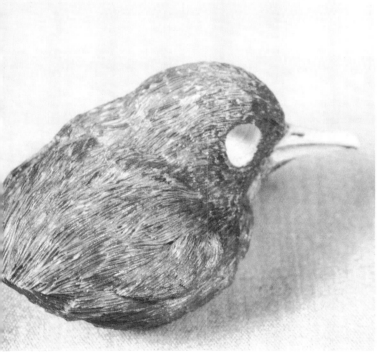

Figure 44. All of the texturing flows from the beak to the tail.

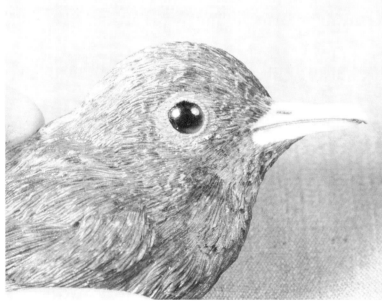

Figure 46. Set the eyes according to the directions at "Setting Eyes" in *Basic Techniques*.

Figure 47. The nestled down chick has foot wires straight into the body.

Figure 48. Some wood needs to be carved out from around the foot holes so that the toes nestle up into the fluff. Retexture any area carved away.

Figure 49. The strutting chick has foot wires bent so that he is raised up on his toes. The 1/16" diameter holes for the wires are balanced across the centerline approximately .50 inches deep. The foot wire is 16 gauge galvanized wire and the toes are 18 gauge copper wire.

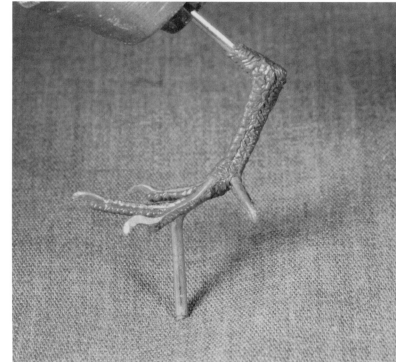

Figure 50. Make the feet according to the directions at "Feet Construction" in *Basic Techniques*.

Figure 51. Super-glue the feet in place. When the glue is dry, a small amount of ribbon putty should be textured around the joint.

The chicks are ready for sealing when the putty has hardened. Spray with Krylon Crystal Clear Spray. When this is dry, the chicks are ready for painting.

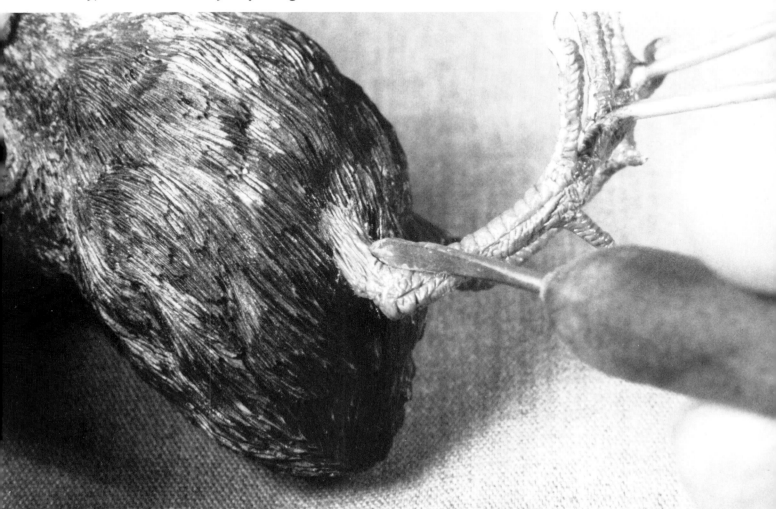

AMERICAN WOODCOCK CHICKS

Chick A

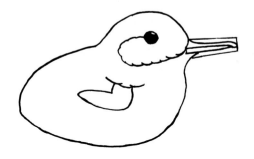

Chick B

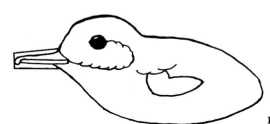

Profile pattern

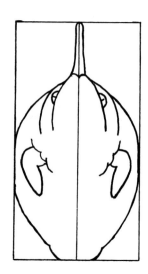

Under planview Top planview Under planview Top planview

Chick A Chick B

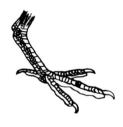

Foot

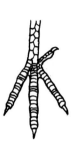

Foot planview

PAINTING THE AMERICAN WOODCOCK CHICKS

Liquitex jar acrylic colors:

Burnt umber=BU
Raw umber=RU
Raw sienna=RS
Yellow ochre/oxide=YO
Paynes grey=PG
Titanium white=W

An * means that a small amount should be added.

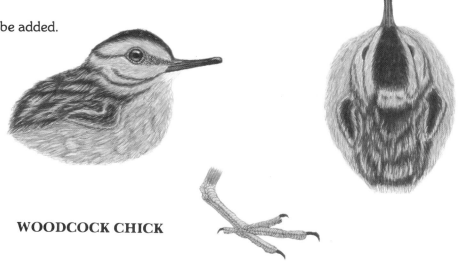

WOODCOCK CHICK

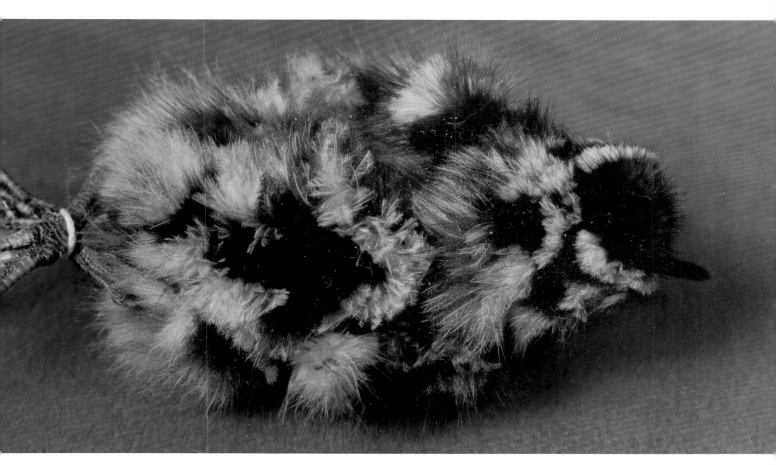

Figure 1. The top plan view of the woodcock chick study skin.

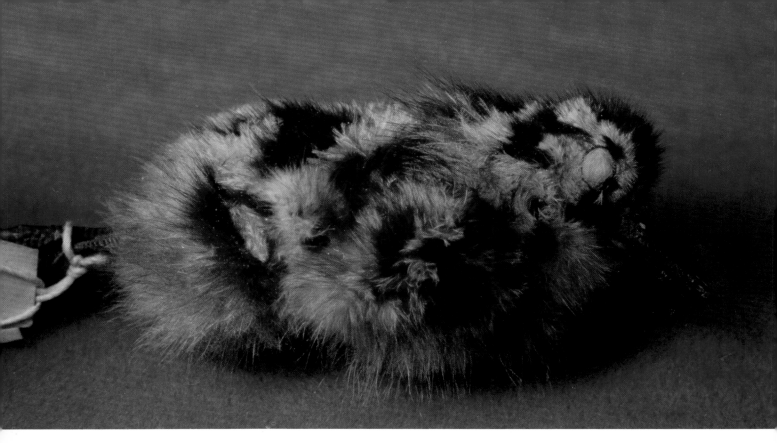

Figure 2. The profile view of the chick.

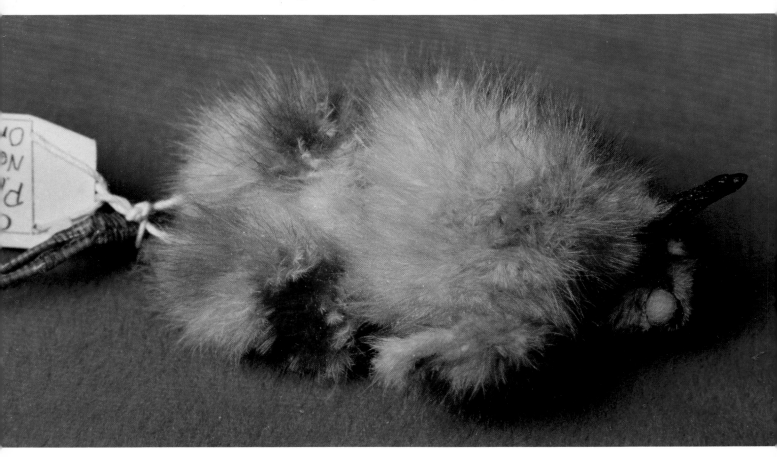

Figure 3. The underside of the chick.

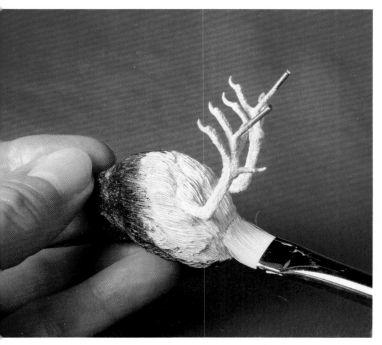

RS +RU	YO + W	BU
Fig. 5		Fig. 6

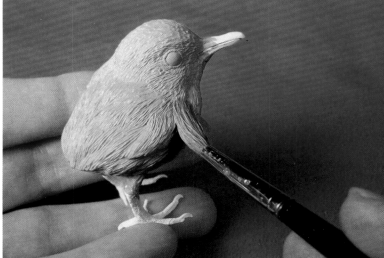

Figure 4. Using a stiff bristle brush, apply gesso right out of the jar. Adding water to gesso causes tiny pinholes to develop in the surface. Load the brush with gesso, wipe most of it on a paper towel and use a dry-brush technique scrubbing it down into the texturing grooves. The stiff brush is very important here because the firm bristles will keep the gesso from puddling in and filling up the texturing. Gesso the entire bird, feet, head and beak included. It usually ire bird except the feet and beak, apply several coats of a mixture of raw sienna, raw umber, yellow ochre, and white. It will take several thin coats to cover the gesso. Keep your paint thin so that it does not fill up the texturing.

Figure 5. Base coat for the entire bird except the beak and feet, apply several coats of a mixture of raw sienna, raw umber, yellow ochre, and white. It will take several thin coats to cover the gesso. Keep your paint thin so it does not fill up the texturing.

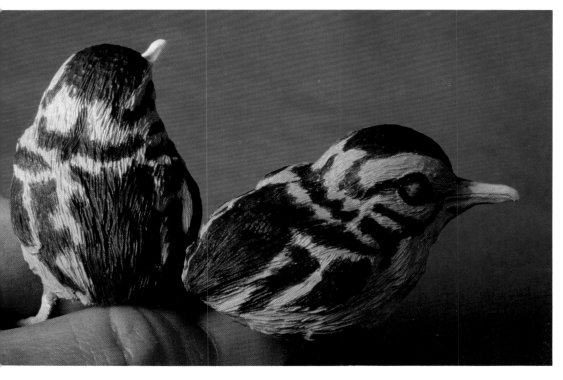

Figure 6. For the dark patches on the head, back, and winglets, use straight burnt umber. Keeping the edges of the dark patches feathery will make it easier to blend the basecoat color into darks.

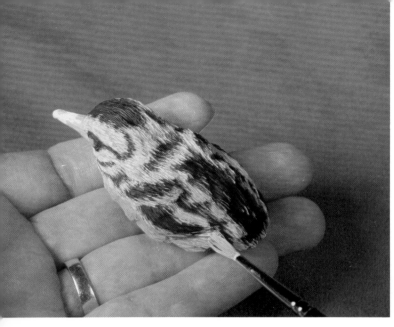

Figure 7. Dry-brush a mixture of white, raw umber, and yellow ochre of the head, winglets, and back for feathery highlights.

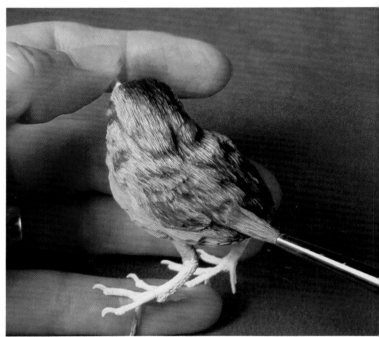

Figure 8. Apply a watery burnt umber wash to the head and entire top side of the bird. Dry-brush in the highlights again and use a wash of raw umber and raw sienna of the highlights.

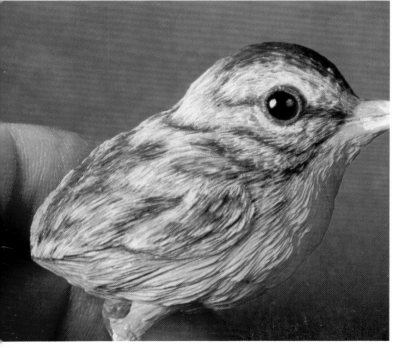

Figure 9. Highlight again and dry-brush a mixture of yellow ochre and raw sienna over the highlights.

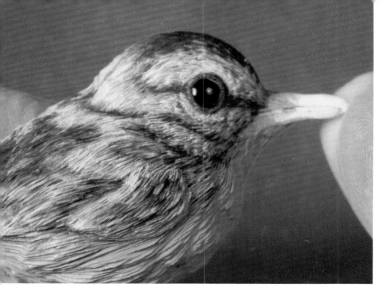

Figure 10. Highlight above and below the eyes with a light mixture of white with a small amount of yellow ochre. The eye ring itself is burnt umber.

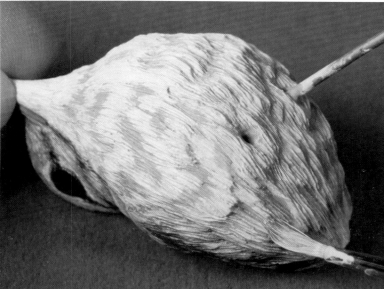

Dry-brushed edging example

Fig. 12

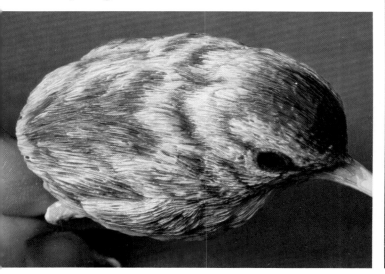

Figure 11. To get the down to look soft, continue highlighting and washing. Use a paynes grey wash over the dark patches.

Figure 12. For the highlights on the underside, use a dry-brush technique and a mixture of white and a small amount of yellow ochre. On the underside concentrate the highlights at the ends of the feather fluffs. Also lighten under the chin and on the tips of the tail with the light highlight mixture.

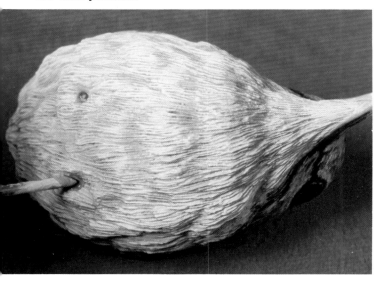

Figure 13. Wash the underside with a mixture of raw sienna and small amounts of raw umber and white. Apply highlights again and wash with a very thin mixture of raw sienna and raw umber to accentuate the texturing depth.

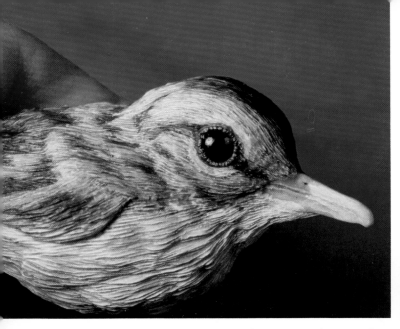

Figure 14. Highlight the eye ring by putting dots on the edge of a light mixture of burnt umber, raw sienna and white.

YO + RS + RU + W YO + RS + RU + W

Fig. 15 Fig. 17

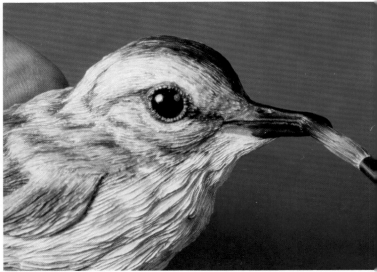

Figure 16. Add paynes grey to darken the end of the beak, the nostrils and the commissure lines. When this is dry, apply a 50/50 mixture of matte and gloss mediums to give the beak a satiny sheen.

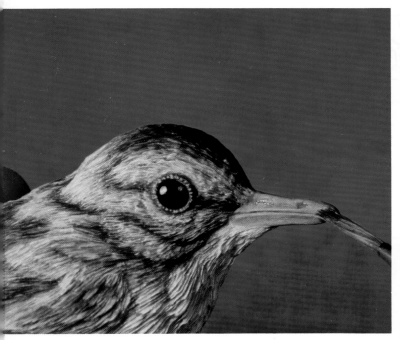

Figure 15. The basecoats for the beak are a mixture of yellow ochre, raw sienna, raw umber, and white. It will take several coats to cover the gesso. Give the entire beak several washes of burnt umber.

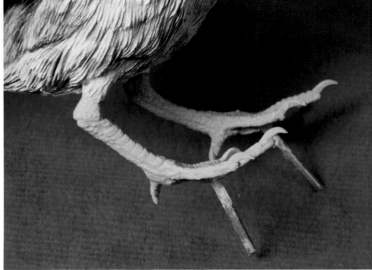

Figure 17. The basecoats for the feet are a mixture of yellow ochre, raw sienna, raw umber, and white.

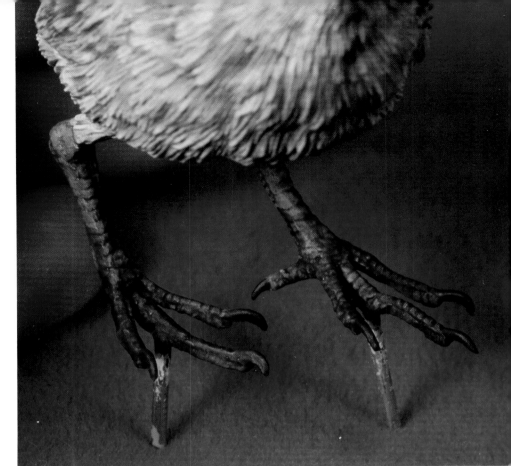

Figure 18. When these are dry, apply two thin burnt umber washes to the entire foot, drying in between. When dry, apply several more burnt umber washes to just the toes. The claws should be painted with undiluted burnt umber. Put a small amount of gloss medium in a large puddle of water and apply to the feet. When this is dry, apply straight gloss to the claws.

Figure 19. Glue the woodcock chick in place with super-glue.

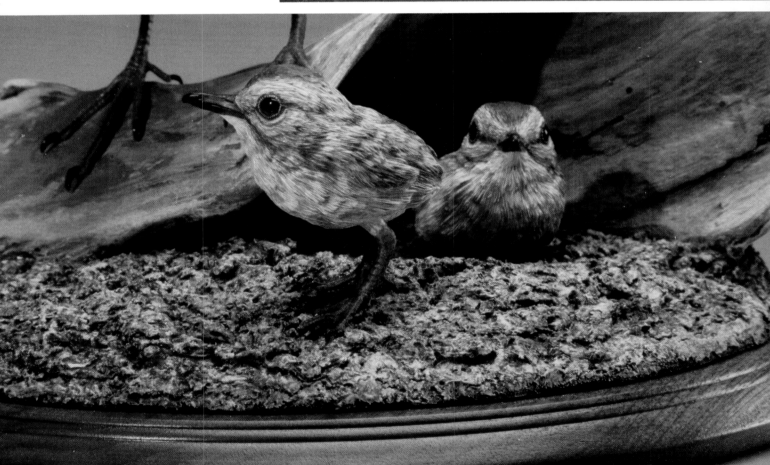

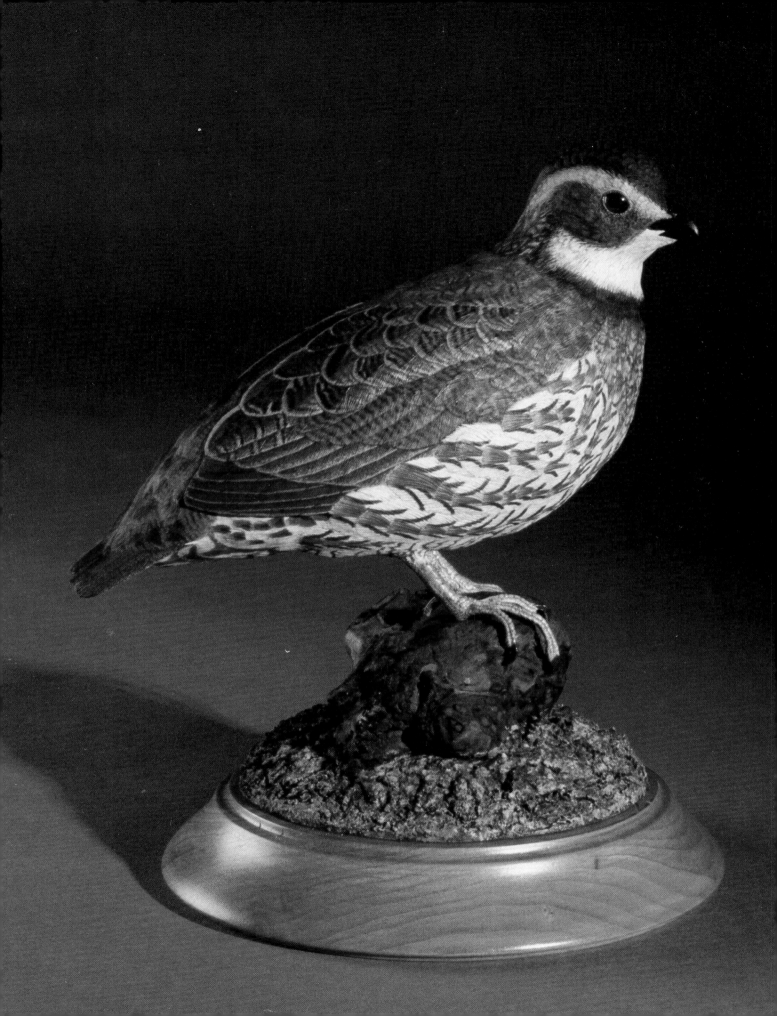

Chapter 5.
Bobwhite Quail
(Colinus virginianus)

The bobwhite quail, a chunky bird, is a resident in the eastern half of the United States and has been introduced in parts of the West and Southwest. Its familiar "bob-white" whistle is widely heard in the country along roadsides and fields, in the canyons and hillsides, in open forests and across the grasslands of the prairies. During the fall and winter, many bobwhites will pull into a tight circle with their tails toward the center. This roosting behavior is for protection and for warmth.

Wary of human interference, the bobwhite will usually run away from any disturbance, since it is not a strong or swift flier. My mother lives on a golf course near the coast in North Carolina. Naturally, she feeds the numerous birds and animals. One of my favorite sights while there is to see the parent quail and young scratching for seeds at the base of the feeders. If something spooks them, off they go, running with their heads bobbing wildly! All that can be seen is a blur-r-r of heads and feet moving across the grass to the safety of the underbrush!

The quail's nest is usually a shallow depression on the ground. It is generally well concealed with grasses over the top and a protected side entrance. Their diet consists mostly of seeds, berries, and some insects.

Both sexes are similar in shape and size. From a distance, their markings appear similar (reddish-brown body with grey tail). However, upon closer inspection, the male has a white chin and upper throat, whereas the female's is more of a buff color. There are many plumage variations of different families found throughout the United States and Central America.

DIMENSIONS FOR MALE BOBWHITE QUAIL
1. End of tail to end of primaries—1.4 inches
2. Length of wing—4.5 inches
3. End of primaries to alula—2.7 inches
4. End of primaries to top of first wing bar—1.4 inches
5. End of primaries to bottom of first wing bar—3.0 inches
6. End of primaries to mantle—3.0 inches
7. End of primaries to end of tertials—.50 inches
8. End of primaries to end of scapulars—1.1 inches
9. End of primaries to end of primary coverts—2.5 inches
10. End of tail to front of wing—5.9 inches
11. Tail length overall—2.5 inches
12. End of tail to upper tail coverts—.50 inches
13. End of tail to lower tail coverts—.50 inches
14. End of tail to vent—2.5 inches
15. Head width at ear coverts—1.1 inches
16. Head width above eyes—.80 inches
17. End of beak to back of head—1.85 inches
18. End of beak to back of crest feathers—1.6 inches
19. Beak length
 top—.54 inches
 center—.56 inches
 bottom—.25 inches
20. Beak height at base—.36 inches
21. End of beak to center of eye (7 mm brown)—.90 inches
22. Beak width at base—.40 inches
23. Tarsus length—1.3 inches
24. Toe length
 inner—1.0 inches
 middle—1.4 inches
 outer—1.0 inches
 hind—.45 inches
25. Overall body width—3.1 inches
26. Overall body length*—7.6 inches

*All of these measurements are for bobwhite quails here in Delaware. According to Bergmann's Rule in ornithology, body size tends to be larger in cooler climates and smaller in warmer climates. Allen's Rule suggests that beaks, tails and other extensions of the body tend to be longer in warmer climates and shorter in cooler climates. Accordingly, you may have to adjust lengths and widths depending on where you live.

TOOLS AND MATERIALS
Bandsaw (or coping saw)
Flexible shaft machine Carbide bits
Ruby carvers and/or diamond bits
Variety of mounted stones
Pointed clay tool or dissecting needle
Compass
Calipers measuring in tenths of an inch
Ruler measuring in tenths of an inch
Rheostat burning machine
Awl
400 Grit sandpaper
Drill and drill bits
Laboratory bristle brush on a mandrel
Needle-nose pliers and wire cutters
Cartridge roll sander on a mandrel
Toothbrush
Safety glasses and dustmask
Super-glue and 5 minute epoxy
Oily clay (brand names Plasticene and Plastilena)
Duro ribbon epoxy putty (blue and yellow variety)
Krylon Crystal Clear 1301 or *Deft Wood Finish*
Pair of 7 mm. brown eyes
Tupelo or basswood block 4.0" (H) x 3.1" (W) x 8.0" (L)
Pair of quail feet to use in bird or as a model for making feet
For making feet:
 3/32" brazing rod
 16 and 18 gauge copper wire
 solder, flux and soldering pen or gun (or silver solder, flux and butane torch)
 permanent ink marker
 hammer and small anvil
 small block of scrap wood and staples (or several pairs of helping hands holding jigs)

BOBWHITE QUAIL

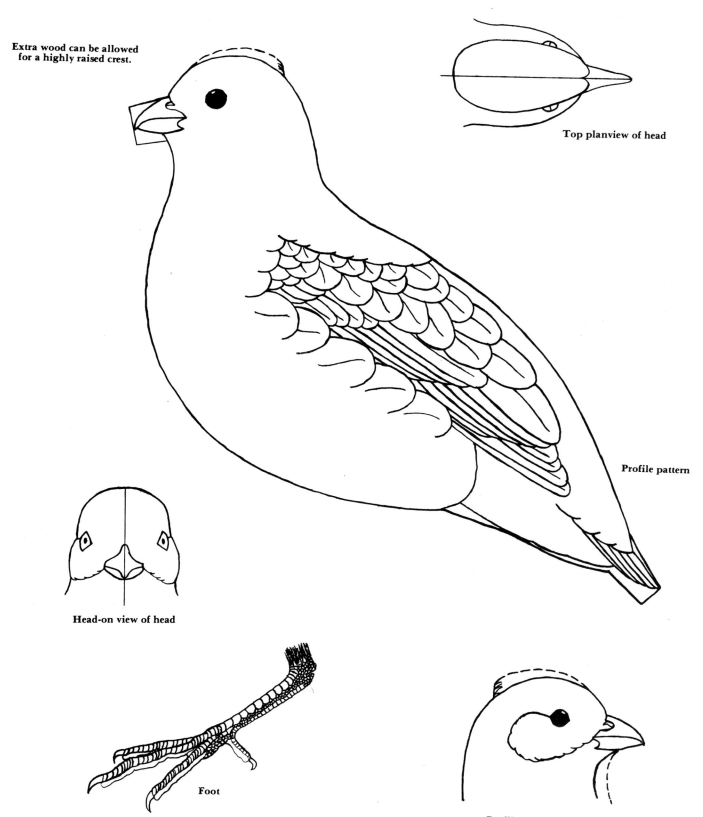

Extra wood can be allowed for a highly raised crest.

Top planview of head

Profile pattern

Head-on view of head

Foot

Profile view of head

BOBWHITE QUAIL

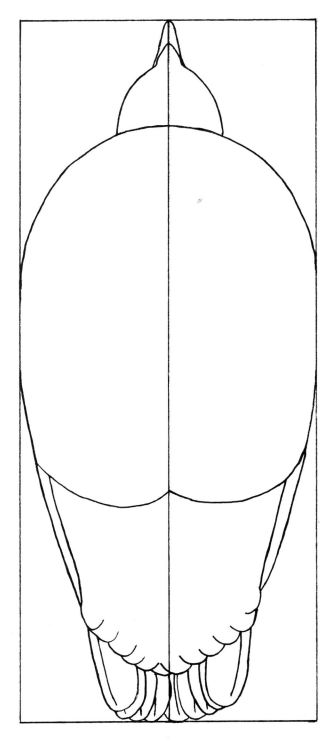

Under planview

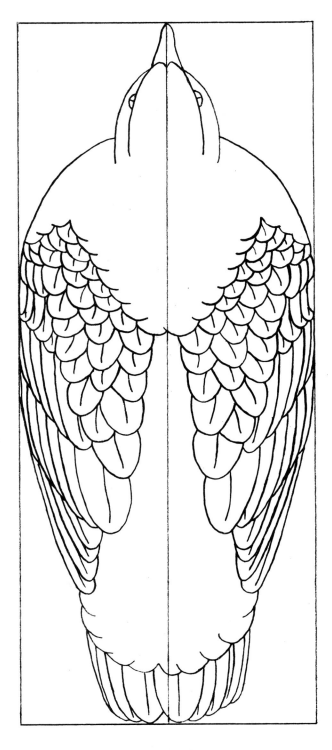

Top planview

*Foreshortening may cause distortions in measurements on plan views. Check the Dimension Chart.

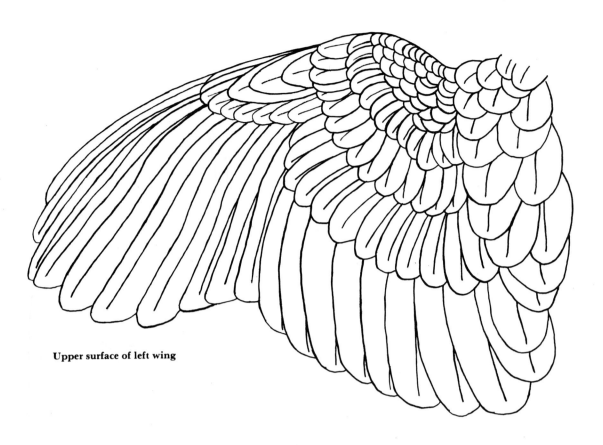

Upper surface of left wing

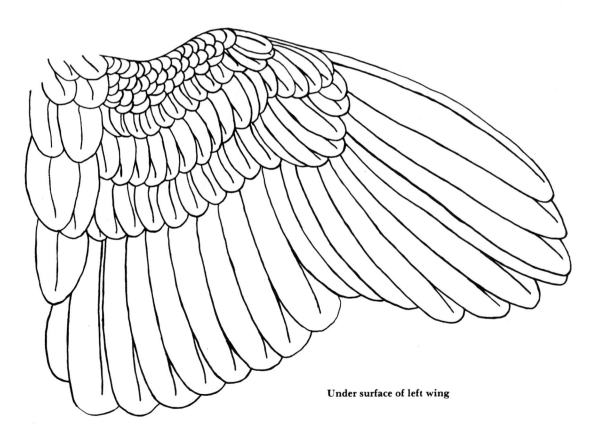

Under surface of left wing

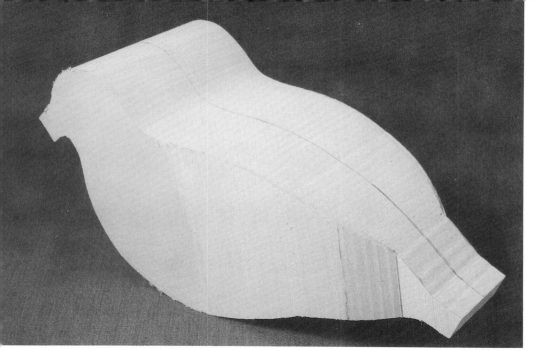

Figure 1. Transfer the pattern to the tupelo block and cut it out with a bandsaw. Draw the centerline on the top and belly of the bird. Draw in the plan view and cut away the excess from the flanks and tail.

Figure 2. Draw a midline on the flanks from the neck back to the tail. Round the bird from the top centerline to each flank midline, not including the head or tail.

Figure 3. Round the belly from the flank midlines to the centerline, not including the lower tail coverts. Measure and mark the lower tail coverts (.50 inches) and the vent (2.5 inches) from the end of the tail.

The Bobwhite Quail 93

Figure 4. Measure (.50 inches from the end of the tail), mark and draw in the upper tail coverts. Draw in the convex shape of the tail's upper surface.

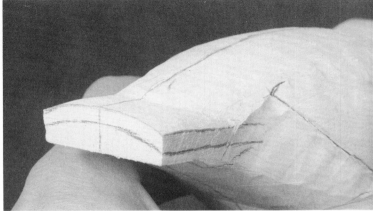

Figure 7. Draw in the tip of the primaries (1.4 inches from the end of the tail) and the shape of the primaries (1.5 inches of exposed lower wing edges). Using a square-edged cylindrical carbide cutter, relieve the excess wood from under the lower wing edges.

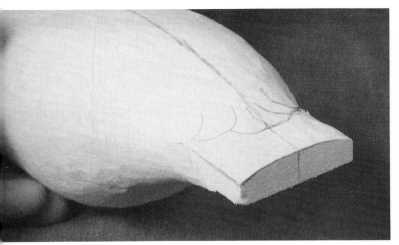

Figure 5. Cut away the excess wood from the top of the tail. Draw in the shape of the upper tail coverts.

Figure 6. Using a pointed ruby carver, relieve the wood from around the upper tail coverts. Flow the channel out onto the tail, maintaining its curvature and round over the coverts' sharp edge, flowing the shelf down to the tail.

Figure 8. Draw a line .15 inches from the top edge of the tail on both sides and the end.

Figure 9. Draw in the shape of the vent and lower tail coverts encompassing the measurement marks.

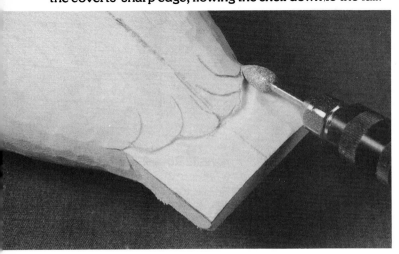

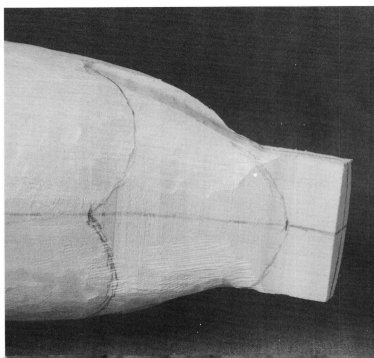

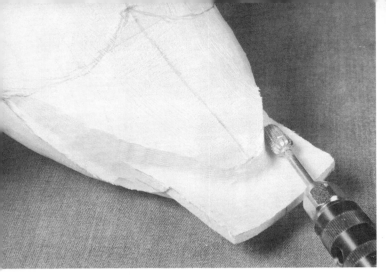

Figure 10. Relieve the excess wood from underneath the tail up to the edge of the lower tail coverts and leave the tail .15 inches thick.

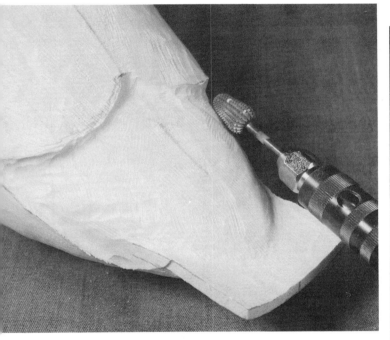

Figure 11. Channel around the vent lines and round over the lower tail coverts, flowing the shelf down to the base of the tail.

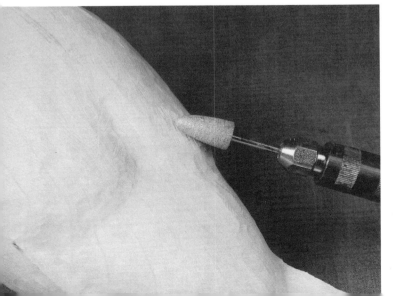

Figure 13. Find the center of the head by placing one finger at the base of the beak and another at the back of the head and sighting the middle high point. Mark the midpoint on the centerline.

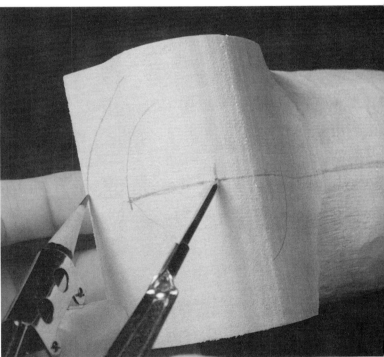

Figure 14. Using this center mark on the centerline as a pivot point, swing an arc from the base of the beak to the side to which you want the bird's head to turn and an arc on the opposite back side for the back of the head. Swing the third arc from the end of the beak to the head turned side.

Figure 12. Carve a channel 1.0 inch from the vent up the belly centerline. Round over the belly and flow the vent shelves down to the lower tail coverts.

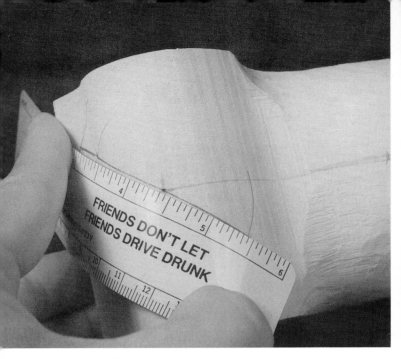

Figure 15. Draw a new head centerline through the pivot point that intersects all three arcs. The wider the angle between the new and old centerlines, the more the head will be turned. It is helpful to erase the old centerline.

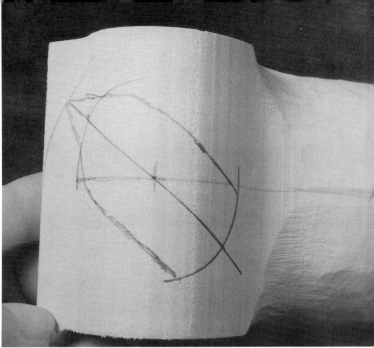

Figure 17. Draw in the top plan view of the head and beak encompassing the measurement marks. Allow some extra wood around the beak and also at the back of the head arc for neck thickness.

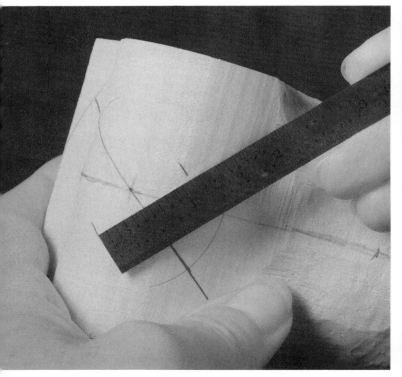

Figure 16. Holding a ruler perpendicular to the new centerline, measure and mark the width of the head at the ear coverts (1.1 inches).

Figure 18. Using a large tapered carbide cutter, carve away the excess wood from the sides of the head and the end of the beak. Keep the sides of the head and beak straight up and down.

Figure 19. When you start getting close to the lines, be careful to keep equal amounts of wood on each side of the centerline, keeping the head shape balanced.

Figure 20. Flow the shelves from the head narrowing procedure down onto the mantle and shoulder area. Do not remove any wood from the hindneck.

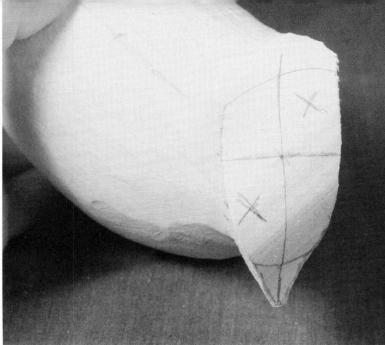

Figure 22. Turning the head of the bird in the wood causes the planes on the top of the head and, sometimes, the beak to be at an angle. To correct the skewed planes, draw a line perpendicular to the centerline at the top of the head pivot point, dividing the head into quadrants. Looking head-on to the bird, mark the high quadrants. The high side on the forehead is on the side to which the head is turned and on the back of the head it is the opposite quadrant. With the quail, the head turn is right and so, the high sides are the right forehead and the opposite back quadrant marked with X's.

Figure 21. Round the breast from the flanks to the centerline. Be careful not to leave any extra wood here, causing the bird to be square-chested. Do not remove any wood from under the chin.

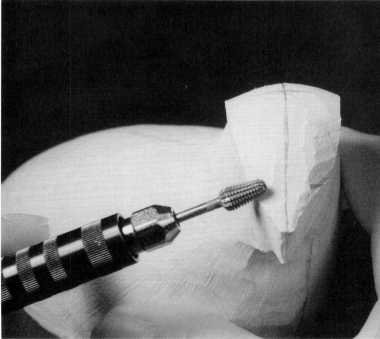

Figure 23. Level the forehead by cutting away the high side. A small amount of wood may have to be taken off the top of the beak at its base, depending upon the degree of head turn.

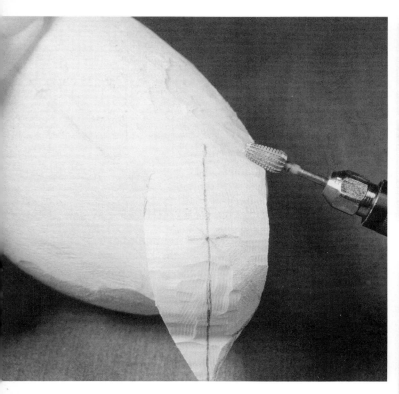

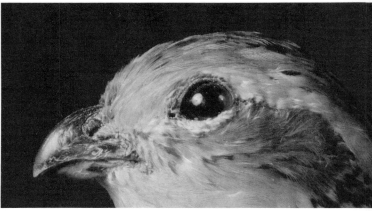

Figure 26. Profile view of the quail's beak.

Figure 24. Level the top and back of the head and neck by cutting away the excess wood. Flow the hindneck down onto the mantle and shoulder area.

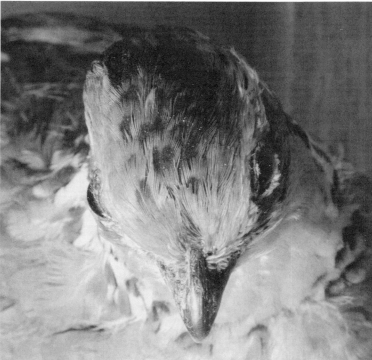

Figure 27. Top plan view.

Figure 28. A study bill is very helpful for details if you do not have a quail mount.

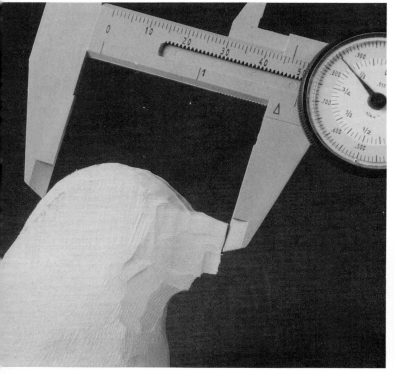

Figure 25. Check the measurement from the end of the beak to the back of the head (1.85 inches). If it is too long, remove equal amounts of wood from the back of the head and end of the beak.

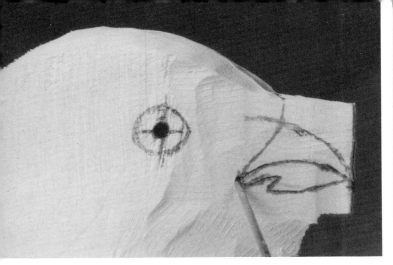

Figure 29. Transfer the head and beak placements and shapes from the profile line drawing. Check all dimensions with a ruler. Pinprick the eye center and the base of the commissure line on both sides.

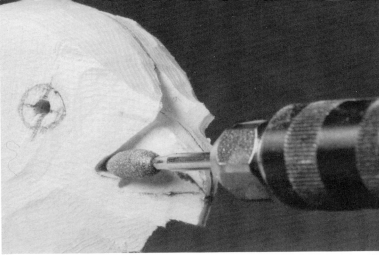

Figure 32. Keeping the sides of the beak vertical, begin removing the excess wood from the sides of the beak.

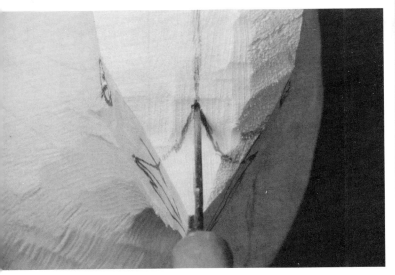

Figure 30. Measure, mark, and pinprick the top beak length on the centerline (.54 inches). Draw in the "V" shape at the beak's base and connect it with an angled line to the pinpricks at the commissure lines on the sides.

Figure 31. Using a pointed ruby carver, cut away the excess above the upper mandible. Keep the top of the beak flat at this time. Redraw the centerline.

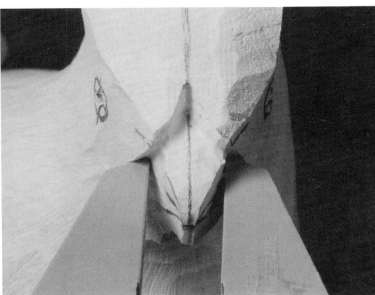

Figure 33. Continue removing wood until you get the calipers all the way back in the corners to measure .40 inches. Be careful to keep equal amounts of wood on each side of the centerline.

Figure 34. Redraw the commissure lines.

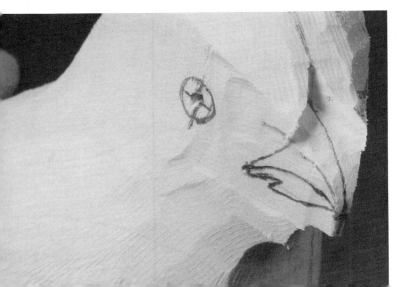

The Bobwhite Quail 99

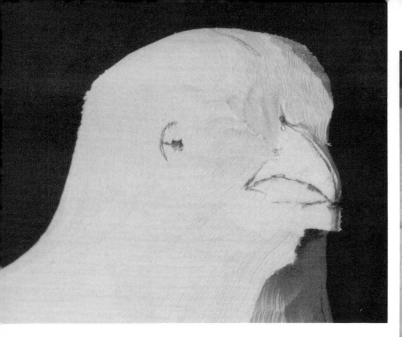

Figure 35. Flow the forehead and both sides of the head down to the base of the beak, eliminating the shelves remaining from the beak narrowing procedure.

Figure 38. Remove any excess wood from the sides of the beak until it is the proper shape on the plan view. Keep the beak's sides vertical and balanced across the centerline. Angle the sides of the upper mandible from the commissure lines to the culmen (top ridge).

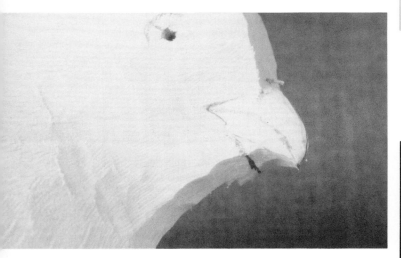

Figure 36. Remove enough wood under the beak so that you can get a ruler to measure .25 inches.

Figure 37. Create the rounded shape of the little tuft of feathers that lay at the base of the chin. Round over the chin and throat areas.

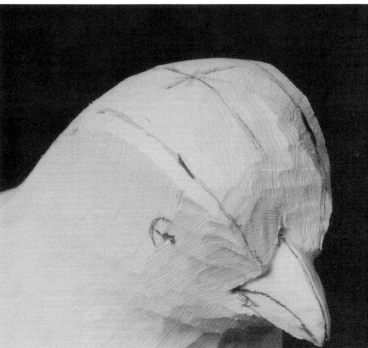

Figure 39. Measure and mark the width of the head above the eyes (.80 inches). Draw the wedge shape of the head incorporating the measurement marks.

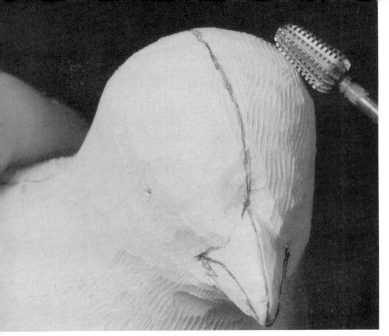

Figure 40. Narrow the top of the head from the eye areas up to the sharp edge of the blank. When the crown measures .80 inches above the eyes, lightly round over the head from the forehead to the back of the neck. Flow the hindneck down onto the mantle and shoulders.

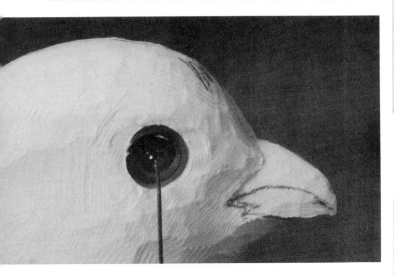

Figure 41. Recheck the eye placements and drill 7 mm. eye holes. Try the eyes for proper fit and depth.

Figure 42. Sand the beak rounding the sharp corners on the culmen and the bottom corners on the lower mandible.

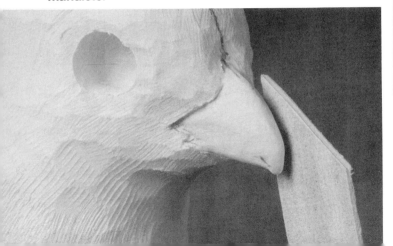

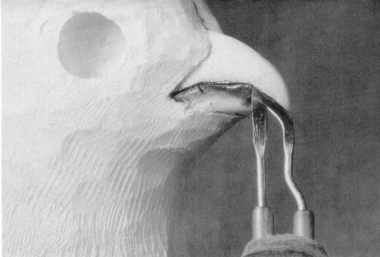

Figure 43. Burn in the commissure lines holding the pen vertical to sides of the beak. Then, lay the burning pen on its side and burn up to the first burn line.

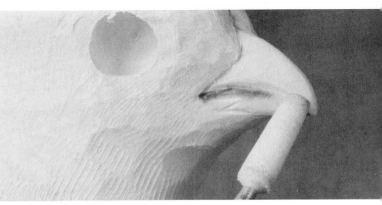

Figure 44. Using a square-edge cylindrical stone, narrow the sides of the lower mandible so that it tucks up and under the upper one. Angle the sharp corner of the upper mandible along the commissure lines.

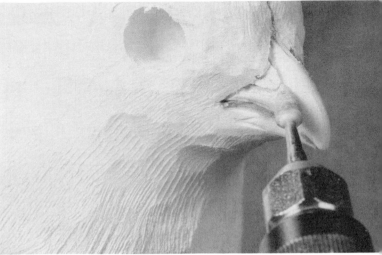

Figure 45. Draw in the "U"-shaped pads at the base of the upper mandible on each side. Carve away the wood from around the pads, using the point of a small stone. Create a small depression just outside the pads.

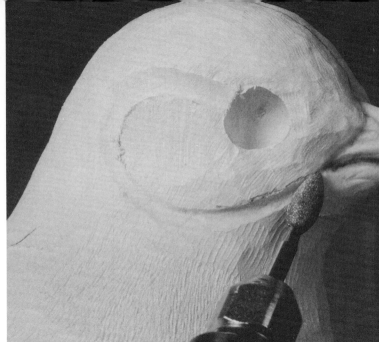

Figure 46. Divide the nostril pads in half with an "S"-shaped line. Use the point of the stone to recess the bottom half of the pad. Round over all of the pad's sharp edges.

Figure 48. Draw in balanced ear coverts. Use a ruby carver to channel around each covert.

Figure 49. Flow the channel out onto the surrounding area and round over the sharp edge on each covert. Remove a small amount of wood from the front corner and bottom of each eye so that the eye sits in a small depression.

Figure 47. Fine sand the entire beak without distorting the details. Saturate the beak with super-glue and when dry, fine sand again.

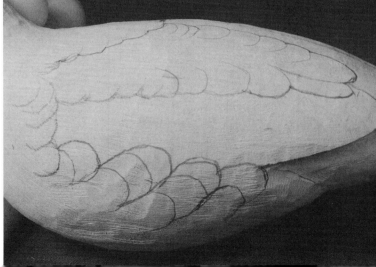

Figure 50. Draw in the mantle, scapulars, side breast, and flank feathers on each side.

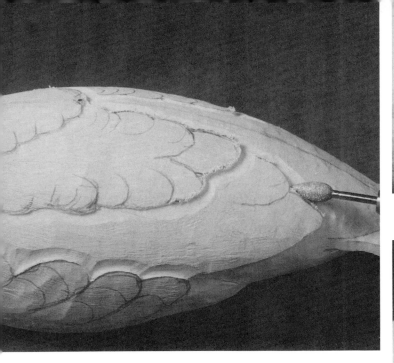

Figure 51. Using a ruby carver, channel around all the lines and flow the channels out onto the surrounding areas.

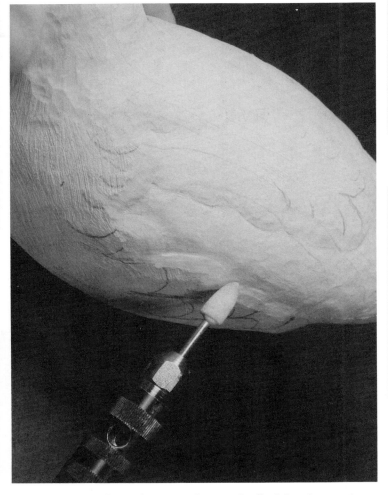

Figure 52. Round over and smooth all of the sharp edges with a bullet-shaped stone.

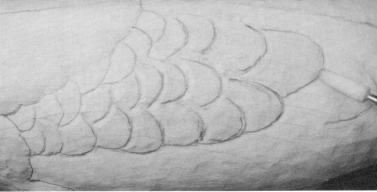

Figure 53. Draw in the scapular feather patterns. Lightly relieve around each of the individual feathers.

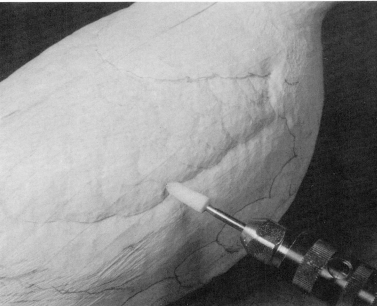

Figure 54. Round over each sharp edge and gently round each feather.

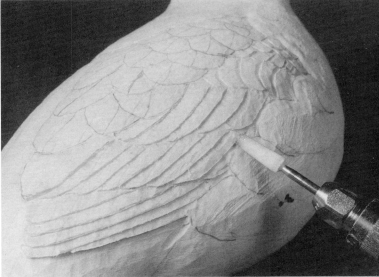

Figure 55. Draw in the wing feathers. Relieve around each of the groups and their individual feathers, beginning at the front of the wing and working toward the tip.

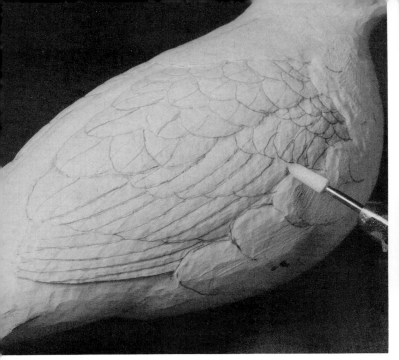

Figure 56. Round over each sharp edge and gently round each feather. A small bullet-shaped stone is useful for this procedure.

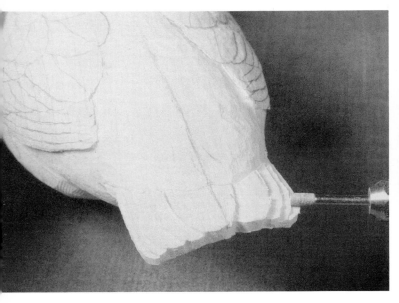

Figure 57. Draw in the feathers on the top of the tail. Starting with the center feathers and working out toward the leading edges, relieve along each edge.

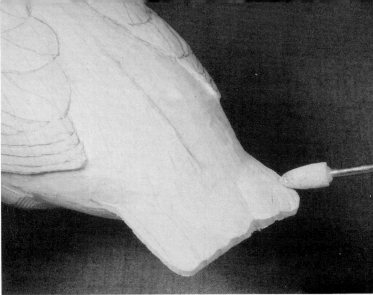

Figure 58. Round over each sharp edge and gently round each feather.

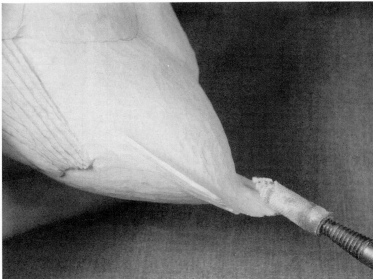

Figure 59. Thin the tail from the underside. The edges need to be thinner than the middle.

Figure 60. Burn around the corner of each tail feather tip. This will indicate the inside edges on the underside.

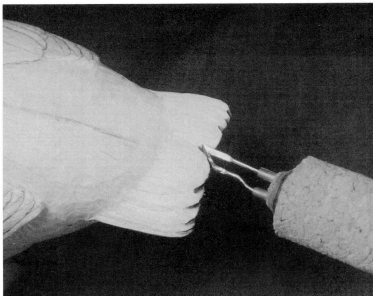

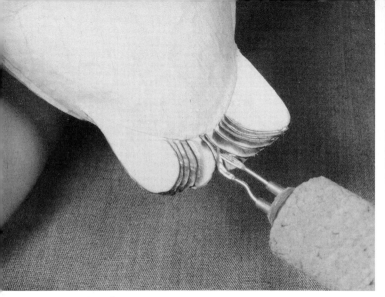

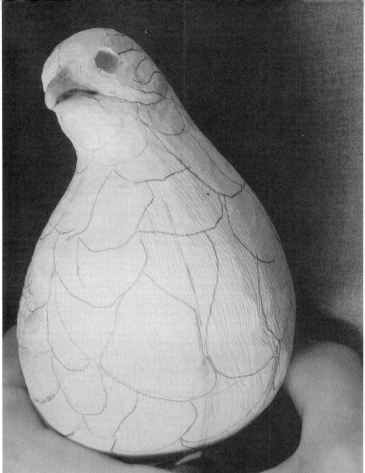

Figure 61. Draw in the edges on the underside and connect with the tips at the burned lines. Lay the burning pen on its side and burn in the edges.

Figure 62. Draw in the random contouring lines of the feather fluffs on the bird's underside.

Figure 63. Keep the shapes and sizes varied so that there are interesting shapes to see.

Figure 64. Draw in the fluffs on the mantle and head.

Figure 65. Break up the monotony of the rump and upper tail coverts with feather contouring lines.

Figure 68. Using a tootsie roll (cartridge roll sander), sand the feather fluffs.

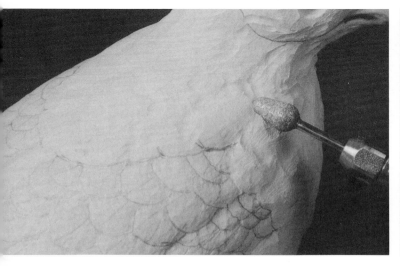

Figure 66. Channel along all of the contouring lines and round over each feather fluff.

Figure 67. Carving with the grain will reduce the amount of sanding needed.

Figure 69. A bullet-shaped stone enables smoothing of the channels where the tootsie roll cannot fit.

Figure 70. Use a pointed ruby carver to relieve wood underneath the lower wing edges. A pointed stone is helpful to use to smooth this area.

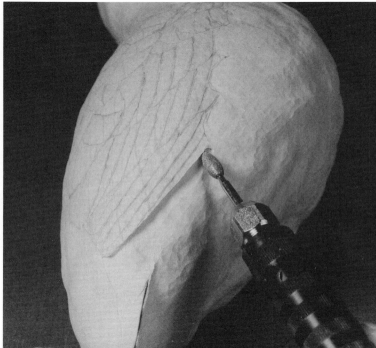

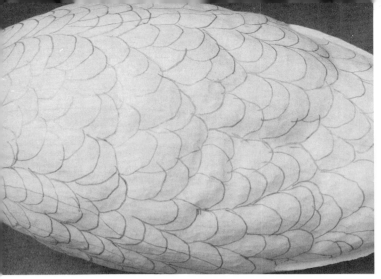

Figure 71. Draw in the feather pattern on the underside.

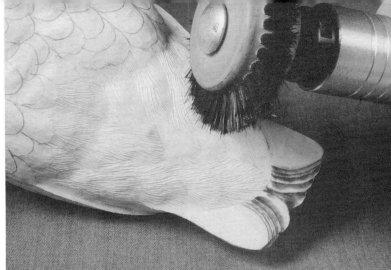

Figure 74. Use a laboratory bristle brush to clean up any fuzzy areas. Be careful not to burn away the stoning by pressing too hard with the brush or running at high speed.

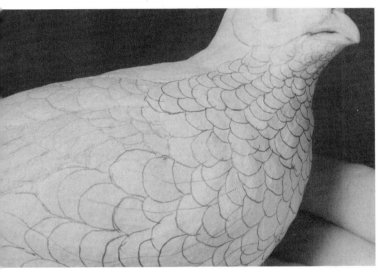

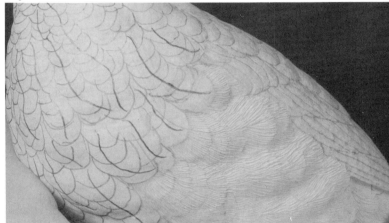

Figure 72. The feathers on the breast, throat and chin get progressively smaller. Directional flow lines will help to keep the stoning flowing.

Figure 73. Begin stoning at the tips of the lower tail coverts and progress up the belly.

Figure 75. Notice how the flow lines sweep the flank feathers out over the wings.

Figure 76. Keep the stoning as tightly together as you possibly can.

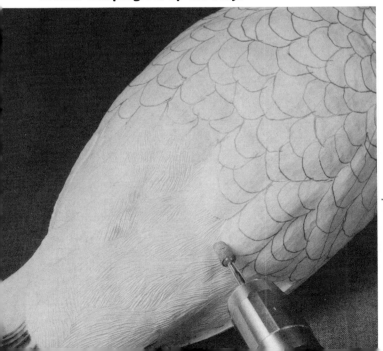

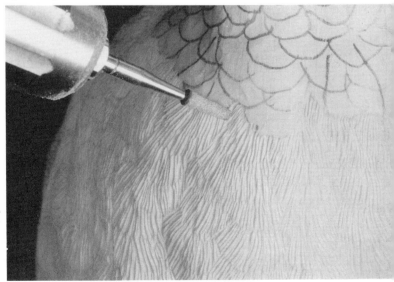

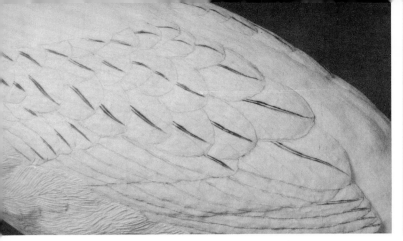

Figure 77. Draw in the quills on the wings. Burn in the quills on the larger feathers with two lines merging just short of each feather tip.

Figure 80. Clean all burned areas with a toothbrush.

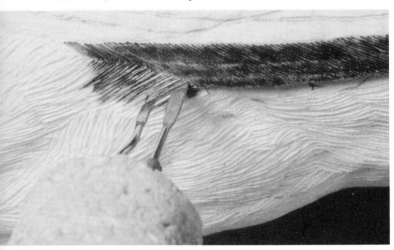

Figure 78. Begin burning in the barbs on the wings at the lowest primary and progressing up and forward on each wing. Burn in the tips of the barbs on the flank feathers laying over top of the wings.

Figure 79. When the barbs on the wings are completed, begin burning the barbs on the scapulars, starting at end and working forward.

Figure 81. Burn in the barbs on the underside of the lower wing edges and along the flanks where the stoning could not reach.

Figure 82. Draw and burn in the quills on the top of the tail. Begin burning in the barbs on the outer feathers and work toward the center.

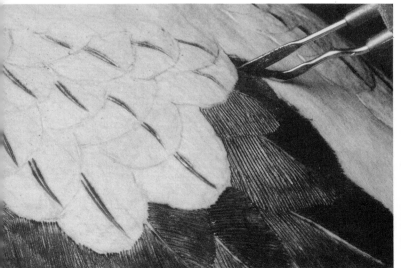

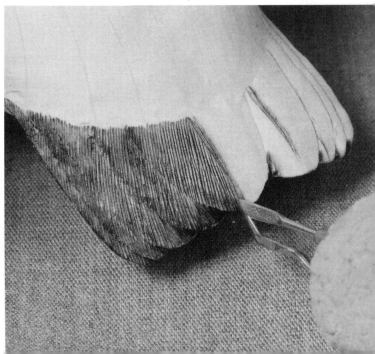

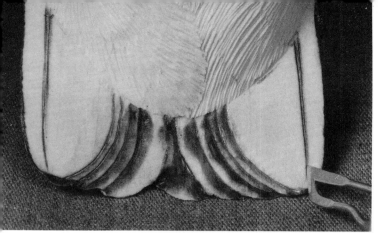

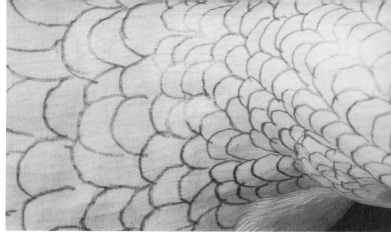

Figure 83. The quills on the shortest tail feathers are near the leading edges. Draw and burn in the underside quills.

Figure 86. Draw in the mantle and hindneck feathers.

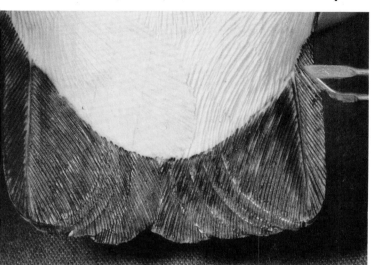

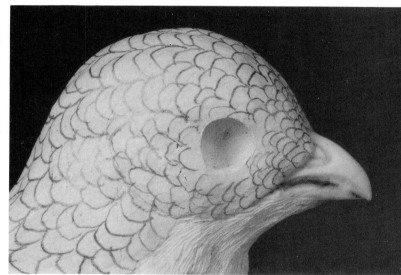

Figure 84. Begin burning in the barbs in the center and work toward the outer edges. Burn in the tips of the barbs along the edges of the lower tail coverts.

Figure 85. Draw in the feathers on the upper tail coverts, rump, and back.

Figure 87. Draw in the feathers on the head.

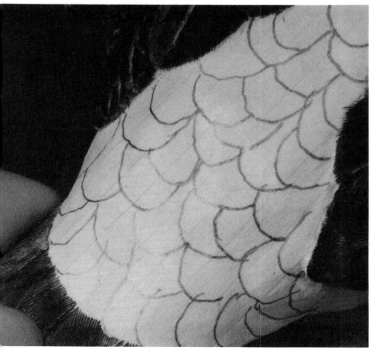

Figure 88. Begin burning in the barbs on the upper tail coverts and work your way forward up the back.

The Bobwhite Quail 109

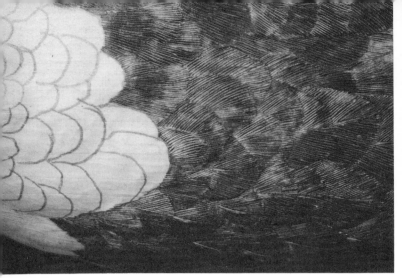

Figure 89. Burn your way up the mantle.

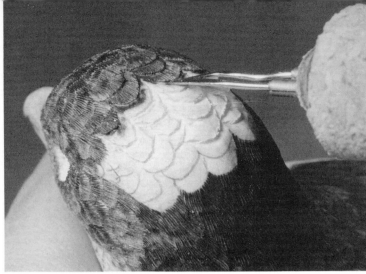

Figure 92. Slightly undercutting the crest feathers with the burning pen will enhance the raised feather appearance.

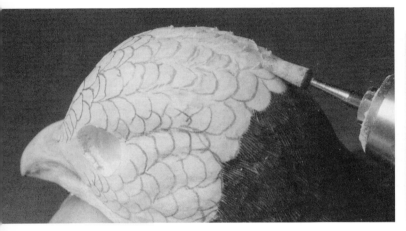

Figure 90. To raise the crest feathers a little, use a small cylindrical stone to relieve around each feather.

Figure 91. Begin burning the head feathers from the base of the beak and work towards the back of the head. This front to back burning gives the feathers a raised look because the base of the feather behind defines the tips of the feather in front. By pausing just a **short** time and letting the burning tip sink a **little** deeper, it appears that the feathers are slightly raised. This type burning is called indent burning and is especially effective on the heads of birds.

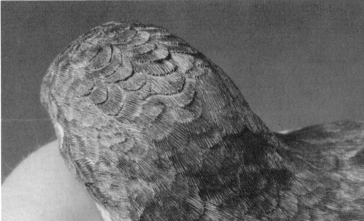

Figure 93. Only the feathers on the center of the head are raised.

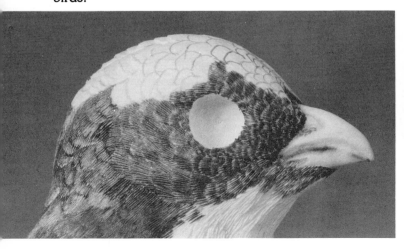

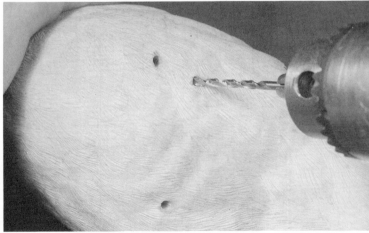

Figure 94. Drill 3/32″ holes into the body for the feet wires. Yes, you are right in that three holes are not needed. The one above the drill bit in the photo is a "OOOOPsy Daisey"!!! The extra hole is what happens when you change your mind in midstream, but this can be easily patched!

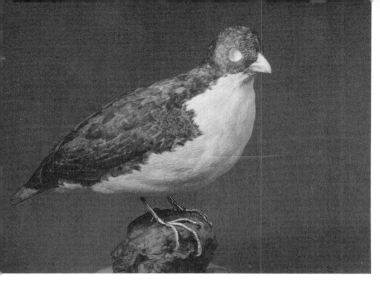

Figure 95. Drill the holes into the mount so that the quail is balanced over his toes. Make the feet according to the directions at "Feet Construction" in *Basic Techniques*.

Figure 98. When the putty has hardened, glue the feet in place with super-glue.

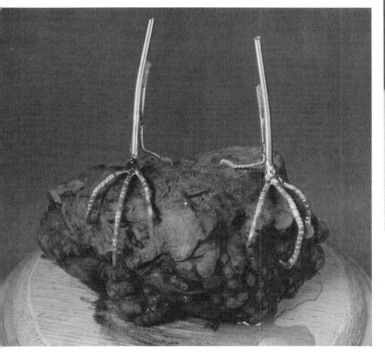

Figure 96. The three forward toes are 16 gauge copper wire and the hind toes are 18 gauge.

Figure 97. Apply ribbon putty for the toe pads and tarsus thickness.

Figure 99. When the glue has dried, apply a small amount of the ribbon putty around joints, pressing in a feathery appearance. Also, the "OOOOPsy Daisey" hole was patched with putty pulled into the surrounding area. Now if you don't tell anybody, no one will know!

Figure 100. Set the eyes according to the directions at "Setting Eyes" in *Basic Techniques*.

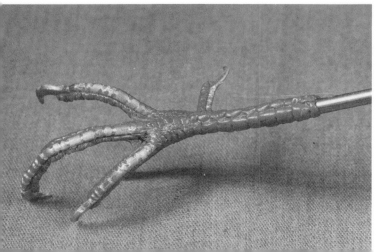

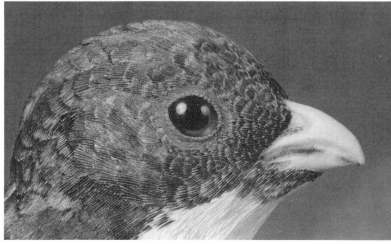

Figure 101. Brushing on a 50/50 mixture of *Deft Wood Finish* and lacquer thinner will seal the bird as well as *Krylon Crystal Clear Spray*. When the sealer is dry, the quail is ready for paint.

PAINTING THE BOBWHITE QUAIL

Liquitex jar acrylic colors:

Burnt umber=BU
Raw umber=RU
Burnt sienna=BS
Raw sienna=RS
Cerulean blue=CB
Paynes grey=PG
Yellow ochre/oxide=YO
Titanium white=W
Mars black=B

An * means that you should add a small amount.

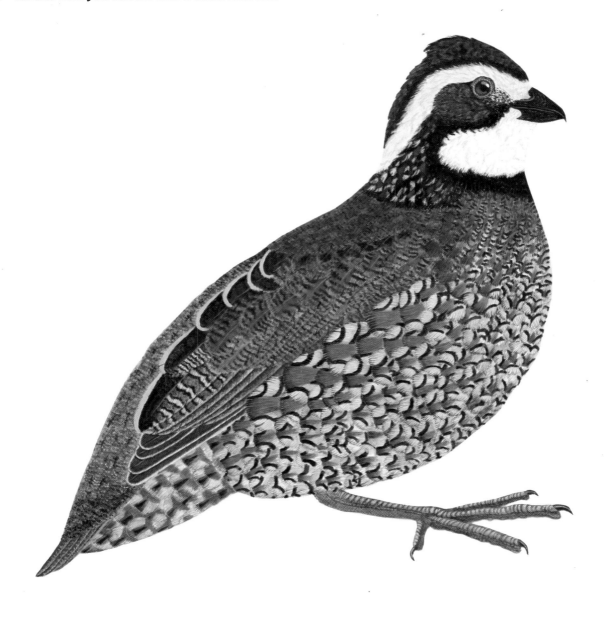

BOBWHITE QUAIL

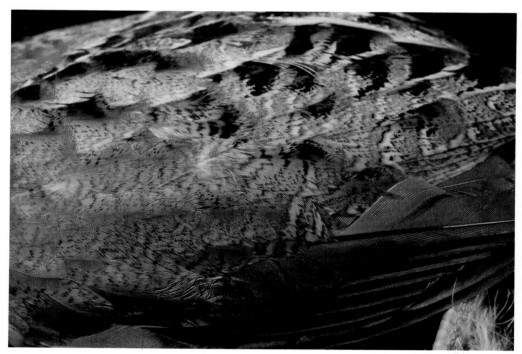

Figure 1. On a close-up of the quail's wing, you can see the grey primaries and the multi-colored patterns of all of the secondary coverts. The feathers with the dark patches above the wing are the scapular.

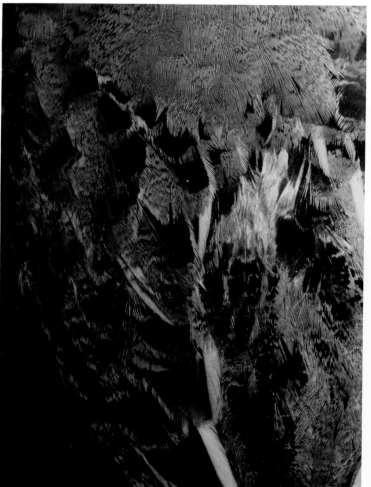

Figure 2. The trailing edge of the inner scapulars have the cream colored edgings.

Figure 3. Note the heavily patterned feathers on the neck blending into the mauve feathers on the mantle.

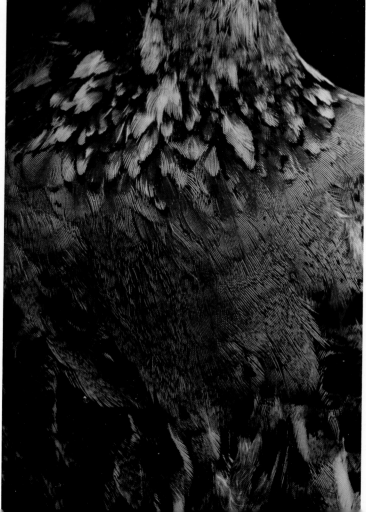

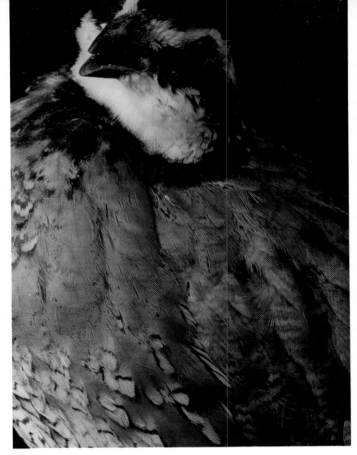

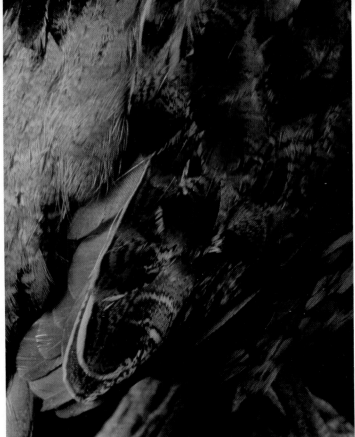

Figure 4. The mauve colored shoulder feathers and those on the side of the neck are colored similarly to the mantle.

Figure 5. Some of the feathers in the center of the back, rump, and upper tail coverts have dark centers.

Figure 6. Note the highly patterned large scapulars and tertials.

Figure 7. The flank feathers have the rusty colored centers with dark markings.

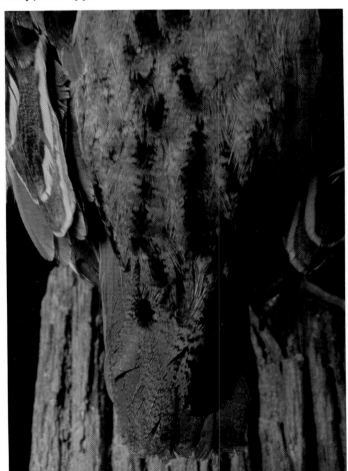

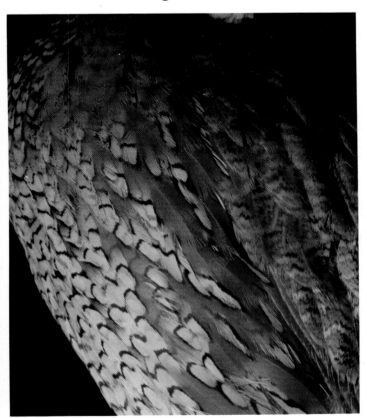

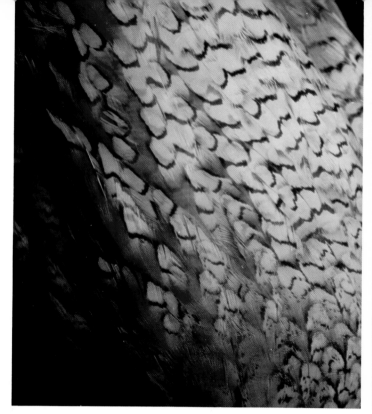

Figure 8. The wide rusty color part of the flank feathers gradually narrows near the belly. The dark markings appear more prominently on the belly.

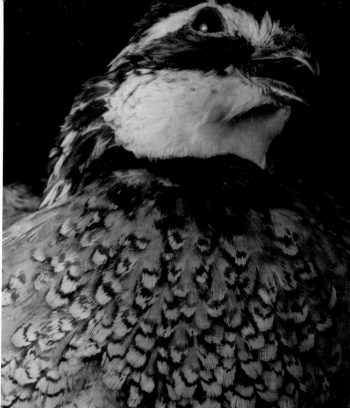

Figure 10. The white throat patch is one of the identifying characteristics of the male bobwhite male.

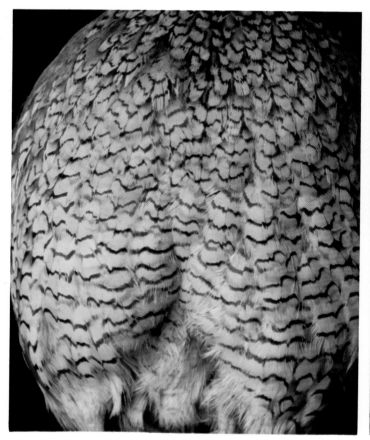

Figure 9. The feathers on the middle of the belly have just the dark markings.

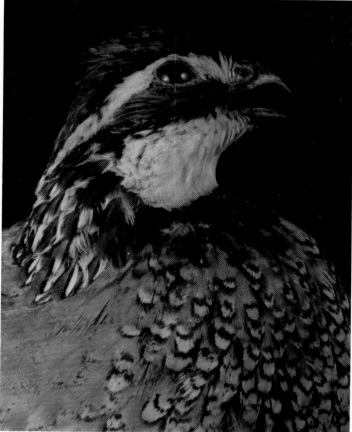

Figure 11. The light eye stripe blends into the highly patterned feathers on the side of the neck.

Figure 12. The light eye stripe extends to the base of the beak and around the forehead. Just in back of the light eye stripe is a dark band of feathers. The feathers on the top of the head are patterned with reddish brown and black.

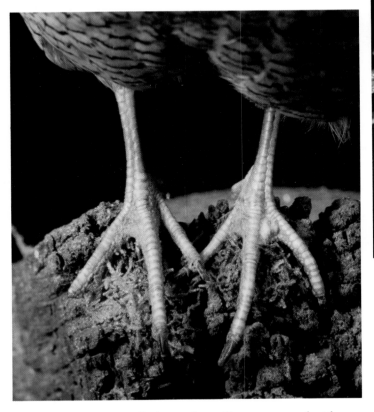

Figure 13. The quail's feet color will vary somewhat from a grey to a light buff color.

Figure 14. Using a stiff bristle brush, apply gesso right out of the jar. Adding water to gesso causes tiny pinholes to develop in the surface. Load the brush with gesso, wipe most of it on a paper towel and use a dry-brush technique scrubbing it down into the texturing grooves. The stiff brush is very important here because the firm bristles will keep the gesso from puddling in and filling up the texturing. Gesso the entire bird, feet, head, and beak included. It usually takes about two coats to even out the color differential of the stoning and burning. Sometimes, it requires a third application over the green putty areas. When the gesso is dry, carefully scrape the eyes.

The Bobwhite Quail 117

RU + PG + W	BS + BU + CB + W	BU + B + *W
Fig. 15	Fig. 16	Fig. 16

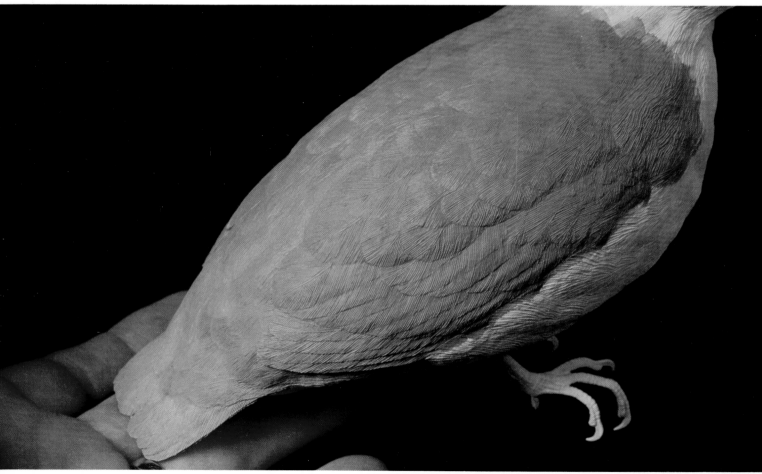

Figure 15. Apply the basecoat mixture of raw umber, paynes grey, and white to a medium grey to the mantle, back, upper tail coverts, and on the side of the breasts. It will take several thin coats to cover the gesso.

Figure 16. On the mantle and side of the breast feathers, paint in the centers with a mixture of burnt sienna, burnt umber, cerulean blue, and white. Add water to the mixture to make a thin wash and apply to the mantle and side breast. The dark squiggles on the sides of each feather are a mixture of burnt umber, black and a small amount of white. Apply light grey squiggles to the feather edges and between the dark squiggles with burnt umber, black and a small amount of white. Use the light squiggle color to blend the edges of the dark ones.

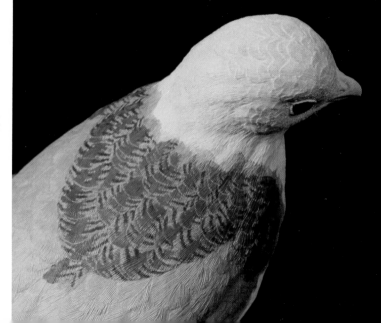

118 The Bobwhite Quail

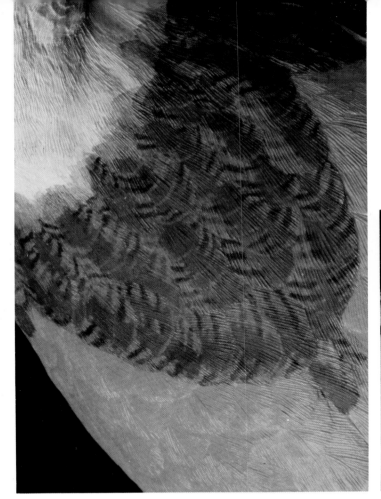

BU + BS + RS + *W

Fig. 18

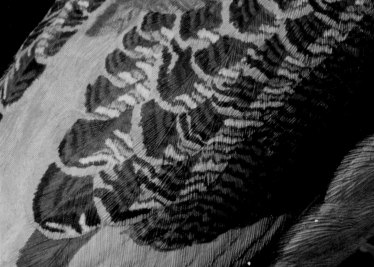

Figure 17. Lighten the trailing half of random feathers with the light grey squiggle color. Apply a burnt umber wash over the entire area.

Figure 18. For the centers of the scapular and the largest tertial, apply a mixture of burnt umber, burnt sienna, raw sienna, and a small amount of white. Add yellow ochre to this same mixture to lighten, and apply to all of the wing coverts.

Figure 19. With black and burnt umber, paint in the squiggles and bars on the trailing halves of the scapulars and all the of the wing coverts. Add a small amount of white to the black and burnt umber mixture to do the thinner, lighter squiggles on the leading halves of the scapulars.

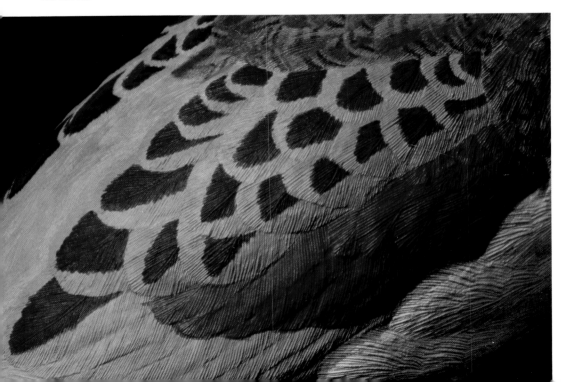

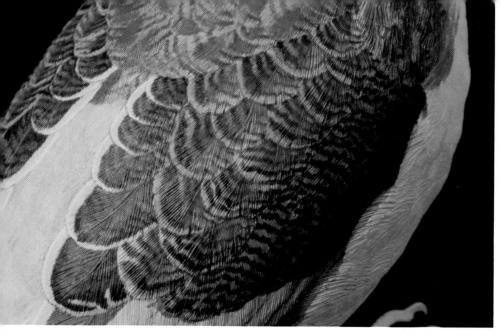

W + YO + RU RS + W Wash

Fig. 20 **Fig. 21**

Figure 20. For the light stripes on the leading edges of the scapulars, apply a mixture of white and small amounts of yellow ochre and raw umber. Apply a thin wash on the scapulars with a mixture of raw umber and raw sienna. The light trailing edge of the inner (medial) scapulars and tertials is a mixture of white, yellow ochre, and raw umber. Apply a thin light grey wash on the leading halves of all but the longest scapulars with a mixture of white and small amounts of burnt umber and black. Blend all of the colors and reinforce the colors as necessary. Using thin paint for all of these steps will allow you to feather in all the edges of the squiggles and feather edges.

Figure 21. Apply two thin raw sienna and white washes over the fronts of the wings except the trailing halves of the large tertial. Use a thin mixture of black and burnt umber to reinforce the squiggles on the coverts and the bars on the larger tertials. Apply several more raw sienna and white washes on the secondaries.

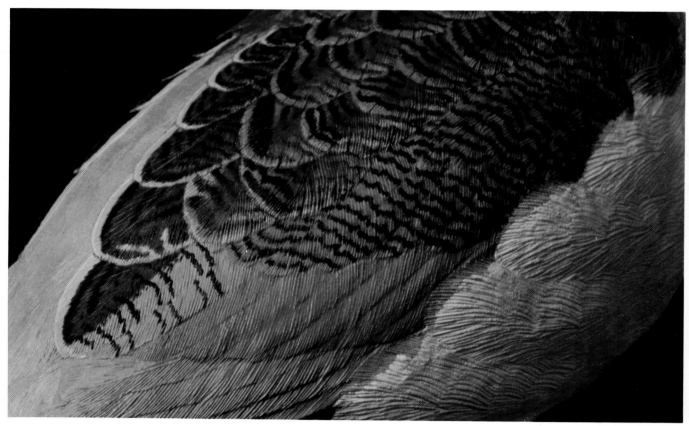

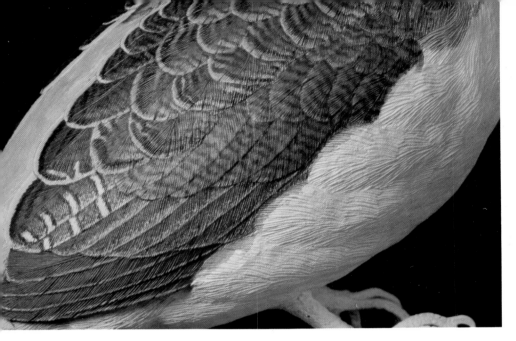

Fig. 22

Figure 22. Apply several thin coats of a mixture of burnt umber and small amounts of black and white on the exposed centers of the secondaries. Add more burnt umber to this mixture and paint the primaries. Dot the leading edges of the secondaries (approximately ⅛″ wide) with the dark mixture. Use a thin mixture of raw sienna and white to randomly dot the leading edge of the secondaries. Thin this mixture even more with water and line the wing feather edges. Lighten the bars on the tertials with white and a small amount of raw umber. Apply a thin burnt umber wash and reinforce all the bars and squiggles again. Then apply a thin raw sienna wash.

Figure 23. On the back and upper tail coverts, paint in the dark center arrow-like patterns with a mixture of burnt umber, black, and a small amount of white. Between the dark patterns, apply a mixture of burnt umber, and a small amount of white. The dark patterns are concentrated near the mantle, center of the back and along the edge feathers of the upper tail coverts.

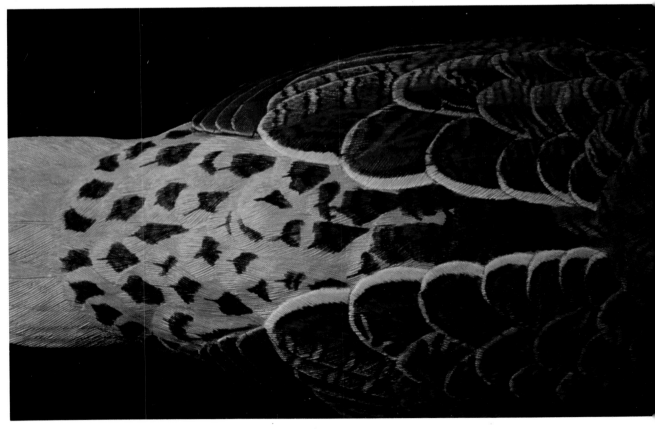

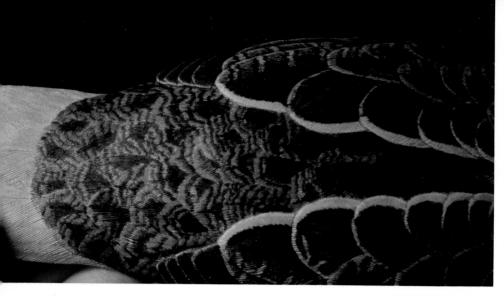

RU + RS + W	BU + B + W
Fig. 24	Fig. 26

Figure 24. Apply the dark grey squiggles on the rest of the back and upper tail coverts with a mixture of burnt umber, black, and a small amount of white. The greenish-yellow squiggles are a mixture of raw umber, raw sienna, and white. Lighten the squiggles on the upper tail coverts with a mixture of paynes grey, burnt umber, and white. Apply a wash of raw umber and raw sienna to the back and a burnt umber wash to the upper tail coverts, blending the two washes at the base of the back.

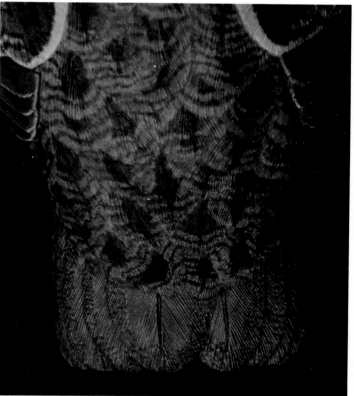

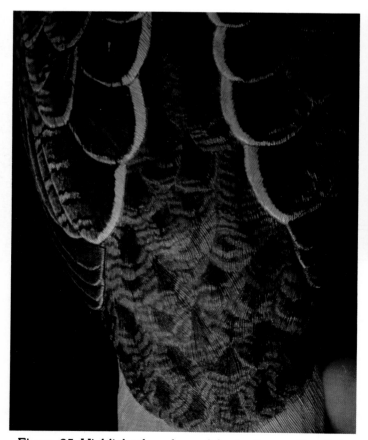

Figure 25. Highlight the edges of the feathers with a light grey of paynes grey, burnt umber, and white. Blend all of the squiggles reinforcing where necessary. Wash, blend, and highlight several times to enhance the softness.

Figure 26. On the upper surface of the tail feathers, apply several grey basecoats of burnt umber, black, and white. With a mixture of burnt umber, black, and a small amount of white, paint the quills and dot the edges (approximately .20 inches). Use a liner brush and thin paint so that the brush will let go of the paint, hold the brush vertically and just touch the brush tip to the surface. If the paint is the proper consistency, the brush will apply a near perfect dot. If the paint is too thin, it will run and if it is too thick, there will be blobs. Experiment with the paint consistency on a piece of paper first before trying it on the bird. Apply light grey dots with a mixture of white and small amounts of burnt umber and black. Apply burnt umber dots, intermingling all of the dot colors. Wash the upper tail with burnt umber and do all of the dots again.

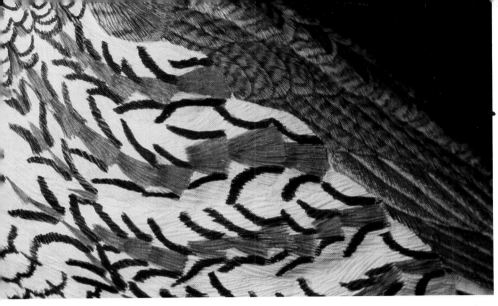

Fig. 27

Figure 27. Touch-up any overruns along the flank feather edges with straight white. On the flanks, lower tail coverts, belly, breast, throat and chin, apply several thin basecoats of a mixture of white with small amounts of black and raw umber. For the rust color, make a mixture of burnt sienna, burnt umber, yellow ochre, and a small amount of white. Apply the rust color to the centers of the flank feathers. Note that the rusty area is wider on the edge flank feathers, and it gradually diminishes in width as the feathers approach the belly. Paint in the dark bars, stripes, and arrow patterns with a mixture of burnt umber and black.

Figure 28. Note the pattern of the rusty color on the lower tail coverts. There is a dark arrow shaped patch in the center of each rusty area at the feather base (where exposed).

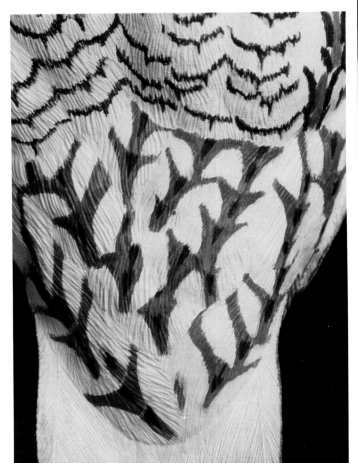

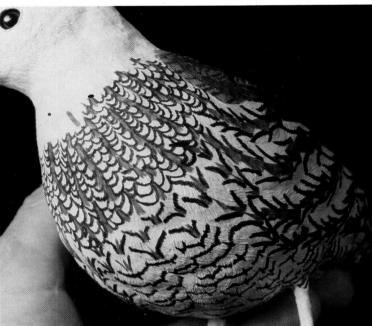

Figure 29. On the breast, the rust color is in the centers of the feathers with dark squiggly bars on the leading and trailing parts of each feather. Apply a thin light grey wash of white with small amounts of black and raw umber to the entire underside.

The Bobwhite Quail 123

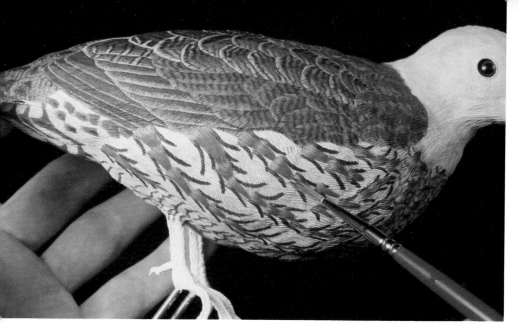

BU + B + W

Fig. 32

Figure 30. On the breast and flanks, lightly highlight each feather edge with a mixture of white and small amounts of black and raw umber. Reinforce the rust patches and dark patterns again. Apply a super thin raw umber and raw sienna wash.

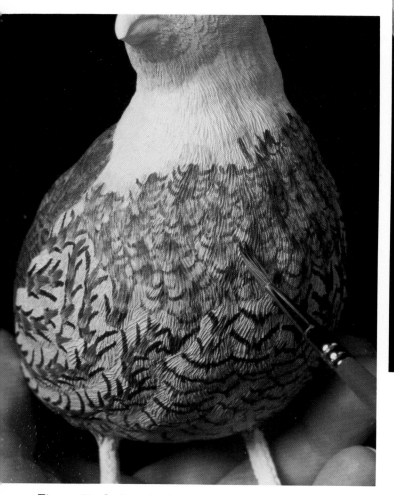

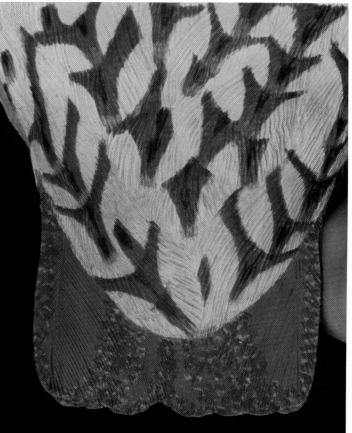

Figure 31. Soften the breast area with dry-brushed rust and light grey highlights. Apply a super thin raw umber and raw sienna wash.

Figure 32. On the under surface of the tail and under the lower wing edges, apply several thin basecoats of a mixture burnt umber, black, and white. Work carefully so that the paint does not track around the edges of the burning. Dot the outer edges of the tail feathers with a dark mixture of burnt umber, black, and a small amount of white. Add more white to the mixture, and blend light grey dots in with the dark ones. Blend burnt umber dots with the light and dark ones. Wash the underside of the tail with very thin burnt umber and blend in more dots of all three colors. Dot and wash until there is a soft blend.

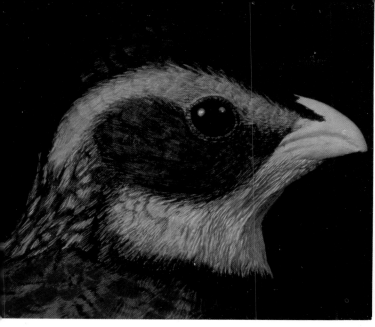

Figure 33. Blending burnt sienna, burnt umber, yellow ochre, and white to a reddish brown, apply the basecoats to the top of the head and back of the head, hindneck, and side of the neck. Lightly brush some of this mixture on the ear coverts. Paint in the buff eye stripe with a mixture of white, yellow ochre, and a small amount of raw umber. With a mixture of white and small amounts of raw umber and black, paint in the white throat patch and the light spots on the side and back of the neck. Paint in the dark band above and below the eye stripe, and the dark feather areas on the side and back of the neck, with a mixture of burnt umber and black. Use the same dark mixture for the throat band. Lightly brush the forehead and the ear coverts with this dark mix.

Pull some of the dark mix from the ear covert edges down into the edges of the white throat patch. The eye ring is a medium grey mixture of burnt umber, black, and white. Add more white to this mixture and highlight the edge of the eye ring.

Figure 34. Along the edges of the white throat patch and the dark band, pull the dark mix into the light and the light into the dark until there is a soft transition area. Apply a thin wash with a mixture of white with small amounts of raw umber and yellow ochre to the white throat patch.

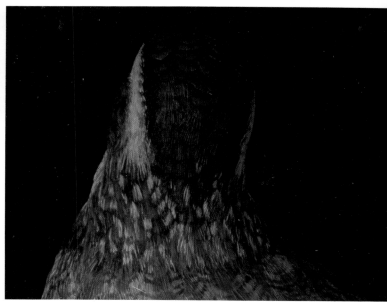

Figure 35. On the back and sides of the neck, you will need to blend the reddish brown, dark, and light patterns. The centers of the feathers are reddish brown with diagonal dark stripes and white triangular edges. When feathers are intermingled and laying on top of one another, there really is no exact pattern. I use a #2 round sable brush loaded with each color with the tip flared, dragging each color lightly into the others.

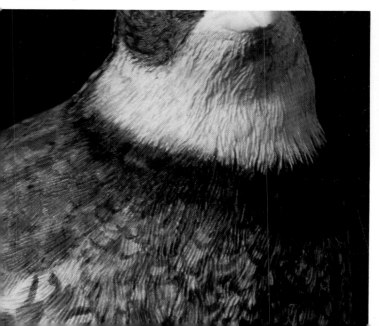

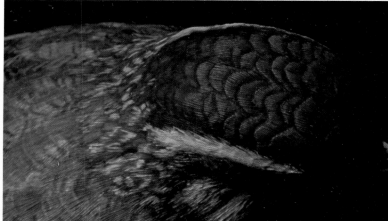

Figure 36. On the top of the head and back of the neck, shadow each feather's base with the dark mixture of burnt umber and black. Paint in a few random splits. Add white to the reddish brown basecoat mixture and lighten each of the feather edges.

The Bobwhite Quail 125

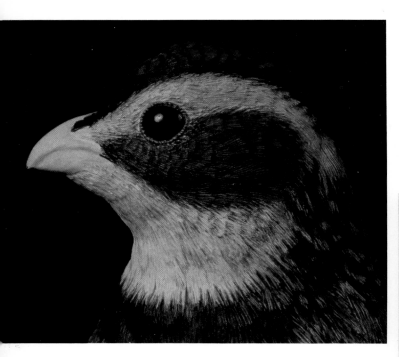

Fig. 38 Fig. 39

Figure 37. For the ear coverts, you will need to blend the reddish brown basecoat color and the dark color back and forth to enhance the softness. Shadow some of the feathers with the dark mixture. Add white to the reddish brown mixture and highlight some of the feather edges. Apply a burnt umber wash to the ear coverts.

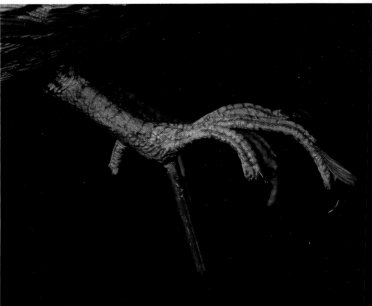

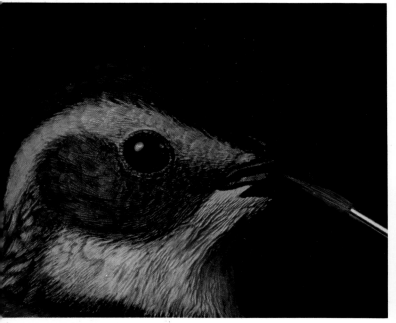

Figure 38. The basecoats for the beak are a mixture of burnt umber, black, and a small amount of white. Use thinned down straight black to shadow the nostril areas and commissure lines. When dry, apply a 50/50 mixture of matte and gloss mediums.

Figure 39. The basecoats for the feet are a mixture of white, raw umber, and yellow ochre. When these are dry, apply a thin wash of a mixture of raw umber and small amounts of black and white. The claw color is a mixture of burnt umber and small amounts of black and white. Put a small amount of gloss medium in a large puddle of water and apply to the feet. When this is dry, apply undiluted gloss to the claws.

Figure 40. Use a liner brush and undiluted gloss to make the quills on the scapulars, wings, and upper and under sides of the tail feathers shiny.

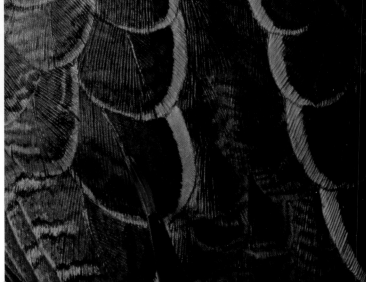

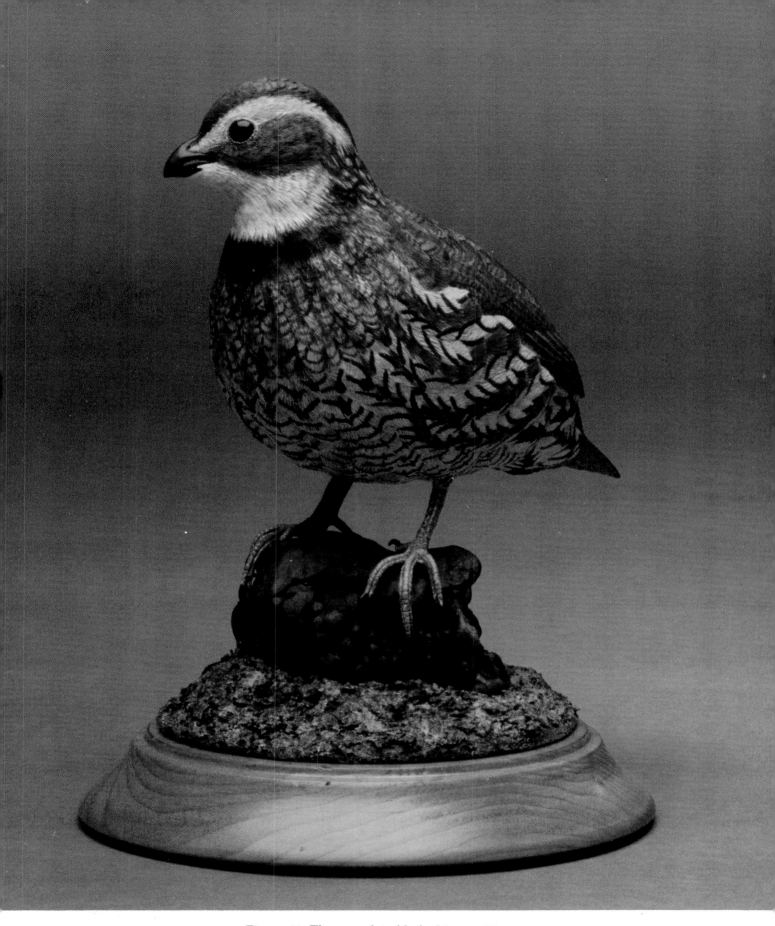

Figure 41. The completed bobwhite quail!

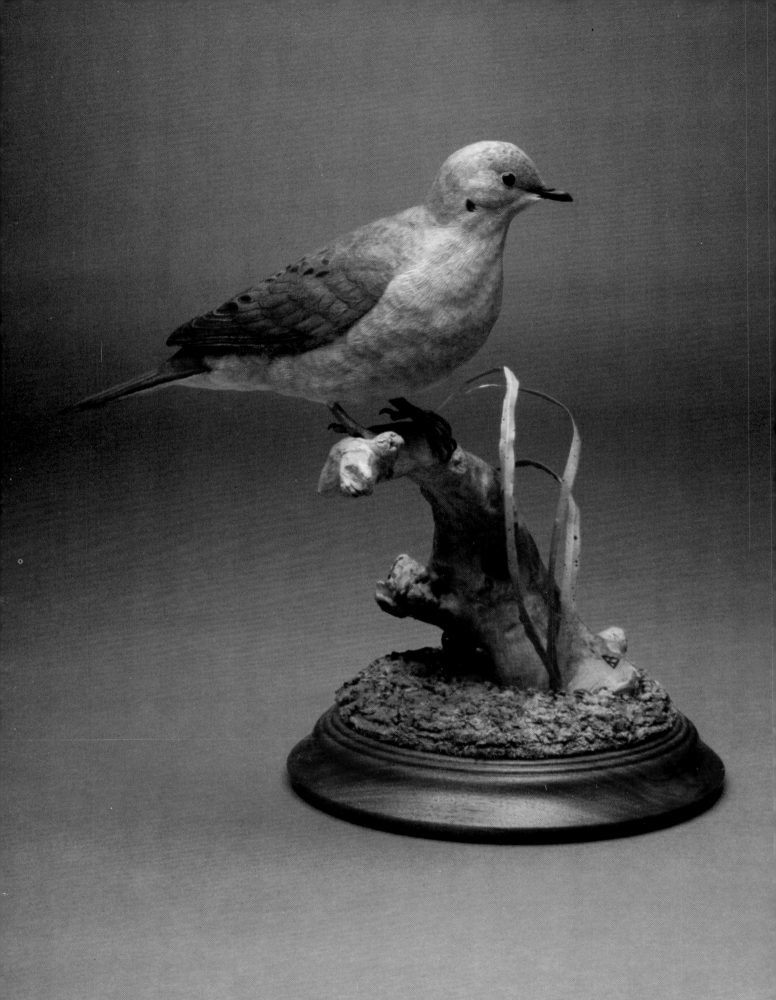

Chapter 6.
The Folded Wing Mourning Dove
(Zenaida macroura)

In 31 states, the mourning dove is a hunted upland game bird and in 17 states, it is classified a song bird. The most widely spread and familiar dove, it is similar to the extinct passenger pigeon except in size. The mourning dove is considerably smaller and shorter in length. Both birds have the distinct, sharply pointed tail with whitish tips on the outer, shorter tail feathers.

I could not do an upland game bird book without including a folded wing dove, a real favorite of mine. The mourning dove is a very popular bird not only with other people who feed the birds but also with hunters. At wildfowl art shows and exhibitions, there are usually many carvings, paintings and photographs of doves.

DIMENSION CHART

1. End of tail to end of primaries (folded wings)—3.2 inches
2. Length of wing—5.6 inches
3. End of primaries to alula—3.5 inches
4. End of primaries to top of first wing bar—2.4 inches
5. End of primaries to bottom of first wing bar—3.5 inches
6. End of primaries to mantle—3.1 inches
7. End of primaries to end of secondaries—1.5 inches
8. End of primaries to end of scapulars—2.7 inches
9. End of primaries to end of primary coverts—3.5 inches
10. End of tail to front of wing—8.8 inches
11. Tail length overall—5.0 inches
12. End of tail to upper tail coverts—2.5 inches
13. End of tail to lower tail coverts—2.6 inches
14. End of tail to vent—5.2 inches
15. Head width at ear coverts—1.15 inches
16. Head width above eyes—.80 inches
17. End of beak to back of head—2.0 inches
18. Beak length
 top—.50 inches
 center—.75 inches
 bottom—.35 inches
19. Beak height at base—.19 inches
20. End of beak to center of eye (6 mm. brown)—1.2 inches
21. Beak width at base—.30 inches
22. Tarsus length—.80 inches
23. Toe length
 inner—.90 inches
 middle—1.1 inches
 outer—.82 inches
 hind—.57 inches
24. Overall body width—2.8 inches
25. Overall body length*—10.2 inches

TOOLS AND MATERIALS

Bandsaw (or coping saw)
Flexible shaft machine
Carbide bits
Ruby carvers and/or diamond bits
Variety of mounted stones
Pointed clay tool or dissecting needle
Compass
Calipers measuring in tenths of an inch
Ruler measuring in tenths of an inch
Rheostat burning machine
Awl
400 Grit sandpaper
Drill and drill bits
Laboratory bristle brush on a mandrel
Needle-nose pliers and wire cutters
Cartridge roller sander on a mandrel
Toothbrush
Safety glasses and dustmask
Super-glue and 5 minute epoxy
Oily clay (brand names Plasticene and Plastilena)
Duro ribbon epoxy putty (blue and yellow variety)
Krylon Crystal Clear 1301
Pair of 6 mm. brown eyes
Tupelo or basswood 3" (W) x 4" (H) x 10.5" (L)
Pair of dove feet to use in bird or as a model for making feet
For making feet:
 3/32" brazing rod
 16 gauge copper wire
 solder, flux, and soldering pen or gun or silver solder, flux, and butane torch
 permanent ink marker
 hammer and small anvil
 small block of scrap wood and staples (or several pairs of helping hands holding jigs)

*All of these measurements are for doves here in Delaware. According to Bergmann's Rule in ornithology, body size tends to be larger in cooler climates and smaller in warmer climates. Allen's Rule states that beaks, tails, and other extensions of the body tend to be longer in warmer climates and shorter in cooler climates. Accordingly, you may have to adjust lengths and widths depending on where you live.

FOLDED WING MOURNING DOVE (Female)

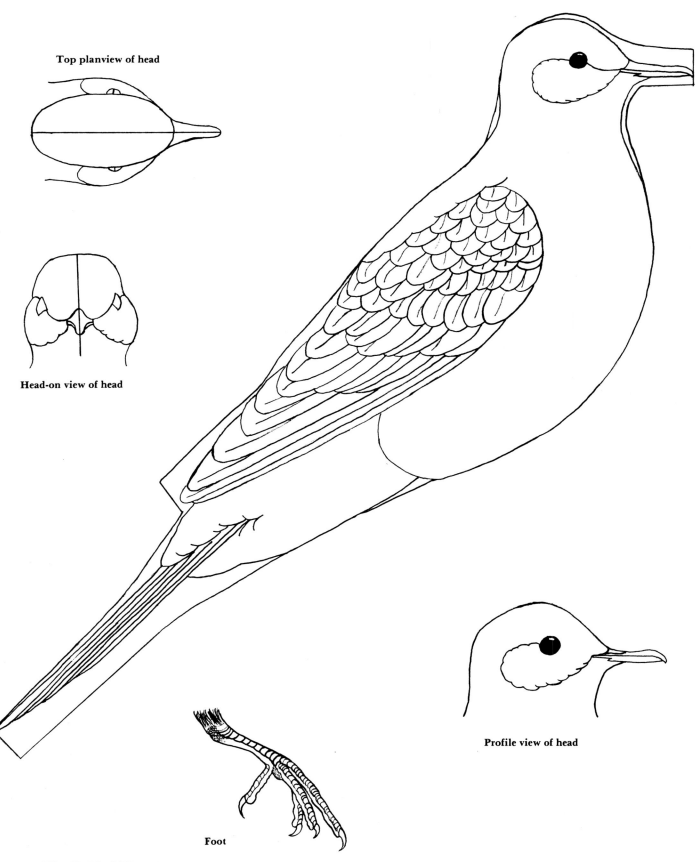

Top planview of head

Head-on view of head

Profile view of head

Foot

Under planview

Top planview

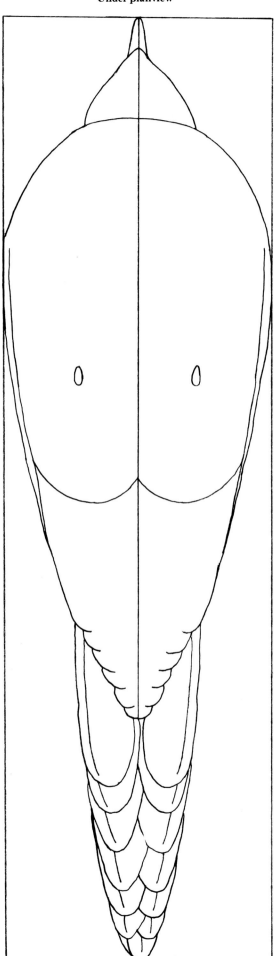

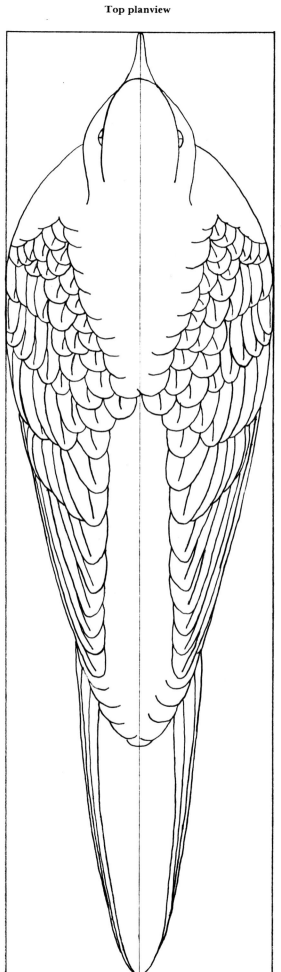

*Foreshortening may cause measurement distortions on both planviews.

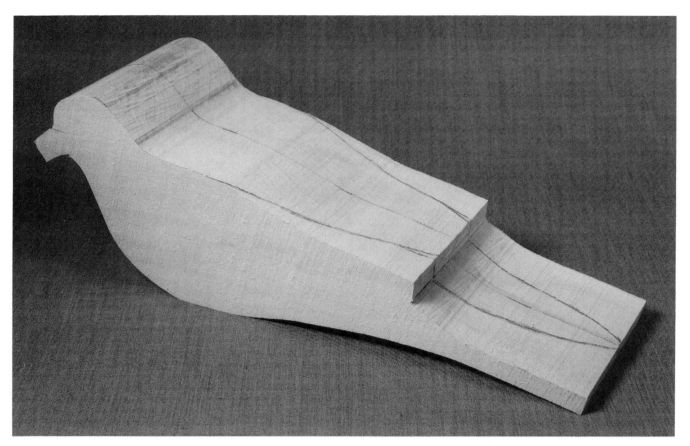

Figure 1. The blank for the perched dove is basswood. There is something very magical and satisfying about cutting a nice piece of basswood with a sharp tool! This project could be done with tupelo if you prefer power carving. Draw the plan view on the blank and cut around the outside lines with a bandsaw or coping saw. Draw in the centerlines on the top of the head and top and underside of the bird.

Figure 2. Draw in the lower wing edge lines on both sides. Using a square edged cylindrical carbide cutter, remove approximately .10 inches under the lower wing edges all the way to belly edge. When starting to cut at the front of the wing, begin your cuts gradually. Do not cut into the side of the tail.

Figure 3. From the end of the tail, measure and mark the distance to the tip of the upper tail coverts 2.5 inches. Draw in their rounded shape. Using a small tapered carbide cutter, relieve wood from the top of the tail around the edge of the upper tail coverts. Make the top of the tail slightly rounded all the way to the tip.

Figure 4. Round the wings and upper back from the centerline to the lower wing edge. The wings are rounded back to the end of the secondaries 1.5 inches from the end of the primaries. The primaries are not rounded but angled.

Figure 5. Note the angle of the primaries.

Figure 6. Draw a line .20 inches from the top edge of the tail on both sides and the tip.

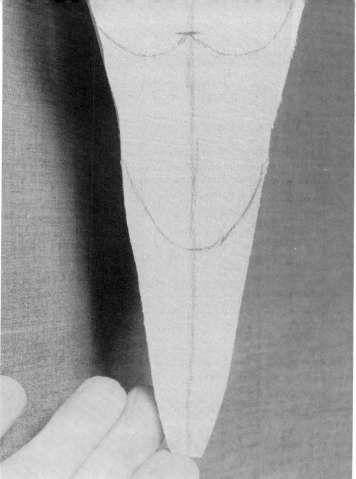

Figure 7. On the underside centerline, measure and mark the vent 5.2 inches and lower tail coverts 2.6 inches from the end of the tail. Draw in the rounded shape of the lower tail coverts and the "baby bottom" shape of the vent area.

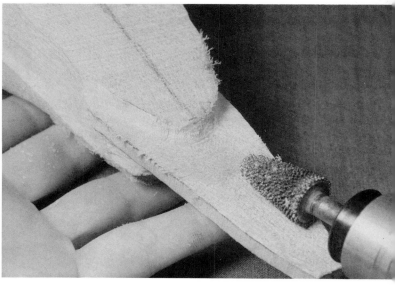

Figure 8. Using a medium tapered carbide cutter, remove the excess wood from the underside of the tail up to the edges of the lower tail coverts. Give the underside of the tail and slightly concave shape to correspond to the convex upper surface.

Figure 9. Channel around the vent lines with the tip of the medium tapered carbide cutter.

Figure 12. Carve a shallow channel from the vent 2.0 inches up the belly on the centerline. Round over the entire belly and flank area. Flow the shelf on the end of each flank down to the side of the lower tail coverts.

Figure 10. Carry the vent channel around the flank corners. Note that the angle of the channel is not straight up, but is pointed at an angle up toward the head.

Figure 13. Find the center point of the head by placing one finger at the base of the beak and another finger at the back of the head. Optically choose the half-way point and mark.

Figure 14. Place the compass point at the chosen center point and swing an arc the same distance as the base of the beak. This first arc should be swung to the side to which the head will be turned. Swing a second arc the same distance as the back of the head on the opposite side as the head turn.

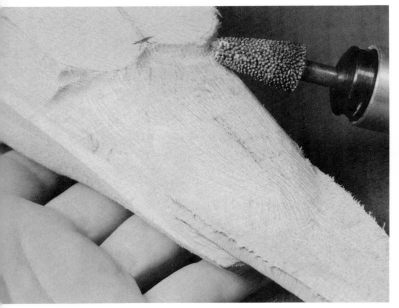

Figure 11. Round over the lower tail coverts from the vent to their edge. Flow the shelf of the coverts' edge to the base of the tail.

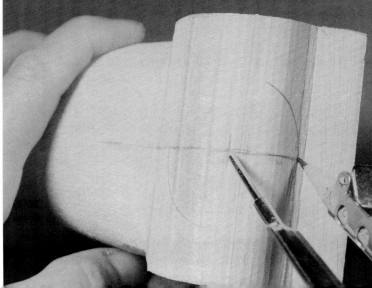

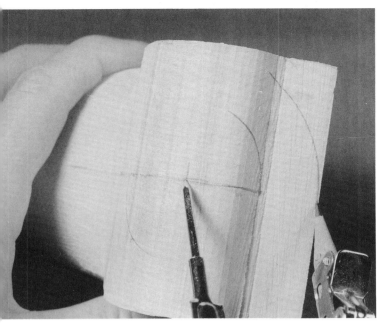

Figure 15. Swing one more arc the distance from the middle of the head to the end of the beak. This arc should be drawn on the head-turned side of the centerline.

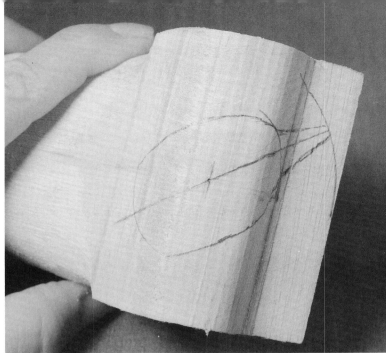

Figure 17. Roughly draw in the top plan view of the head encompassing the head width marks.

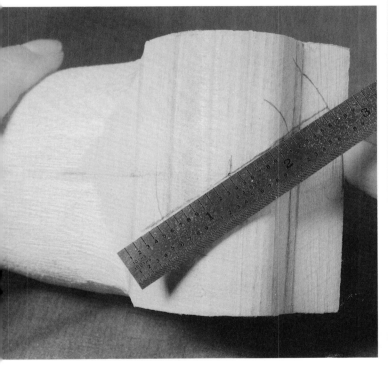

Figure 16. Draw a new centerline. The degree of the angle of the new centerline will represent the amount of head turn. The more the head is turned the more the beak will be across the grain and in basswood, the more fragile it will be. I usually keep it less than the corner of the blank.

Measure and mark the head width at the ear coverts 1.15 inches. Hold the ruler perpendicular to the new centerline and put half the distance on each side.

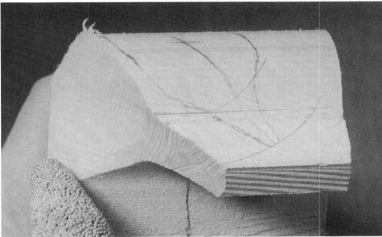

Figure 18. Using a large tapered carbide cutter, begin cutting away the excess wood from around the head.

Figure 19. Keep the sides of the head straight up and down. There is a tendency to make U-shaped cuts which should be avoided. Note that just the wood around the head is removed down to the shoulders.

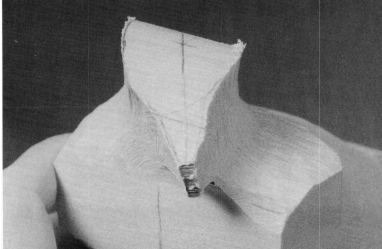

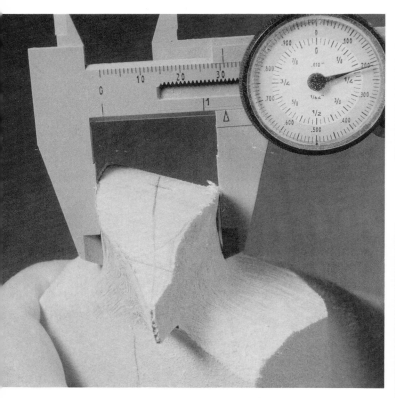

Figure 20. Keep removing wood until the head measures 1.15 inches. Well okay, 1.2 inches will do!

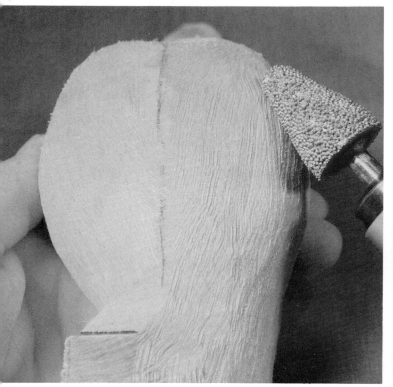

Figure 21. Round the breast and upper belly all the way to the centerline. There is a tendency to leave the bird square breasted...fight it!!

Figure 22. Roll the side of the head down onto the shoulders cutting away the shelves from the head narrowing procedure.

Figure 23. There should be a nice gentle roll from the side breast up to the side of the head.

Figure 24. A v-tool such as the one made by Warren Tools (PTV-1 or PTV-2) is a real joy to use on basswood. Since I am right-handed, I push the tool with the right hand and use the left hand to hold the bird and the left thumb to supply pressure for controlling the cutting edge.

Figure 25. Since v-tools are difficult to sharpen, I fashioned covers to protect their edges out of ribbon putty. The covers, Tweedle Dee and Tweedle Dum, slide on and off easily but keep the edges protected in my traveling tool box.

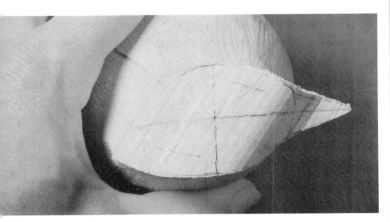

Figure 26. Draw a line on the top of the head through the pivot point dividing the top of the head into quadrants. The "x" on the front left quadrant and the opposite back quadrant indicate the high spots that need trimming. Cutting out a bird blank from the profile view and turning its head in the wood causes the planes on the top of the head to be too high in spots.

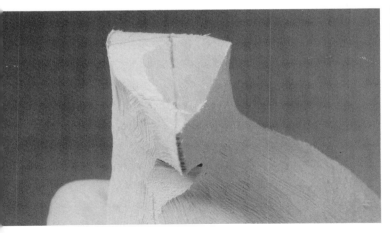

Figure 27. The front high quadrant is on the side to which the head is turned. Trim the excess off and level it with the opposite forehead plane. Depending on the amount of head turn, you may have to cut through and past the centerline. If you cut away the centerline, be sure to redraw it.

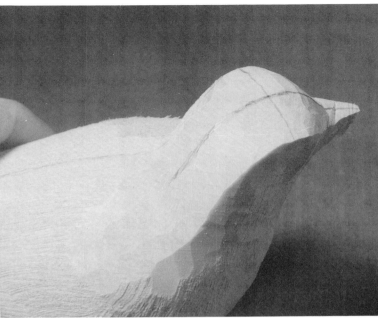

Figure 28. When cutting away the high spots on the back quadrant, you will need to remove the excess wood on that same side of the neck. Flow the neck down onto the mantle.

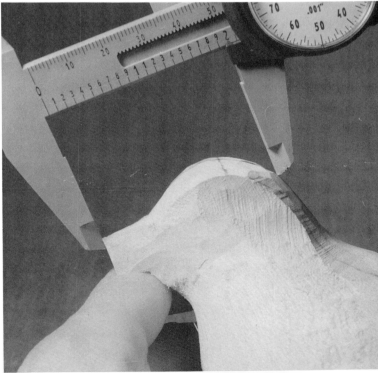

Figure 29. Check the measurement from the end of the beak to the back of the head. If it is more than 2.0 inches, trim equal amounts off the end of the beak and back of the head.

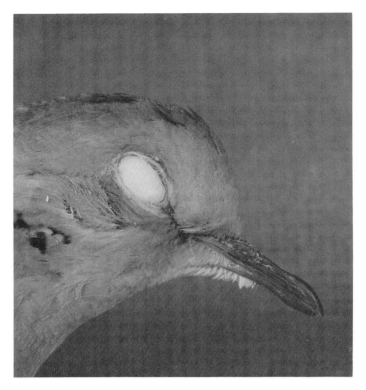

Figure 30A. Profile of dove head and beak.

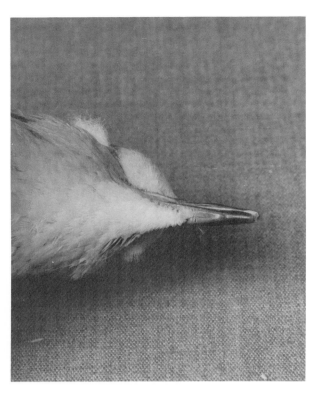

Figure 30B. Underside of dove beak.

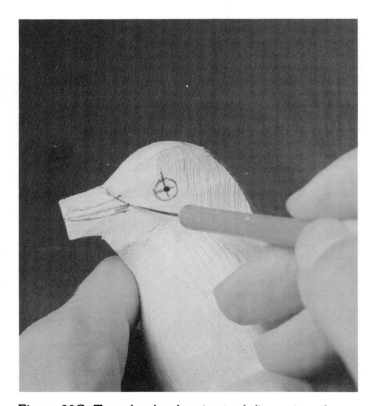

Figure 30C. Transfer the drawing and dimensions from the profile line drawing. Recheck all the dimensions with a ruler. Pinprick the center length of the beak and eye center on both sides.

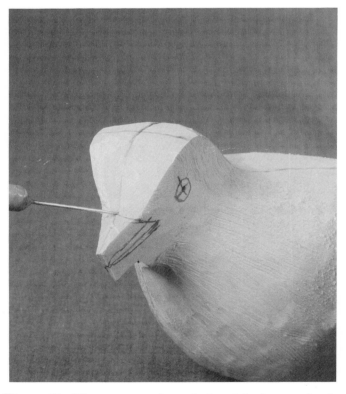

Figure 31. Measure, mark and pinprick the top beak length .50 inches. Draw in the top and side beak shape from the top length, around the corner of the blank and down to the center beak length on both sides.

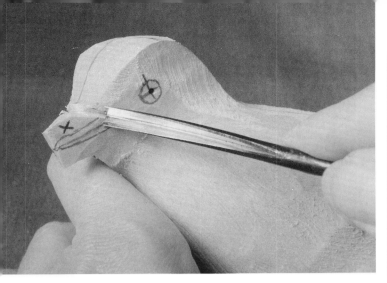

Figure 32. Begin removing the excess from above the upper mandible. Be careful of the grain direction so that you do not chip out parts you want to save.

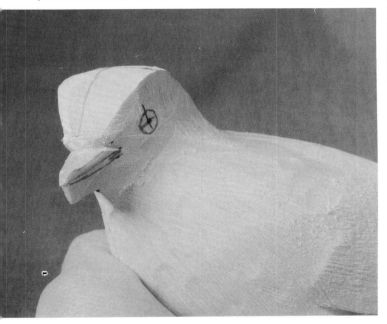

Figure 33. Keep the top of the upper mandible flat at this point. Redraw the beak centerline.

Figure 34. Using a v-tool or the tip of a pointed ruby carver cut a stop cut along the side beak lines. Remove a small amount of wood from under the beak tip.

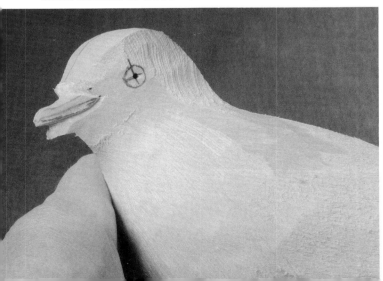

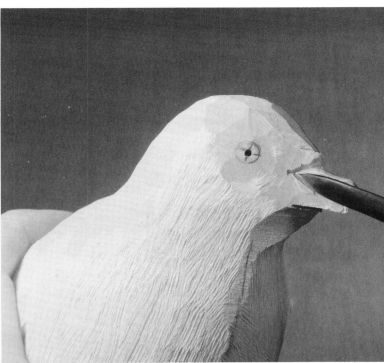

Figure 35. Begin cutting chips out of the sides of the beak. Be sure to remove equal amounts across the centerline and keep the sides of the beak straight up and down. Because of the grain changes, you will be cutting against the grain on one side. It will be helpful to use a sharp thin-bladed knife in cutting against the grain.

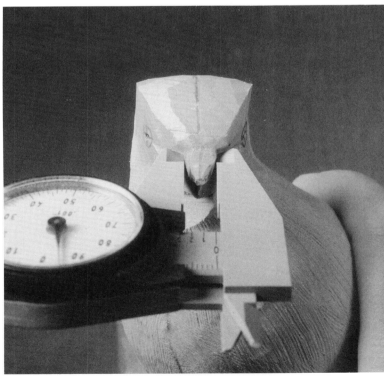

Figure 36. Keep narrowing the sides of the beak until the base measures .30 inches.

The Folded Wing Mourning Dove 139

Figure 37. On the beak's underside, measure and mark .35 inches.

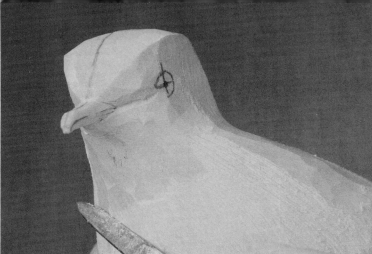

Figure 40. Flow the throat and chin down to the base of the beak's underside, cutting away the shelf from the previous step. Round the throat and chin.

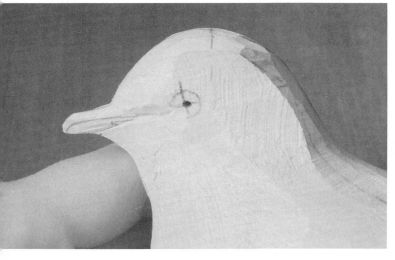

Figure 38. Flow the forehead and sides of the head down to the base of the beak, maintaining their original planes. Remove a small amount of wood along the crevice line between the base of the beak and eye on both sides.

Figure 39. Remove the excess wood from the underside of the beak back to the measurement mark.

Figure 41. Measure and mark .80 inches across the top of the head above the eyes. Draw in the wedge shape of the head encompassing these marks.

Figure 42. Cut away the excess from along side of the top of the head. Work from the eye to the top corner. Keep equal amounts across the centerline.

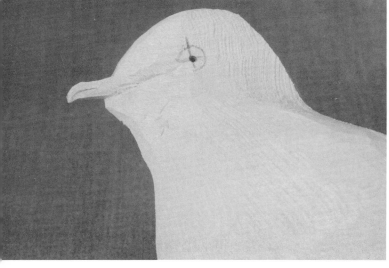

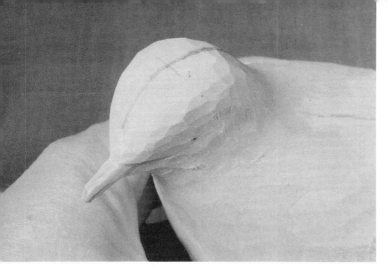

Figure 43. Lightly round the top of the head from the forehead to the top and on down the back of the neck. Do not round all the way to the centerline. There is a flat area along the centerline. This procedure is only slightly more than rounding the corners off.

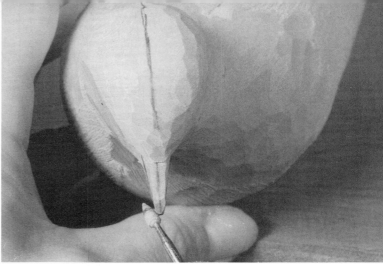

Figure 45. Create the proper shape of the plan view by removing the excess wood from the sides of the beak. Thin the tip width to .12 inches. Slightly round the beak tip.

Figure 44. Flow the hindneck onto the mantle and shoulders. Thin the neck width to approximately 1.2 inches and the neck thickness to 1.4 inches.

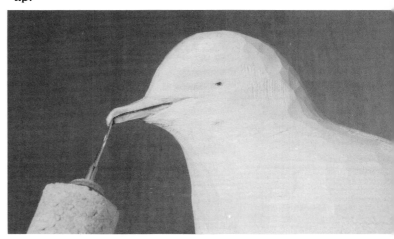

Figure 46. Redraw and burn in the commissure line on each side holding the burning pen perpendicular to the beak's surface. Narrow the tip of the lower mandible underneath the overhanging upper mandible.

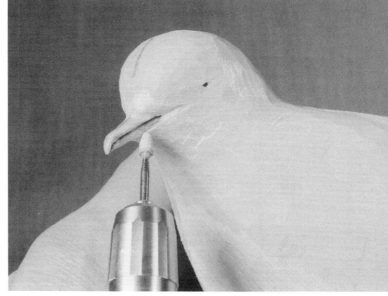

Figure 47. Create and smooth the little triangular tufts of feathers on each side of the lower mandible with the tip of a small pointed stone. Use the stone to round all of the sharp corners on the beak.

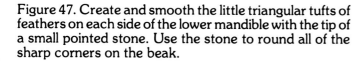

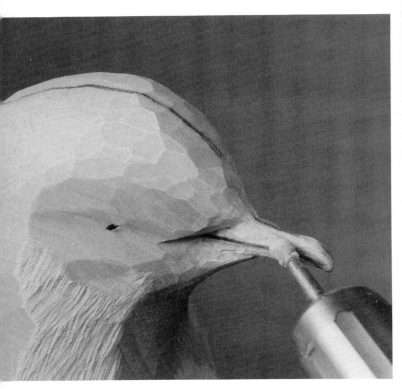

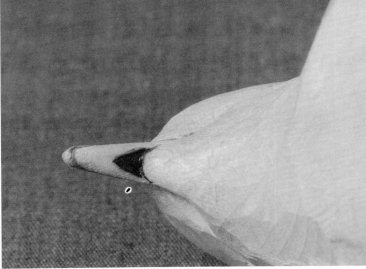

Figure 50. Use to burning pen to depress the small triangular shaped area on the underside of the lower mandible.

Figure 48. Draw in the little teardrop-shaped nostril coverings on each side of the upper mandible. Using the point of a small stone, carve around the coverings and round over their edges.

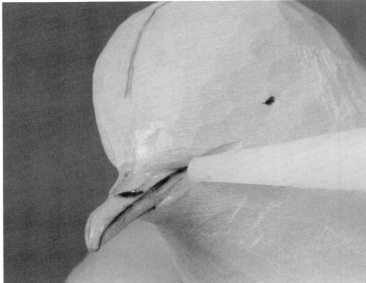

Figure 51. Fine sand the beak and saturate it with super-glue. When the glue is dry, fine sand again.

Figure 52. Recheck the eye positions. Drill 6 mm. eyes approximately .20 inches deep. Check the eyes for proper fit.

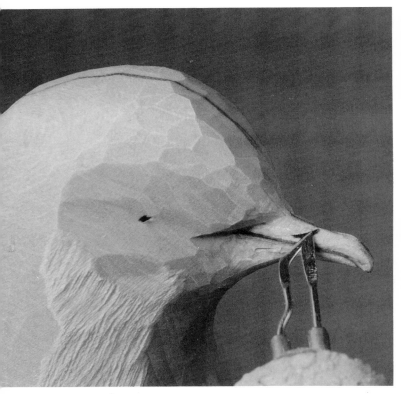

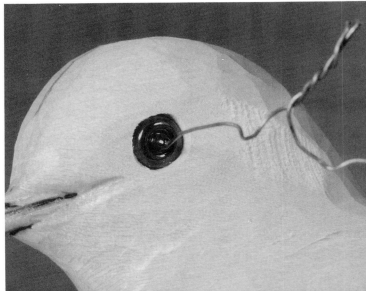

Figure 49. Use the tip of a small burning pen to burn the nostril slit just under the covering.

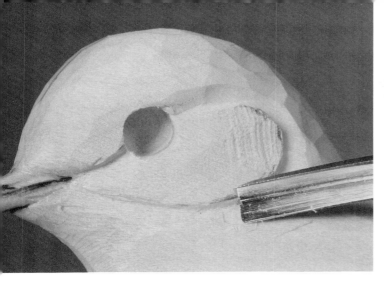

Figure 53. Draw in the ear coverts, keeping them balanced. Using a v-tool or ruby carver, cut around each covert. Also draw in and cut the droopy patch of feathers between the base of the beak and eye.

Figure 54. Flow the bottom of the covert channel out onto the surrounding head and neck areas. Round over the sharp edge on the coverts. Cut away a small amount of the wood underneath the droopy feather area and round over its sharp edge. You may need to remove a small amount of wood from under the eye so that it has a slightly depressed area in which to be set.

Figure 55. Be careful to keep all of the features on the head and beak balanced from the head-on view.

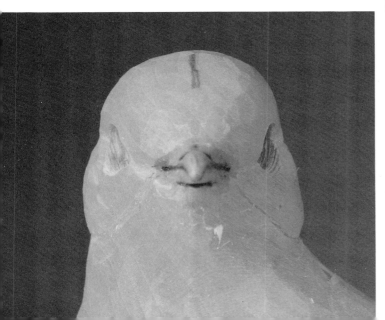

Figure 56. Cutting off the carbide cutter's scratches allows drawing in wing details more easily. Redraw centerline if it is cut away.

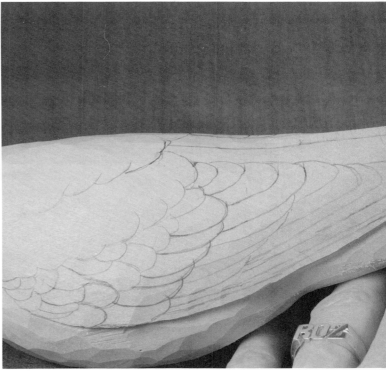

Figure 57. Transfer the mantle, scapular, and wing feathers to the carving.

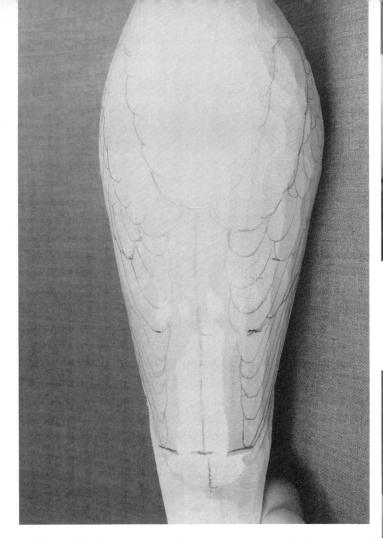

Figure 58. Here you see the top plan view of the mantle, scapulars and wing feathers.

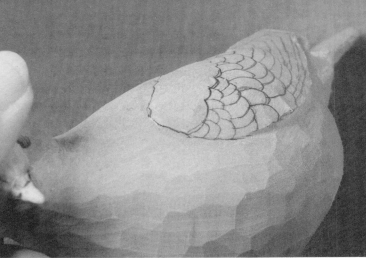

Figure 60. Flow the channel out onto the wings and scapulars and round over the sharp edge along the mantle and patches of side breast feathers. Channel around the scapulars. Flow the channel out onto the wing and round over the sharp corner along the edges of the scapulars. Redraw any lines cut away.

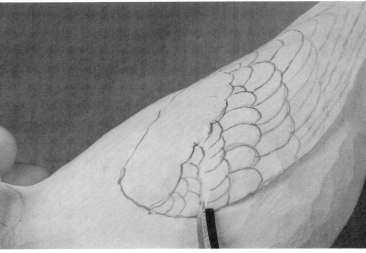

Figure 61. Laying a v-tool on its side, cut along the edge of the marginal coverts. Roll down the sharp edge and redraw any lines cut away.

Figure 62. Cut along the tips of the lesser secondary coverts. You can use a burning pen laying on its side to depress the wood around each of the individual feathers.

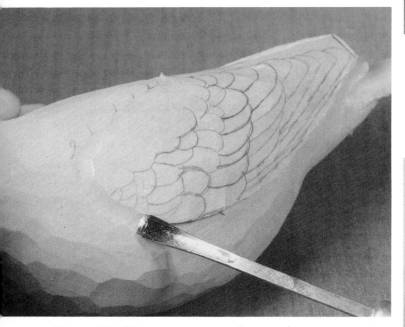

Figure 59. Using a gouge or large ruby carver, cut a channel along the side breast and mantle lines.

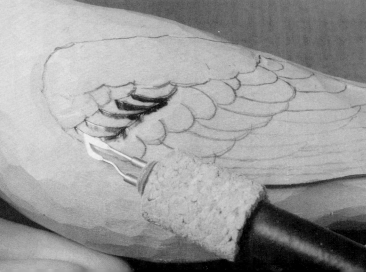

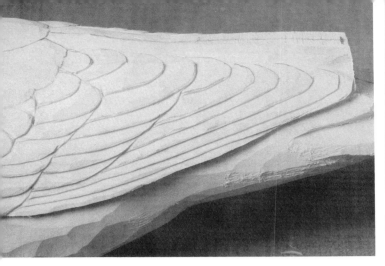

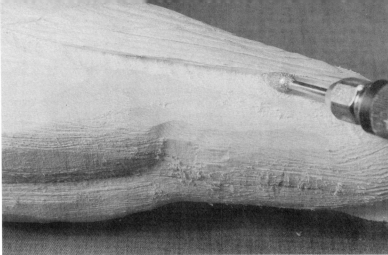

Figure 63. Cut around each of the remaining groups on both wings, laying the v-tool or burning pen on its side and rounding over the sharp edges. Working from front to back and top to bottom allows you to cut out the feathers on top of the ones underneath successively.

Figure 66. Use the tip of a small pointed ruby carver to relieve a small amount of wood from under the lower wing edges.

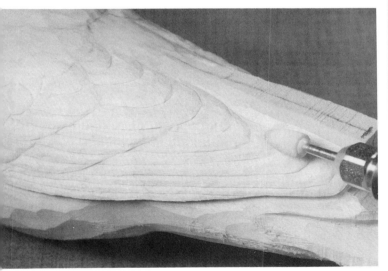

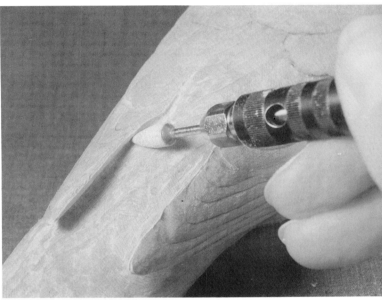

Figure 64. Use a bullet shaped stone to complete the rounding over procedure and to generally smooth all of the wing feathers.

Figure 65. After the wings are completed, cut away the wood between the primaries. Use a pointed ruby carver to relieve the wood from under the primary tips.

Figure 67. Smooth the area under the primary tips and the tips' underside with a pointed stone.

Figure 68. Draw in the feathers on the topside of the tail. Cut away any excess wood from around the tips of the feathers. Cut along the edges of the center feather.

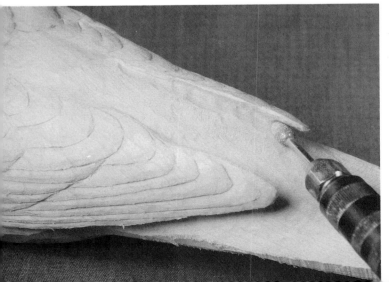

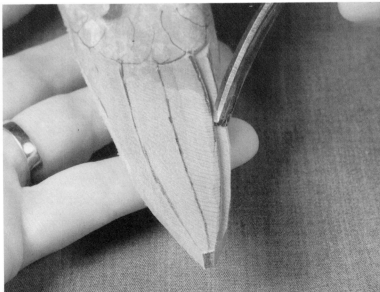

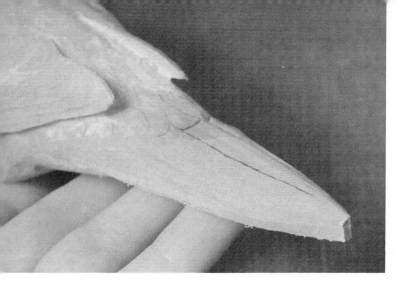

Figure 69. Round over the sharp edges of the center feather. Cut in the edges of the other exposed tail feathers and round over the edges.

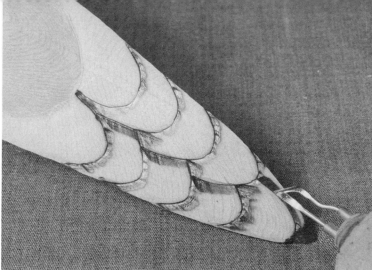

Figure 72. Sand the underside of the tail and draw in the feather tips. Laying the burning pen on its side, burn in the tip edges.

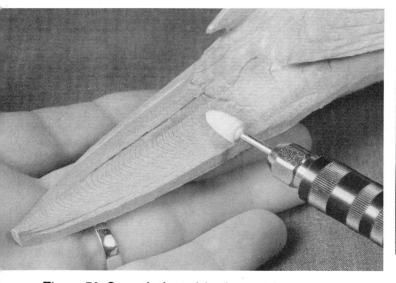

Figure 70. Smooth the tail feathers with a stone.

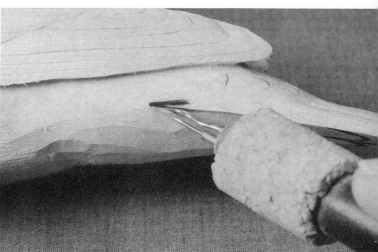

Figure 73. Burn a small separation between the tail and the upper and lower tail coverts.

Figure 74. Draw in the feather puffs contouring on the underside, mantle, back, upper tail coverts, neck, and back of the head.

Figure 71. Thin the tail from the underside.

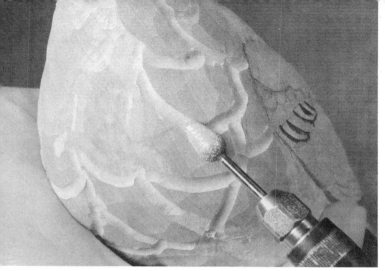

Figure 75. Channel along the lines with a ruby carver and round over each of the feather puffs.

Figure 78. Draw in the feather shapes. The feathers under the chin are small and get progressively larger going back toward the tail.

Figure 76. Sand all of the contoured surfaces with a cartridge roll sander. Use a bullet shaped stone to access areas that the sander cannot reach.

Figure 77. Clean up under the lower wing edges and tips of the primaries with a burning pen.

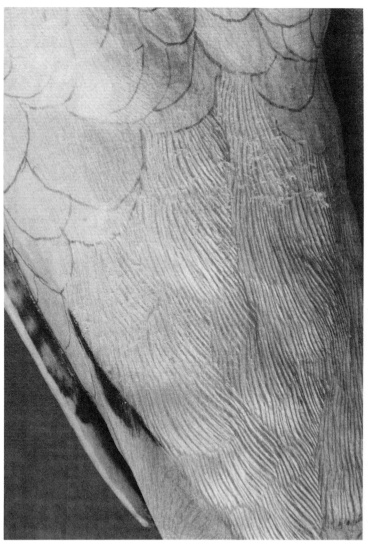

Figure 79. Begin stoning at the tips of the lower tail coverts and progress up the belly toward the head. Here you can see the infamous basswood "fuzz" from the stoning.

The Folded Wing Mourning Dove 147

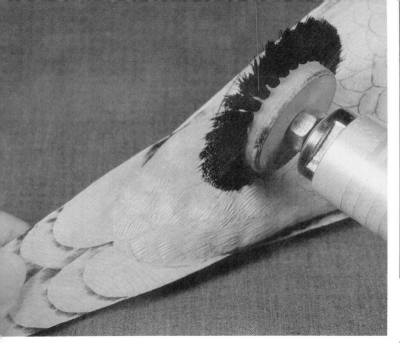

Figure 80. Use a laboratory bristle brush with a light touch and low speed to whisk away the fuzz.

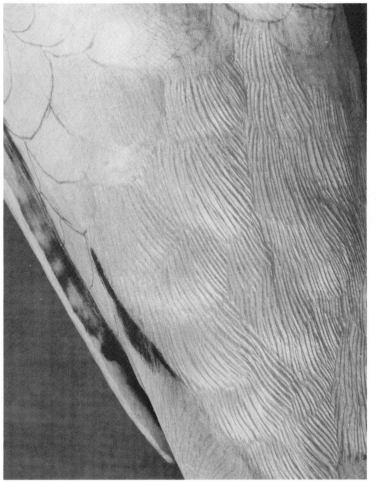

Figure 81. Note the lack of fuzz now that the same area has been brushed. Finish the remainder of the underside stoning all the way up to the chin. Clean all stoned surfaces with the brush when the stoning is completed.

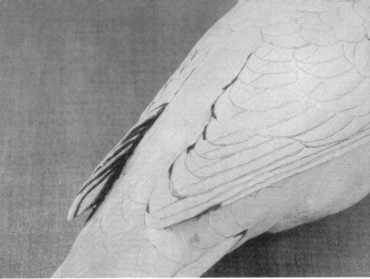

Figure 82. Use the burning pen to burn around the edges of the primary tips and the trailing edges on the underside.

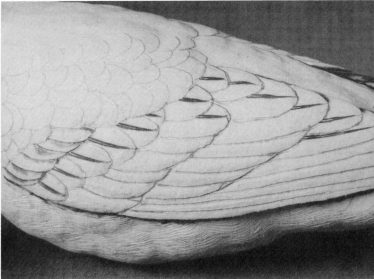

Figure 83. Draw and burn in the quills on the wings.

Figure 84. Starting with the outer primary begin burning in the barbs on the wing feathers. Work your way upward and forward on each wing, burning the feather underneath and then the one on top.

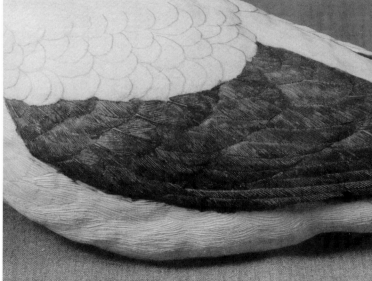

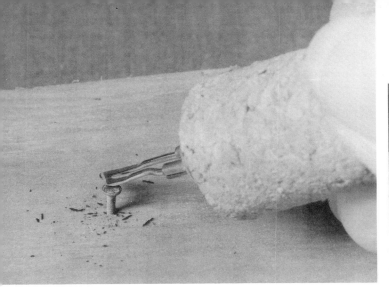

Figure 85. If carbon begins to build up on the burning pen, gently drag the tip edge along the edge of a small flathead nail to pop off the carbon deposits. This does not appear to harm the wire and is a fast way to get rid of deposits without altering the tip's surface or bevel.

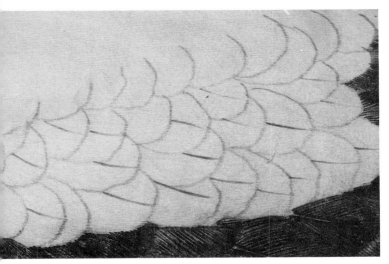

Figure 86. Draw in all of the scapular feathers. Draw and burn in the quills. Since these quills are so small, a single line quill is sufficient.

Figure 87. Clean all burned texturing with a toothbrush.

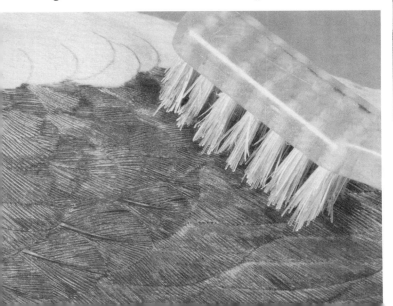

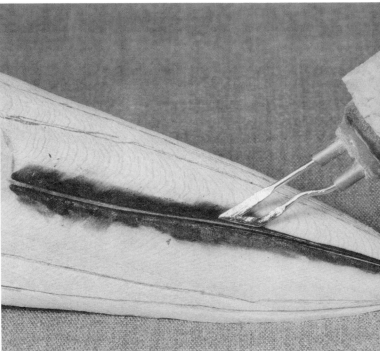

Figure 88. Draw and burn in the quill on the tail's upper surface. After burning in the first strokes with the pen held vertically, lay the pen down and use the "pull away" stroke that depresses the wood along side of the quill.

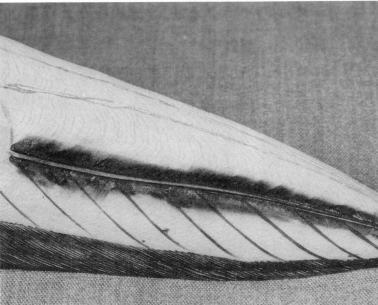

Figure 89. Begin burning in the barbs on the tail on the outer feathers and progress in toward the center feather from each side. When there is a large feather such as this one, burning in direction lines every little bit will help keep the barbs' angle in the proper position. After the direction lines are burned, just fill in with barbs in between.

Figure 92. Burn in the barbs on the underside of the lower wing edges.

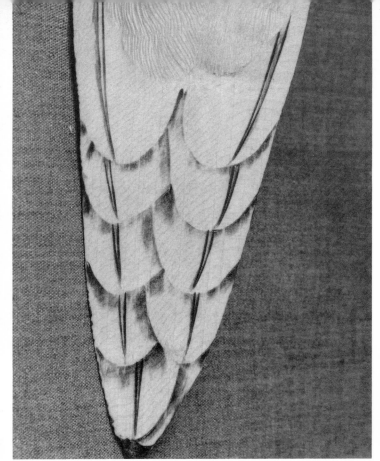

Figure 90. Draw and burn in the quills on the underside of the tail. Pay particular attention to the quill placement on the tips. Note that on the short feathers, which are the outer feathers when the tail is spread, have quills near the leading outside edge.

Figure 93. Burn in the one quill exposed under each set of primary tips and then burn in the barbs. A long, slender burning pen tip is helpful working under the primary tips.

Figure 94. Burn in the barbs on the flank feathers that could not be stoned. Also, if there is any fuzz that the laboratory brush could not whisk away, the burning pen can scorch it away.

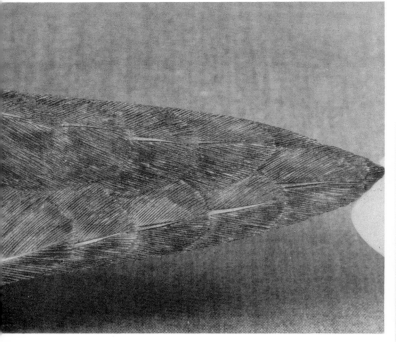

Figure 91. Burn in the barbs on the tail's underside starting at the tip and working forward to the base of the tail.

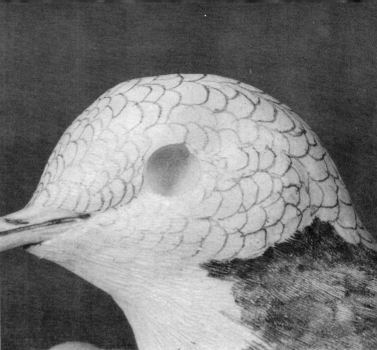

Figure 95. Draw in the feathers on the upper tail coverts, back, mantle and head. Begin burning in the barbs at the edges of the upper tail coverts and progress up the bird.

Figure 96. Use a long, slender burning pen to burn in the barbs under the primary tips without marring the underside of the tips. Work your way up the back toward the head.

Figure 97. The feathers are small on the head.

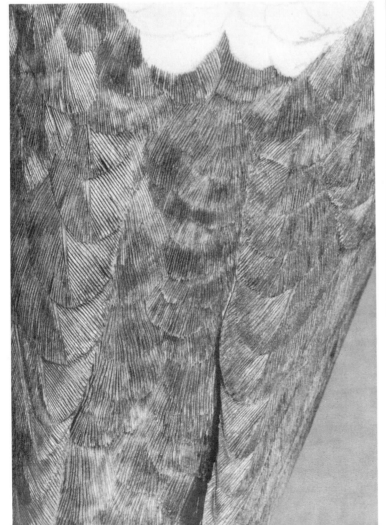

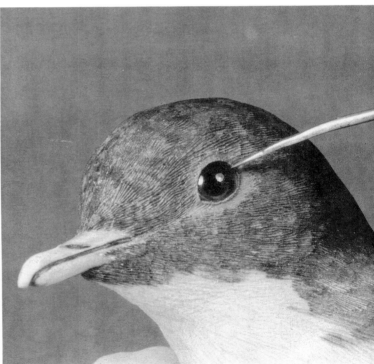

Figure 98. Finish burning the feathers on the head. Burn the barbs in close to the beak's underside where the stoning could not reach. Blend the stoning into the burning in the shoulder and side breast areas. Clean all of the burning with a toothbrush.

Recheck the eye placements, fill the eye holes with clay and put the eyes in place. Set the eyes according to the directions at "Setting Eyes" in *Basic Techniques*.

The Folded Wing Mourning Dove 151

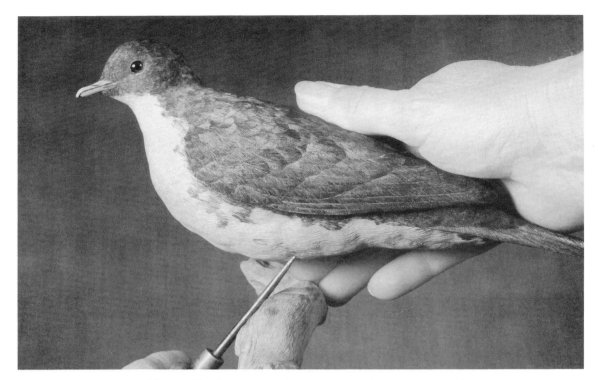

Figure 99. Determine the exit points for the feet so that the bird is balanced over the toes. Make the feet according to the directions at "Feet Construction" in *Basic Techniques*.

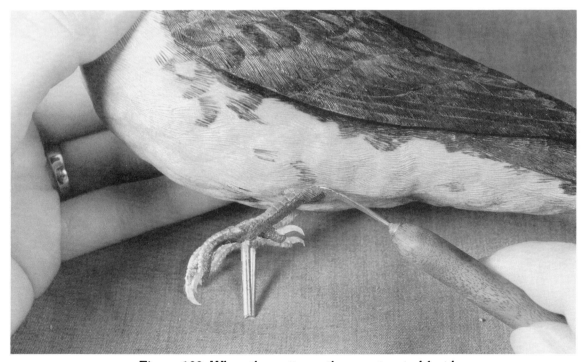

Figure 100. When the putty on the constructed feet has hardened, glue into place. When the glue is dry, apply a small amount of ribbon epoxy putty around the joint. Pull some putty down onto the top of the tarsus and press in a feathery appearance. Pull the putty into the surrounding texturing on the belly.

Allow the putty time to harden and spray with *Krylon Crystal Clear Spray*.

PAINTING THE FOLDED WING MOURNING DOVE

Liquitex jar acrylic colors:

Raw umber=RU
Burnt umber=BU
Cerulean blue=CB
Raw sienna=RS
Titanium white=W
Mars black=B
Paynes grey=PG
Yellow ochre/oxide=YO
Naphthol crimson=NC
Iredescent white=IW

An * indicates that a small amount should be added.

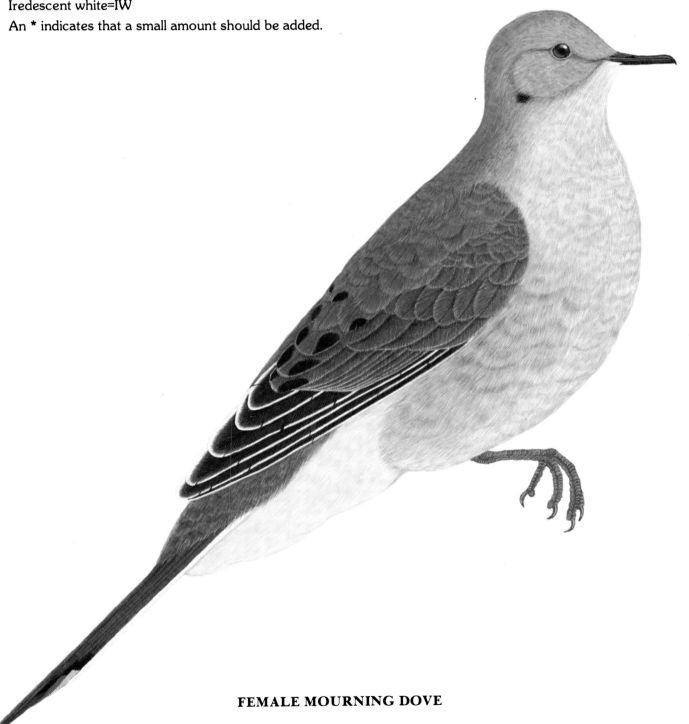

FEMALE MOURNING DOVE

Figure 1a. The grey on the female dove's head and neck is slightly less vivid than the male's.

Figure 1b. Note the subtle coloring of the mantle and hindneck.

Figure 2a. Note the soft greys and browns on the wings.

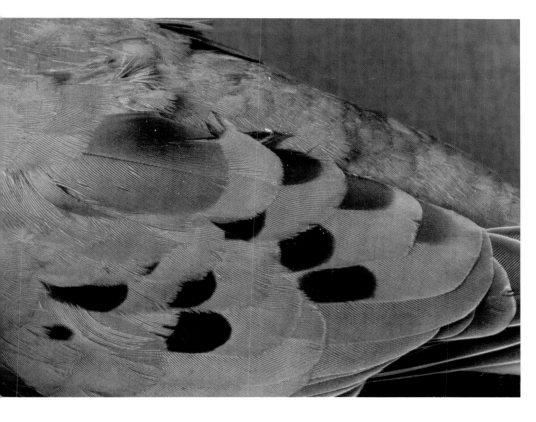

Figure 2b. Note the dark spots on the tertials and scapulars.

Figure 3. The colors on her head and breast are slightly lighter than the male's.

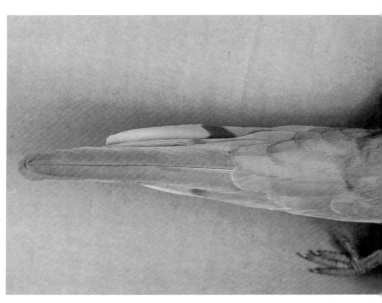

Figure 5. Note the mourning dove's closed tail.

Figure 4. The female has a buff colored breast and belly.

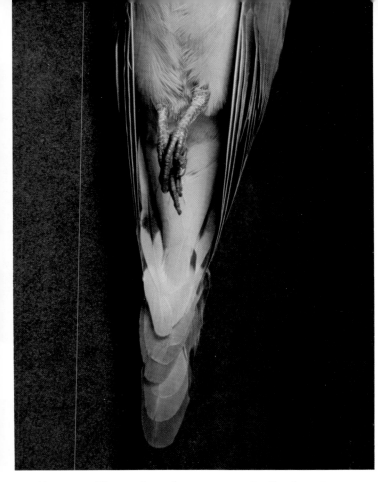

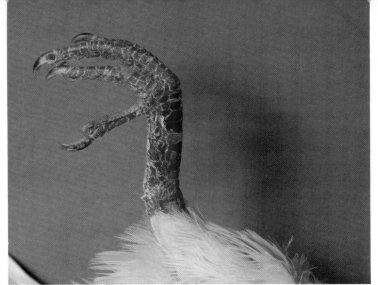

Figure 7. Note the foot color.

Figure 8. Using a stiff bristle brush, apply gesso right out of the jar. Adding water to gesso causes tiny pinholes to develop in the surface. Load the brush with gesso, wipe most of it on a paper towel and use a dry-brush technique scrubbing it down into the texturing grooves. The stiff brush is very important here because the firm bristles will keep the gesso from puddling in and filling up the texturing. Gesso the entire bird, feet, head and beak included. It usually takes about two coats to even out the color differential of the stoning and burning. Sometimes, it requires a third application over the green putty areas. When the gesso is dry, carefully scrape the eyes.

Figure 6. The undertail coverts are buff colored.

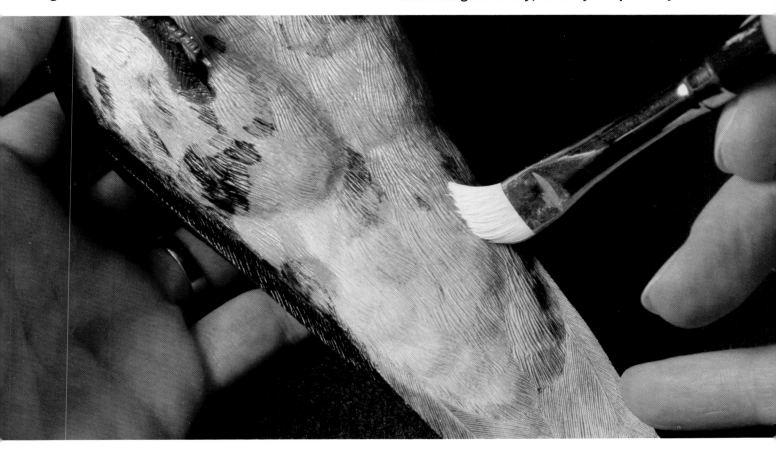

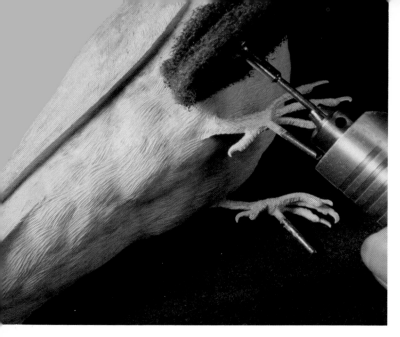

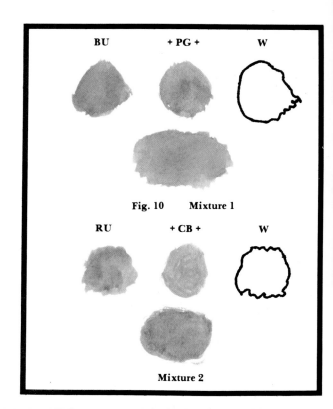

BU | + PG + | W

Fig. 10 Mixture 1

RU | + CB + | W

Mixture 2

Figure 9. On basswood, occasionally fuzz will appear after applying the gesso. Use a defuzzer pad on a mandrel to carefully whisk off the fuzz. Do not use near the feet or green putty. Use a light touch and low speed. Reapply gesso to the areas defuzzed if necessary.

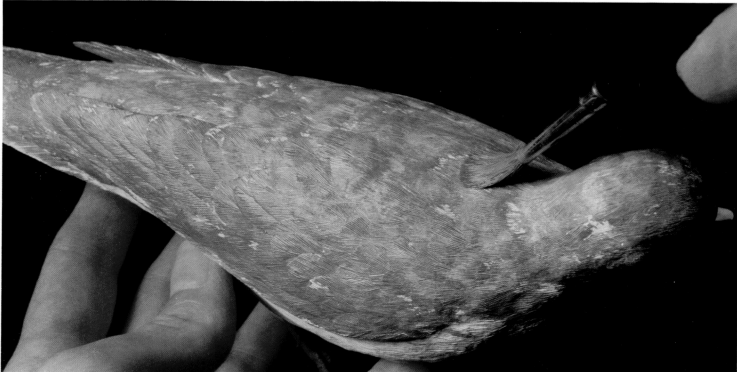

Figure 10. Mix up a puddle of each of the following mixtures: a grey mixture of burnt umber, paynes grey, and white; and a greenish grey mixture of raw umber, cerulean blue, and white. Load a large round sable brush with the first mixture, lightly dry the brush on a paper towel and begin applying it to the bird. Use a dry dabbing stroke randomly placing the paint on the head, hindneck, mantle, wings, back, uppertail coverts, underside of the primary tips, and upper surface of the tail. When applying any grey paint, remember that grey will usually dry a shade darker. It is easier to darken a color than it is to lighten it. So, keep the greys on the light side. Concentrate this first grey mixture especially on the wings.

It is not necessary to wait for this to dry. Clean the brush or use another one and load the greenish grey mixture. Dry the brush on a paper towel and begin applying random dry dabs over the same areas.

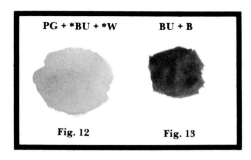

PG + *BU + *W BU + B

Fig. 12 Fig. 13

Figure 11. Continue alternating the two mixtures until there is sufficient coverage over the gesso. Keep the mixtures very thin so that the texturing is not filled up. If you find the dove getting too dark, add more white to the mixtures. When working the colors wet, there will come a time when the brush will pull off more paint than it deposits. At this time, allow the paint to dry or dry it with a hair dryer and start again.

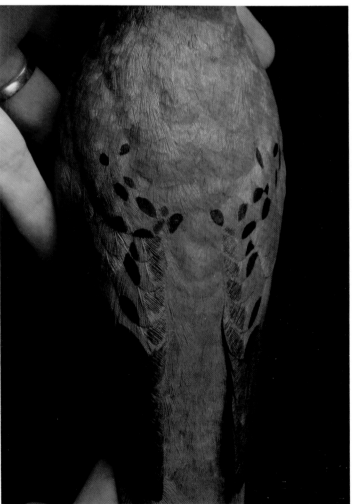

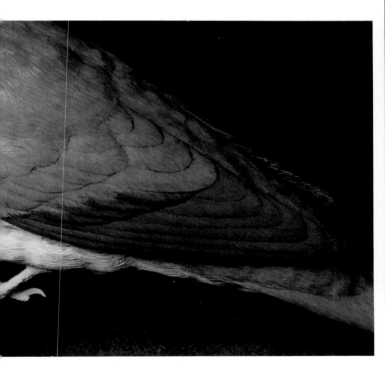

Figure 12. Apply several thin washes of a mixture of paynes grey, burnt umber, and a small amount of white to the primaries, and the tips of the secondaries and their leading edges.

Figure 13. For the quills and the spots on the scapulars and tertials, apply a mixture of burnt umber and black. Wipe most of the paint on the brush on a paper towel and dry-brush a little of the dark color on the trailing half of the tertials and longer scapulars. Paint the quill on the center tail feather the dark color. For the other quills on the scapulars and all three groups of secondary coverts, use straight burnt umber.

RU + CB + W PG + RU + W

Fig. 16 Fig. 16

Figure 14. Blend burnt umber, paynes grey, and a small amount of white to a dark charcoal color, and apply the mixture to the two exposed tips on both sides of the center tail feather. With a mixture of burnt umber and black, paint the part of the tail's arrow-shaped markings that are exposed.

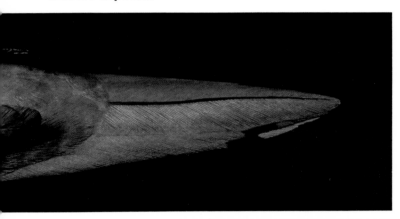

Figure 15. Dry-brush a mixture of burnt umber, paynes grey, and a small amount of white along the edges of the tail feathers. Add more white to this mixture and lighten the area on the part of the outer feather tip that is exposed. Apply two very thin raw umber washes to the tail.

Figure 16. With a thin mixture of raw umber, cerulean blue and white, pull a fine line edging on all the feathers on the mantle, scapulars, back, upper tail coverts, and all wing feathers except the primaries. For the edgings on the primaries, apply a thin mixture of paynes grey, raw umber, and white. Apply two thin raw umber washes to the mantle, scapulars, back, upper tail coverts, and wings.

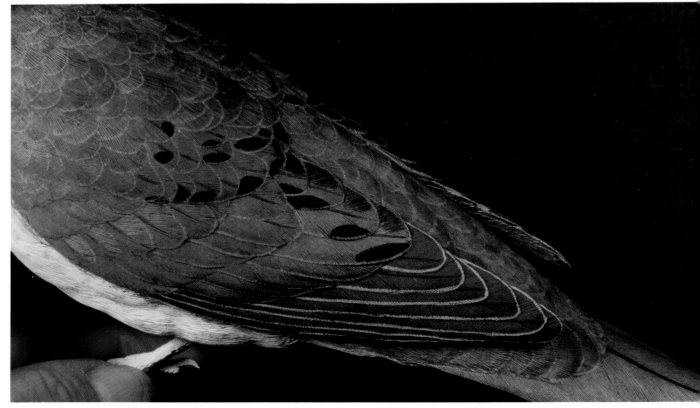

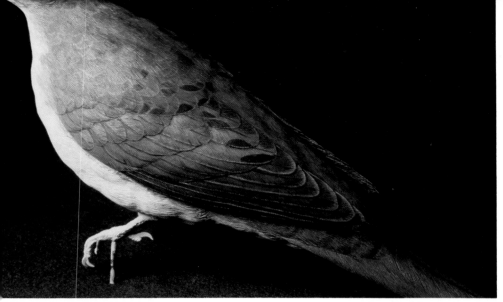

Figure 17. Make the edgings on the tips of the primaries a little wider with the paynes grey, raw umber, and white mixture, and then apply two very thin washes of a mixture of paynes grey and a small amount of burnt umber. Use a watery mixture of paynes grey and burnt umber to accentuate splits on the wings and tail. Also use the watery mixture to add a shadow line on the base of each primary just below the light edging of the feather above. Use a watery mixture of raw umber and a small amount of paynes grey to shadow the other wing feathers. On the mantle, wings, back, upper tail coverts and upper surface of the tail, apply a watery burnt umber wash. When this is dry apply a thin wash of a mixture of raw umber and raw sienna.

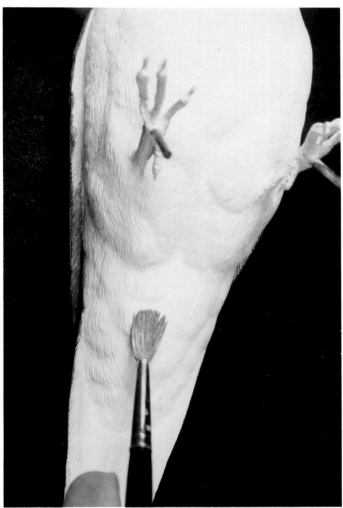

Figure 19. On the middle of the belly and the lower tail coverts, apply a blend of yellow ochre and white.

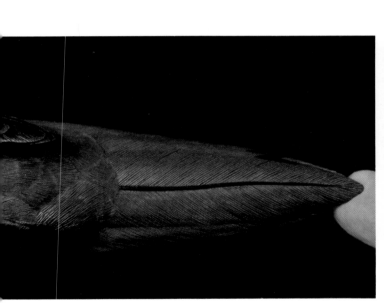

Figure 18. Apply a thin mixture of paynes grey and white along the area on each side of the center quill on the upper tail. Dry-brush a small amount of burnt umber along the edges of the tail feathers.

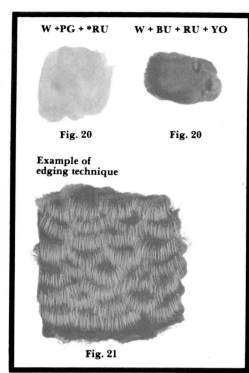

W +PG + *RU W + BU + RU + YO

Fig. 20 Fig. 20

Example of
edging technique

Fig. 21

Figure 20. On the flanks, apply a mixture of white, paynes grey, and a small amount of raw umber. The side of the head, neck, throat, and breast basecoats are a mixture of white, burnt umber, raw umber, and yellow ochre. Under the chin, wet-blend straight white into the breast basecoat color.

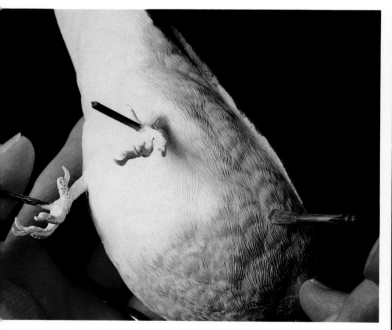

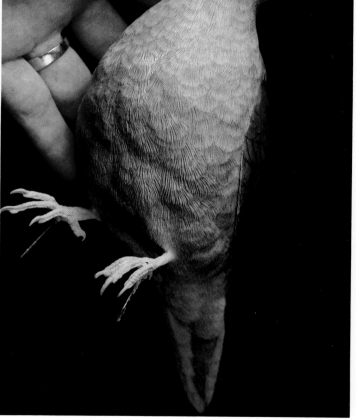

Figure 21. Add white to all three underside basecoat mixtures and pull feathery edges on all of the feathers. Mix your colors. Use a round sable brush, load the paint on the brush and wipe any excess off. Anchor your hand with your little finger, hold the brush vertically to the bird's surface and pull the light edging from each feather tip toward its base for approximately ⅛″, gradually lifting the brush up.

Figure 22. Make a wash out of each of the edging mixtures by adding lots of water and wash the respective areas. Do all the edgings and washes again until the feathers look soft. If the areas start getting too light (check reference photos), add more of the original basecoat colors.

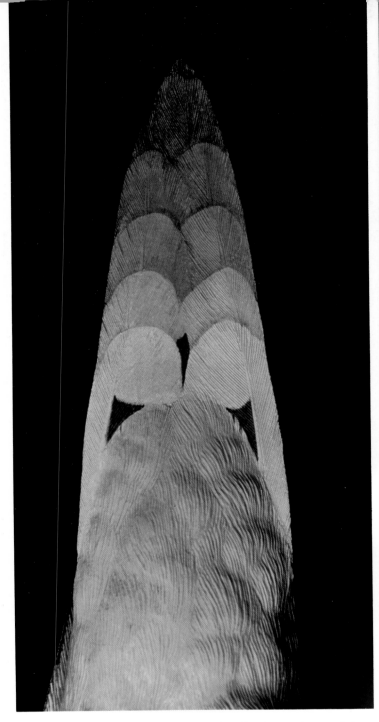

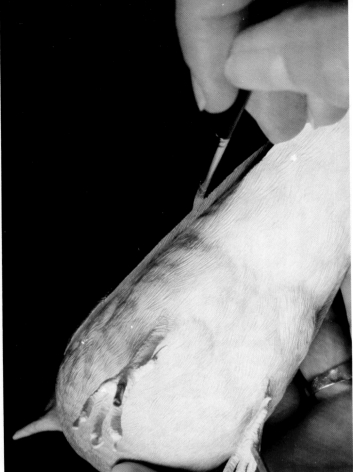

Figure 24. Apply a mixture of burnt umber, black, and white to a medium grey to the underwing edges and the undersides of the primary tips.

Figure 23. For the shortest feather leading edge and tip, and the second set of feather tips, apply a mixture of white with small amounts of paynes grey and raw umber. For the dark trailing part of the shortest feather and the exposed bases of any other feathers, use a mixture of paynes grey, raw umber, and a small amount of white.

Adding a little more paynes grey and raw umber to the whitish mixture used for the shortest feathers, paint the tips of the third set of feathers. Add a little more of the dark colors to the mix and paint the fourth set of tips. Add a little more of the dark colors and paint the fifth set. And one more time, add a little more and paint the last tip. When these are dry, apply a very thin wash of a mixture of white and raw umber to give the undertail a silvery cast.

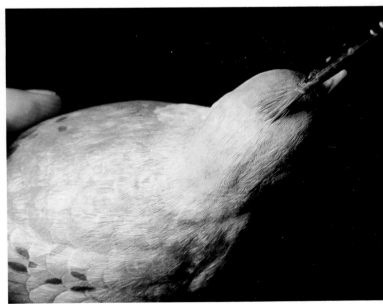

Figure 25. On the top of the head and down the hindneck, use a dry dabbing stroke to apply a small amount of a mixture of paynes grey, white, and a little raw umber. You will have to mix up the mantle basecoat mixtures to blend with the grey to get a soft transition area along the nape of the neck.

The Folded Wing Mourning Dove 163

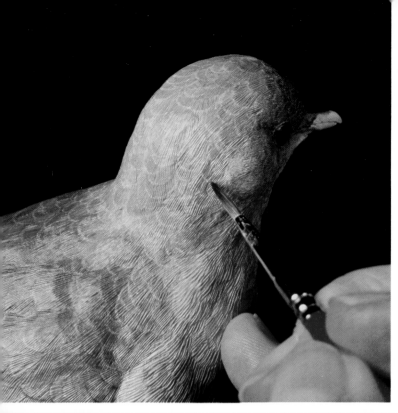

CB + *RU + *W

Fig. 27

Figure 26. You will need to blend the grey into the beige basecoat color on the sides of the head. Lighten the grey basecoat mixture on the top of the head and the beige basecoat mixture on the sides of the head and add water to thin. Pull a fine edge line around each feather edge with the respective mixture. Make washes out of the lighter edging colors and apply to the respective areas. Apply a watery burnt umber wash to the entire head.

Figure 27. After carefully cleaning the eyes, apply a mixture of cerulean blue and small amounts of raw umber and white to the eye rings. Apply a mixture of burnt umber, black, and a small amount of white to the dark spots just below the ear coverts.

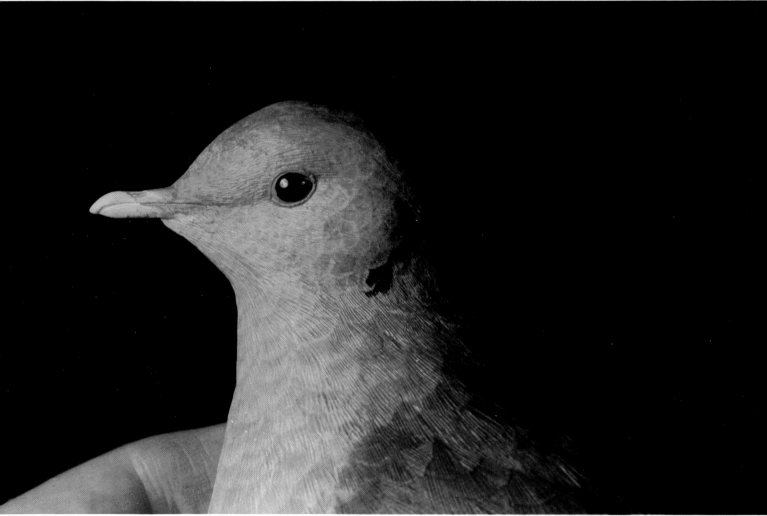

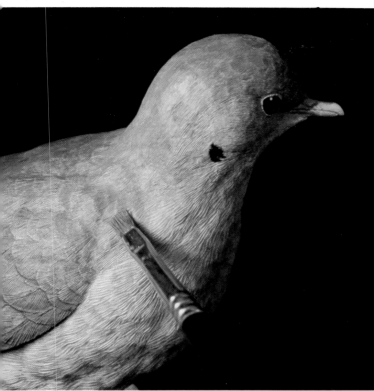

NC + IW + W + *CB	NC + PG + BU + W
Fig. 28	Fig. 29

Figure 28. For the iridescent patches on the shoulders, make a mixture of naphthol crimson, iredescent white, white, and a small amount of cerulean blue. Load a small sable bright (a short, square brush) with the mixture and clean almost all of the paint out on a paper towel. Lightly dry-brush a hint of color on the shoulder patches.

Figure 29. For the feet, apply basecoats of a mixture of naphthol crimson, paynes grey, burnt umber, and white. When these are dry, apply a washy mixture of burnt umber and white. Apply straight burnt umber to the claws. When these are dry, mix a small amount of gloss medium in a large puddle of water and apply to the feet. When this is dry, apply straight gloss to the claws and the quills.

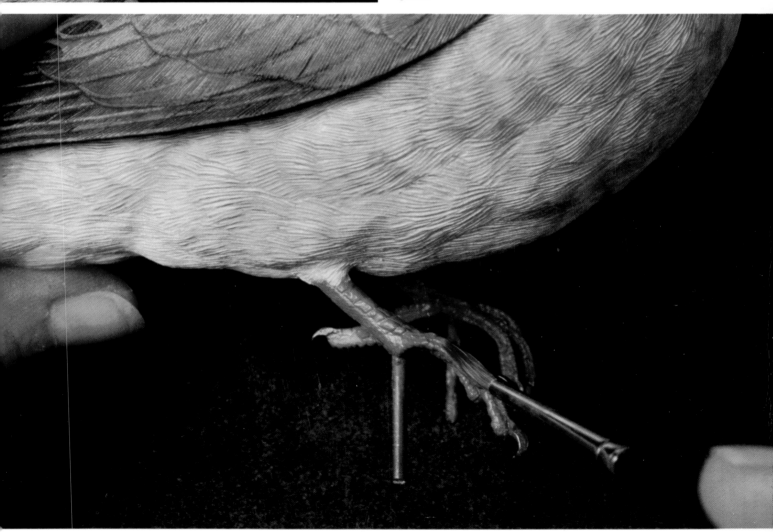

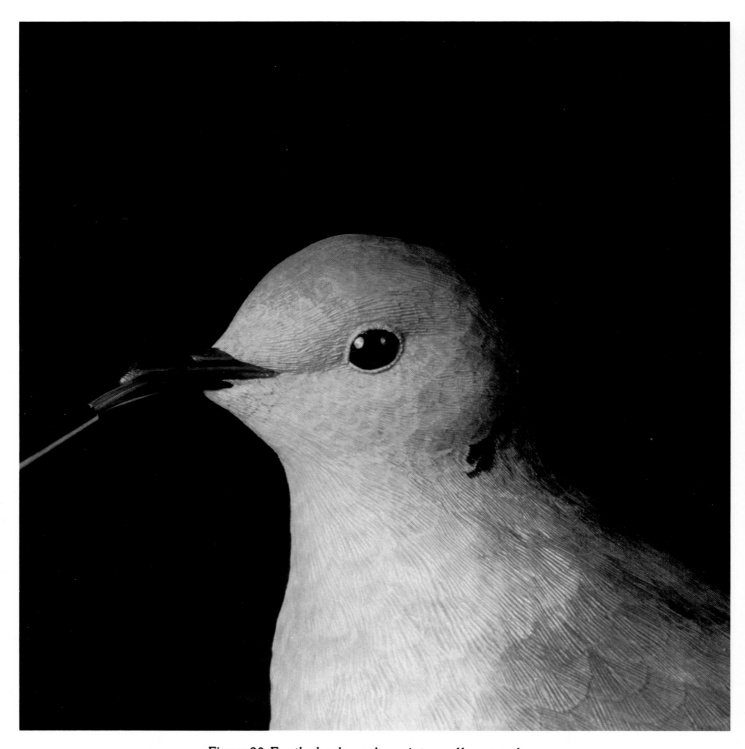

Figure 30. For the beak, apply a mixture of burnt umber, black, and a small amount of white. Before this dries, wet-blend naphthol crimson to the base of the beak at the commissure line. It will take several coats of the charcoal color to sufficiently cover the gesso. When these are dry, apply a 50/50 mixture of matte and gloss mediums.

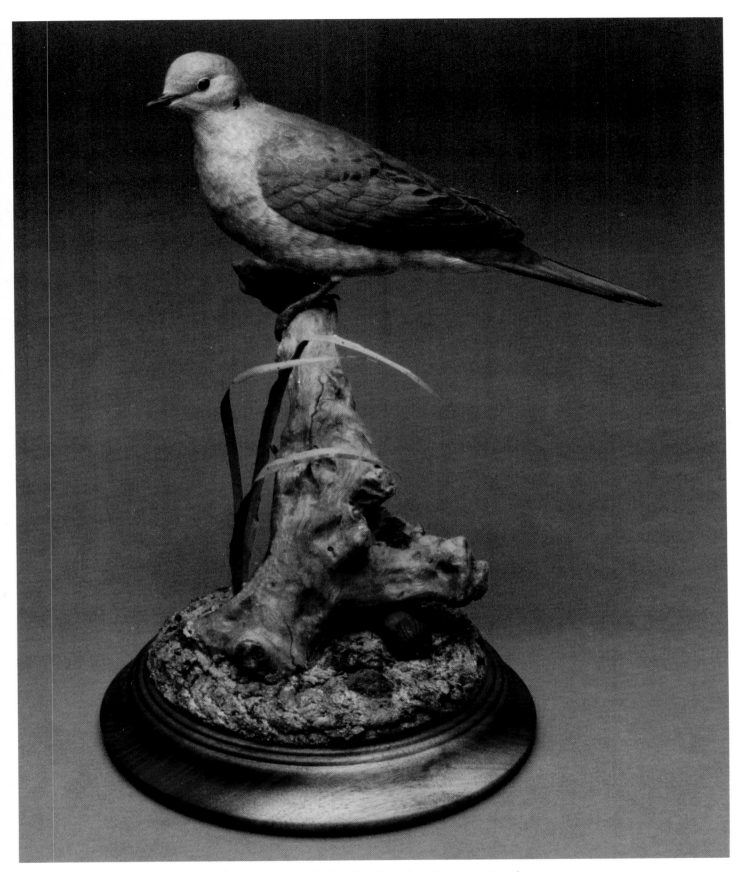

Figure 31. When the beak is dry, glue the mourning dove
to her mount.

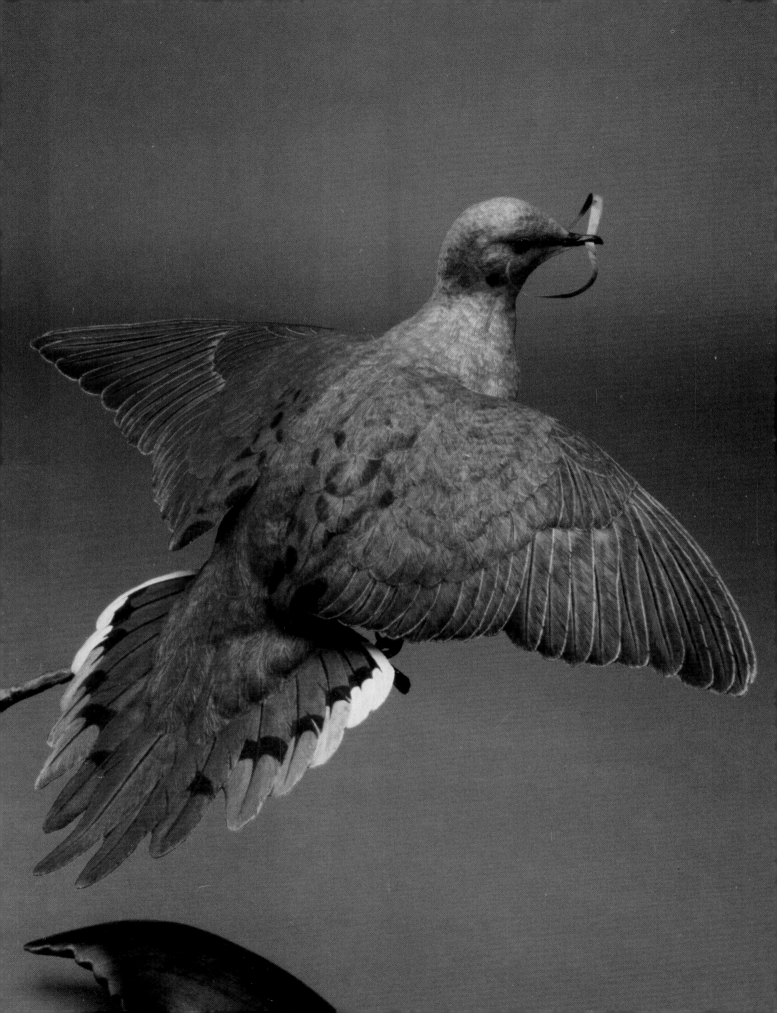

Chapter 7.
The Flying Mourning Dove
(Zenaida Macrura)

The mourning dove is the most common of the native doves and is found throughout the United States during most of the year. Its mournful cooing is a sound that most people have heard and can identify. The dove will likely be a common visitor to your feeding stations. I must admit that the mourning dove is my favorite larger bird to watch and to carve. The subtle and varied colors of its plumage are a real joy and challenge to paint. There is something very sensual and magical about the way the piece of basswood or tupelo shaped into a dove fits in the palm of your hand! Here in Delaware, it is not uncommon to see twenty or thirty doves, nestled in the backyard grass, soaking up the rays on a crisply cold day in the middle of winter. If startled, they will be off quickly and the whistling of their wings is a sound not soon forgotten.

Both sexes are similar in shape and size. The differences in plumage between the male and female are very subtle even in breeding season. The male has a rosier colored breast and slightly more brilliant grey on the top of his head. The female's breast is a beige color. They both molt once a year.

The dove is most commonly found in the suburbs and countryside. It feeds mostly on grain and weed seeds, but also dines on insects and small snails. The dove will consume gravel from the ground and roadside to help grind the seeds. Their nest is usually located 3-30 feet up in a tree but may be atop a fence post or stump. The male usually selects the site of the nest and will bring a few twigs for the female to arrange. Grasses, weeds and pine needles will be added, as needed, to enlarge and strengthen the nest. Both will share in incubating the eggs and feeding the young. A young dove will insert its beak into one of the parent's beaks. The parent will regurgitate a creamy liquid called "pigeon's milk" that nourishes the young bird. The young doves remain in the nest from 12-15 days. The parents will continue feeding them for a few days and then the young doves will begin feeding on the ground.

Since the open tail of the mourning dove is one of its most striking features, the flying bird with a spread tail would be very dramatic and eye-catching. The original idea that I had was to have a carved shadow or reflection (initially, I had not locked in on which one) with the flying bird somehow coming off of it. I worked up the bird in *Super-Sculpey* with the aluminum flashing wings and tail. I always solicit opinions of major pieces from other carvers whose opinion I value and also, in this case, from hunters who know the birds well. One of the people with whom I consulted was Bill Veasey, whose judgment and ideas are held in high regard throughout the carving world. As soon as he saw the piece and was informed about the shadow/reflection, Bill suggested that I actually light the piece in some way. When I left Bill's studio, I wasn't yet sure what else I was going to do, but that piece was going to be lighted in some way! As you go through this project, be aware that not all the engineering problems were yet solved in the beginning stages. This whole project just evolved and metamorphosed.

DIMENSIONS FOR OPEN WING DOVE*

SIZE 3/4

 1. End of tail to end of tertials—4.1 inches 3.1
 2. Length of wing (wrist to end of primaries)—5.7 4.3 inches
 3. End of primaries to end of longest alula—4.0 inches 3.0
 4. End of primaries to end of primary coverts—3.3 2.5 inches
 5. Tail length overall—5.0 inches 3.75
 6. End of tail to upper tail coverts—2.5 inches 1.9
 7. End of tail to lower tail coverts—2.6 inches 2.0
 8. End of tail to vent—5.2 inches 3.9
 9. Head width at ear coverts—1.15 inches .9
 10. Head width above eyes—.80 inches .6
 11. End of beak to back of head—2.0 inches 1.5
 12. Beak length
 top—.50 inches .375
 middle—.75 inches .6
 bottom—.35 inches .26
 13. Beak height at base—.19 inches .14
 14. End of beak to center of eye (6 mm. brown)—1.2 .9 inches
 15. Beak width at base—.30 inches .23
 16. Tarsus length—.80 inches .6
 17. Toe length
 inner—.90 inches .68
 middle—1.1 inches .83
 outer—.82 inches .61
 hind—.57 inches .4
 18. Overall body width—2.6 inches 1.95
 19. Overall body length*—11.8 inches 8.85 8 7/8

*All of these measurements are for doves here in Delaware. According to Bergmann's Rule in ornithology, body size tends to be larger in cooler climates and smaller in warmer climates. Allen's Rule suggests that beaks, tails, and other extensions of the body tend to be longer in warmer climates and shorter in cooler climates. Accordingly, you may have to adjust lengths and widths depending on where you live.

MOURNING DOVE

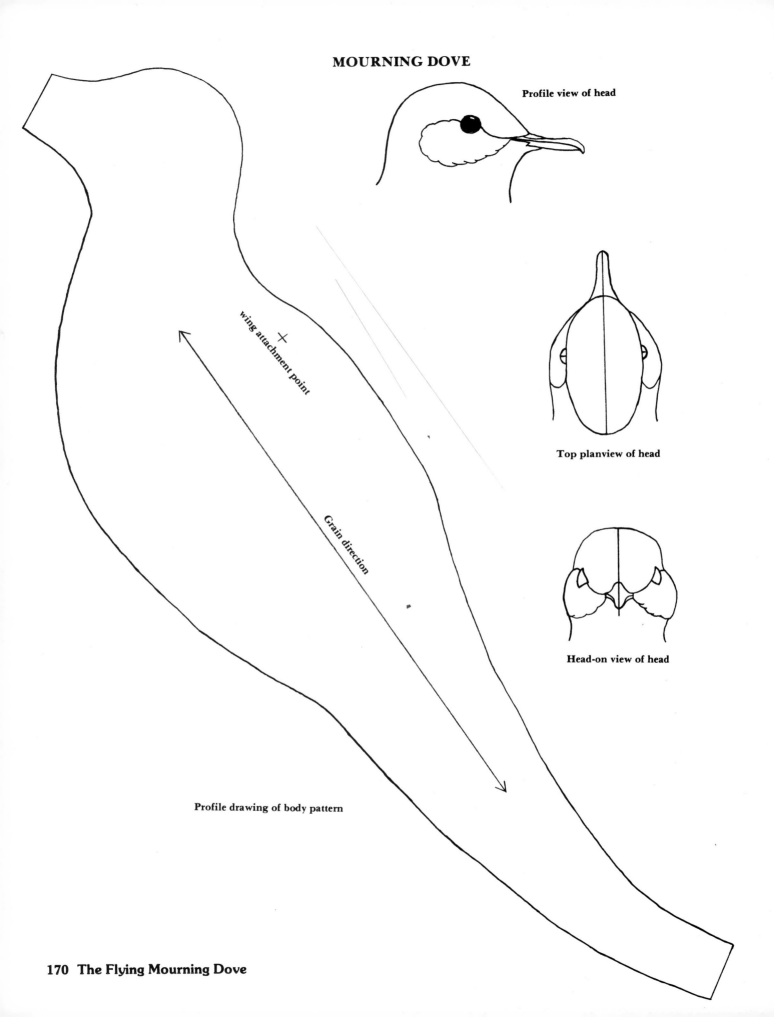

Profile view of head

Top planview of head

Head-on view of head

wing attachment point

Grain direction

Profile drawing of body pattern

MOURNING DOVE WING FEATHER GROUPS

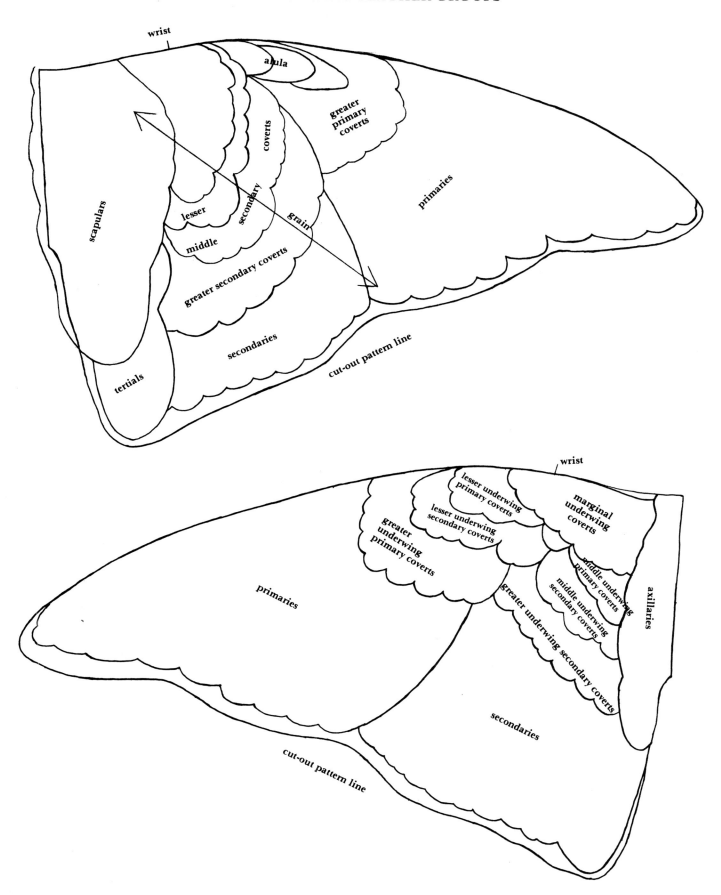

MOURNING DOVE WING PATTERNS

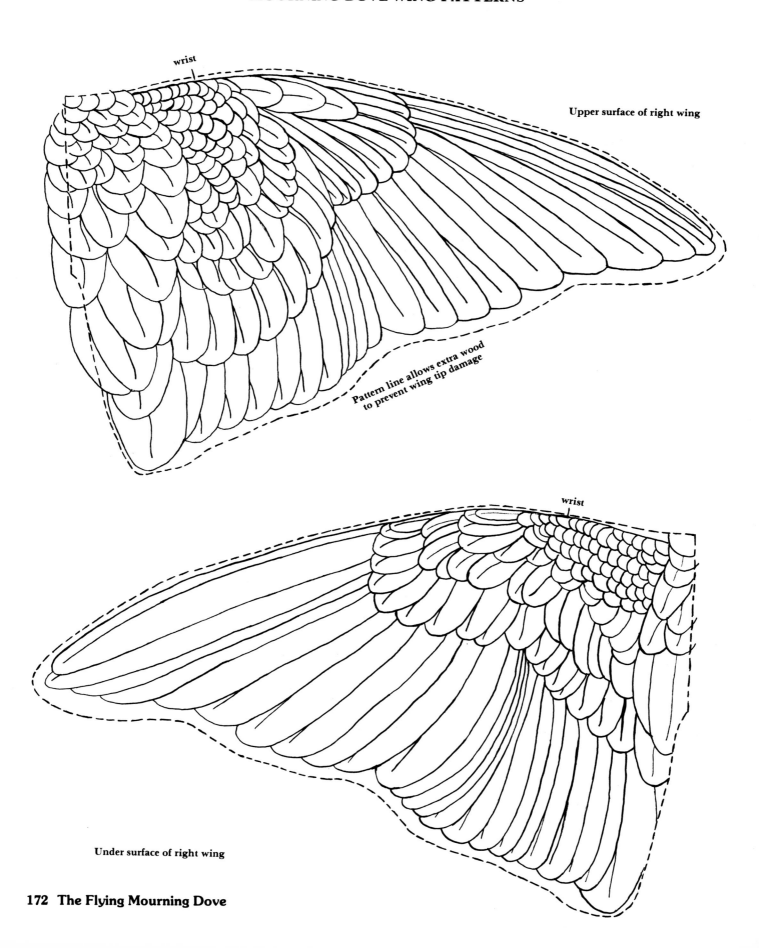

wrist

Upper surface of right wing

Pattern line allows extra wood
to prevent wing tip damage

Under surface of right wing

wrist

MOURNING DOVE

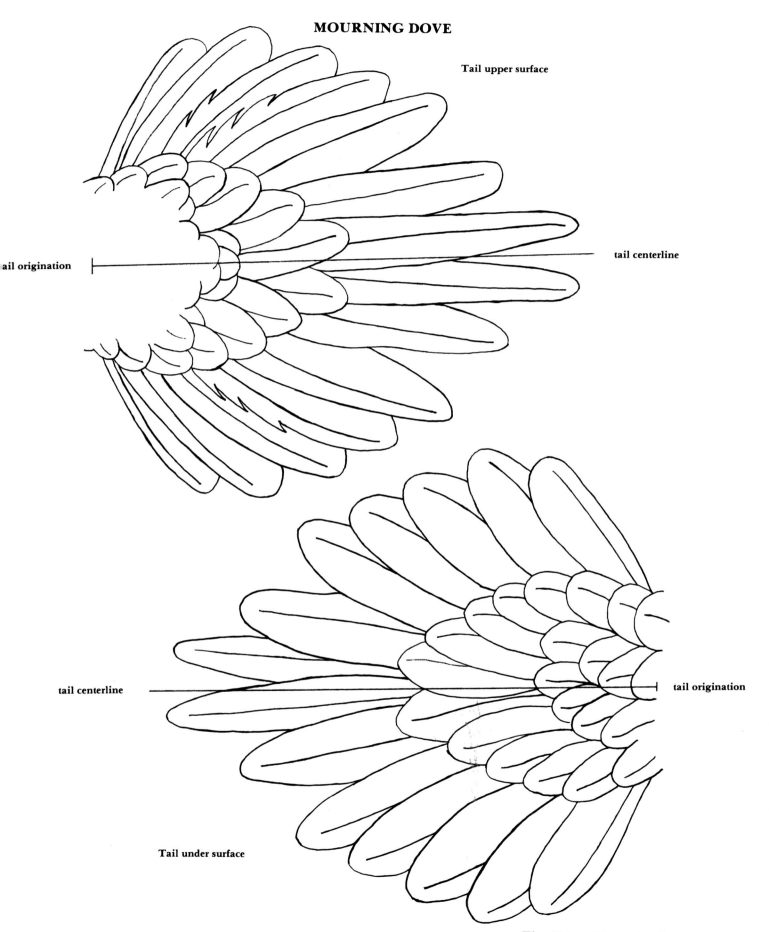

Tail upper surface

tail origination

tail centerline

tail centerline

tail origination

Tail under surface

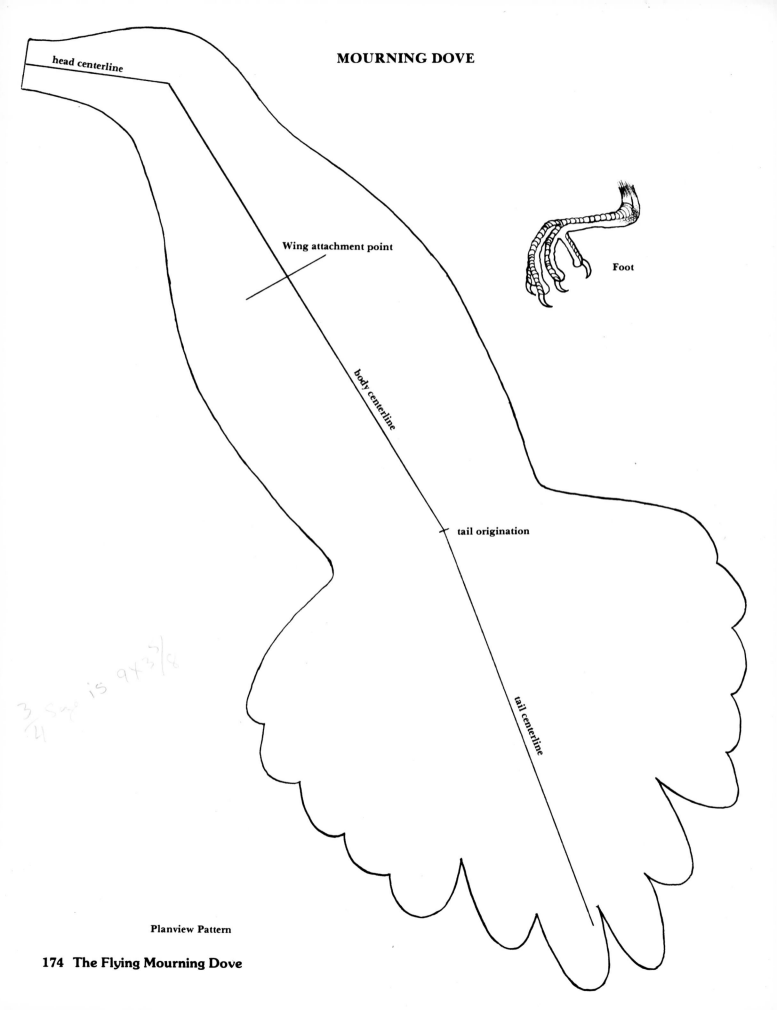

MOURNING DOVE

head centerline

Wing attachment point

body centerline

tail origination

Foot

tail centerline

3 sp is 9 x 3/8
21

Planview Pattern

174 The Flying Mourning Dove

TOOLS AND MATERIALS

Bandsaw (or coping saw)
Flexible shaft machine
Carbide bits
Ruby carvers and/or diamond bits
Variety of mounted stones
Pointed clay tool or dissecting needle
Calipers measuring in tenths of an inch
Ruler measuring in tenths of an inch
Knife
Compass
Rheostat burning machine
Awl
400 Grit abrasive cloth
Padded drum sander
16 Gauge galvanized wire
Drill and drill bits
Laboratory bristle brush on a mandrel
Needle-nose pliers and wire cutters
Cartridge roll sander on a mandrel
Toothbrush
Safety glasses and dustmask
Super-glue and 5 minute epoxy

Oily clay (brand names Plasticene and Plastilena)
Duro ribbon epoxy putty (blue and yellow variety)
Krylon Crystal Clear 1301
Pair of 6 mm. brown eyes
Pair of cast feet to use as a model
Mourning dove study bill
Clear Acetate
Tupelo blocks:
 2 wing pieces 7" (W) x 1.5" (H) x 5" (L)
 1 head and body piece 5.5" (W) x 4" (H) x 12" (L)
Poplar block 2" x 20" x 18"
Hacksaw or small cut-off wheel on mandrel
Brass square and round tubing of various diameters
⅛" Brazing rod
40 Gauge sheet copper
For making feet:
 14 and 16 gauge copper wire
 silver solder, flux and butane torch
 3/32" brazing rod
 permanent ink marker
 hammer and small anvil
 several pairs of helping hands holding jigs

Figure 1. With every complex or complicated carving that I do, working out the anatomy, size, topography, and engineering problems in clay is absolutely necessary. The flying dove could have been done in regular oily, non-hardening modeling clay, but I prefer a product, *Super-Sculpey*, which is hardened by baking at low temperature in a regular oven.

An armature or support is needed for the clay or *Super-Sculpey*. Drill a 3/16" hole in a scrap piece of hard wood. Cut another small piece of scrap wood (basswood or tupelo) and carve it roughly egg-shaped. Drill a 3/16" hole into the second scrap which is now the body armature. Insert a piece of 3/16" rod into both holes (this reminds me of Tinker-Toys!).

Figure 2. A small saw is used to cut the tail slot in the body armature.

Figure 4. A sliding bevel is used to ensure a sufficient angle between the body and tail centerlines for the cocked tail. Setting the sliding bevel at this angle will allow you to maintain this same angle of the bird in clay and later in the wood blank. Super-glue is used to attach the tail in the slot.

Figure 3. The pattern of the dove's tail is copied on a piece of aluminum flashing. Aviation shears are used to cut out the tail. Note the tab that fits into the tail slot is added to the pattern and cut-out.

Figure 5. When building up the *Super-Sculpey* around the armature, details are not necessary. The actual size of the bird and correct anatomy are the most important considerations. I find that over building the material and carving away the excess works well. This is now the time to make any changes to the head and body. I cannot begin to recall the adding and the carving away that I did at this stage, but I know it was many times.

Figure 6. The wing patterns are also cut out of aluminum flashing with extension tabs to fit into the clay. The tabs are also essential for the wooden bird wings insertion. Both the aluminum wings and tail pieces should be bent to whatever curvature is desired.

Figure 8. The wings are placed into the *Super-Sculpey* and the scapulars are built up on top. The wings are then gently cut out of the body part. The two wings and the body (still attached to the working base with the steel rod) is baked for 15-20 minutes at 300 degrees.

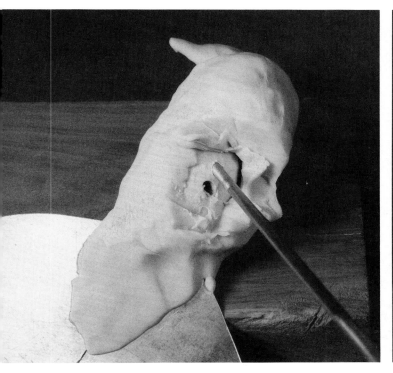

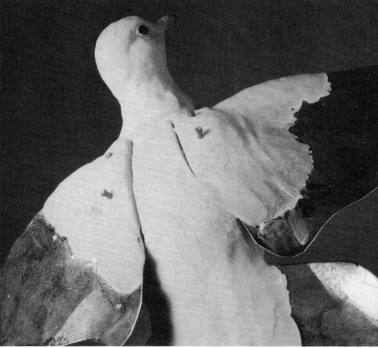

Figure 7. Desiring a more vertical composition, I redrilled the 3/16″ hole in the body block after cutting away the body clay.

Figure 9. When the body and wings have cooled, reattach the wings by drilling appropriate size holes through the wing and into the body for shortened finishing nails.

Figure 10. To make the wing blanks, place the model wings on a piece of tupelo at least 1.5″ thick and trace around them. Note that one wing is placed upside down. Allow a little (approximately ⅛″) extra along the trailing wing edges.

Figure 11. After cutting out the wing blanks, each wing is held up to its wing block so that the curvature can be drawn on its front edge. Allow extra thickness above and below for the actual wing thickness. Using a large tapered carbide cutter, remove the excess wood above and below the curvature lines, leaving a little extra. Leave the scapular area near the wing attachment points thick. Each top and bottom of the wings is marked. It is amazingly easy to get them confused during the roughing out process!

Figure 12. Using the method that duck carvers use to cut out a decoy, cut the profile pattern out of the body block, leaving a small amount of wood on the back and the belly uncut. After the planview has been bandsawed, bandsaw the small sections of wood on the back and belly of the profile view.

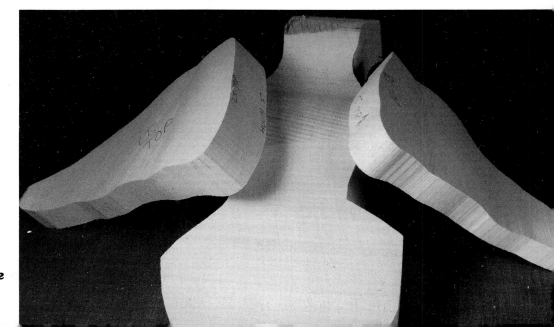

Figure 13. Here you see the body and the two wing blanks.

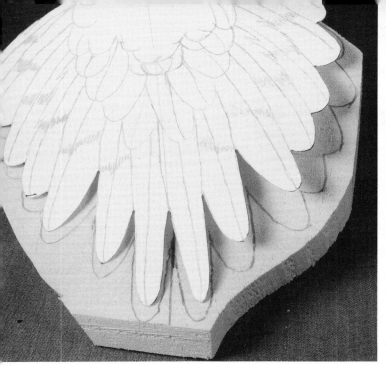

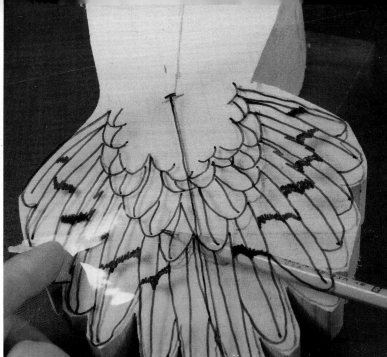

Figure 14. Trace around the tail pattern and draw in the tail centerline.

Figure 16. On a clear piece of acetate that can be found in most hobby or art stores, trace the entire tail, upper tail coverts, centerline and tail attachment point (the actual length of the dove's tail) with a permanent marker. Hold it above the blank and use a pencil underneath the acetate to draw in the upper tail coverts, individual tail feathers and the tail attachment point.

Figure 17. From the front of the wing attachment point mark 1 inch across the upper back, tapering to a .50 inches at the tail attachment point. The area marked will remain flat, while the body is roughly rounded. Draw in centerlines on both flanks midway between the upper back and the belly. Draw the centerlines on the underside of the body for the belly, breast and under tail.

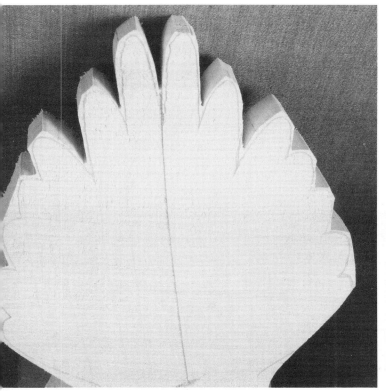

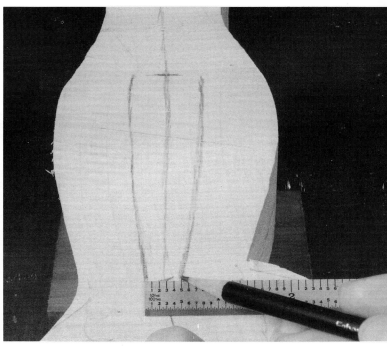

Figure 15. Using a bandsaw or coping saw, cut out around the widest separated tail feathers allowing a small amount of extra wood.

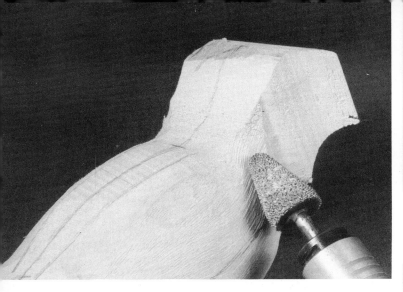

Figure 18. Using a large tapered carbide cutter, round the body from the .50-1" lines on the back to each flank line and from the belly centerline to each flank line.

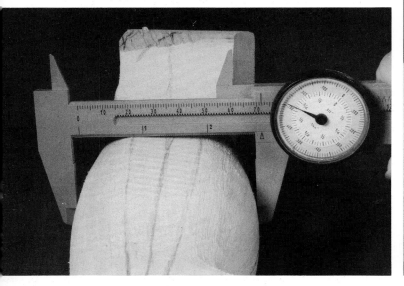

Figure 19. The body should not be any wider than 2.7 inches at this roughing out stage.

(2.02)

Figure 20. Draw in a mid-line on the edge of the tail all the way around. On the left side, the tail feathers will be curved down. Draw in the downward curve of the outer feathers.

180 The Flying Mourning Dove

Figure 21. On the right side, the tail feathers will be curved up. Draw in the upward curve of the outer feathers.

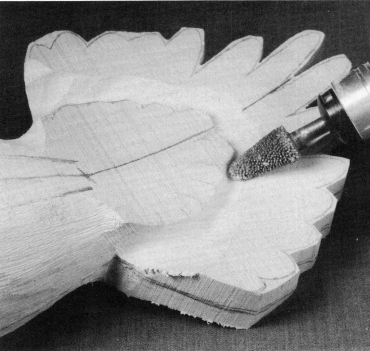

Figure 22. Using a medium tapered carbide cutter, channel around the upper tail coverts. The channel should be deeper near the sides of the body and slightly above the midline drawn around the tail. The channel should be shallower out near the tip of the upper tail coverts.

Figure 23. Round over the upper tail coverts.

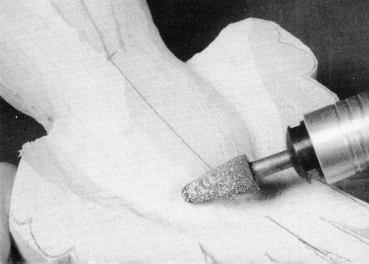

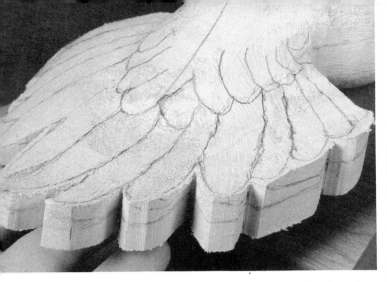

Figure 24. Flow the channel out towards the tips following the "S" curve established on the edge of the tips (down on the left side and up on the right side). Using the acetate or a compass to transfer dimensions from the drawings, redraw the upper tail coverts and the tail feathers.

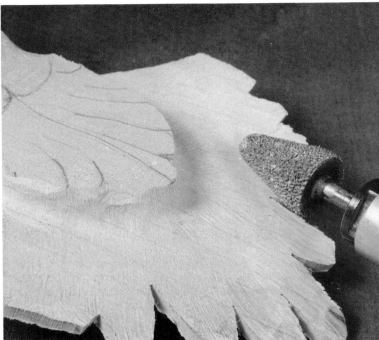

Figure 27. Flow the channel out towards the tips of the tail feathers. Leave the tips about .20 inches thick at this roughing out stage. The tail feathers nearer the coverts should measure approximately .30 inches thick.

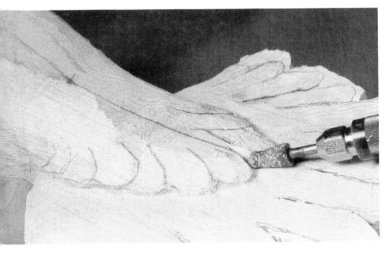

Figure 25. Using a small tapered carbide cutter, relieve the wood around each of the upper tail coverts. Angle the tail feathers so that they go straight towards the body, midway between the upper and lower tail coverts. Again, redraw any feather lines that were cut away.

Figure 26. Draw in the lower tail coverts 2.6 inches from the end of the longest tail feather. Channel about .20 inches deep around the edges of the coverts. A medium tapered carbide pulled along the drawn line allows safe control of the flexible shaft machine.

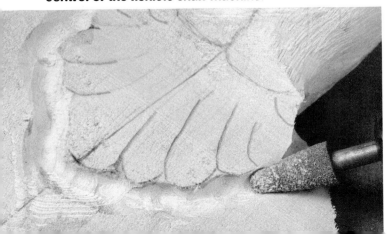

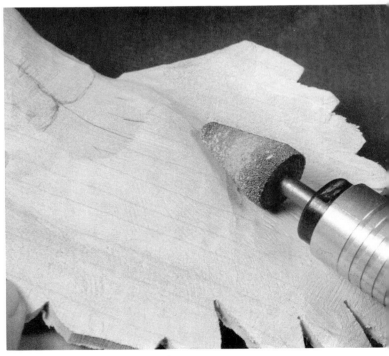

Figure 28. Round over the lower tail coverts and flow the edges down to base of the tail feathers.

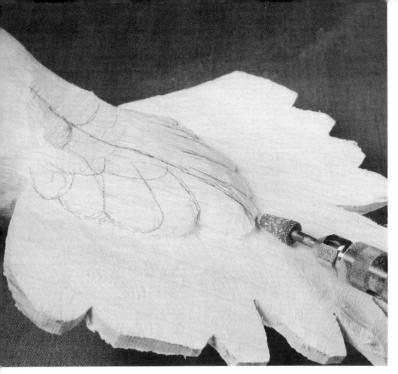

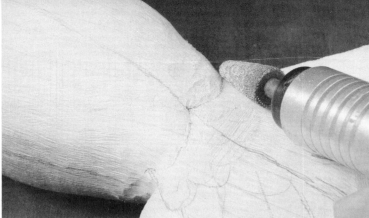

Figure 31. Channel around the vent. Flow the shallow channel out towards the tips of the lower tail coverts. Round over the other sharp edge of the channel, rolling the vent down.

Figure 29. Redraw the lower tail coverts. Using a small tapered carbide bit, cut more closely around the edges of the coverts, making sure that the tail goes straight in towards the body between the upper and lower tail coverts. Picture a letter coming out of a large clam shell: the top and bottom halves of the clam flow down to the envelope which comes straight out between the two shells. Now, the tail is much thicker at this point than an envelope, but it is the same idea.

Figure 32. Measure and mark the head width at the ear coverts 1.2 inches at this roughing out stage.

Figure 33. Grind away the excess, keeping the sides of the head straight up and down.

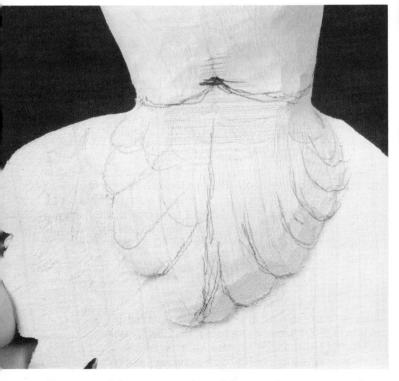

Figure 30. Measure, mark and draw in the vent 5.2 inches from the end of the longest tail feather.

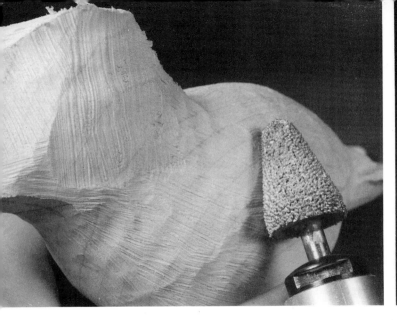

Figure 34. Remove the excess wood on both sides of the neck and shoulders and rounding over the upper breast area. Do not remove any wood from under the chin or the back of the neck at this time.

Figure 37. You will have to remove the wood beyond the centerline to get the planes to be level. Redraw the centerlines.

Figure 35. Determine optically the center of the head from the profile viewpoint and mark. At the midpoint, draw a line perpendicular to the centerline, dividing the head into quadrants.

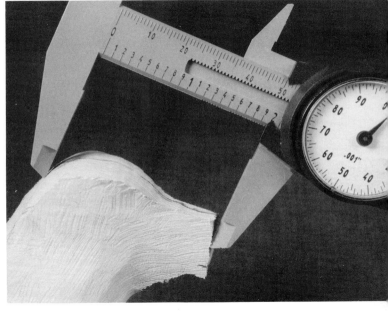

Figure 38. Check the measure from the end of the beak to the back of the head which should be approximately 2.0 inches. If it is too long, remove equal amounts of wood off the tip of the beak and the back of the head.

At this point, the body, head and tail of the dove is roughed out. Now, let's move on to roughing out the wings.

Figure 36. Turning the head of the bird in the wood distorts the angles on the top of the head, neck and beak. The front quadrant on the side to which the head is turned and the opposite back quadrant are the ones that are too high. Grind away the excess wood to level out the planes on head and hindneck. Do not round over at this roughing out stage.

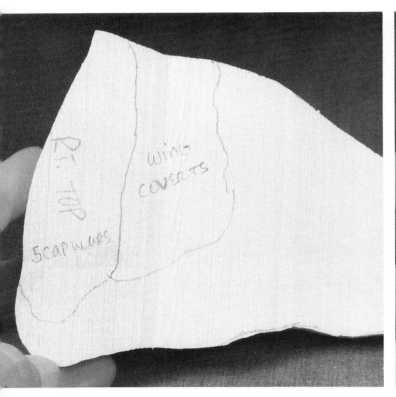

Figure 39. Roughly draw in the shape of the scapulars and wing covert areas on the tops of both wings. All of the steps that are pictured and done on one of the wings, should also be done on the other one.

Figure 41. Channel around the wing covert line and flow it out towards the tip and trailing edge of the wing. This is a shallower channel than the scapular one.

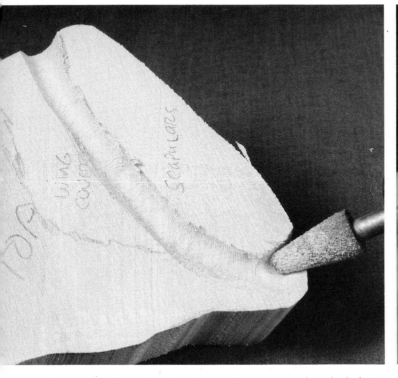

Figure 40. Using the tip of a medium tapered carbide bit, channel around the scapular line, flow the channel out over the covert area and round over the top sharp edge.

Figure 42. Round over the sharp edge of the wing covert area. Slightly round over the front edge of the scapulars and wing covert areas, rolling down the front wing edge.

Figure 43. Draw in a narrow triangular shaped area outside the wing covert area. Relieve a small amount of wood within the triangle, rolling the wing down toward the secondaries.

Figure 44. Rolling down the front and the back edges of the wings will leave a convex shape to the top surface of the wing.

Figure 45. Using a cartridge roll sander on a mandrel, sand the top surface of the wings. Removing the scratches and digs of the carbide cutters allows you to draw more easily on the wood's surface.

Figure 46. Draw a line .30 inches from the top edge of the scapulars.

Figure 47. Draw a line .15 inches from the top edge on the wing's leading edge, trailing edge, and tip.

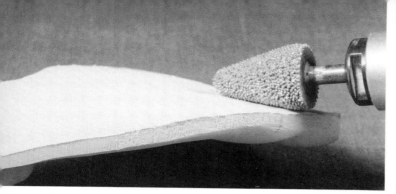

Figure 48. Using a large tapered carbide cutter, thin the wing to the .15 and .30 inches lines by removing wood on the underside.

Figure 51. Flow the channel out toward the wing edges and tip, thinning the edges to .10 inches. Round over the sharp edge of the channel.

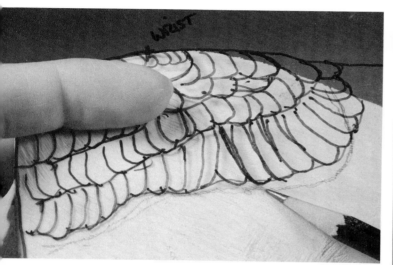

Figure 49. Trace the underside covert feathers on clear acetate with a permanent ink marker. Adjusting the acetate periodically because of the contoured surface, sneak a pencil underneath and draw the outer line of the covert area. Flip the acetate over to do the opposite wing.

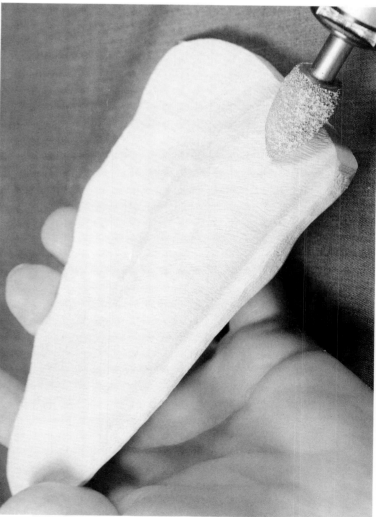

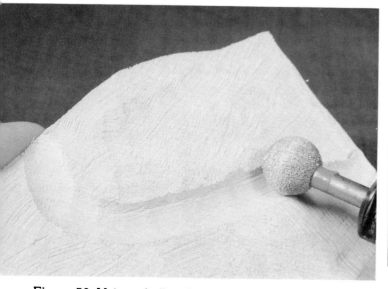

Figure 50. Using a ball carbide cutter, channel along the covert line.

Figure 52. On the top of the wing round over the leading edge. On the underside of the leading edge, relieve some wood to give the area a concave contour.

Figure 53. Sand the wing. A padded drum sander with 220 abrasive cloth does a nice job on tupelo especially. The wings will begin to get very slippery. Squeezing a sanded contoured piece of tupelo can easily shoot it out of your hands and onto the floor or even across the room!

Figure 55. The distance between the two wing insertion points is .70 inches. Trace around the medial corners of the wings.

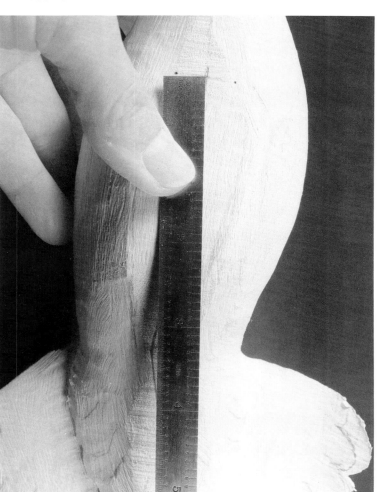

Figure 54. Measure and mark the wing insertion points 8.3 inches from the end of the tail.

Figure 56. To sink the wings into the body, begin cutting inside of the lines traced around the medial edges. Using carbon paper between the wing and the body will mark the high spots to be cut away. A sharp knife can be used to get into the tight corners. Take your time with this cutting and fitting process, removing small amounts of wood at a time.

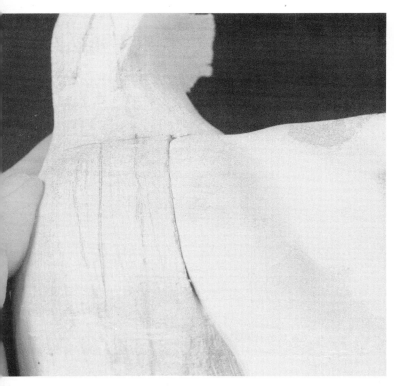

Figure 57. Keep cutting and fitting until the wing sinks into the body with the top surface flush with the middle of the back. Make sure that the angle of wing is consistent. Do not have the wings flat with the back. Angle them up or down slightly for a more flowing composition.

Figure 59. Drill two 1/16″ diameter holes .30 inches deep into the fat part of the scapulars, making sure that the drill goes straight in and not through the top or underside of the wing's surface. Fit two short pieces of 16 gauge galvanized wire into the holes.

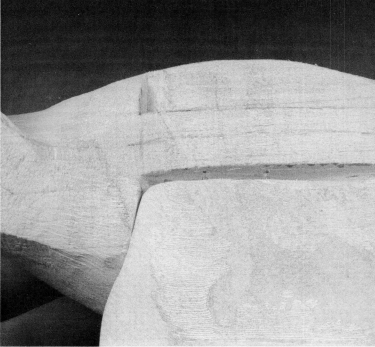

Figure 58. Here you can see the underside fit. Any gaps can later be filled with the ribbon putty when the wings are finally attached.

Figure 60. Put the wings in place and press the wire ends into the shelf on the back. This marks the holes to be drilled into the shelf. Drill the holes in the shelf approximately .30 inches deep.

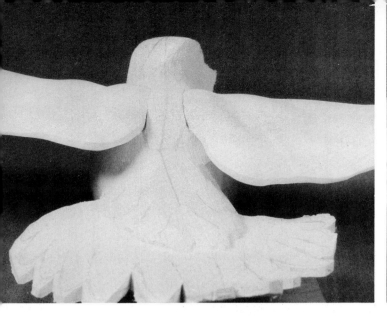

Figure 61. Cut longer wires and fit both wings. Glue the wires into the wing with super-glue. To keep the holes into the body from enlarging, you can put a small amount of super-glue into these to harden the surrounding wood. Do not glue the wings into the body yet!

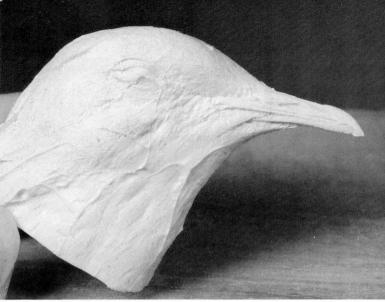

Figure 64. A study bill for a mourning dove is very helpful. Keep in mind that, when the mold for this is made, the feathers are pushed tight against the skull. A live bird's fluffy feathers will enlarge the dimensions of the head. The details on the bill itself are not altered by the mold making procedure.

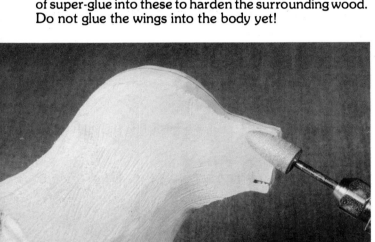

Figure 62. Smoothing the scratches from the carbide cutter with a fine cutting ruby carver allows you draw on the surface more easily.

Figure 63. Thin the sides of the beak to .20 inches with equal amounts on each side of the centerline.

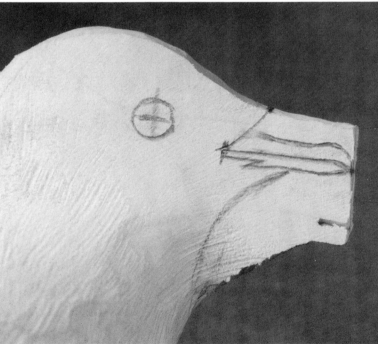

Figure 65. Transfer the beak and eye dimensions from the profile line drawing. If you use tracing paper or acetate to transfer the beak and eye, always confirm the detail with measurements from the Dimension Chart.

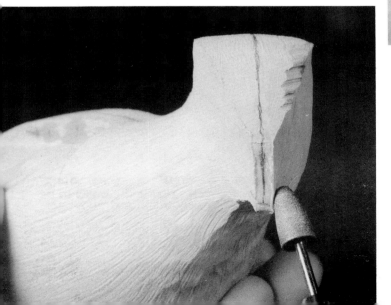

Figure 66. Another way of transferring dimensions is to use a compass. The top of the beak length is .50 inches. Stretch the compass to .50 inches against a ruler.

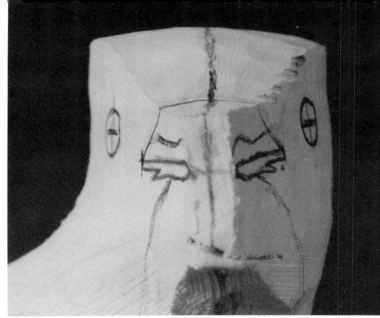

Figure 68. Keep the beak and eye placements balanced on both sides. Sighting from the head-on view is essential.

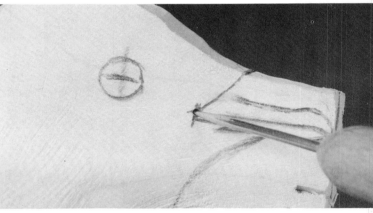

Figure 69. Pinprick the eye centers and the top and center beak lengths with a dissecting needle or clay tool. Pinpricking dimensions allows you to cut away wood and still maintain the length mark. You may have to pinprick deeply if there is much wood to be removed.

Figure 70. Using two of these thingamajigs allows you to check the balance of both the beak and eyes.

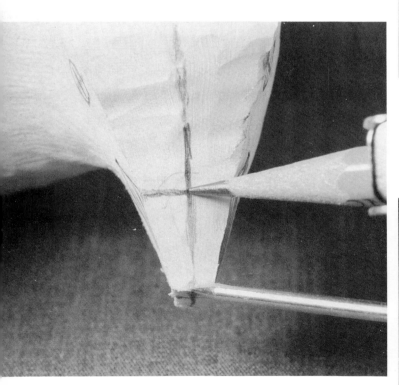

Figure 67. Without disturbing the compass, hold it against the carving and mark the dimension with the pencil end.

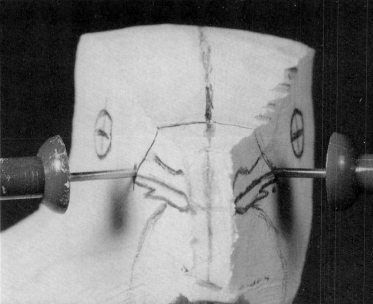

Figure 71. Check the top plan view.

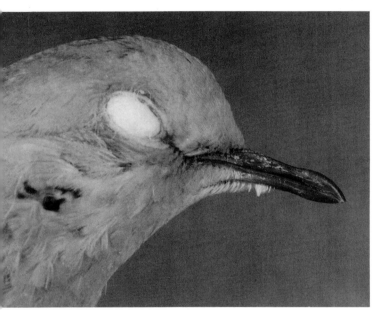

Figure 72. Note the little triangular patch of feathers on the side of the lower mandible.

Figure 73. The top view of the beak.

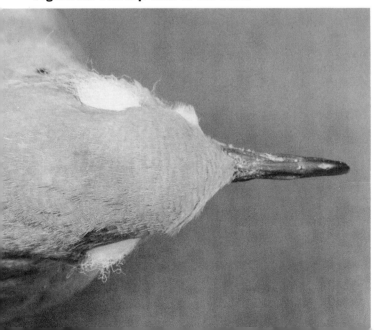

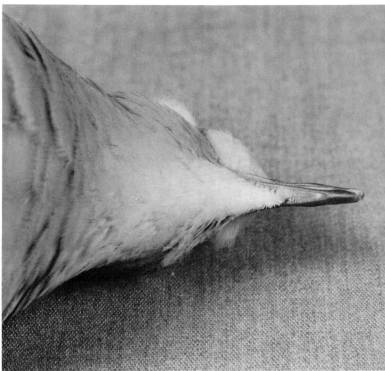

Figure 74. The underside view of the beak.

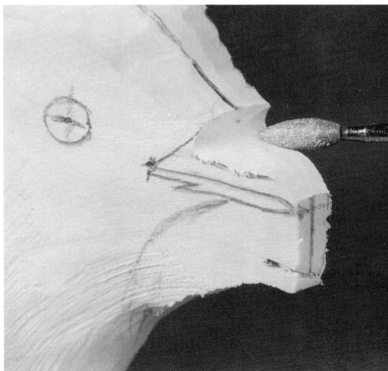

Figure 75. Using a medium pointed ruby carver, grind away the excess wood above the upper mandible. Keep the top of the upper mandible flat. Redraw the centerline.

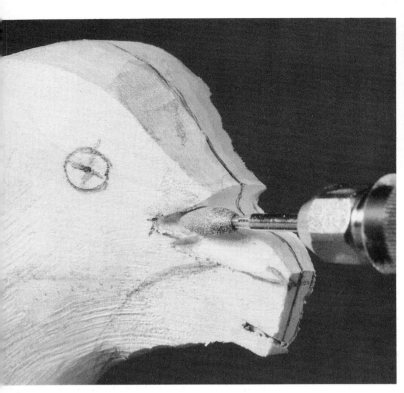

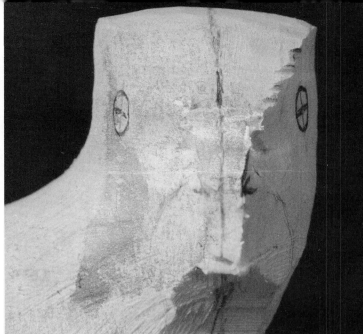

Figure 76. Begin cutting away the excess on the sides of the beak with the point of the ruby carver. Keep equal amounts on each side of the centerline. Checking the balance from the head-on view will enable you to see that there are equal amounts of wood on each side. Keep the sides of the beak flat and parallel.

Figure 78. You may need to remove some of the wood just behind the beak if the high shelves prevent the tip of the ruby carver from getting back in the corners.

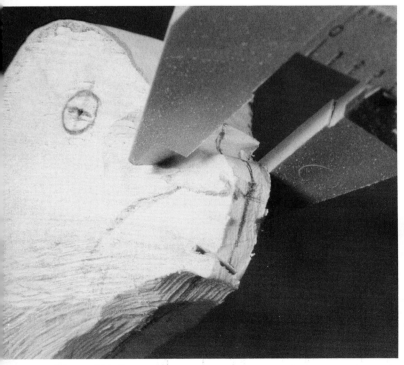

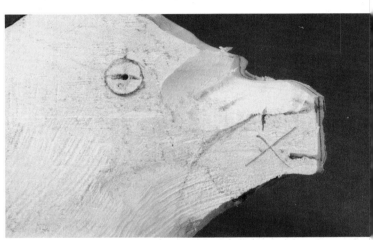

Figure 79. Remove some of the excess wood from the underside of the beak.

Figure 80. Measure and mark .35 inches from the beak tip on the underside. Draw in a small arc encompassing the mark for the little tuft of feathers on the chin.

Figure 77. Continue removing wood from the sides of the beak until it measures .30 inches way back in the corners at its base.

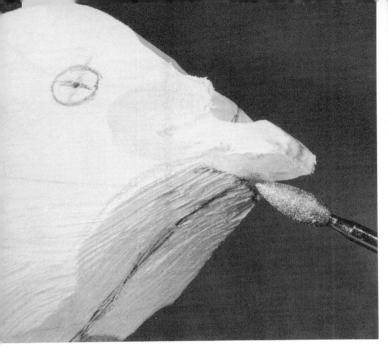

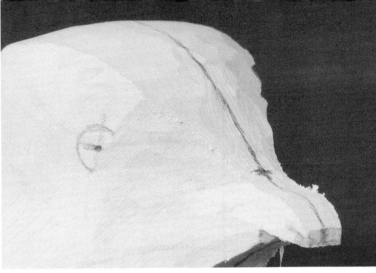

Figure 83. Flow the forehead down to the topside base of the beak, keeping a flat plane.

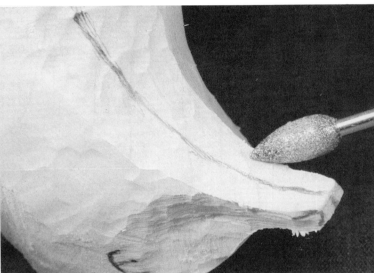

Figure 81. Remove the remaining excess wood from the underside of the beak back to the .35 inches mark, keeping a flat plane and working the arc shape back towards the base of the beak.

At this point, the base of the beak is the proper size on all four sides. Let's get the head itself down to the proper size and shape before finishing the details on the beak. Since the beak is a fragile projection, finishing the details last may prevent a catastrophe if the beak should get bumped or heaven forbid, the bird get dropped! E-E-E-E, that's a loud scream in book talk!

Figure 84. Flow the chin down to the underside base of the beak, again keeping the plane flat.

Figure 85. Measure and mark .80 inches across the crown above the eyes.

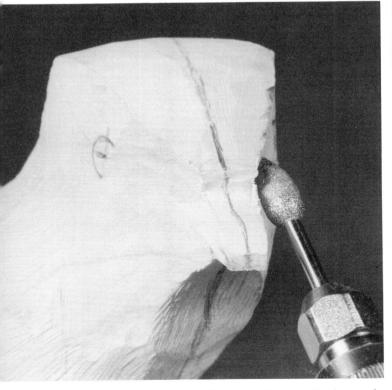

Figure 82. Flow the sides of the head down to the base of the beak, maintaining the wedge shape of the head.

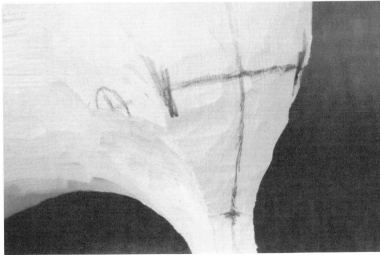

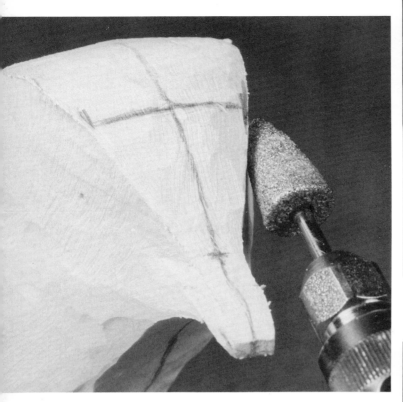

Figure 86. After making sure the eyes are pinpricked deeply, remove the excess from the sides of the head from the eye area to the crown.

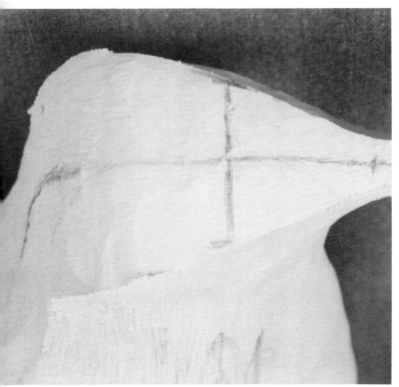

Figure 87. Note the wedge shape of the head from the top plan view.

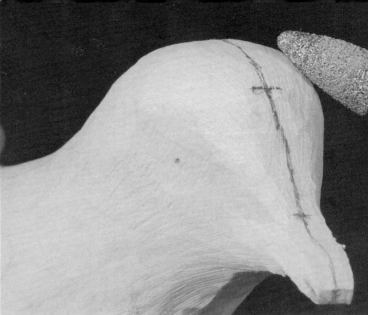

Figure 88. Now it's time to round the head from the forehead on down the back of the neck. Round the chin and throat areas.

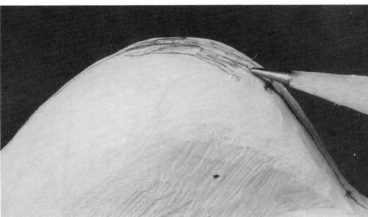

Figure 89. Remove some of the wood on the back of the top of the head to give the bird a characteristic dove appearance.

Figure 90. On the profile view of the carving, note that the highest point of the head is above the eyes, sloping down and back. As the head is carved to the proper size and shape, the whole bird begins to come into perspective. While handling the bird, notice shapes and sizes of other parts of the bird. Putting the bird aside for awhile will give you a fresh perspective when you return. If you find areas that need changing, use your pencil to scribble on the part that needs reducing or changing in some way.

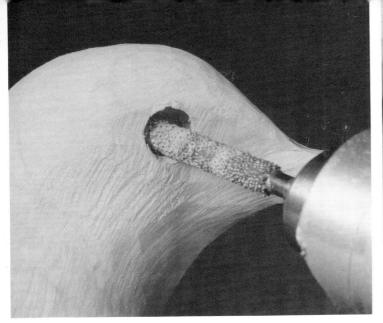

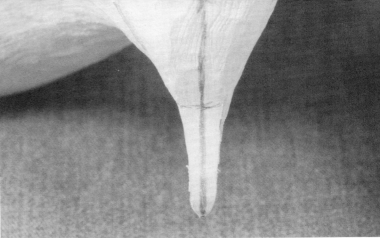

Figure 91. Recheck the eye positions, distance and balance. Drill 6 mm eye holes deeply but not all the way through the head. 4.5 mm

Figure 94. Round the tip to a soft point.

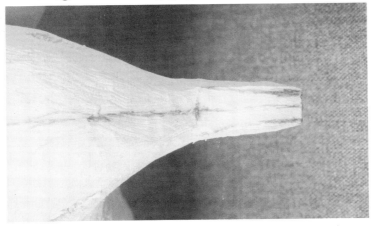

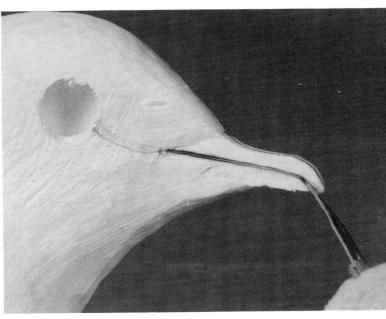

Figure 92. For the details on the beak, draw in the plan view shape with the tip .12 inches wide.

Figure 93. Remove the excess from the sides of the beak until the tip measures .12 inches. Be sure to keep equal amounts across the centerline and keep the sides flat and parallel.

Figure 95. Recheck all of the beak measurements and adjust if necessary. Burn in the commissure lines with the pen held perpendicular to the side of the beak.

Figure 96. Using a stone, round over all of the sharp corners on the upper and lower mandibles. You may need to further round over the forehead as well.

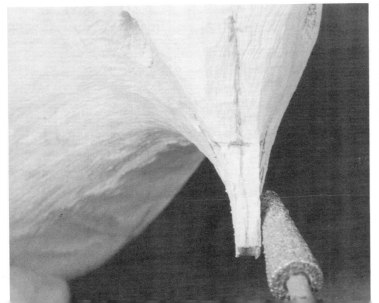

Figure 97. Draw in the teardrop shaped nostril coverings on each side of the upper mandible.

Figure 98. Using the tip of a small pointed stone, carve around the nostril coverings and round them over.

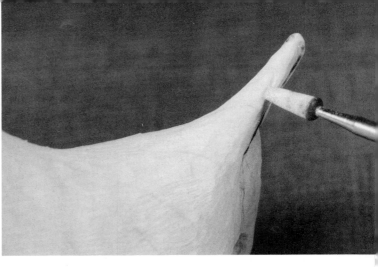

Figure 99. Using a small cylindrical stone, clean up the base of the beak around the little tufts of feathers on the chin and on the sides of the lower mandible. Also remove a small amount of wood from the tip of the lower mandible, so that there is an overhang of the upper mandible.

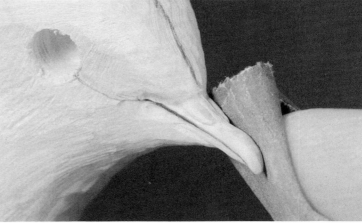

Figure 100. Fine sand the beak with 400 grit abrasive cloth.

Figure 101. Using a small pointed burning pen, lightly burn a small slit just under the front of the nostril covers on both sides. You will only need a little heat since the tupelo is so soft.

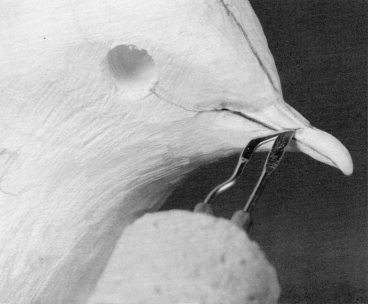

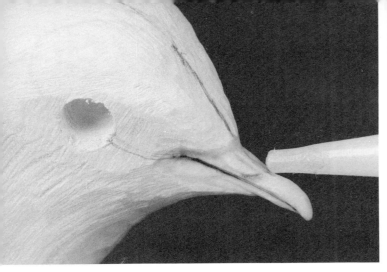

Figure 102. Saturate the beak with super-glue. Allow the glue to dry and then fine sand again.

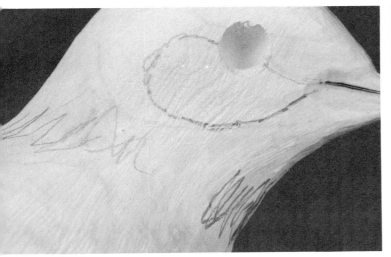

Figure 103. Draw in the ear coverts, keeping them balanced in depth and length on both sides. The ear coverts come out of the middle of the back of the eye, swing down and around and go up to the commissure line. Note my scribbles on the hindneck and throat which indicate the necessity of more wood removal.

Figure 104. Using a medium teardrop ruby carver, channel around the ear coverts. Pulling the running tool along the line allows more control than pushing it forward. Do not use the tip of the ruby (except near the beak). Use the fattest diameter of the bit.

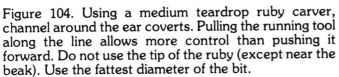
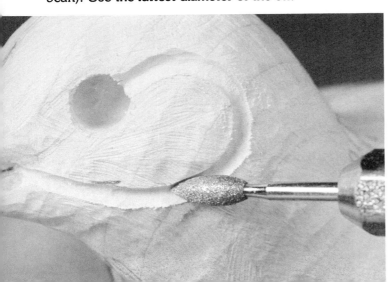

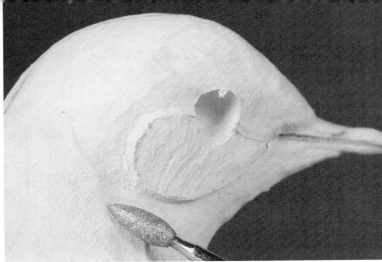

Figure 105. Flow the channel out from around the ear covert onto the surrounding areas of the neck.

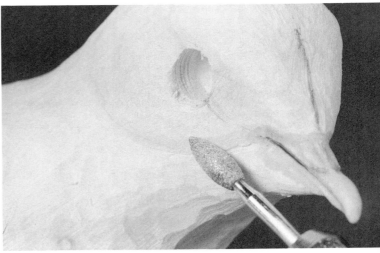

Figure 106. Round over the sharp edge on the ear coverts.

Figure 107. Narrow the neck to 1.2 inches from hindneck to throat.

The Flying Mourning Dove 197

Figure 108. The width of the neck from side to side should be approximately 1.0 inch.

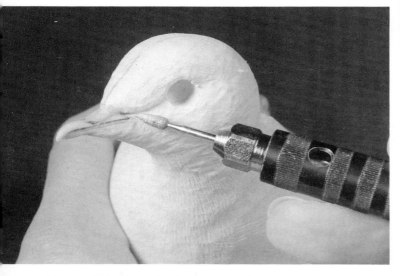

Figure 109. Draw in the large puffs of feathers between the beak and eyes. Channel along the drooping arcs, flow out underneath and round over the top sharp edge. You may have to remove a small amount of wood from underneath the eye so that it has a concave area in which to sit.

Figure 110. Reinsert the wings and provide a good flow from the hindneck onto the upper back and scapulars.

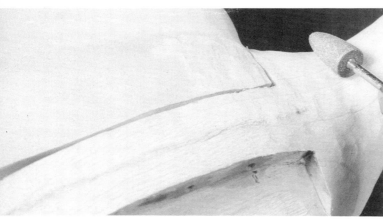

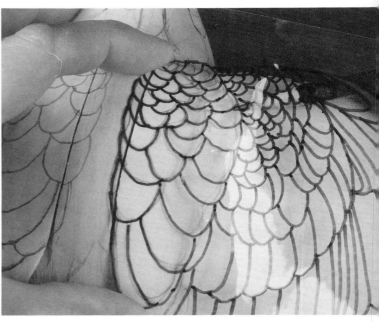

Figure 111. From the tip of the wing, measure and mark the wrist 5.6 inches on both wings. Trace the wing and scapular feather patterns on acetate with a permanent marker. With the wings attached to the body, sneak a pencil under the acetate and draw in the scapular feathers, keeping the wrist marks on the tracing and the wings aligned. Tracing paper could be used for this procedure. After tracing the wing and scapular layout patterns onto the tracing paper, turn the tracing paper over and go over the lines with a soft pencil. Hold or tape the tracing paper in place on the wing and over the scapulars so that the wrist marks align. With a soft pencil, go over the scapular feather shapes with a soft pencil. Do not press so hard that you dent the tupelo in case adjustments have to be made.

Figure 112. With either way of transferring the feather patterns, adjustment of the acetate or tracing paper will need to be made because of the curvature of the wing and scapulars. Complete the scapulars on both sides with the wings attached.

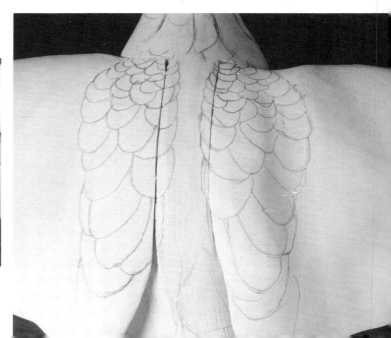

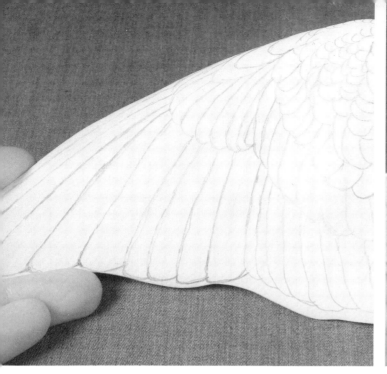

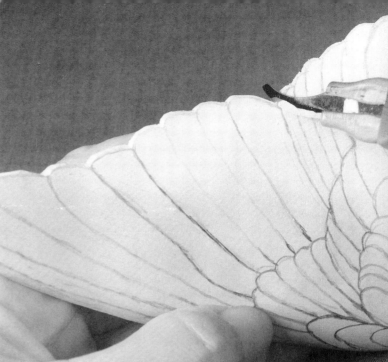

Figure 113. The wings can be detached from the body to transfer the remainder of the wing feather groups.

Figure 114. Here you see the shapes of the wing feathers.

Figure 115. Using a sharp knife, cut away the excess from the tips of the primaries and secondaries.

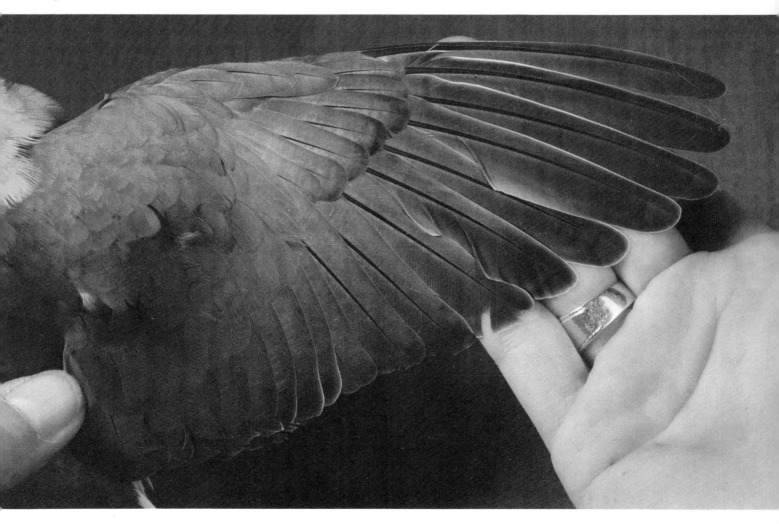

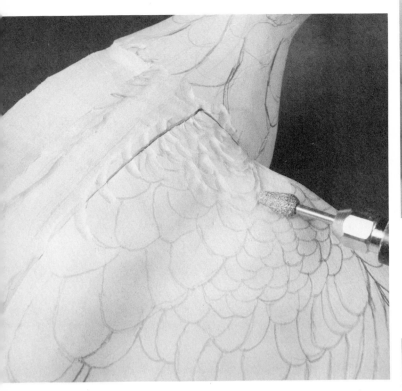

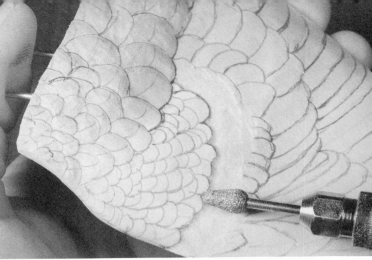

Figure 116. Starting in the front of the scapulars, relieve lightly around each of the scapular feathers, using a rounded end ruby carver. Laying the bit on its side will flow out the channels as each one is carved.

Figure 118. Using a bullet shaped stone, round over each of the scapulars and tertials. The wing can be removed from the body as soon as you have completed those feathers along the joint line. Draw in the scapular and tertial quills. Scapular feathers are attached to the body in the shoulder area. When drawing in these quills, make sure that the quills flow from the shoulder area.

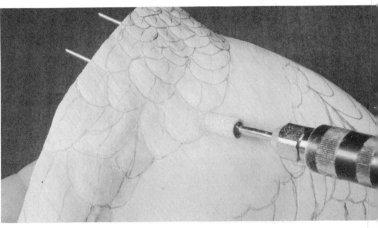

Figure 119. Cut around the marginal coverts, laying the bit down on its side.

Figure 120. A ball shaped stone can be used to round over the marginal covert edge and to create rolling contours within the group. Redraw any feathers ground away.

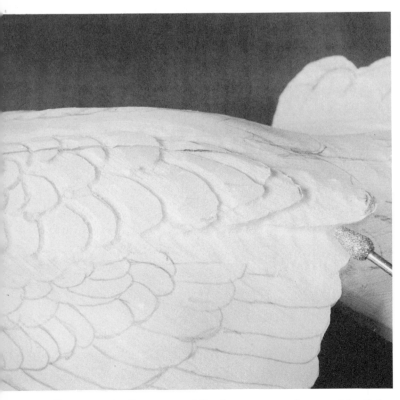

Figure 117. Cut around the larger scapulars and tertials more deeply. Redraw any feather lines cut away.

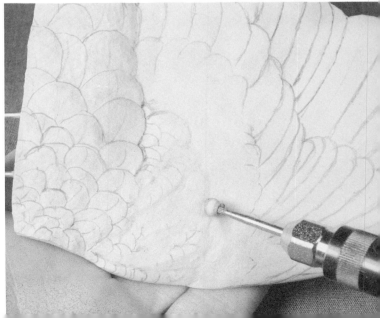

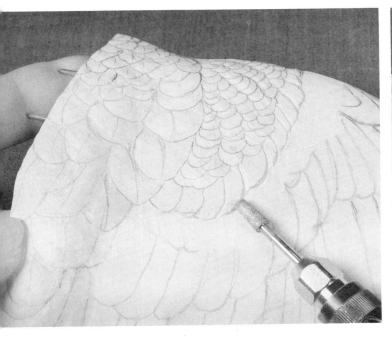

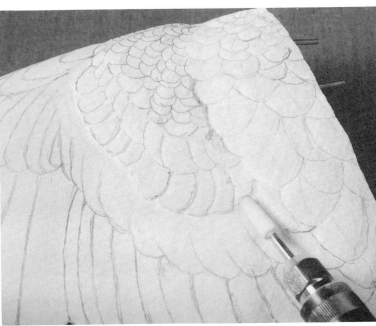

Figure 121. Relieve around the lesser secondary coverts working from the inner feathers out towards the ones near the leading edge. In this case, I am using a cylindrical diamond bit laid on its side. There are many different bits that will do these numbers. Try several shapes, sizes and kinds of ruby carvers or diamond bits to see which you find the best.

Figure 123. Relieve around each of the middle secondary coverts. Yes, even a cylindrical stone can cut around feathers. Using a stone leaves a smooth surface. Because of the reverse overlap of this group, work from the feathers out near the leading edge back in towards the body. Using a bullet shaped stone to round over each feathers sharp edge.

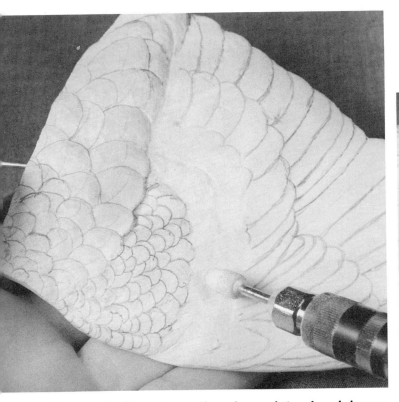

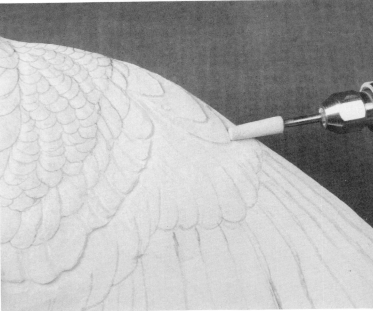

Figure 122. Round over the edge and tip of each lesser secondary covert, smoothing out its surface with a stone.

Figure 124. Relieve around each of the three alula feathers, working from the smallest to the largest one.

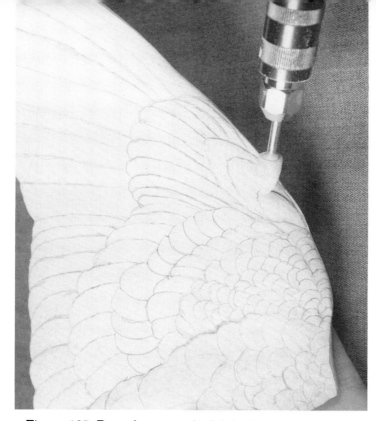

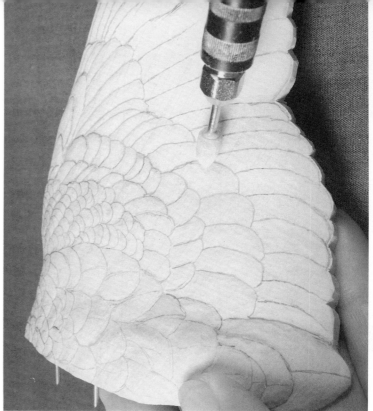

Figure 125. Round over each alula's sharp edge.

Figure 126. Relieve around each of the greater secondary coverts and then the primary coverts, working from the inside to the outside edge.

Figure 127. Round over the sharp edges and generally smooth each feather.

Figure 128. Cut around each of the secondaries and then the primaries, working from the inside to the outside edge.

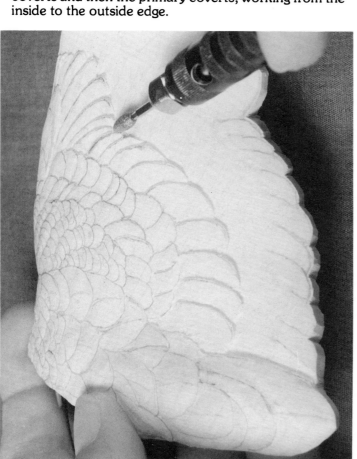

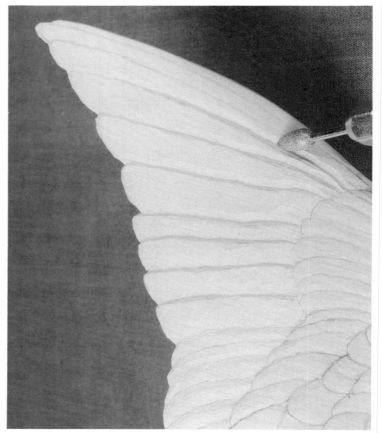

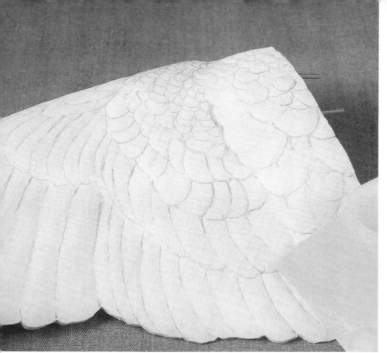

Figure 129. Round over the sharp edges and generally smooth each of the secondaries and primaries. Lightly sand and smooth the entire top surface of the wing. Do not sand away the detail you worked so diligently to put in. Concentrate on smoothing the centers of the feathers in particular where the quills will be located.

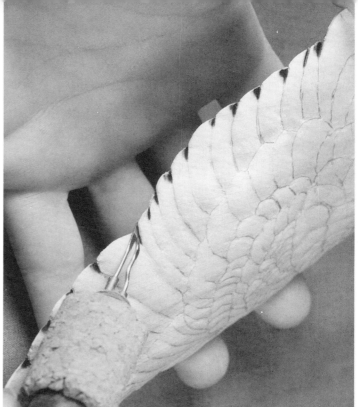

Figure 131. Using a burning pen, burn in the separations between the tertials, secondaries and primaries. This will enable you to match the edges from the underside.

Figure 132. Here you see the dove's underwing coverts.

Figure 130. Carefully thin the wing from the underside using a padded drum sander. The thickest part of the wing should be in the covert areas (top and underside) which should measure approximately .35 inches. The underside of the wing should have a concave surface that corresponds to the convex upper surface. As you are sanding away wood, keep feeling the thickness of the wing so that you do not get too thin in any part. You will need sufficient thickness to cut around the underwing groups. Holding the wing up to a light bulb will allow you to see the light through the thinnest parts. Thin the tips of the tertials, secondaries and primaries to a knife-edge.

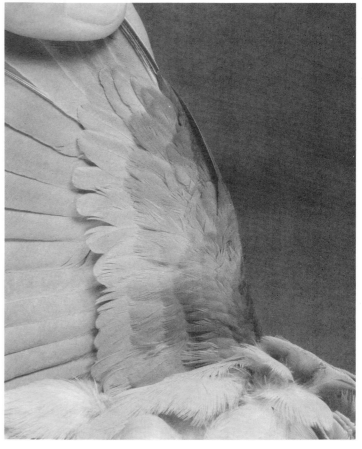

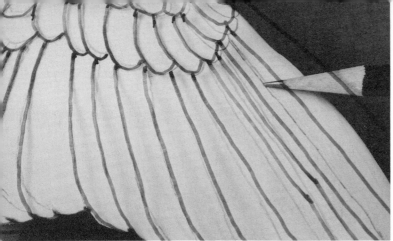

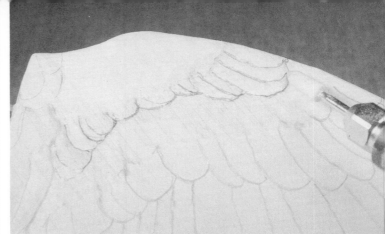

Figure 133. Trace the underside feathers on acetate and transfer to the undersurfaces of both wings. You may have to adjust the tips of the tertials, secondaries and primaries with the marks burned around the edge.

Figure 136. Lightly relieve around each of the lesser underwing secondary and primary coverts, working from the outside toward the inside edge. Flow out the light channel and round over each edge.

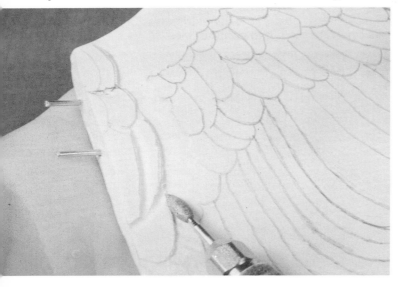

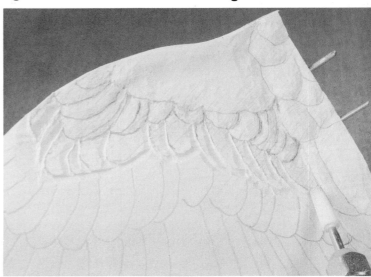

Figure 134. Relieve around the axillaries. Even though most all of these will be hidden, enough of the outer edges may be exposed and will need to be finished. Round over and smooth each feather into a rounded, fluffy contour. As with the top surface, redraw any feather lines that are cut away.

Figure 135. Work carefully on the underside and keep doing the light bulb number periodically checking for thin spots. Placing the wing you are working on in the opposite hand will privide support for the now fragile wing.

 Lightly relieve around the marginal underwing coverts. Flow the channel out and round over the group's sharp edge.

Figure 137. Lightly relieve around each of the middle underwing secondary and primary coverts. Because of the reverse overlay of this group, work from the inside to the outside edge. Flow out the light channel and round over each edge. Check for thinness.

Figure 138. Lightly relieve around each of the greater underwing secondary and primary coverts, working from the outside toward the inside edge. Flow the channel out and round over each edge.

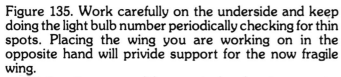

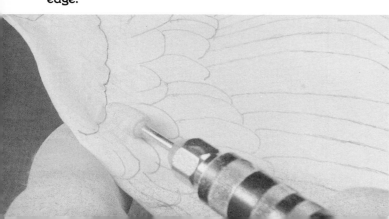

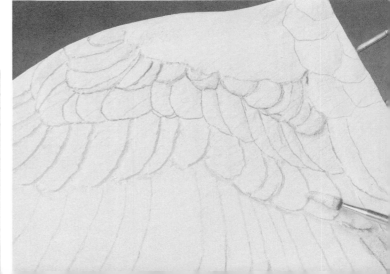

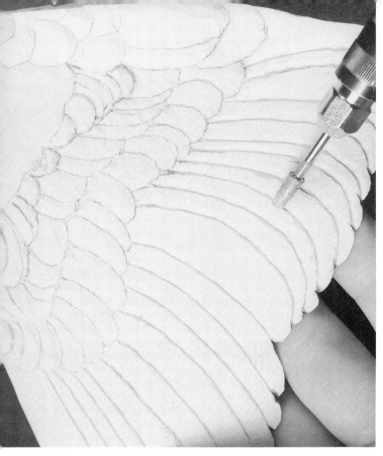

Figure 141. Draw in the random feather group contour lines on the body. Mark the exit points for the feet and incorporate them into contour lines.

Figure 139. Relieve around each of the primaries and secondaries working from the outside to the inside edge.

Figure 140. Round over each primary and secondary edge. Lightly hand sand especially on the quill placement areas.

Figure 142. Draw in the feather group contour lines on the head, neck and back.

Figure 143. Begin channeling the contour lines on the head, rounding each group as you work towards the body.

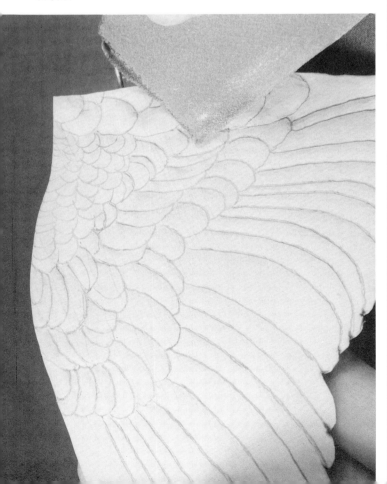

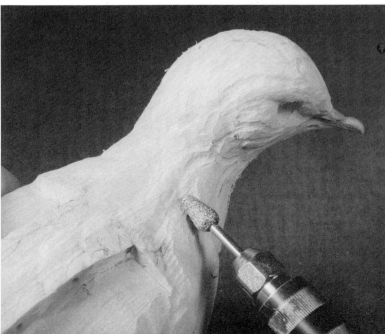

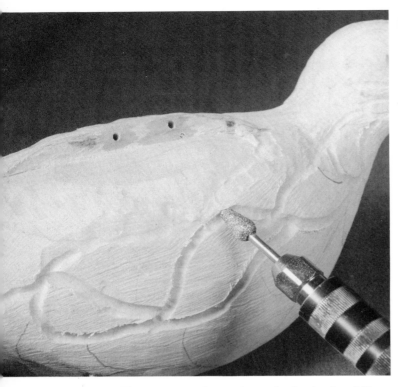

Figure 144. The contour channels on the body should be deeper, enabling the fluffs of feathers to have higher contours.

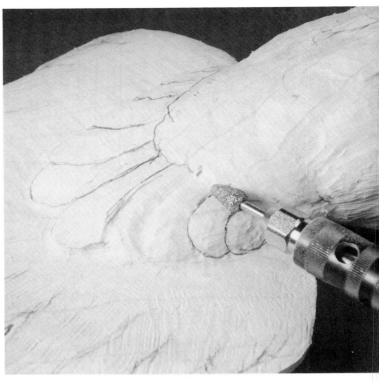

Figure 146. Channel around each of the upper tail coverts beginning with the outer ones and working towards the center. Flow each channel out and round over each feather. The contouring of individual feathers enhances the fluffy appearance.

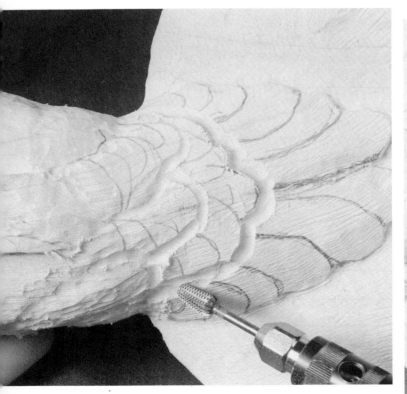

Figure 145. Channel around some of the groups of feathers above the upper tail coverts. Round each group over.

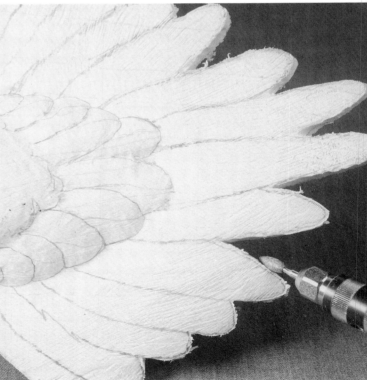

Figure 147. Draw in each tail feather. Cut away any excess wood from around the tips or sides.

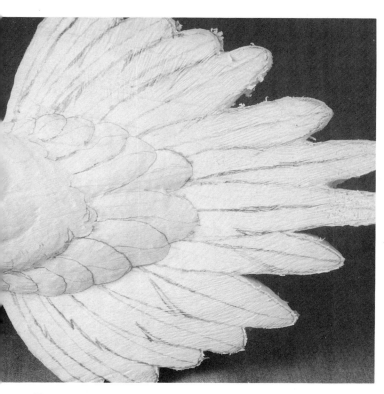

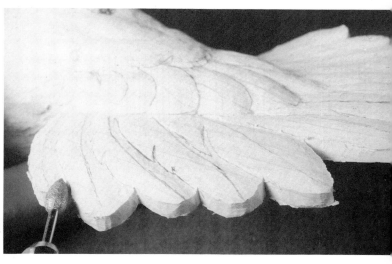

Figure 150. Note the convex contour of each feather.

Figure 148. Draw in the quills and larger splits on the upper tail coverts and tail feathers. To ensure that the quills have the proper direction, draw in the tail attachment point 5.0 inches from the end of the longest center tail feather. All of the quills should radiate from this point. There is a gentle arc to each quill. Note that the longer center feathers have the quill in the center of each feather. The quill progressively moves toward the leading (outer) edge of each feather the closer the feather is to the shortest outside one.

Figure 149. Beginning in the center of the tail, channel around each of the feathers and cut in the larger quills. Round over each edge. Work progressively towards the outer, shorter tail feathers.

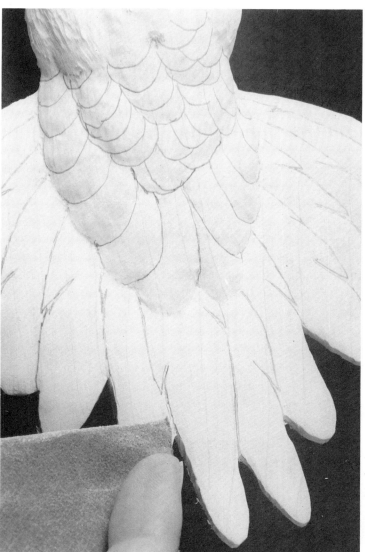

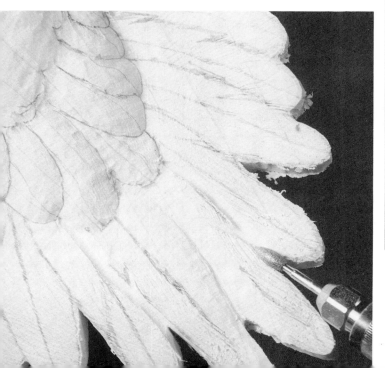

Figure 151. Lightly sand concentrating on the quill placement areas.

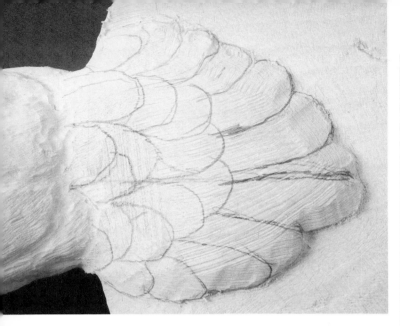

Figure 152. Draw in the lower tail coverts. Thin the underside of the tail.

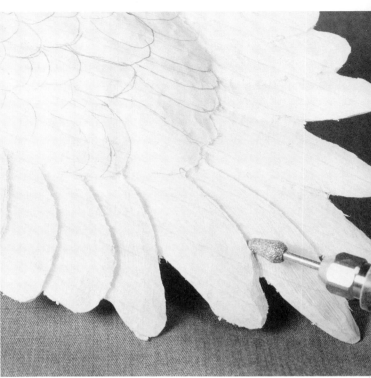

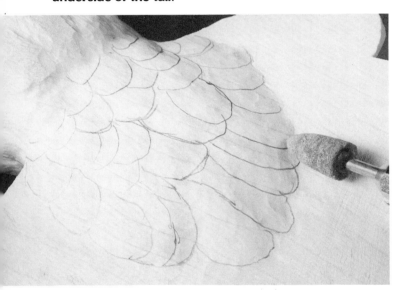

Figure 153. Channel around the larger coverts, flow out and round over the edge, giving each one its own fluffy contour. Flow the tips of the lower tail coverts down to the base of the tail.

Figure 154. Thin the tips and exposed edges of the tail feathers on the underside.

Figure 155. Draw in the edges of the tail feathers on the underside. Relieve around each edge beginning with the shorter, outer feathers and working towards the center ones.

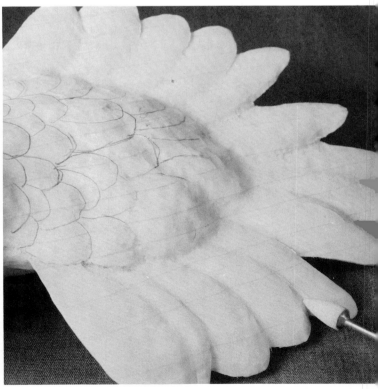

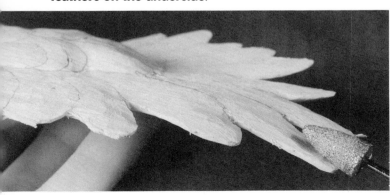

Figure 156. Round over each edge and lightly sand. A long, pointed stone is useful in getting between the tight edges of the overlapping feathers.

Figure 157. Sand the head, neck, body, and upper and lower tail coverts with a cartridge roll sander.

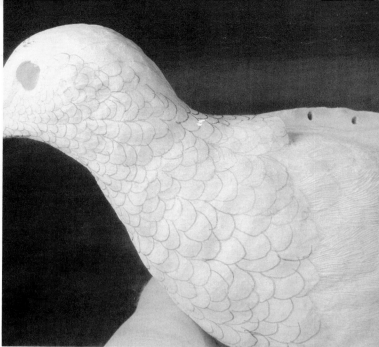

Figure 160. Draw in the feathers on the breast, neck, throat and chin. Continue stoning progressively working your way toward the head.

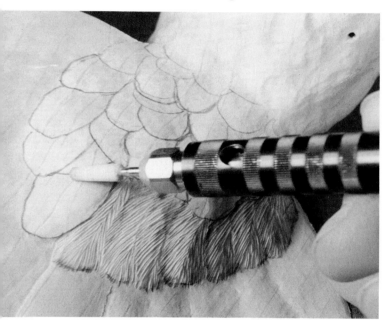

Figure 158. Draw in the feathers on the lower tail coverts. Begin stoning at the tip of the coverts and progress toward the vent.

Figure 159. Draw in the feathers on the belly and flanks. Continue stoning up the body.

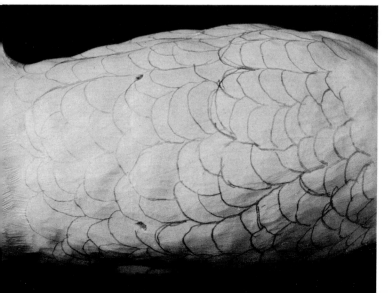

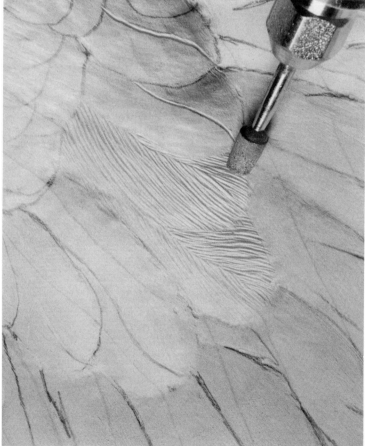

Figure 161. When the stoning on the underside of the bird is complete, begin stoning the upper tail coverts by first stoning in a single line quill. Then stone in the barbs on each side of quill, curving each stroke.

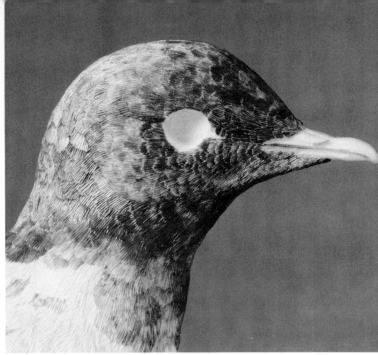

Figure 162. Continue stoning the feathers up the upper tail coverts and onto the middle of the back. It is helpful to have the wings in place to determine the flow of the scapular edges.

Figure 165. Here you see the feathers on the head completely burned.

Figure 163. Draw in the feathers on the neck and head. The small triangle in the front corner of each eye will remain untextured.

Figure 166. To keep carbon from building up on the pen doing fine burning, you can buff the burning pen tip. With a hard felt bob on a screw mandrel, hold a bar of white buffing rouge lightly while spinning the bob. The felt will load up with the rouge.

Figure 167. Hold the bevel of the burning pen tip so that the felt bob turns away from the sharp edge. Run the tool at a moderate speed while pressing the bevel to the felt. Buff both bevels. Buffing the scratches off the tip will help to keep the carbon from grabbing onto the metal.

Figure 164. Because of the small size of the head feathers, I chose to burn in the barbs. I blended the burn strokes into the stoned strokes to create a smooth transition.

210 The Flying Mourning Dove

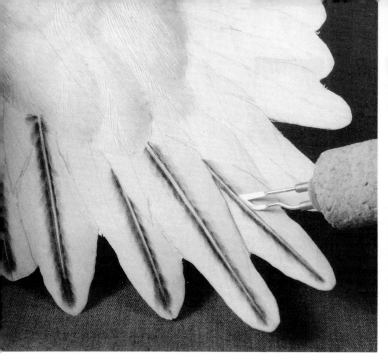

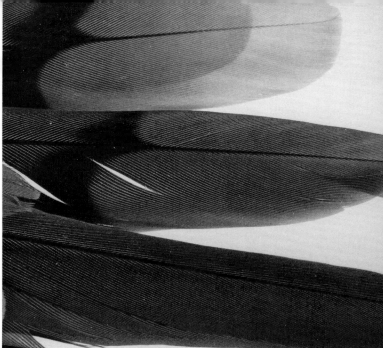

Figure 168. To burn in the large quills on the upper tail, burn the first stroke on each side of the quill with the pen held perpendicular to the feather's surface. Narrow the quill as it approaches the tip of the feather. For the second part of the procedure, lay the burning pen down on its side and pull away from the quill. The quill will be at a higher level since the pull away stroke will burn away and depress the wood near the quill. Some people call this procedure "raising the quills."

Figure 169. Use a burning pen to further separate the tight connections of each set of tail feathers.

Figure 170. Note the sharp angle that the barbs come off the quills on the dove's tail feathers.

Figure 171. On the top surface of the tail, begin burning in the barbs on the shortest outside feather and work your way towards the center. Burning the barbs on the underneath feather first allows you to pull the upper feather edges tightly and smoothly over the ones already burned. You will have to turn the bird around to burn from the feather edge towards the quill so that the pen heel does not mar the barbs on the feather below. Be sure that the barbs start right next to the quill. When the quills are raised by burning them in, it is often easy not to get the barbs close to the quill since the area is already dark. The blank space between the quill and the start of the barb will not be readily apparent until the area is painted, and then "fer sure," you are going to see it!

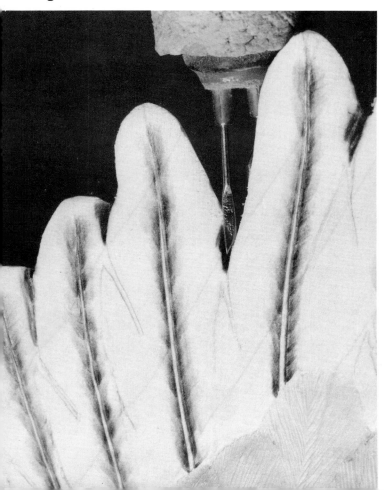

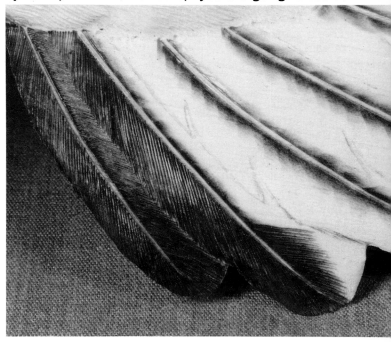

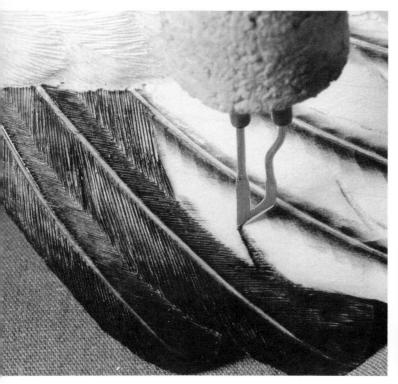

Figure 172. It will be necessary to use the point of a small burning pen tip to continue the barbs within the splits.

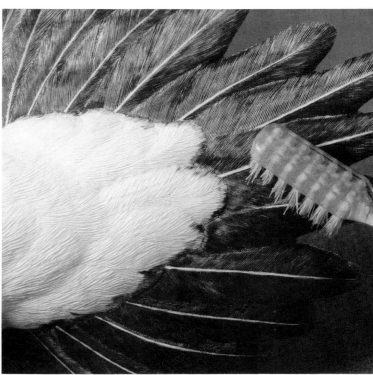

Figure 174. Clean all burning with a toothbrush to remove any loose carbon.

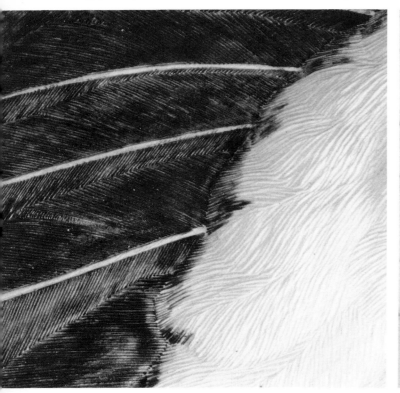

Figure 173. After you have burned both sides of the tail, working from the outside toward the center, burn the edges and tips of the upper tail coverts. Burning slightly more deeply on random barbs will create small splits that can be accentuated with darker paint.

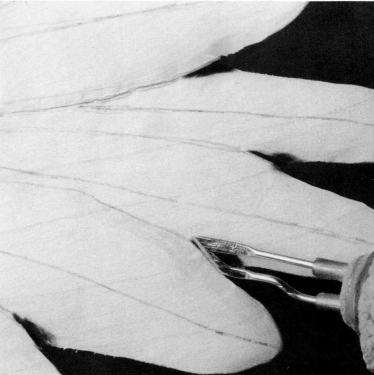

Figure 175. Draw in the quills on the underside of the tail and clean up the feather separations with the burning pen.

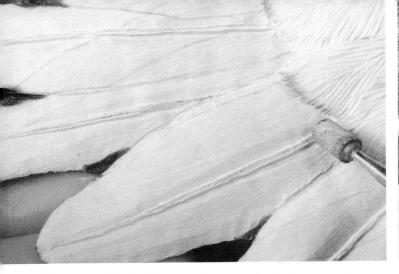

Figure 176. Quills can be carved in by running a cylindrical stone down each side of the quill line, tapering to a point near the tip. Quills on the underside of the tail and wings of every bird are more stout and strong than on the topside.

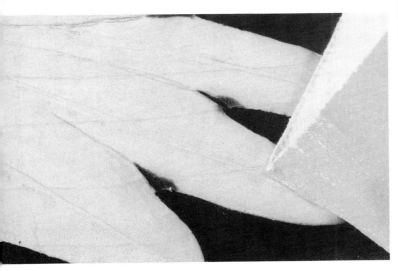

Figure 177. Lightly sand the quills' edges.

Figure 178. Begin burning in the barbs on the tail's underside at the center feathers and progress out toward the shorter ones.

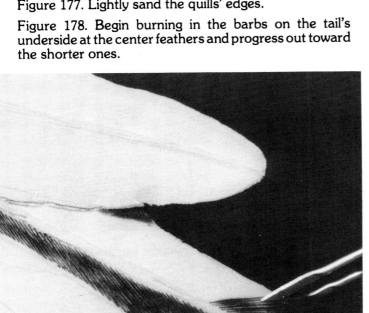

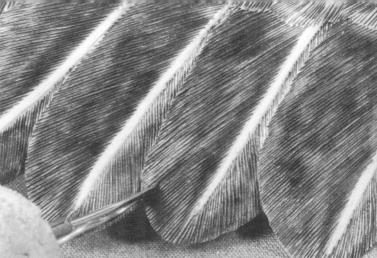

Figure 179. After all the barbs are completed, burn in a few random splits and also burn in the barbs along the tips of the lower tail coverts. Clean the burning with the toothbrush.

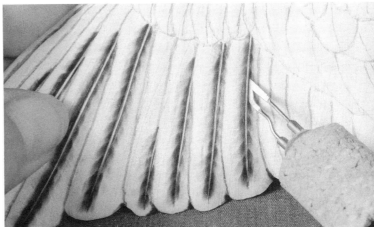

Figure 180. Draw in the quills on the top surface of the wings, paying particular attention to the direction. Refer to the wing line drawing.

Figure 181. Burn in the large quills on the primaries and secondaries in the same way as for the tail quills.

The Flying Mourning Dove 213

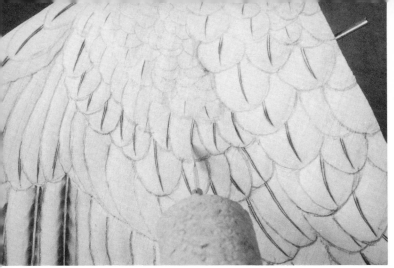

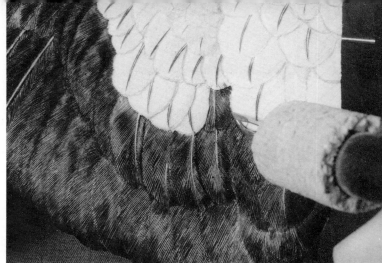

Figure 182. For the smaller quills on the wings and scapulars, just burn in two lines meeting at a point just short of the feather tip. The burning pen is held perpendicular to each feather surface.

Figure 185. Because of the reverse overlay, begin burning the barbs on the middle secondary coverts along the scapular edge and progress out toward the leading edge. Start burning in the scapulars at their tip and work each feather up toward the front wing edge as each group of coverts is completed.

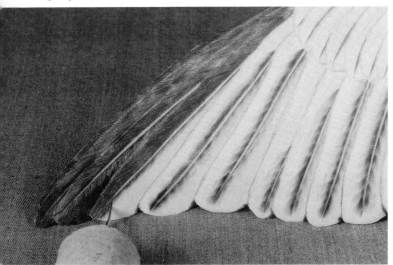

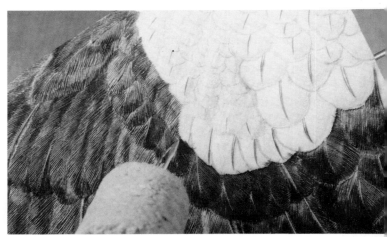

Figure 183. Begin burning in the barbs along the leading edge of the outer primary, progressing toward the secondaries and tertials.

Figure 184. Begin burning in the barbs on the primary coverts along the leading edge, working toward the great secondary coverts and then toward the scapulars.

Figure 186. Burn the barbs in on the largest alula and burn your way towards the smallest one. Begin burning in the barbs on the lesser secondary coverts out near the leading edge and progress in toward the scapulars.

Figure 187. Burn in the barbs on the marginal coverts along its outer edge and work towards the front of the wing. Finish burning in the scapulars. Clean the burning with the toothbrush.

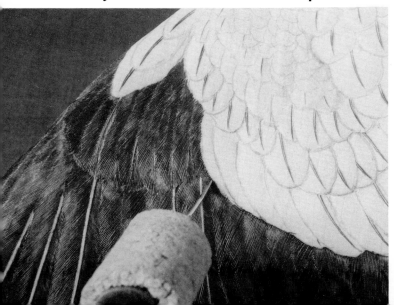

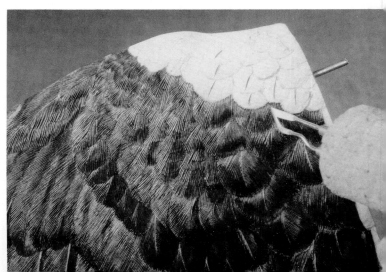

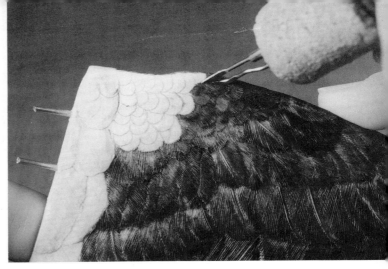

Figure 190. Burn your way up toward the inside front corner of the wing.

Figure 188. Draw in the quills on the underside of the wings, pay particular attention to the direction and origination of the feather. Using a small cylindrical stone, relieve a little wood from each side of the quill line tapering to a point near the feather tip. Lightly sand the sharp corners of the quills.

Figure 189. Burn in the quills on the smaller feathers. Begin burning in the barbs on the tertials and secondaries, progressing out toward the primaries. Begin burning in the barbs on the remainder of the underwing, always burning the feather underneath and then the one on top.

Figure 191. I am going to describe the procedure that I used for making the support and base for this particular piece. Pick and chose what suits the setting for your dove. This whole procedure should spark some creative ideas for various settings.

To make the support for the dove, a strong piece of a cedar branch was chosen. A piece of 16 gauge galvanized wire was glued into the angled end of the branch.

Figure 192. At this point, I had not carved the reflection. The cedar branch was hot-glued to a scrap piece of 2 x 10 lumber.

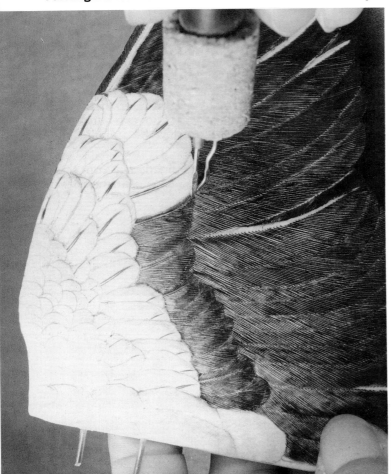

Figure 195. A good bit that cuts and grinds away brass is a cut-off wheel on a mandrel. The hole near the bend is for the toe support. The hole the bit is opening is for another sprout coming off the branch.

Figure 193. Near the base of the branch, I channeled out an area for the ⅛" brazing rod bent to shape.

Figure 194. I inserted into the working base another piece of brazing rod at the same angle as that coming off the branch. Using brass tubing of successively smaller diameters, I constructed the "branch" that would fit over the brazing rod. Each piece was cut and the ends lightly sanded to provide good adhesion for the silver solder.

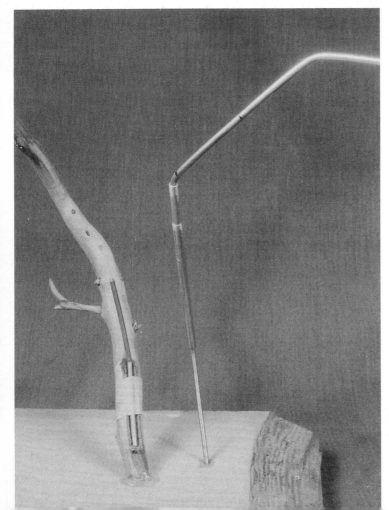

Figure 196. The joints have been fluxed and silver soldered using a small butane torch. Silver solder is a stronger solder for supportive joints. When using silver solder, the tubing itself should be heated with the flame. The heat and the flux inside the joint will cause the solder to be sucked into the joint, just as in sweating pipe joints in plumbing.

Figure 197. A pair of dove feet castings is helpful as a model for constructing feet.

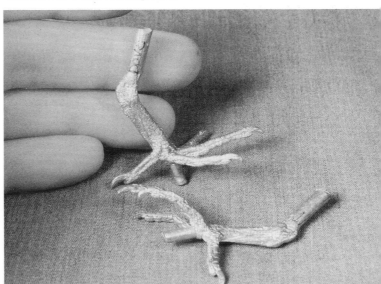

Figure 198. The proper diameter holes were drilled rather deeply into the body at the proper angle. The foot part (a short piece of tarsus and the middle toe) in the foreground is the dangling foot and is made out of 14 gauge copper wire. The 3/32" brazing rod in the background is for the supportive foot.

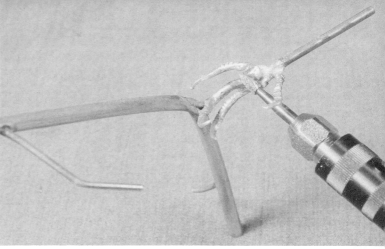

Figure 201. The inner, outer, and hind toes for the supportive foot were made and silver soldered to the main toe joint. The carbide cutter is cutting away some excess solder from under the footpad area.

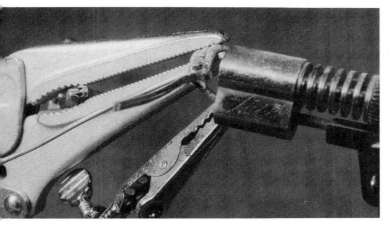

Figure 199. The toes (armature wires for the ribbon putty) for the non-supportive foot were constructed according to the instructions at "Feet Construction" in *Basic Techniques*.

Figure 200. The part of the middle toe of the supportive foot was silver soldered into the brass tubing. The remainder of the middle toe was fashioned out of 14 gauge copper wire and silver soldered so that it appeared to come straight back off of the support part of the toe/rod.

Figure 202. Silver solder the brass tubing/branch to the bent support rod. Super-glue the ⅛" support rod into the channel. Sprinkling the glue with ordinary kitchen baking soda provides a strong and quickly hardened surface.

Figure 203. Tears came into my eyes when I put the dove on its support foot. It really does fly!

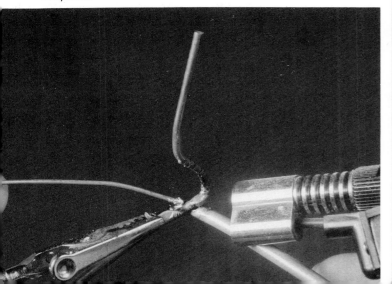

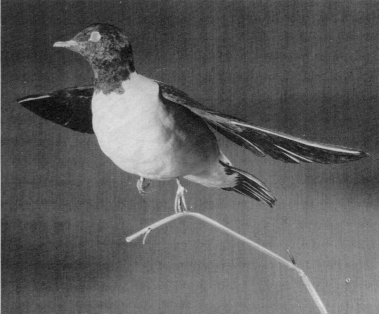

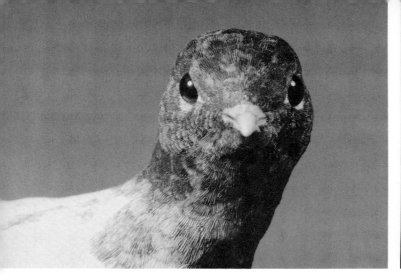

Figure 204. Fill the eye holes with clay. Clip the eye wire close to the back of the eyes. Press the eyes into clay using the wooden handle of an awl. Check and adjust for balance.

Figure 207. Cut and shape a piece of 40 gauge copper sheet into a blade of grass.

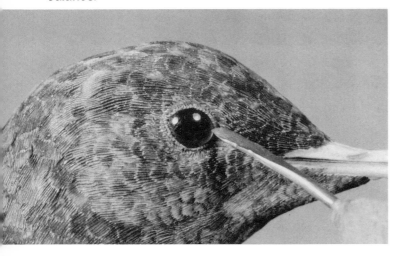

Figure 205. Set the eyes according to the directions at "Setting Eyes" in *Basic Techniques*.

Figure 206. Apply the ribbon putty to the pads and tarsi of both feet. A small amount of putty was needed to fill in around the support rod.

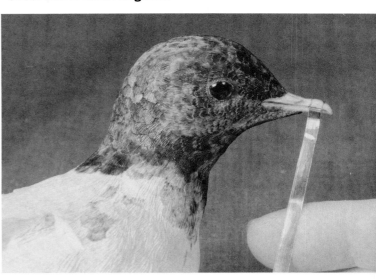

Figure 208. Cut the grass blade in half. Burn a small slit the width of the grass blade into both sides of the commissure.

Figure 209. Choose two mating squares of brass of which the smaller one snugly fits over the 3/32" brazing rod of the support tarsus.

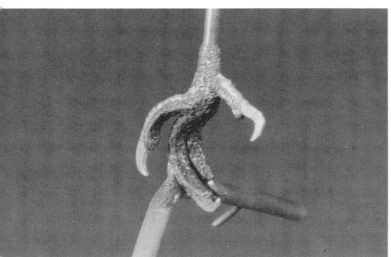

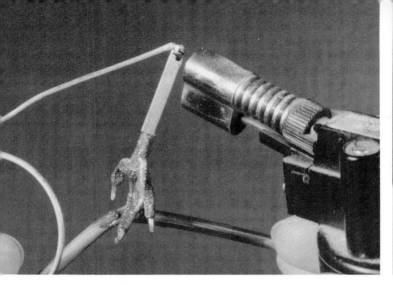

Figure 210. Silver solder a short piece of the smaller square over the rod.

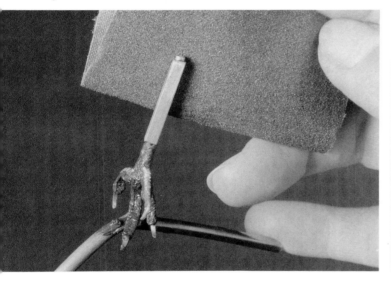

Figure 211. Lightly sand the top edge so that it will slide easily into the larger square.

Figure 212. Drill a sufficiently large hole for the size of the larger brass square. Be careful to maintain the same angle as the original hole was drilled. Mark and cut the length of the square to the depth of the body.

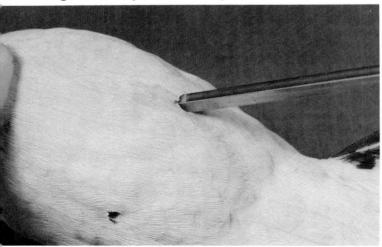

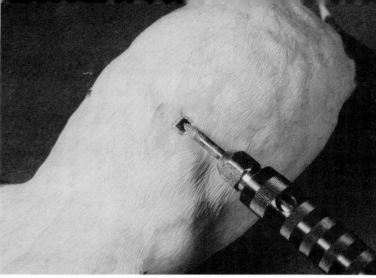

Figure 213. Tape the end of the square, insert super-glue into the hole and insert the square maintaining the proper angle and position. Use a carbide cutter to trim off any excess. Retexture any of the surrounding area saturated with glue.

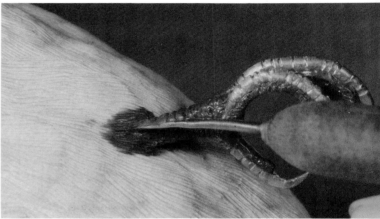

Figure 214. Glue the dangling foot in place once the putty has hardened. When the glue has dried, apply a small amount of the ribbon putty around the joint and blend into the surrounding texture. Leave a textured, feathery edge on the tarsus itself.

Figure 215. Apply a small amount of clay to a scrap piece of the smaller square that fits into the body square to keep the putty from adhering inserted piece. Apply a small amount of the putty around the square and blend it into the surrounding texture. Gently remove the scrap of square without disturbing the putty and allow it to harden.

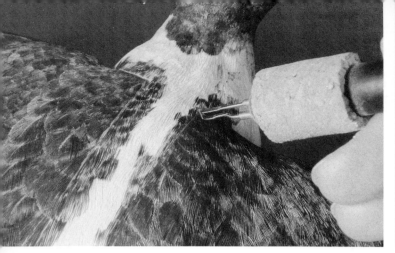

Figure 216. Super-glue the wings in place. When the glue has set, finish burning the edges of the scapulars and the feathers on the back.

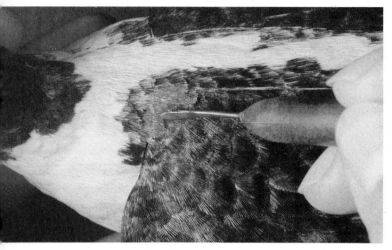

Figure 217. Use the ribbon putty to camouflage the joint, working small sections at a time. Pull the putty into the texturing along the edge of the scapulars and the surrounding back and shoulder feathers.

Figure 218. Apply the putty all the way around the joint, working in the texture as you go.

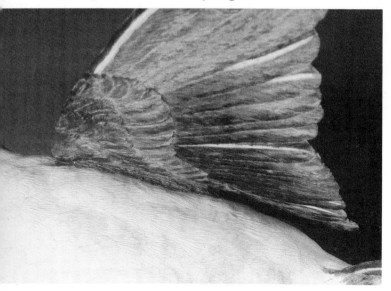

Figure 219. To make the upper branch containing the lights, brass tubing of successive diameters was used. A cut-off wheel was used not only to cut the lengths but also to cut small triangles out of the tubing so that it could be bent into naturalistic shapes.

Figure 220. The lights that were used are small self-contained units with two wires coming out of the back.

Figure 221. The lights were fitted into the proper size tubing so that they just peeked out of the ends.

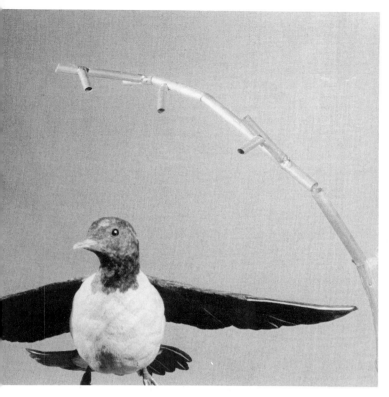

Figure 222. Here you see the upper branch with the three tubes/branches for the lights to be directed onto the dove's back. The constructed branch was fashioned to fit over the end of the natural branch.

Figure 224. The last two light wires were soldered to two pieces of 16 gauge covered wire that is connected to the battery eliminator. All of the soldered joints were insulated with nail polish and then shrink tubing. After the joints were insulated, the tubing was attached to the natural branch with a small screw. A channel was grooved down the outside of the natural branch to conceal the wires.

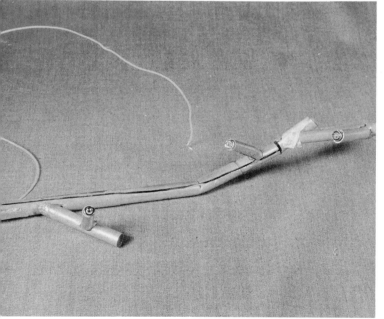

Figure 223. The lights were inserted into the tubing and wired. The two wires of the top light were wired and soldered to the two wires of the second light. Then those two wires were soldered to two wires that were connected to the two wires of the last light. It was easier to slit the brass tubing with the cut-off wheel so that the wires could be inserted and hidden.

Figure 225. Using a battery eliminator allows changes in the voltage and control in the light brightness.

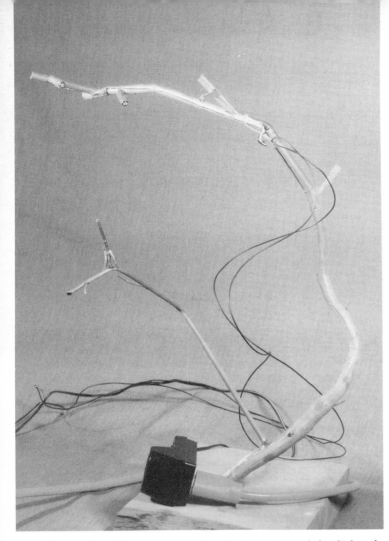

Figure 226. Here you see the first version of the lighted branch. Several weeks after the entire piece was finished, one of the lights burned out which necessitated redoing the lighted part of the branch. Since the lights are self-contained units, you just cannot unscrew the bad light bulb and screw in a new one. However, in the final version the lights do slide out of the ends and a new bulb can be resoldered to the connection.

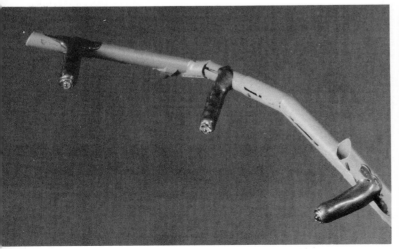

Figure 227. All of the metal parts were primed with metal primer.

Figure 228. The covering for the tubing and the branch is a mixture of model paste, gel medium, and paint. A soft grey was mixed using white, burnt and raw umbers, and black.

Figure 229. The goopy mixture was spread over the tubing and branch in several applications creating nooks and crannies simulating a natural tree branch. Sufficient drying time in between applications insures a good bond. When the goop had completely dried, I added washes of burnt umber and paynes grey with dry-brushed highlights of various mixtures of white, yellow ochre, burnt umber, raw umber, and black. It was a very playful activity working the darks and lights together to make the branch look real!

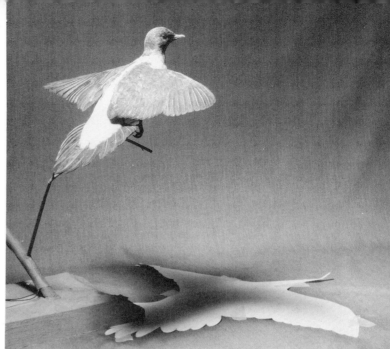

Figure 230. In order to handle the bird off the branch, a holding jig was made using the proper size brass square over brazing rod and held in a pin vise. Holding a bird during the painting process deposits skin oils on the wood surface preventing paint adhesion.

Figure 231. Seal the bird with *Krylon Spray*.

Figure 232. To get the shape of the shadow/reflection I put the bird in place in the setting. The paper pattern in the photo is the reduced size but same shape of the shadow created by the lights. The size of the shadow actually created by the setting would have overwhelmed the composition. So I used the old "artistic license" and made it smaller!

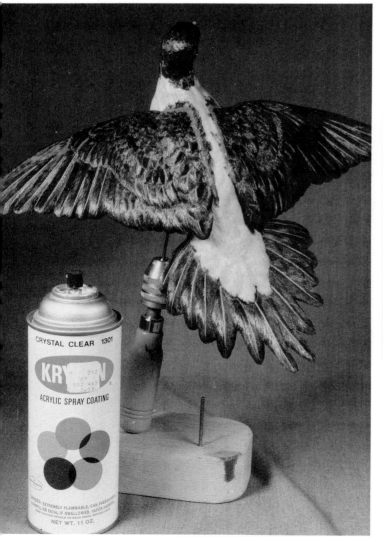

Figure 233. The pattern was used to cut the shape out of a large plank of poplar (2.5" x 20").

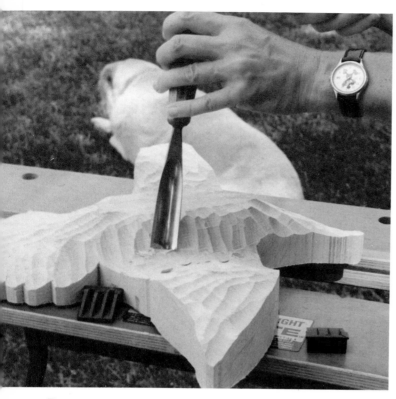

Figure 234. A large gouge and mallet was used to shape the shadow/reflection. The yellow lab in the background is Sunshine, a wonderful spirited companion!

Figure 236. One of the shadow wings was relieved to accept the branch. Before the branch was screwed into place, the shadow was stained dark and sealed.
Now, on to painting the dove!

Figure 235. The smoothing of the shadow was executed with carbide cutters and a padded drum sander.

PAINTING THE FLYING MOURNING DOVE

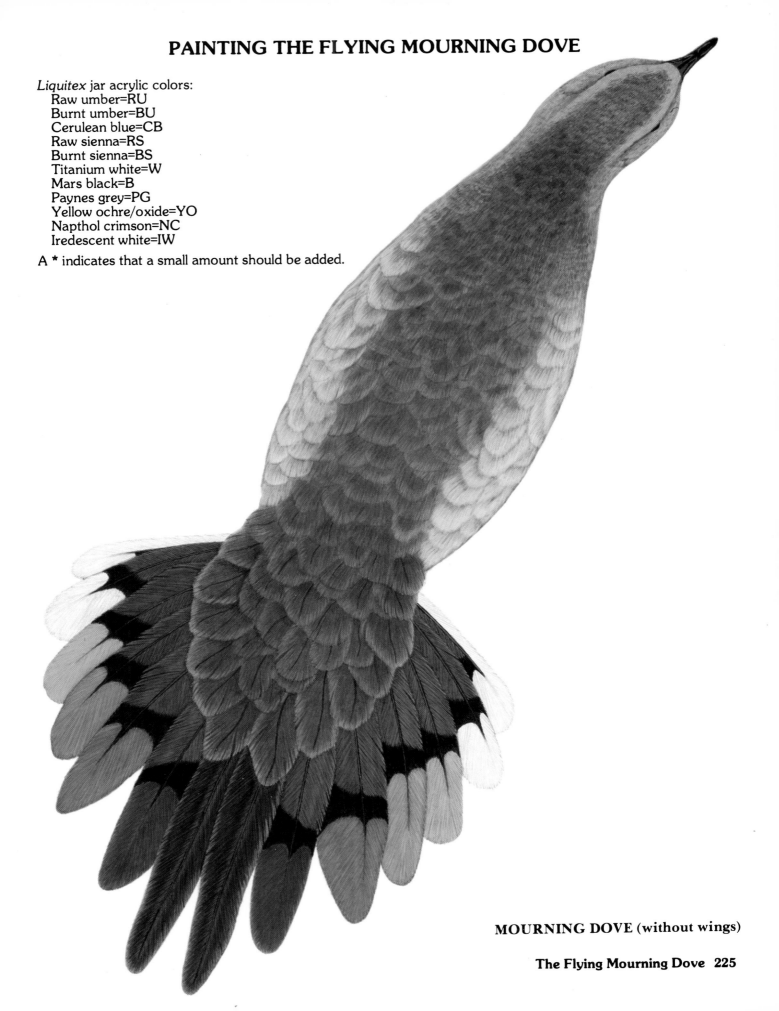

Liquitex jar acrylic colors:
Raw umber=RU
Burnt umber=BU
Cerulean blue=CB
Raw sienna=RS
Burnt sienna=BS
Titanium white=W
Mars black=B
Paynes grey=PG
Yellow ochre/oxide=YO
Napthol crimson=NC
Iredescent white=IW

A * indicates that a small amount should be added.

MOURNING DOVE (without wings)

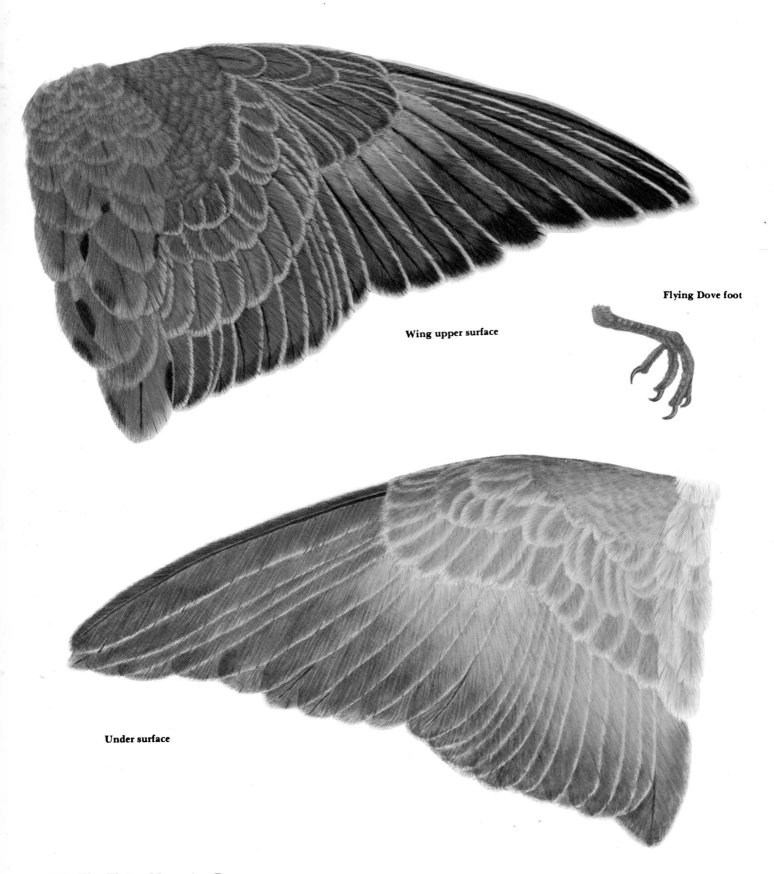

Wing upper surface

Flying Dove foot

Under surface

Figure 1. Note the soft shades of brown and grey in the scapulars and wing of the male mourning dove.

Figure 3. The dark spots just behind and below the ear coverts are evident in the profile view of the head.

Figure 2. The dark spots are very evident on the scapulars and tertials.

Figure 4. The top of the head, the back of the neck and the upper portion of the mantle are a bluish grey color.

Figure 5. The male dove's breast is a rosy beige with a light patch under the chin.

Figure 6. The breast color lightens near the upper belly.

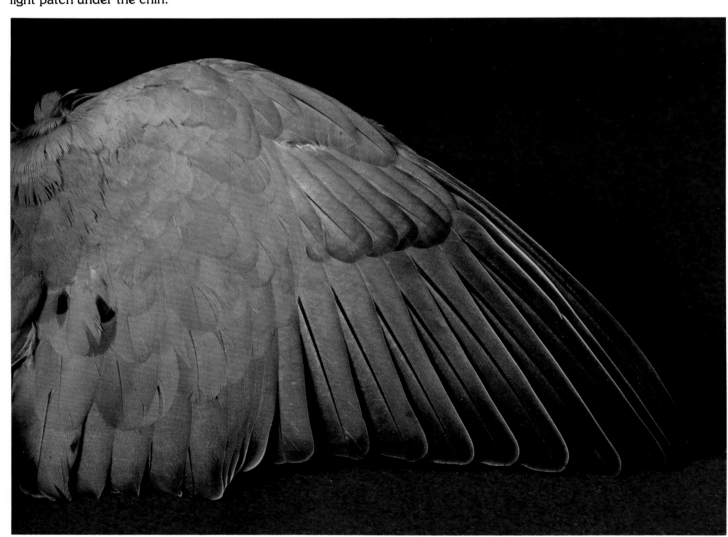

Figure 7. Note the darkening tips of the primaries, secondaries, primary coverts and the alula feathers on the top surface of the wing.

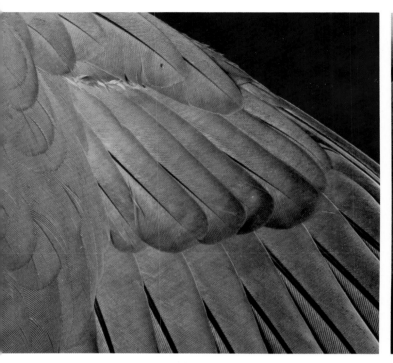

Figure 8. The dark quills contrast with the softer grey of the feathers at the base of the primaries and on the primary coverts.

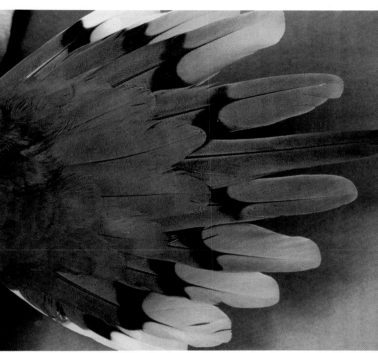

Figure 10. The spread tail of the mourning dove exhibits the progressively lighter feather tips toward the leading edge.

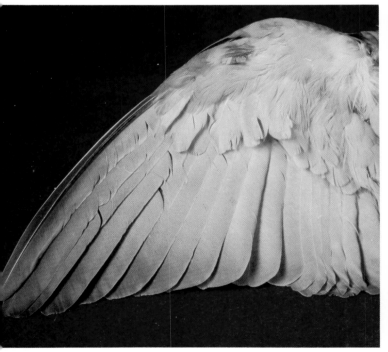

Figure 9. The underside of the wing is a softer, lighter grey.

Figure 11. Note the variation of grey and greenish brown on the middle of the tail.

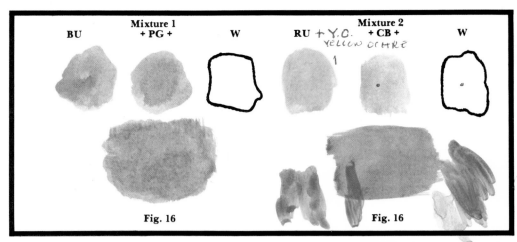

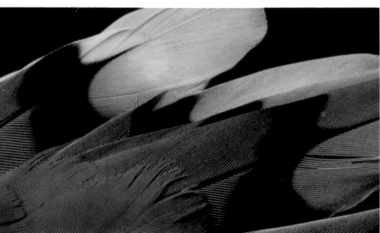

Figure 12. Note the shape of the dark striping on the outer tail feathers.

Figure 13. The underside of the tail is lighter in value than the upper surface.

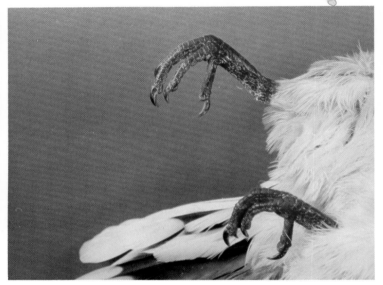

Figure 14. Note the dark pink color of the feet.

Figure 15. Using a stiff bristle brush, apply gesso right out of the jar. Adding water to gesso causes tiny pinholes to develop in the surface. Load the brush with gesso, wipe most of it on a paper towel and use a dry-brush technique scrubbing it down into the texturing grooves. The stiff brush is very important here because the firm bristles will keep the gesso from puddling in and filling up the texturing. Gesso the entire bird, feet, head, and beak included. It usually takes about two coats to even out the color differential of the stoning and burning. Sometimes, it requires a third application over the green putty areas. When the gesso is dry, carefully scrape the eyes.

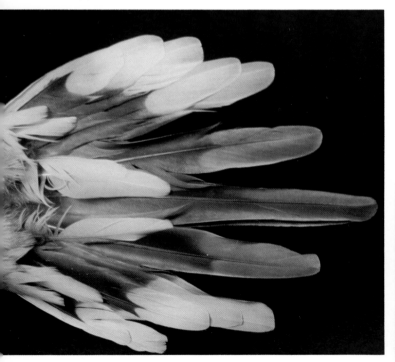

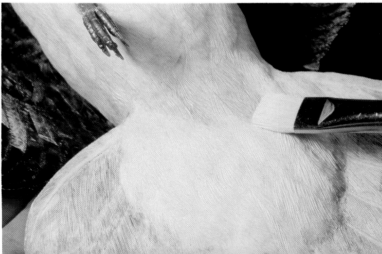

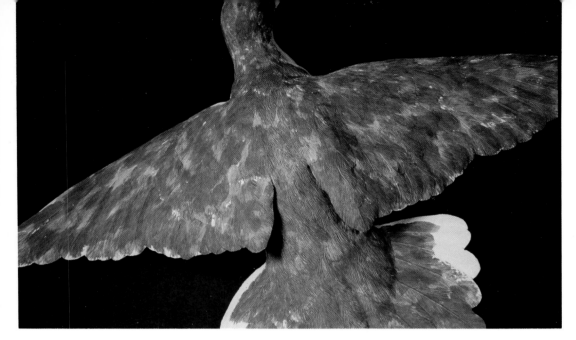

PG + *BU + *W

Fig. 19

Figure 16. Mix two puddles of paint: 1. a medium grey of burnt umber, paynes grey, and white and 2. a greenish brown of raw umber, cerulean blue, and white. Load a large round sable with the first mixture, lightly dry the brush on a paper towel and begin applying it to the bird. Concentrate the paint on the top and lightly on the sides of the head, hindneck, back, top of the wings, upper tail coverts, and on the upper surface of the middle of the tail. Do not paint on the leading edge of the shortest tail feathers or on the tips of outer three feathers on both sides. Use a dry dabbing stroke randomly placing the paint on the surface. If the paint puddles in any area, the brush has not been wiped off sufficiently.

It is not necessary to wait for this to dry. Clean the brush or use another one and load the greenish brown mixture. Dry the brush off on a paper towel and begin applying dry random dabs over the same area.

Figure 17. Keep the mixtures very thin so that the texturing is not filled up. If you find the dove getting too dark, add more white to the mixtures. Concentrate the grey mixture more on the wings, top of the head and neck, and upper part of the mantle. Making only small puddles of both mixtures will force you to mix more, since there is a lot of area to be eventually covered. Each time you mix there will be variations of the concentrations of the different colors. It is impossible to exactly duplicate any color, so relax. You want the color to be close but not exact. Using variations is a good thing because it will give the surface many subtle hues just as on the real bird. When working the colors wet, there will come a time when the brush will pull off more paint than it deposits. At this time, allow the paint to dry or dry it with a hair dryer and start again.

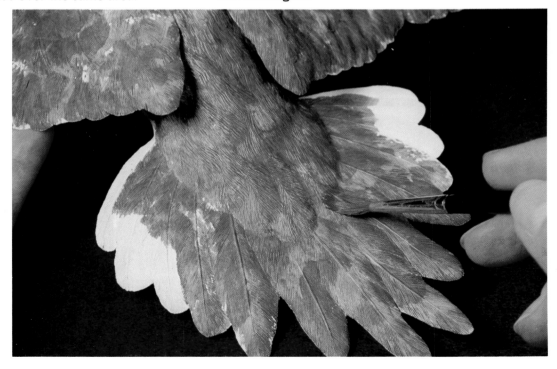

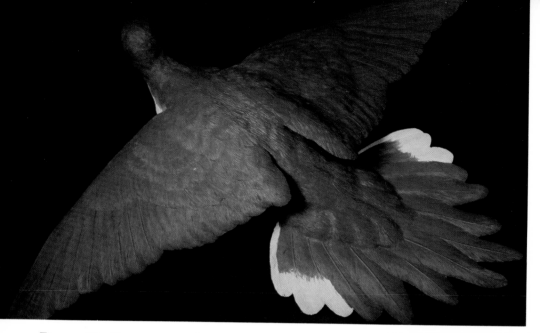

BU + *B + *W

Fig. 20

Figure 18. Continue applying the two mixtures until there is sufficient coverage over the gesso. The paint will develop a soft shine, not a sheen. If it starts getting shiny, the paint is too thick and you will need to add more water.

Figure 19. To make the wings even more grey, apply 2 very thin washes of a mixture of paynes grey, a small amount of burnt umber and a small amount of white to the alula, primary coverts, primaries, and secondaries.

Figure 20. Darken the quills on the alula, primary coverts, primaries and secondaries with a mixture of burnt umber and small amounts of black and white. Water this mixture down to darken the edges and tips of the same feathers.

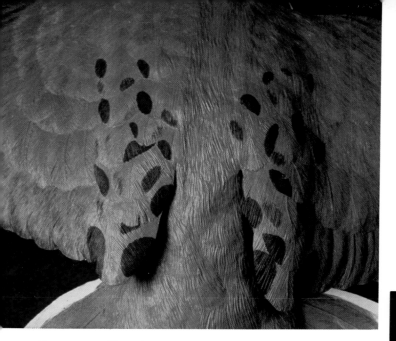

BU + RU RU + *B + *W

Fig. 22 Fig. 23

Figure 21. For the dark spots on the scapulars and tertials use a mixture of burnt umber and black. Some of the spots on the real bird are very subtle. Use a dry-brush technique to do these. The majority of the spots are fairly heavy and you will have to use several applications of the mixture to get sufficient coverage.

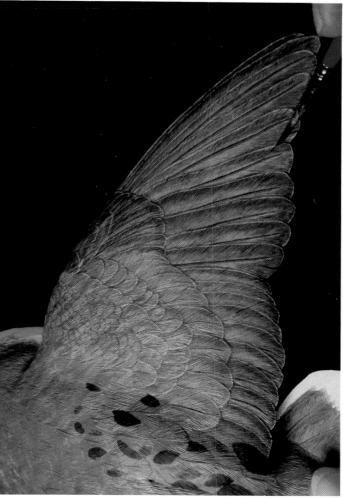

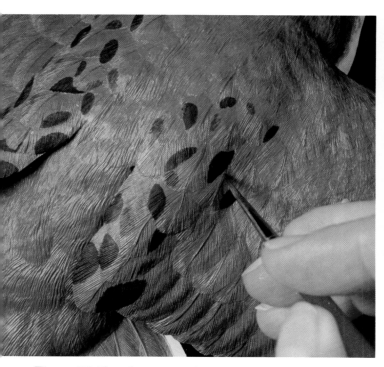

Figure 22. For the remainder of the quills on the wings and scapulars, use a mixture of burnt umber and raw umber. A fine liner brush is useful for quills and narrow lines.

Figure 23. Lighten just the tips (approximately ⅛″) with a mixture of raw umber and small amounts of black and white. Use this same mixture to pull a fine line edging on lesser, middle and greater secondary coverts, alula, primary coverts, primaries, and secondaries. Mixing raw umber and a small amount of paynes grey, pull a fine line edging on the marginal coverts. Add a little more water to this mix and paint in a shadow line along the base of each feather on the entire wing. Small feather splits can be accentuated with this mix.

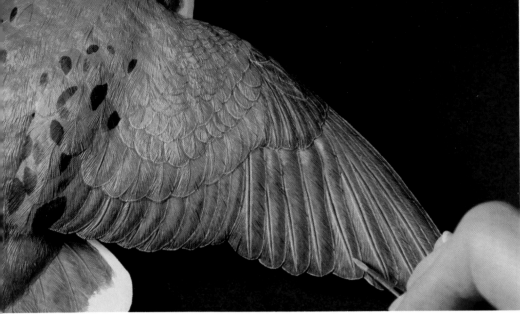

Fig. 26

Figure 24. With a thin mixture of white, raw umber, and paynes grey, lighten both sides of the feather area next to the quills of the alula, primary coverts, primaries, and secondaries. Also apply this thin mixture to the bases of the primaries just below the primary coverts.

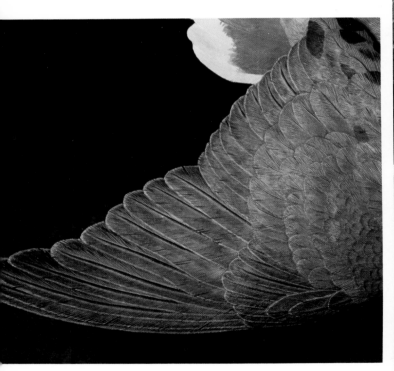

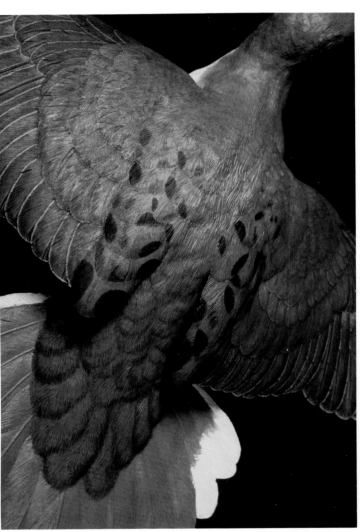

Figure 25. When this is dry, apply two super-watery raw umber washes to the wings and scapulars, drying in between. When these are dry, apply two super-watery washes of a mixture of cerulean blue with a small amount of paynes grey added to the wings and scapulars. Doing the edges, shadows, highlights, and washes several times will render the feathers very soft. Yes, it takes time. There are no shortcuts to softness.

Figure 26. Dry-brush wide edgings on the scapulars, back, rump and upper tail coverts with a mixture of burnt umber and a small amount of paynes grey. Apply two very thin burnt umber washes to the scapulars. When these are dry, apply two very thin raw umber washes.

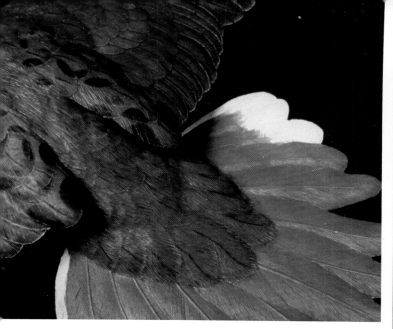

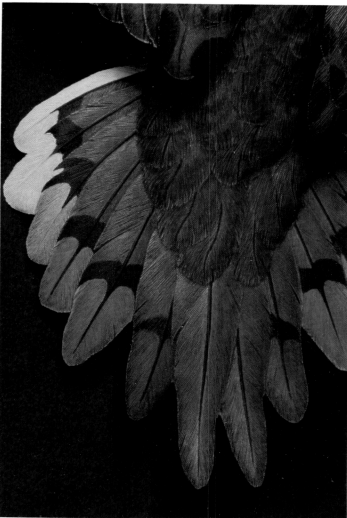

Figure 27. Lightly highlight the bases of the larger upper tail coverts with a light grey mix of raw umber, paynes grey, and white. Darken the quills and the centers of some feathers on the upper tail coverts and rump with a mixture of raw umber and small amounts of black and white. On the large upper tail covert quills, use a mixture of raw umber and black. When these are dry, apply two very thin washes of a mixture of raw umber and raw sienna.

Figure 28. For the dark arrow-shaped patterns and the quills on the upper surface of the tail feathers, use a mixture of burnt umber and black. It will take several thin applications for sufficient coverage. If you were sloppy applying the first two dry dabbing mixtures as I was, you will need to clean up the leading edge of the shortest feather and the two outer tips with straight white paint. Apply a thin white wash to lighten the tips of the third, fourth, and fifth feather (counting from the outside edge). Except for the two long center feathers, apply several thin washes of a mixture of burnt umber, black, and a small amount of white to the base of the tail feathers. Use this grey color to blend the dark arrow-shaped pattern edges into the color of the feather bases.

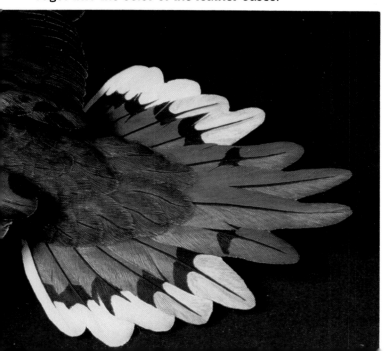

Figure 29. Blending white with small amounts of raw umber and paynes grey to a light grey, paint the shortest feather's outer edge and tip, and the tip of the second feather. Add a little more raw umber and paynes grey to the mixture and paint the third tip on both sides. Add a little more raw umber and paynes grey to that mixture and paint the fourth tip on both sides. And yes, one more time, add a little more raw umber and paynes grey and paint the fifth tip on both sides. Don't shoot, but you will need to go back and do this again. Use a light grey wash of a mixture of white, raw umber and paynes grey along side of each quill. Darken all of the splits with a color darker than the part of the feather exposed. You will need straight black in some cases, or dark grey, medium grey, and possibly light grey depending on the split's location. Use a thin medium grey mixture of raw umber, paynes grey, and white lightly along each feather edge. To lighten the edges of the tips of the third, fourth, and fifth feathers, you will need to add a little more white to this mixture.

When all this is dry, apply a very thin burnt umber wash to the entire tail except the shortest feather leading edge and tip and the tip of the second feather. For these white areas, you will need to use a thin wash of a mixture of white and a small amount of raw umber.

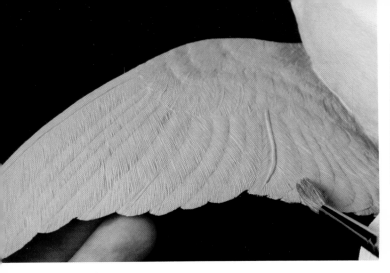

W + RU + PG	RU + PG + *W	BS + BU + YO + W	W + YO + RU
Fig. 30	Fig. 31	Fig. 33	Fig. 33

Figure 30. All of these next steps will be for the underwing and flanks. Apply several thin coats of a mixture of white, raw umber, and paynes grey. Work carefully along the wing's edges so that this lighter mixture does not track onto the top side.

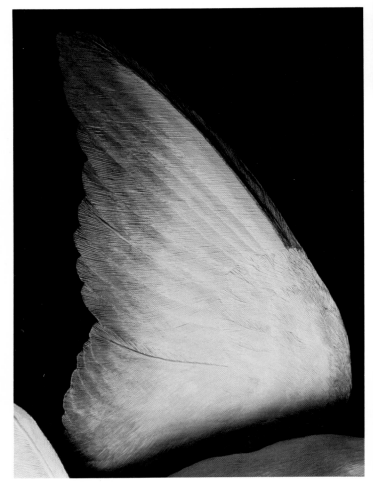

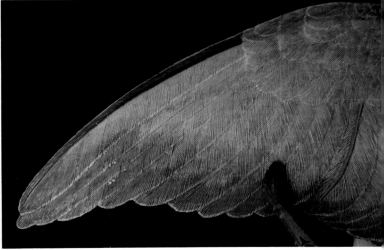

Figure 31. Using a blend of raw umber, paynes grey, and a small amount of white, darken the leading edge of the outer primary, the tips of the primaries, secondaries, and tertials, and the leading edge of the wrist. Blend the basecoat color into the edges of the darker color until there is a soft blend transition. Darken the quills of the primaries and secondaries with the darker grey.

Figure 32. Edge all of the underwing feathers with a blend of white with a small amount of raw umber. When these are dry, apply a thin wash on the underwings with a mixture of paynes grey, burnt umber, and a small amount of white.

Figure 33. On the breast and belly, apply a mixture of burnt sienna, burnt umber, yellow ochre, and white. While this mixture is still wet, add a little white to the center of the belly and brush out. It will take several applications of the basecoat to get sufficient coverage. This basecoat should cover the throat and chin. While it is still wet, blend straight white into the chin area. For the lower tail coverts, apply a mixture of white, yellow ochre, and raw umber. Blend this into the belly basecoat color at the vent.

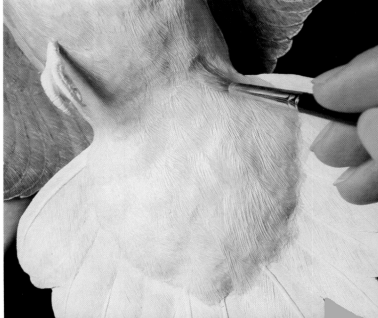

Figure 34. Blend the belly basecoat color into the light grey on the flanks. Work the two colors back and forth until there is a soft transition area.

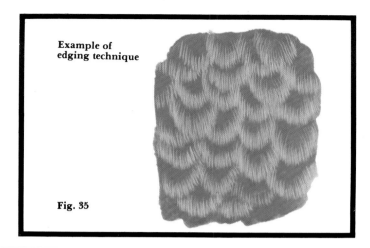

Example of edging technique

Fig. 35

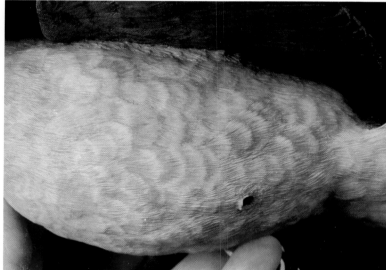

Figure 36. For the flank edgings, add more white to the grey mixture and pull wide edgings on each feather. Add water to the whitish mixture and wash the edged area.

Figure 37. For the belly and breast edgings, add more white to the basecoat color and pull wide edgings on each feather. Add water to the mixture and wash the belly and breast edgings. Do all of the edgings again and apply the appropriate washes.

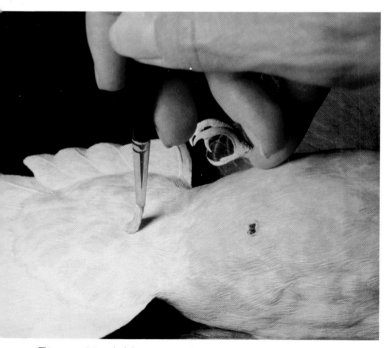

Figure 35. Add more white to the lower tail covert basecoat color and edge all of the feathers. Note the angle that the brush is held. The brush is a #4 round sable. I anchor my hand with my little finger, hold the brush vertical to the bird's surface, and pull the edging from the tip for approximately ⅛" and gradually lift the brush up. This type of pulled edging gives a soft feathery look to the feathers. Add a lot of water to the whitish mixture and wash the edged area.

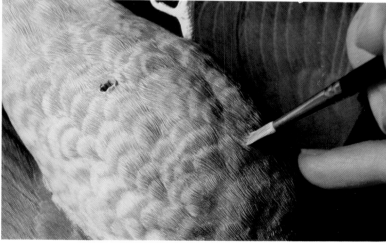

The Flying Mourning Dove 237

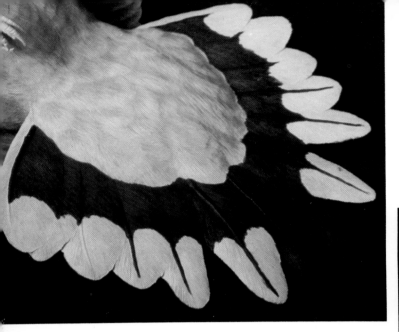

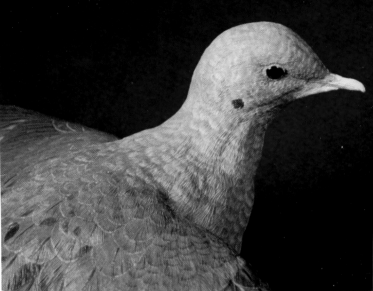

Figure 38. For the underside of the tail feathers, apply a mixture of burnt umber, black, and a small amount of white to the bases of all the feathers except the leading edge of the shortest ones. Also paint the quills of the fourth, fifth, and sixth feathers. Apply several black washes to correspond with the location of the dark arrow-shaped patterns and the quills of the longer feathers.

Figure 39. Mix a light grey from white with small amounts of raw umber and paynes grey, and apply to the leading edges of the shortest feather and tip, and the tip of the second feather. Add a little more raw umber and paynes grey to the mix and paint the third feather tip on each side. Yep, here we go again! Add a little more raw umber and paynes grey to that mix and paint the fourth feather tip on both sides. Then, add more you know what and do the fifth and more you know what and, ta-da, the sixth! Lighten the bases of the quills of the four center feathers with a mixture of white and raw umber. Wash the dark parts of the undertail with a very thin raw umber wash. Wash the light parts with a very thin mixture of white with a small amount of raw umber. TA-DA!! That's a big ta-da because you are done with the under tail!

Figure 40. On the top of the head and on the hindneck, dry dab a mixture of paynes grey, raw umber, and white. Blend this into the mantle basecoat color and into the breast color on the side of the breast and neck. Add white to the grey mixture and edge the feathers on the head, neck, upper mantle, and side breast. Give the grey areas a thin wash of a mixture of paynes grey, raw umber, and white. Apply a super thin cerulean blue wash to the top of the head and back of the neck.

On the sides of the head and neck, and on the forehead, dry dab a mixture of burnt umber, raw sienna, and white. For the dark spots just below the back of the ear coverts, use a mixture of burnt umber, black, and a small amount of white to a dark charcoal color. On the sides of the head, apply a super thin wash of a mixture of burnt umber, raw sienna, and white.

Figure 41. Carefully clean the paint off the eyes. For the eye ring, apply a mixture of cerulean blue and small amounts of raw umber and white. When dry, carefully scrape the eye again.

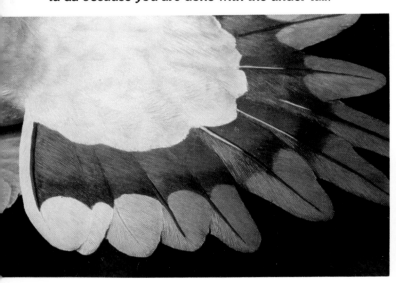

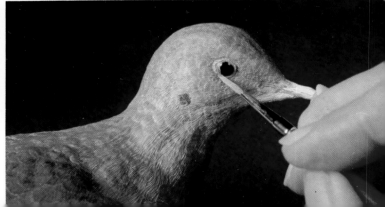

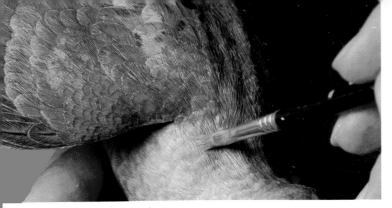

NC + 1W + W + *CB	NC + PG + BU + W	BU + B + *W

Fig. 42 Fig. 43 Fig. 44

Figure 42. For the iridescent patches on the shoulders, make a mixture of naphthol crimson, iredescent white, white, and a small amount of cerulean blue. Load a small sable bright (a short, square brush) with the mixture and clean almost all of the paint out on a paper towel. Lightly dry-brush a hint of color on the shoulder patches. It is much easier to apply this too lightly and have to add a dab more, than it is to have to repaint the shoulders because you got too much pink on them!

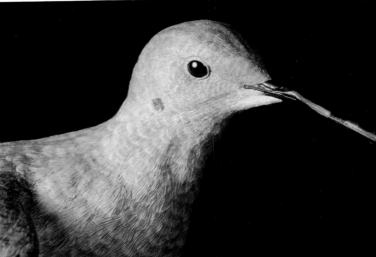

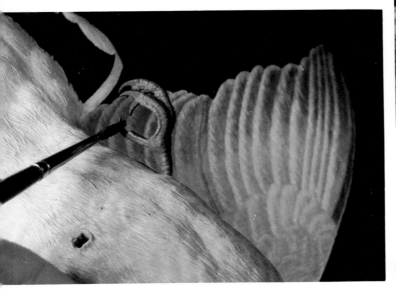

Figure 44. For the beak, apply a mixture of burnt umber, black, and a small amount of white. Before this dries, wet-blend naphthol crimson to the base of the beak at the commissure line. It will take several coats of the charcoal color to sufficiently cover the gesso. When these are dry, apply a 50/50 mixture of matte and gloss mediums.

Figure 43. For the feet, apply basecoats of a mixture of naphthol crimson, paynes grey, burnt umber, and white. When these are dry, apply a washy mixture of burnt umber and white. Apply straight burnt umber to the claws. When these are dry, mix a small amount of gloss medium in a large puddle of water and apply to the feet. When this is dry, apply straight gloss to the claws and quills on the top and under surfaces of the wings and tail.

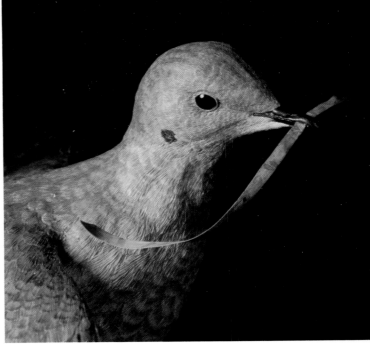

Figure 45. Apply metal primer to the piece of grass that was previously fitted in the beak. When this is dry, apply a mixture of raw sienna, burnt umber and white for the basecoats. Spatter spots of white and burnt umber to give that natural look. When dry, apply two coats of matte medium. When these are dry, dab the cut end that goes into the beak in a small amount of super-glue and put it in the slit in the beak. Glue the other piece in place.

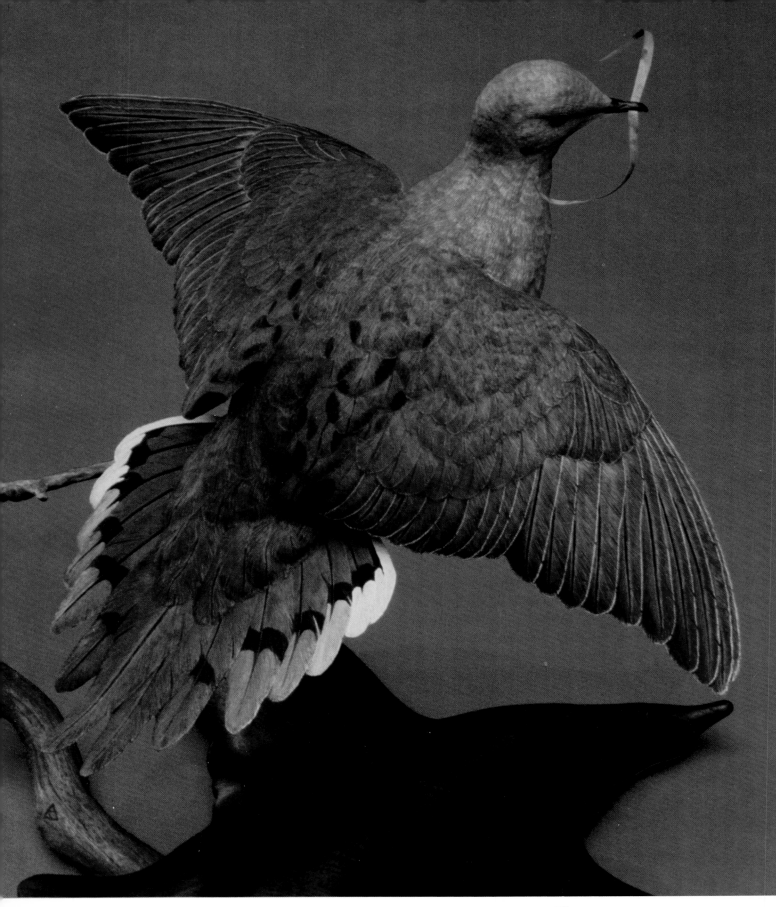

Figure 46. I saved the biggest TA-DA for last! The finished dove, up, up and away!